Things That Talk

Things That Talk

Object Lessons
from Art and Science

edited by Lorraine Daston

ZONE BOOKS · NEW YORK

2004

© 2004 Lorraine Daston
ZONE BOOKS
1226 Prospect Avenue
Brooklyn, New York 11218

Printed in the United States of America.

Distributed by The MIT Press,
Cambridge, Massachusetts, and London, England

Library of Congress Cataloging-in-Publication Data

Things that talk : object lessons from art and science
/ Lorraine Daston, editor.
 p. cm.
 Includes bibliographical references and index.
 ISBN 1-890951-43-9 (cloth)
 1. Art and science. 2. Semiotics and art.
 3. Object (Aesthetics). 4. Object (Philosophy).
 I. Daston, Lorraine.

N72.S3T55 2004
701'.1 — dc21 20033053811

Contents

Things That Talk

Lorraine Daston

This book was written by a working group of historians of art
and historians of science who met three times over the course of
the academic year 2001–2002 at the Max Planck Institute for the
History of Science in Berlin to discuss, write, and rewrite their
essays. Although each essay is the work of an individual author,
and each is indeed strongly voiced, all went through multiple
drafts, shaped by our energetic group discussions in ways that
none of the authors could have predicted at the outset of the pro-
ject. This is a form of intensive collaboration especially well suited
to interdisciplinary projects, which usually require a shift in per-
spective as well as instruction in the details of a new topic. But
constraints of time, space, and support — as well as of patience and
ingrained intellectual habits — often mitigate against such collabo-
rations. Hence the participants in the working group are grateful
to the Institute for its hospitality (especially to Carola Kuntze and
Doris Müller-Ziem) and support, and the Institute is still more
grateful to the participants for their generous gifts of time, intelli-
gence, and hard work to the project. The members of the group
also profited greatly from the comments of three guests who
attended one or another of our three meetings and whom we
thank warmly for enlivening and enlightening our discussions:

James Clifford from the University of California at Santa Cruz, Ken Goldberg from the University of California at Berkeley, and Miguel Tamen from the University of Lisbon and the University of Chicago.

INTRODUCTION

Speechless

Lorraine Daston

> Unfortunately poetry cannot celebrate them
> [scientists], because their deeds are concerned with
> things, not persons, and are, therefore, speechless.
> — W.H. Auden, "The Poet and the City" (1963)

Imagine a world without things. It would be not so much an empty world as a blurry, frictionless one: no sharp outlines would separate one part of the uniform plenum from another; there would be no resistance against which to stub a toe or test a theory or struggle stalwartly. Nor would there be anything to describe, or to explain, remark on, interpret, or complain about — just a kind of porridgy oneness. Without things, we would stop talking. We would become as mute as things are alleged to be. If things are "speechless," perhaps it is because they are drowned out by all the talk about them. These essays are an attempt to make things eloquent without resorting to ventriloquism or projection. From a miscellany of things drawn from the preoccupations of historians of art and historians of science, this book explores the meaning of things in situ, gaze fixed firmly on this or that thing in particular rather than on the ontology of things in general. Yet although we write as historians in the manner of historians, in

9

gritty detail about specifics, we are indebted to philosophical and anthropological reflections about things, and we hope that these essays will in part repay that debt by showing how variously things knit together matter and meaning. This variety suggests that not just things-as-they-are but thing-making may be rich in surprises relevant to philosophical questions about evidence and meta-physics and to anthropological concerns about significance and salience.

Each essay examines a thing; these things are the dramatis personae of the book. It is not always easy to explain briefly and colloquially what the thing in question is or wherein its thingness inheres — fruitful quandaries to which I will return below. More-over, some of the things in question are individuals, others are genera, some are in between. Indeed, all of these things exhibit a certain resistance to tidy classification, though they are all of a sort to be seen, touched, and otherwise dealt with in the manner of tables, pencils, and other banalities. They are neither mermaids nor quarks. But it should be kept in mind that both "talk" and "things" are terms that require further illumination. For the sake of orientation and a first approximation, here is our list of things: Hieronymus Bosch's drawing *The Treeman*, the eighteenth-century freestanding column, Peacock Island in the Prussian river Havel, soap bubbles, early photographs entered as courtroom evidence, the Glass Flowers at Harvard, Rorschach blots, newspaper clip-pings, and certain paintings by Jackson Pollock as seen by the critic Clement Greenberg. This is a motley crew; no attempt was made to make it more homogeneous along conventional dimensions of similarity.

Why these things and not others? Surely any number of lists, all of them just as reminiscent of the entries in a Borgesian ency-clopedia as this one, might have been generated by another group; we lay absolutely no claim to the unique suitability of this list to

show how things talk. It was the list of things chosen by the members of our group, and obviously shaped by our idiosyncratic interests and backgrounds. But they are not the things we would have written about without the collective challenge to write about things in all their obdurate objecthood. These are the things that made each of us want to talk about how these particular things talk to us. They are objects of fascination, association, and endless consideration. We noticed early in discussions of our drafts that the essays were, for better or ill, unusually voiced by the ordinary standards of disciplinary prose. By some process of reciprocity, our things individualized us as we picked them out of all the possibilities. What these things have in common is loquaciousness: they give rise to an astonishing amount of talk. We are interested in how talkativeness and thingness hang together.

First, talk. The things in these essays talk; they do not merely repeat. They are not instruments for recording and playing back the human voice. Recall that the fates of Echo and Narcissus are intertwined in the same Ovidian tale — not only because echoes mimic reflections in another medium but also because the lovelorn nymph Echo falls victim to Narcissus's self-absorption in his own image. Narcissism was originally a certain self-regarding (and ultimately fatal) conceit that reduces others to repeat what is said to them. Cartesian anthropocentrism, which asserts a monopoly on language for human beings, is a form of narcissism that condemns things merely to echo what people say. As Descartes pointed out in the *Discours de la méthode* (1637), genuine language must be inventive and apt, capable of an indefinite number of utterances that suit the circumstances in which they are uttered. Hence parrots and all manner of parroting devices, from echo chambers to tape recorders, are disqualified from true speech. Descartes believed that language was distinctively human, a criterion for distinguishing *anthropos* from automaton. Yet the things treated in

11

these pages manifest something of the plenitude, spontaneity, and fitness of utterance Descartes ascribed to language. Even if they do not literally whisper and shout, these things press their messages on attentive auditors — many messages, delicately adjusted to context, revelatory, and right on target. Skeptics will insist that all this talk of talk with respect to things is at best metaphoric and at worst a childish fantasy about tongues in trees and books in brooks. Accept these doubts for the sake of argument: there is still the puzzle of the stubborn persistence of the illusion, if illusion it be. If we humans do all the talking, why do we need things not only to talk about but to talk with?[1]

Historically, things have been said to talk for themselves in two ways, which, from an epistemological point of view, are diametrically opposed to one another. On the one hand, there are idols: false gods made of gold or bronze or stone that make portentous pronouncements to the devout who consult them. Even in Antiquity, opinions differed as to just how the idols spoke: priests hiding in the temple basement speaking through cleverly hidden tubes, or demons masquerading as effigies of Apollo or Zeus? But at least in the Judeo-Christian tradition, there was unanimity that whatever an idol said was *ipso facto* untrustworthy, intended to manipulate and deceive. The very word "idol" became a metaphor for epistemological error, as in Francis Bacon's idols of the cave, tribe, marketplace, and theater.[2] An odor of fraud and folly hangs about this sort of talking thing. On the other hand, there is self-evidence: *res ipsa loquitur*, the thing speaks for itself. It does so in mathematics, law, and religion. Geometric self-evidence comes in the form of axioms and postulates about spatial magnitudes too blindingly obvious to require (or admit of) demonstration: for example, the whole is greater than the part.[3] In early-modern European legal codes, certain pieces of material evidence were called "violent presumptions" and deemed almost

equivalent to full proof of guilt, as opposed to merely "probable indices": the bloody sword in the hand of the murder suspect versus the pallor of a woman believed to be pregnant.[4] Finally, within Christianity, miracles were almost always worked in things, be it the body of a cripple suddenly made whole or the water turned to wine at the wedding feast, and constituted an immediate and irrefragable token of God's will.[5] In all these cases, the talking thing spoke the truth, the purest, most indubitable truth conceivable. The chief reason why the truth was so pure was that it had been uttered by things themselves, without the distorting filter of human interpretation.

Several of the essays in this volume testify to the enduring ambivalence of idols versus evidence that still surrounds things that talk. What is particularly disconcerting is that both extremes of the epistemological polarity appear to work by the same mechanisms of reversal and replacement. The things Bosch depicted in his drawings and paintings threaten to turn the tables on spectators: "potentially active agents that engage with viewers as if *they* (the artworks) were the persons and their viewers were mere things." They are depicted with hyperreal verisimilitude because they are more real (and therefore more efficacious) than the wordly things they seem to be. A similar fear of the counterfeit usurping the place of the real, the idol replacing God, provoked the horrified response of some botanists to the Glass Flowers, which were to replace the plants themselves. Although the valuation flip-flops from negative to positive, early arguments concerning the use of photographs as courtroom evidence in the United States exhibit a symmetrical logic. Opponents contended that the photograph was a pale substitute for firsthand evidence, the "hearsay of the sun," and therefore inadmissible; proponents also stressed that the photograph was a substitute, but this time for the mental images stored in memory on which witness testimony was based

— zerohand evidence, as it were. Whether the thing at issue purportedly replaces people or nature, whether it is imagined as agent (the artwork) or patient (the photograph), there is something *unheimlich*, either demonic (the idol) or divine (the miracle), about its impostures.

No one has written more perceptively about the impostures, or, as he called them, the "mythologies," surrounding things than the French critic Roland Barthes. For Barthes, the things around which the mythologies of modern bourgeois life were woven — Einstein's brain, the Citroën DS 19, laundry detergents — also spoke a language, or rather displayed a semiology, albeit of a vampirish kind. The significance of the myth was abstract ideological "form" — for example, French imperialism or transcendent technology — but one covertly nourished by the contextualized, embodied "sense" of its totem object: "a rich, real-life, spontaneous, innocent, *indisputable* image." Barthes's mythic objects talk by appropriation; myths "steal" language in order to "naturalize" contentious concepts like empire. Almost any language, even the well-formed language of mathematics, can fall prey to myth; almost any object can become a myth, "for the universe is infinitely suggestive." In this account, history and context, masquerading as nature and fact, can bend any and all things to ideological ends. The thingness of things disappears in the mythologies analyzed by Barthes, because it eludes the peculiar metalanguage of myth that flickers between form and sense: "Outside of all speech, the DS 19 is a technologically defined object: it attains a certain speed, it hits the wind in a certain way, etc. And of this reality, the mythologue cannot speak."[6]

Although these essays (and all readings of objects as cultural artifacts) profit from Barthes's insights, they query both the semiology and the plasticity of Barthes's mythic objects. Some things speak irresistibly, and not only by interpretation, projection,

and puppetry. It is neither entirely arbitrary nor entirely entailed which objects will become eloquent when, and in what cause. The language of things derives from certain properties of the things themselves, which suit the cultural purposes for which they are enlisted. It is neither the language of purely conventional connections between sign and signified nor the Adamic language of perfect fit between the two. This is the language wistfully invoked in Hugo von Hofmannsthal's short story "Ein Brief" (1902), in which the talented Lord Chandos confesses to Sir Francis Bacon that his long-awaited literary projects will never come to fruition, for there is no known language in which "the mute things speak to me."[7] These essays explore the space between these two extreme visions of the way words and world mesh together, and thereby unsettle views about the nature of both talk and things.

Second, things. The departure point for this project was a shared perplexity about how to capture the thingness of things in our respective disciplines. Given the distance separating the subject matter and methods of historians of art and historians of science, the convergence of the terms in which the dilemma was posed was striking. Joseph Leo Koerner formulates it pithily for the history of art: "Art historians today tend to be divided between those who study what objects mean and those who study how objects are made."[8] For historians of science, the polarization is starker still. Because the objects in question have long been assumed to be as inexorable and universal as nature itself, the history of inquiry into these objects — that is, the history of science — has traditionally been narrated as just as inexorable and universal. A chasm yawns between this older historiography and recent studies of "science in context," which emphasize the local character and cultural specificity of natural knowledge. Once again, the opposition between matter and meaning (sometimes tricked out as that

between nature and culture) is reproduced. On the one side, there are the brute intransigence of matter, everywhere and always the same, and the positivist historiography of facts that goes with it; on the other side, there are the plasticity of meaning, bound to specific times and places, and the corresponding hermeneutic historiography of culture. This Manichaean metaphysics is, of course, a caricature, which the work of historians of art and of science often shades and softens. But the metaphysics nonetheless exerts a powerful influence on how practitioners of both disciplines grapple — or fail to grapple — with things, those nodes at which matter and meaning intersect. Entities that lie precisely at the fault line of a great metaphysical divide tend to appear paradoxical for just that reason.

The classical philosophical treatments of things are of limited assistance in overcoming the paradox. Martin Heidegger's famous essay "Das Ding" blames the paradox on Kantian metaphysics, or, rather, on Kant's reduction of metaphysics to epistemology. The "thing" must, Heidegger insists, be sharply distinguished from the Kantian "object" (*Gegenstand*), the latter being the product of ideas and representations of the thing. The thing, by contrast, is "self-sufficient," and its essence is captured neither by its appearance as given by perception nor by scientific theories about it. Self-sufficiency does not, however, imply inertness for Heidegger; indeed, the thingness of the thing lies in its power to "gather" other elements to it: the humble jug gathers to itself heaven and earth, mortals and immortals. But Heidegger is mute on how "the thingness gathers [das Dingen versammelt]" and why it gathers these items and not others.[9]

The anthropological literature on gifts, commodities, and exchange is more illuminating on these specifics. Detailed studies examine how the same thing may become sacred or profane, gift or commodity, alienable or inalienable in different cultural con-

texts.[10] Although the materiality of things "as a physically con-
crete form independent of any individual's mental image of it"
and even specific properties like durability or corruptibility figure
prominently in some of these accounts, the accent has been on
the malleability of interpretation.[11] As Nicholas Thomas puts it:
"Hence, although certain influential theorists of material culture
have stressed the objectivity of the artifact, I can only recognize
the reverse: the mutability of things in recontextualization."[12] Since
anthropological studies are primarily concerned with things as
they are enlisted to concretize social classifications, to regulate
exchange and hierarchy, and to fashion selves and subjectivities, it
is natural that they should highlight cultural meanings.[13] But they,
too, leave the paradoxical status of the thing unresolved.

The approach of the essays in this volume has been to confront
the paradox head-on and to take it for granted that things are simul-
taneously material and meaningful. We assume that matter con-
strains meanings and vice versa. The chemical properties of pho-
tographic emulsions and the techniques of the darkroom play a
role in how photographs are construed as courtroom evidence,
but so do historical analogies with hearsay testimony. Botanical
models made of wax may be visually indistinguishable from those
made of glass, but the modeling procedures are entirely different,
and that difference in turn makes curiosities out of the one but
marvels out of the other. Certain properties of soap bubbles — elas-
ticity, thinness, fragility — lend themselves to scientific analogies
with the ether, but their fascination for Victorian men of science
also stemmed from the myriad associations of soap as commodity,
emissary of empire, and nostalgic plaything. In the case of works
of art and architecture, materiality stakes its claim at at least two
levels: in the stuff of and gestures by which the work is made, and
in the material objects depicted or invented therein. The columns
of the Panthéon and the repetitive, assembly-line movements

frozen in Jackson Pollock's *Mural* may seem more obviously material than the strange hybrids of trees and humans in Bosch's drawing *The Treeman* or than George Grosz's café scenes created out of newspaper clippings, but they are not more essentially so. Bosch's chimeras were not only constructed out of commonplace objects; they were organic fusions that showed "the impossible zones of *material* transition" between, say, tree and boat. Grosz's montages deliberately display the seams between the elements of, for example, the *Brillantenschieber im Café Kaiserhof*, but here again the matter of the subject matter matters to the *mise-en-abyme* effect: a picture of a gangster reading a newspaper made out of newspapers about gangsters.

Even the most malleable things treated in these essays have a bony materiality that makes them what they are. Since the utopian romances of the Renaissance, islands have been a favorite screen for the projection of cultural fantasies (a function taken over by planets in science fiction). The *Pfaueninsel* (Peacock Island) in the Havel River between Berlin and Potsdam served as just such a screen of projection for the fantasies of Prussian monarchs, a royal theme park that mingled Petit Trianon, South Sea paradise, English garden, and zoo. More utilitarian projects settled on the island — model farms and factories — partook equally of the phantasmagoric, alongside the fake ruins and imported crocodiles. Yet the landscape of the *Pfaueninsel* itself, its hills and hollows, set the stage for the most spectacular utilitarian phantasmagoria of all, a noisy, smoke-spewing steam engine that pumped water up to the highest point of the island, from whence it cascaded downward in showy fountains. The island's watery perimeter set it off as an object of aesthetic attention as a frame does a painting in a museum. Its situation — just right for a day's pleasure trip from Berlin or Potsdam — required visitors to set aside present preoccupations for a short journey, just as the island's attractions were figurative

journeys to pasts and futures not very far from Prussia's present. Not just any screen could catch and reflect the projections cast upon Peacock Island.

The whole point of the Rorschach test is projection: subjects allegedly reveal their deepest selves by telling the examiner what they see in an inkblot. Since examiners are schooled to offer no guidance as to the proper response, the number of potential interpretations of the Rorschach cards is vast. Presumably any inkblot, suitably amorphous, would serve this purpose — or, for that matter, the clouds, cracks, and glowing embers of art-historical legends about the image made by chance.[14] But in fact, the things themselves, the Rorschach cards, have been rigidly fixed by both copyright and method of manufacture, all produced by a single antique printing press in Bern. In the name of standardization, coding, and comparison, the accidents recorded on the cards — drips, splotches, smears — are now produced and reproduced with a deterministic uniformity seldom achieved even by the billiard balls of classical mechanics. Even second-order accidents — inkblots that for one reason or another came out too faint in the printing press — become regimented into the canon, used for a special test to detect psychic responses to indeterminacy. The cards are as identical as the interpretations of them are protean.

Conversely, the most stolidly functional things — buildings, soap, newspapers — radiate an aura of the symbolic. The invisible iron skeleton of the eighteenth-century freestanding column recalled the human skeleton; the architectural articulations of the parts of the colonnade harmonized with the analytic methods of the *philosophes*. Victorian soap was an imperial commodity, a harbinger of civilization, a sentimental evocation of childhood, and a microcosm of the best-kept secrets of the physical macrocosm. Newspaper clippings circa 1920 caught the speed, the evanescence, and the immediacy of modern life on the run, already

forgotten the day after tomorrow. Like seeds around which an elaborate crystal can suddenly congeal, things in a supersaturated cultural solution can crystallize ways of thinking, feeling, and acting. These thickenings of significance are one way that things can be made to talk.

But their utterances are never disembodied. Things communicate by what they are as well as by how they mean. A particular cultural setting may accentuate this or that property, but a thing without any properties is silent. Claude Lévi-Strauss once singled out certain things as "good to think with"; these essays explore more generally the mode of thinking with things, how things helpfully epitomize and concentrate complex relationships that cohere without being logical in the strict sense, much as images in Freud's interpretation of dreams or certain figures of speech — allegory, synecdoche, prosopopoeia — condense, displace, and concretize.[15] Thinking with things is very different from thinking with words, for the relationship between sign and signified is never arbitrary — nor self-evident.

These essays are as much about how things are made as about what things are. Shifting attention from being to becoming can undermine seemingly obvious assumptions about thingness. One of the most thing-like properties of prosaic things is sharp outlines: it belongs to the essence of things to be neatly circumscribed; we know where one leaves off and the next begins. Commonsense thing-ontology is chunky and discrete. Moreover, things on this account come tidily parsed into the categories of art and nature: *artificialia* are made, *naturalia* are found. A glance usually suffices to tell us which is which. Finally, everyday things belong by definition to the realm of the objective, as opposed to the subjective realm of the self. It is at once a matter of morals and a matter of metaphysics to distinguish clearly between persons and things. All these banal certainties begin to unravel when the

processes by which things come into being are scrutinized more closely, especially when the things in question are talkative.

Things that talk are often chimeras, composites of different species. The difference in species must be stressed: the composites in question don't just weld together different elements of the same kind (for example, the wood, nails, glue, and paint stuck together to make a chair); they straddle boundaries between kinds. Art and nature, persons and things, objective and subjective are somehow brought together in these things, and the fusions result in considerable blurring of outlines.

The critic-artwork dyad of Clement Greenberg and Jackson Pollock's paintings creates an entity, Jackson-Pollock-as-modernist-artist, that is neither a truth waiting to be discovered by any perceptive viewer of the *Totem* and *Mural* paintings nor the invention of the fertile imagination of Clement Greenberg. A pre-arranged harmony of urban grids, industrial time-motion studies, and the domestication of emotion by rational control created shared ways of seeing that artist and critic could express in tandem, and only in tandem. Greenberg talks Pollock-the-modernist-artist into being; Pollock paints Greenberg-the-modernist-critic into being. Hybrids multiply with Bosch's "equipment," his Heideggerian *Zeug*. Here there are chimeras within chimeras. The Treeman that gives the drawing its name is a literal chimera, but each of its components, so whole and homely at first glance, dissolves into a figurative chimera on closer inspection. Are Bosch's odd but oddly familiar things — trees, boats, body parts — constructed or portrayed with his doodling pen strokes? They seem almost as haptic, as handy as they are visible. Their robustness is rooted in more than the artist's illusionistic skill; they are also invigorated by an anti-worldly Christian metaphysics in which symbols can be more real than objects, more active than human agents.

21

Art/nature chimeras abound among these things. The first photographs were described as photogenic drawings and credited to the pencil of nature; bewilderment about whether they were made by the sun or by the photographer dogged debates about their status as evidence in court and as handiwork meriting copyright. The Glass Flowers were emphatically, even hyperbolically handiwork, but their eerie verisimilitude tempted some botanists to treat them as type specimens, more authentic than their originals in nature. Soap is undeniably an artifact and, in Victorian Britain, a highly industrialized and commercialized one to boot. Yet soap bubbles became models for nature writ small and large, from molecules to the ether swirling between stars. Like all gardens, Peacock Island blended nature and art. In the aesthetic vision of the island's architects, *physis* reverted to *cosmos*, the ancient Greek word that meant both world and ornament and that supplied Alexander von Humboldt with the title of his most famous work. Not only Peacock Island but all of nature became a *Gesamtkunstwerk*.

Artworks have often been accorded a special status as midway between the objective and the subjective, things that purportedly incarnate selves (both individual and collective) as objects, the word made flesh. There is also a long tradition of illusionistic art flirting with nature, trompe l'oeil renditions of grapes and tulips, fish and fowl, that trick the eye for an instant. Hence the difficulties of placing these kinds of things squarely on one side or another of the subjective/objective or art/nature divide might have been anticipated, though it is perhaps more surprising to find them athwart the person/thing divide as well. But the same cannot be said for the businesslike apparatus of the Rorschach test, a set of ten cards routinely shown to thousands of people by psychologists every day, all over the world. Yet it is precisely the nature of this thing to conflate the objective and the subjective, to

map the innermost self onto a carefully coded array of perfectly ordinary inkblots. At once completely accidental and irresistibly significant, the inkblots become "images of self," subjectivities revealed and classified by the mechanical methods of objectivity.

These elements of chance and self recur in collections of newspaper clippings: even the newspaper collage-poems created by the studiously random methods of the Dadaists curiously resembled their makers: "This poem will be similar to you." Equally accidental juxtapositions of topics on a newspaper page seemed to unveil previously unsuspected affinities between, say, a horse and the Einstein Tower. Clippings collected over years from that most dryly objective of all modern media, the black-and-white newspaper, gradually became transformed into new subjectivities, "paper personae." Psychologist and paranoiac meet in the conviction that nothing is an accident; everything — the inkblot, the newspaper layout — is saturated with significance for those who can crack the code.

All these things threaten to overflow their outlines. How to draw a line around chimeras that refuse so obstinately to fit into the prepared classificatory pigeonholes? A good part of the work of thing-making is fashioning new pigeonholes, both literally and figuratively. An ingenious new genre of furniture was created to organize newspaper clippings, full of nooks and crannies, and supplemented by boxes, albums, and drawers — all material ways of joining together into new wholes what scissors had put asunder. The river fringing Peacock Island and the internal framing elements of *The Treeman* also serve to make a composition out of a congeries. Even the articulate elements of the freestanding column, which lent themselves so well to the Enlightenment habit of visual and mental decomposition, blended into a single functional entity and eventually even into a single recognizable style. Scale plays an important role in the work of outlining. An empire

contracted to an island, a universe modeled by a soap bubble, the plant kingdom brought inside and put into museum cases — all these acts of miniaturization are also acts of domestication. Unwieldy things — too big, too small, too heterogeneous, too open-ended — are shepherded into the fold of "moderate-sized specimens of dry goods."

Thing-making is not bricolage; chimeras are not mere composites. However disparate, fragmentary, and even contradictory their parts may appear to be to the analytically minded historian, things worthy of the name must have a physiognomy. It is precisely the tension between their chimerical composition and their unified gestalt that distinguishes the talkative thing from the speechless sort. Talkative things instantiate novel, previously unthinkable combinations. Their thingness lends vivacity and reality to new constellations of experience that break the old molds. Photographs cannot be subsumed within the Aristotelian categories of art and nature; Rorschach tests challenge Kantian categories of objectivity and subjectivity. As in the case of constellations of stars, the trick is to connect the dots into a plausible whole, a thing. Once circumscribed and concretized, the new thing becomes a magnet for intense interest, a paradox incarnate. It is richly evocative; it is eloquent. Only when the paradox becomes prosaic do things that talk subside into speechlessness.

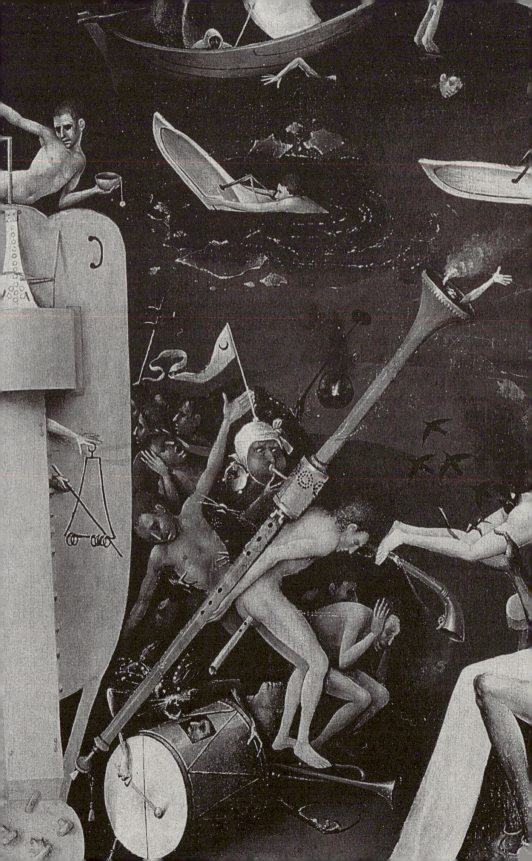

CHAPTER ONE

Bosch's Equipment

Joseph Leo Koerner

Found objects

The recent Hieronymus Bosch exhibition in Rotterdam featured
sections on the material culture of the artist's hometown.[1] In the
outer channel of the show's spiral architecture, the curators dis-
played a hoard of craft goods, "chiefly archaeological in char-
acter," used in 's-Hertogenbosch five centuries ago: jugs, pans,
tripods, piss pots, candlesticks, knives, prick daggers, spoons,
dice, flutes, spurs, pitchforks, spinning accessories, feeding bottles,
and badges.[2] Much of it found in excavated cesspits, this everyday
equipment made the paintings and drawings displayed nearby
look more thingly than ever.

This mixture wasn't new. Curators often insert "decorative
objects" into paintings galleries to suggest period tastes. Such
efforts suit some epochs better than others. Eighteenth-century
portraiture gains popular appeal in period rooms, where it con-
jures ideas of lineage, status, and opulence. For other periods,
mixing remains unacceptable. Imagine a Gerhard Richter show
hung in a simulated 1980s flat. Nor is the ideal of the "white
cube" restricted to modernism.[3] Isolating artworks from objects
of utility has long articulated the space of aesthetic experience.
Three centuries before Kant, the cultural prestige of the framed

27

oil painting modeled art's autonomy from practical conditions. Early in the "era of art," however, connoisseurs of a different kind of artifact already challenged the modern conventions of display.[4]

In 1810, Sulpiz and Melchior Boisserée sought to display early religious paintings from Germany and the Low Countries in a simulacrum of their original sacred settings.[5] To counteract the seizure of church property by the Napoleonic regime that made their own collecting possible, the Boisserées created an eerie candlelit space inimical to the total, clarifying daylight of the Enlightenment museum but in keeping — so they hoped — with the vanished ambience of the object's original use.[6] For these early installationists, what gave northern European art of the late Middle Ages special value was its liturgical purpose. The Romantics understood art's autonomy to be the historical product of secularization. To the Boisserées, the panel paintings of the so-called primitives of Germany and the Netherlands — from the anonymous Cologne School painters through Jan van Eyck, Rogier van der Weyden, and Hans Memlinc to Bosch — offered a nostalgic alternative of a culturally situated art. Here was an early "primitivist" gesture in museology. Wrenched from the vanished totality of their lifeworld,[7] crafted use-objects, and especially religious equipment (such as altarpieces) which had maintained that cultural whole, promised a naive, savage beauty. That beauty had somehow to be insulated from the insulating conditions of the modern museum through a semblance of its lost integration in time and place.[8] For its part, the Rotterdam show distinguished the panels and sheets decorated by Bosch from everyday objects from 's-Hertogenbosch. But the thought behind displaying the latter derived in part from the impulse to reconstruct for this last medieval painter the primal functionality of his art.

The ordinary objects included in the show, so the exhibition catalog explained, "tell us how realistically he [Bosch] worked."[9]

28

They served the artist as *models* for the things depicted in his paintings; setting the prototypes beside their painted or sketched likenesses allowed us to appreciate Bosch's realism. Already in 1560, Bosch's first apologist, Felipe de Guevara, wagered that this painter "never painted in his life anything unnatural," except when he painted hell, where strangeness was natural.[10] And indeed a thing like the hellish harp in *The Garden of Earthly Delights* is fantastical only in the bizarre context in which it is placed, being otherwise the painted token of an existing type of twenty-one-string harps (figure 1.1).[11] Importantly, some of the goods displayed in Rotterdam were not (as it were) naked implements but featured grotesque motifs that, over and above the objects themselves, served as models for Bosch as well (figure 1.2). The windmills, bagpipes, dice, and such painted on or applied to jugs and plates constitute a second order of prototype. Bosch had more imagination and mimetic skill than most potters, however.[12] He utilized their imagery indirectly, purging it of the ideogrammatic style in which it typically appears.[13] Bosch returned to the real-world objects on which his repertoire is based. He looked to the real Brabant windmills, bagpipes, and dice that the craft goods crudely depicted.

Sometimes these goods cannot be separated from their decor. The so-called *bartmanskrug* shares Bosch's vocabulary and his method (figure 1.3). The bearded potbellied man, a sort of parody of the jug's user, belongs to the same ornamental language as do Bosch's monsters. And this decor, not merely being applied to but shaping the jug itself, is akin to the imaginative process behind a Boschian beast. Bestowing a face on the jug while objectifying the drinker's "potbelly," a *bartmanskrug* gives a comical twist to the relation between people and objects. Marilyn Strathern has demonstrated that societies reveal themselves by the way they personify goods. Not some primitive, magical condition of the object,

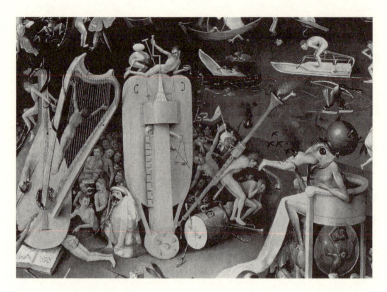

Figure 1.1. Detail of harp from Hieronymus Bosch, *The Garden of Earthly Delights*, "Hell" panel. Prado, Madrid.

Figure 1.2. *Plate (fragment) with Coat-of-Arms with Dice* from Dordrecht,
ca. 1500, lead-glazed earthenware. Stadtsarcheologische Dienst, Dordrecht.

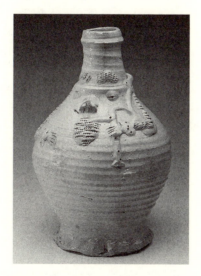

Figure 1.3. *Jug with Bagpiper on Shoulder* (*Bartmanskrug*), from Aachen ca. 1500,
salt-glazed stoneware. Inv. F 2260, Museum Boijmans Van Beuningen, Rotterdam.

personification generates social worlds by articulating relations within them among persons and things and persons and persons.[14] As far as I know, though, Bosch doesn't portray a *bartmanskrug* or anything like it. Nor would his reverting to the decoration's prototype get him anywhere, since the model in question is neither the bearded man nor the bulging jug. Instead, he fashions the hybrid's impossible prototype, a chimerical person-object. Bosch makes it seem like he had observed man-jugs, shoe-beasts, and tree-men in the physical world and then depicted them from life, "naer het leven," in the period phrase.[15]

Two generations later, Pieter Bruegel, known in his day as Bosch "once more returned to the world," attended obsessively to the crafted nature of figurative artifacts.[16] In his *Battle Between Carnival and Lent*, a "bogeyman" sits in the upper window of a bakery, a customary reprimand for undone spring cleaning; only at a second glance do we see it is not some monster but a life-size doll made of everyday materials (figure 1.4). In his subjects and style, Bosch is Bruegel's *global* vernacular; he would have turned the bogeyman into the demon the natives (that is, those who make the masks and props) seek crudely to represent.[17] Or he would have left uncertain whether he represented a dummy or a demon, since it is fiendishly hard to tell what the things Bosch depicts are made of. Bruegel shows demons to be people in masks, and laughs with and at them. Bosch shows reality itself to be a mask, one that continues to deceive and fascinate even after it is lifted. For both painters, however, unmasking hinges on the distance they take from vernacular craft. Both primitivize their sources — Bosch, by reinjecting magic into things like *bartmanskruge*; Bruegel, by delighting in the coarse way such things were made.

In Rotterdam, the boundaries between Bosch's pictures and the craft goods on display seemed most porous in the ensemble of badges. Cast in huge numbers, these cheap insignia manifest a

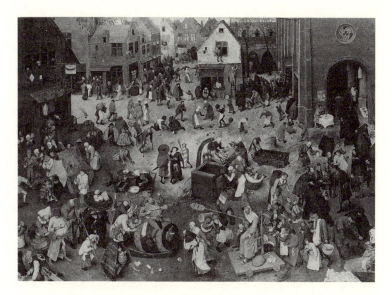

Figure 1.4. Detail of "bogeyman" from Pieter Bruegel the Elder, *Battle Between Carnival and Lent*. Kunsthistorisches Museum, Vienna.

huge spectrum of motifs, from holy persons and things, through genre subjects, down to the scatological and lewd.[18] Instances of the latter made Bosch seem less strange, since nothing he made is as indecorous as, say, the lead-tin badge from Bruges circa 1400 showing phallic beasts processing a vulva (figure 1.5). What is Bosch's relation to such a thing?

Bosch took a professional interest in badges, banners, and signs. Members of his trade made not only what we term "paintings" but also flags, pennants, badges, and coats of arms. The German and Dutch word for painter, *schilder* (shield maker), reflects this task.[19] In his paintings proper, Bosch metabolized such everyday productions. Indeed, more than in any area of labor besides the craft of painting itself, it was in the realm of vernacular insignia — the fabricated marks worn by, imposed on, or secretly signaled between members of the social order — that Bosch displayed a special expertise. In his art, moreover, such artificial signs mingle uncannily with the physical signs (physiognomy, hair color, body shape, and so on) that his society imagined were distinctive of certain groups. From the ambiguous marks ascribed to outcasts, especially Jews, Muslims, witches, charlatans, prostitutes, criminals, and drifters, Bosch assembled an ambiguous vocabulary of demonic insignia. In a study sheet that is close to Bosch's own hand, many of the cripples wear small badges — called *schilder* (shields) or *merckteeken* (notice tokens)[20] — required of beggars in towns throughout the Low Countries (figure 1.6); in Bosch's day, a *schilddrager* (shieldbearer) was synonymous with beggar.[21] One cripple carries someone's (presumably his) amputated leg on a string around his neck. This is a public token of his deformity, that is, of the fact that his plight is real. Beggars were suspected of pretending to be cripples or of maiming themselves for effect. They therefore functioned (unwittingly) as tokens of guile *per se*, rather like the American myth of the Welfare Queen.[22] The inscription on an

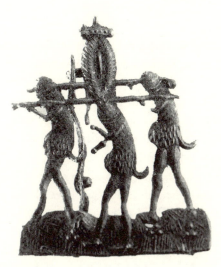

Figure 1.5. *Badge, a Mock Procession*, from Bruges, lead-tin. Collection H.J.E. van Beuningen, Cöthen.

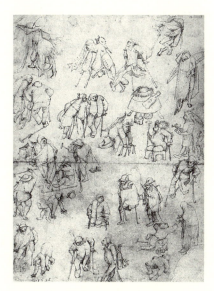

Figure 1.6. Hieronymus Bosch, *Cripples*, pen and ink. Bibliothek Royale de Belgique, Cabinet des Estampes, Brussels.

engraving after the Boschian drawing calls the cripples' clothing a "trugelsack," implying, counter-empirically, that their disabilities are feigned and that such dissimulations symbolize all forms of deception. "Through me, all shall learn how to recognize what awful, fraudulent practices have been conceived by many beggars," wrote Jakob Köbel in 1520 in a text against itinerant card sharks and other such "vermin."[23]

In displaying actual badges from the period, the Rotterdam curators were less concerned with how these feature directly in Bosch's pictures than with what they depict and in how they originally functioned. Here "in miniature" was Bosch's iconographic repertoire along with his imaginative modus operandi.[24] The range of sacred and profane imagery, the bewildering coexistence within each item of piety, magic, and satire (there exist pilgrimage badges that parody pilgrimage), even the hybrid form of the cast representations themselves, which meld together diverse details into a single silhouette: all these features make the badges a telling prototype for Bosch's art. In addition to having been *models for* Bosch, however, these insignia were also *models of* this painter's pictures.[25] Pilgrimage badges did more than merely label who their wearer was or where he or she had been. Worn by mere beggars, they dissembled a religious calling.[26] Invested with talismanic power, they transmitted to their wearer the virtue of the holy person or place, turning away evil forces that might harm the wearer or thwart his or her progress. It is their *agency*, their capacity, as Alfred Gell put it, to cause events "by acts of mind or will or intention," that made these things models *of* Bosch's art.[27]

In the midst of the badge assemblage, the curators set a most fascinating middle term between the artworks and these artefacts: a small, painted wooden shield decorated with a Boschian army of hellish monsters and tempters together with the place-name

"Santiago" (figure 1.7).[28] This thing was probably carried to Saint James's tomb in Spain in order to protect its bearer from the sort of demons that assaulted Saint James and Saint Anthony, too — in their spiritual missions. Applied to a wooden effigy of a shield, portraits *of* the spirits guard the user *against* those spirits. The apotropaic function of this eccentric mid-sixteenth-century production suggests that Bosch's own paintings dedicated to Saint James and Saint Anthony, and the devilry featured throughout his art, were likewise meant to ward off what they show. Bosch never tires of announcing that the things he makes are potentially active agents that engage with viewers as if *they* (the artworks) were the persons and their viewers were mere things. His *Seven Deadly Sins* in the Prado gives evil and its ends the shape of a giant round eye that "sees" the picture's beholder (figure 1.8). We who will be sinners, or who will at least have lost ourselves in the perfidious pleasure of sin's depiction by Bosch: we become the passive object of this picture's gaze, just as in the Saint Anthony triptych we are fictively the focus of the hermit's devil-deflecting outward gaze. In the *Seven Deadly Sins*, inside the dark pupil of its center, we glimpse the agent of our surveillance: rising from his tomb, Christ looks out at us from the all-seeing picture. Not only does the object see; it also talks. "Beware, beware, God sees," warns text on the iris's inner edge.

Der Dichter spricht

So many things speak that we hardly give them a thought. Voice recorders and voice transmitters talk. But unless we are not used to them or angry when they fail, we don't ordinarily attribute a voice to the machine itself. True, a certain distrustful view of modernity such as Martin Heidegger's takes our oblivion to the workings of technology to betoken its fiendish power, which, concealing how things work, makes them disappear.[29] When we

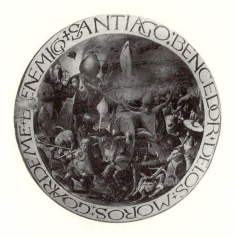

Figure 1.7. Follower of Hieronymus Bosch (Pieter Huys?), *Badge of Santiago Pilgrimage*, ca. 1550, panel. Národní Galerie, Prague.

Figure 1.8. Hieronymus Bosch, *The Seven Deadly Sins and Four Last Things*, Prado, Madrid.

cast about for an example of a "thing that talks," we are likelier to choose Chatty Cathy than a phonograph, even though experience tells us that, of all the dolls one can imaginatively animate, the talking toy launched by Mattel in 1959 with the motto "I really can talk" was one of the more passive dolls, its repertoire of eleven sentences paling in comparison to the discourse that play can give a toy not thus rigged.

In our impulse to take Chatty Cathy as an example, we encounter not the fetish but the projected idea of what a fetish is to its believer, to the child or savage.[30] Talking effigies haunt the historiographical psyche. At the beginning of what traditionally counted as European art, there were the sacred statues inscribed with what they say: "I am Chares, statue and joy of Apollo."[31] In the Greek view, to possess spirit was synonymous with having a voice, as when Empedocles imagined the ancestors of humans to be mere "types" prior to the addition of language.[32] This prerequisite was fulfilled by cult effigies, hence Democritus's definition of the names of the gods as "statues with voice."[33] However, simultaneous with such apparent animism was another model, still with us, of how such speech can come about. In a fragment of a comedy by Plato Comicus, a statue of Hermes stumbles onstage and must answer the skeptic's question: "Who are you? Tell me at once. Why are you silent? Won't you speak?" To which the image replies, "I am Hermes, with a voice of Daidalos, made of wood, but I came here by walking on my own."[34] The name of the primordial artist suffices to explain the automaton's apparent agency, since it "abducts" it (Gell's term) from the proficiency or *technē* of an artist.[35] The context here is comic; elsewhere, in stories about Aphrodite statues, it is erotic, Daedalus's pouring of mercury into the image's hollows being likened (by way of the lust his statue will then inspire) to insemination.[36] Such bathetic treatments of image magic belong to the gestures of iconoclasm. The

effigy is believed by *some* (the iconophobes) to be naively believed by *others* (the iconophiles) to be invested with agency and voice, so that, when smashed, it gets mocked for not complaining.[37]

Another thing, it would seem, are effigies that elicit long speeches from their beholders. The cultivation of discourse on artworks, together with the high status accorded such speech, characterized the modern idea of art. And it fit a modern world *picture* that set the *ego cogito* as a *res cogitans* off from the *res corpora*.[38] Through this ventriloquy, the artwork inhabited an imaginary space between subject and object and served as model for the mediation done by culture.[39] By way of their interpreters, artworks seem to speak the voice of their maker, who inhabits the stock and stone like an invisible homunculus.[40] At the end of Robert Schumann's *Kinderszenen*, when the child sleeps, a voice speaks through the piano, as well as through Schumann and the child, who is both audience and muse: "Der Dichter spricht."[41]

On the one hand, then, the idol, enchanted instrument of natural man; on the other, the work of art, culture's representative achievement: two talking things articulating a movement from tradition to modernity, from fetish to fact. Bosch scholarship routinely places the artist at precisely the threshold of this shift, in the twilight of idols and at the eve of modern art.[42] I wish to complicate this model with evidence of abiding promiscuity, where fetishism and reification conjoin.

The Structure of Complex Things

The thing in question is a drawing in pen and dark brown ink (color plate I). At one level, it is a simple sheet of paper decorated with an arrangement of elemental objects: jugs, trees, and other "moderately sized specimens of dry goods."[43] Yet as the large, conflicted literature on this work suggests, nothing about it is straightforward, not even its purpose.[44] Kept in the Albertina in

Vienna, and believed by most scholars (including myself) to be one of its maker's few surviving autograph sketches, this quintessential Bosch plays echoes through several other works. The "Hell" panel of Bosch's *Garden of Earthly Delights* features the same motif (figure 1.9); two sketches by epigones recycle Bosch's original invention (figure 1.10); and an anonymous engraving from the late sixteenth century launches Bosch's monstrosity as an art-historical curio, auguring our own distance from it (figure 1.11).[45] The heterogeneous, intricate, and rigged-together nature of the monstrous entity it displays is complicated by the entangled historical object the drawing itself is.

Bosch's earliest commentator expressed the difficulty of talking about such a thing. Antonio de Beatis, secretary to Cardinal Luis of Aragon, kept a diary of his travels throughout Europe. On July 30, 1517, he toured the fabulous Brussels palace of the Nassau counts. There he saw a giant bed into which fifty revelers could be tossed to sleep off their drink; he admired the palace's trompe l'oeil doors, expensive oak paneling, and nude paintings of the Judgment of Paris and of Hercules and Deianira. Somewhere in this maze of wonders Beatis arrived at "various other panel paintings of diverse bizarreness," which at first he set about to describe, but then gave up. These pictures, he concluded, showed "such pleasant and fantastical things that it is impossible to describe them to those who don't know them."[46]

Thanks to J.K. Steppe, it is now believed these panels were those of Bosch's so-called *Garden of Earthly Delights*.[47] We who can see them displayed in the Prado in Madrid or reproduced will know what Beatis meant. Bosch confounds description through the volume and strangeness of his details; in 1593, an inventory of works sent by Philip II of Spain to El Escorial lists the *Garden* as "una pintura en tabla al ollio, con dos puertas, de la bariedad del mundo."[48] This "variety" consists of forms that, each of them

41

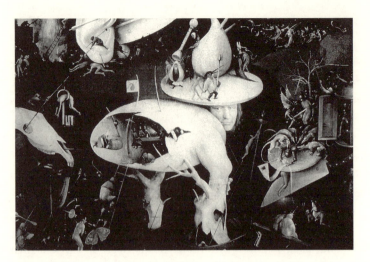

Figure 1.9. Detail of "Treeman" from Hieronymus Bosch, *The Garden of Earthly Delights*, "Hell" panel. Prado, Madrid.

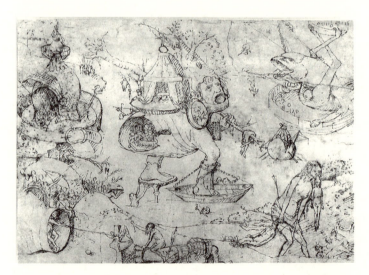

Figure 1.10. Anonymous engraver, *The Treeman*, copper-plate engraving, round. Provinciaal Genootschap van Kunsten en Wetenschappen in Noord-Brabant, 's-Hertogenbosch.

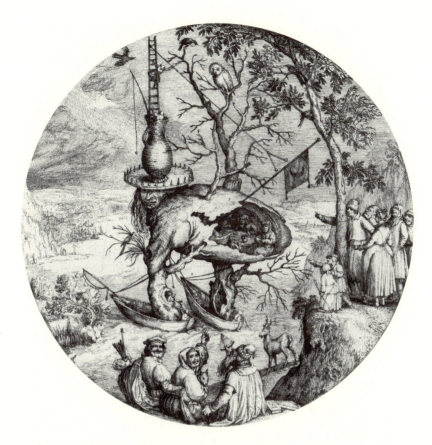

Figure 1.11. Follower of Hieronymus Bosch, *Infernal Scenes with Elements from the Garden of Earthly Delights*. Staatliche Kunstsammlungen, Kupferstichkabinett, Dresden.

anomalous and hybrid, simultaneously demand and frustrate description. To begin to talk about something in Bosch's pictures, you first have to point it out. And if you happen not to stand with your listener before the picture, this requires long statements about where the item in question is.[49] Confounding such labor is an abiding uncertainty about what *anything* in the picture represents. Scholarship on Bosch stagnates partly because, even when it reaches plausible conclusions, readers balk at the process of getting there. Dissatisfaction with what others say runs through the entire literature on Bosch. Even in the midst of the Prado's crowds, one wanders this artist's paintings alone.[50]

Bosch's panels have occasioned countless futile soliloquies partly because they have no stable title. In the Brussels palace, Beatis easily processed Jan Gossaert's *Hercules and Deianira* because, recognizing its subject, he gave it that name. A modern contrivance, the title *The Garden of Earthly Delights* was unavailable to him, and there's hardly been an interpreter who has not aspired to rename this work according to his or her own convictions.[51] Bosch seems to have predicted this confusion. His "Paradise" panel gathers round Adam — whom God allowed to name "every living creature" (Genesis 2.19) — a collection of animals not found in any bestiary.[52] Beholding a unique thing, we are invited newly to name Bosch's creation, aware that, due to its being an anomaly, it will also remain unnameable or at least that no name will quite stick.[53] The multitude of professional, popular, and occult interpretations that the *Garden* has spawned is in some measure motivated by the fact that, because no one quite agrees on what, even in the most general sense, this thing is, it and its myriad details can be made to mean almost anything. This "perpetual *aggiornamento* of latent senses" is further compounded by the hope, expressed by nearly every commentator, that there shall someday be found a key unlocking the secret of the whole.[54] For some, this

key has merely been forgotten and can be retrieved by trolling through texts available to Bosch; for others, it was purposely concealed by Bosch, whose wisdom was of an esoteric or heretical kind.[55] Though I doubt whether the artist intended this confusion, Beatis stood baffled before his panels, and defenses that Bosch's pictures were orthodox rather than heretical begin with his earliest commentators.[56] Acquired during his lifetime by some of Europe's most sophisticated collectors, and fitted to their intellectual propensities, Bosch's works were intended, at least partly, as "conversation pieces"—things made for talk.

At one level, such ventriloquy is but a conspicuous instance of what my discipline does with its objects. The phrase "things that talk" shorthands what artworks are for art history: effective generators of discourse. At another level, talk about Bosch discloses the *primitivism* at work in the phrase, for while I don't believe that the things I write about physically speak to me, there is something satisfying about pretending they do. Bosch's things invite us to slip back and forth between a metaphoric, or rationalist, sense of the phrase and an atavistic sense. When, in 1504, Philip the Fair of Burgundy, in an economic transaction unusual at the time, not only commissioned but also prepaid Bosch to paint a Last Judgment "for his noble pleasure," the enjoyment he imagined taking in a spectacle of pain was of an aesthetic kind.[57] Bosch's things are coy, like our motto. Yet perhaps by holding close to one of them, and by "conjuring and exorcizing" it to speak, we can summon a more exact fantasy of things that talk.[58]

I shall examine Bosch's drawing in three movements: (1) the monstrosity that gives the sheet its conventional title; (2) the simple things that make up the monster; and (3) the drawing itself as thing. These movements correspond roughly to the thing understood as object, as equipment, and as work. Needless to say, Bosch's hybrid will confuse more than confirm these Heideggerian

categories, mocking their pretense at retrieving the elemental, premodern thing.[59]

The Tree-Boat-Tavern-Goose-Anus-Devil-Man

Bosch's Treeman — in the first place the monster rather than the titled sketch — dramatizes the condition of the thing as object. "Object" comes from the Latin *obicere*, meaning "to throw in the way"; the German *gegenstand* or *gegenwurf* preserves this sense. The Treeman seems tossed lewdly in the way of our sight. Sight is given its avenue in the surrounding landscape. Bosch structures a view of a bay or unregulated river enclosed by land. Water becomes our meandering path into the distance, were it not for that thing floating there. The thing is obstinate and conspicuous. Through elements in the landscape that measure it, it must also be gigantic. The man reaching up from the stern of one of the boats (his outline is a masterpiece of penmanship) further swells the colossus. Size makes gawking seem natural, no matter what the object is, since anything that big *would* get in the way. Of course, the Treeman is not just anything: it is an emblem of anomaly.

Anomaly here has its typical derivations: improbable combinations and analogies; erratic articulations of part and whole; heterogeneity of material, shape, scale, function, and direction; instances of the impossible, of what the Greeks termed *adynata* (a tree rooted in a dinghy!); a hyperbolically irregular, imbalanced, contorted form.[60] The twisting that this contortion consists of is perversely anthropomorphic. Beyond the torqued trunk and limbs of its "tree" parts, the monstrosity seems to turn backward from its ostensible direction, magnifying our sense that what is most in our way is the object's gaping ass. Inside we glimpse, as antithesis to our open view, a gloomy interior scene. The monster's backward gaze has a visceral relation to ourselves, inhabiting, as we do, bodies that gaze. Drawn to the curiosity standing in our way,

46

and losing ourselves in the dark space inside it, we will be re-
pelled in reverse by and with the monster, as if mimicking it. The
monster, in turn, mimes — and mocks — the *Gegenstand* as stand-
ing (*stehend*) against (*gegen*), travestying the enclosure of objects
and of subjects. Unlike the surrounding world that invites free
movement through its extent, the thing twists in upon itself, like
a dog considering its behind.

But I've jumped the gun. These stories unfold by way of aspects
that have still to be disclosed. For the dark cavity to be under-
stood as the monster's gut, we must first have grasped the anthro-
pomorphism of the monstrosity as a man. This depends on a set of
visual synecdoches and metaphors that only partly synthesize the
anomaly into something that *is* and that has a *name*, say, the "Tree-
man." In casting a glance as if over a shoulder, the monstrosity's
face posits all that it surveys as body, no matter how improbable
that comes to seem as we try to bring this aspect to bear on the
whole. Having taken the split and open oval to be a sort of torso,
we hasten to see the supporting elements as legs with boats for
shoes or feet; at which point another aspect will already have come
in view. Those legs, extending from a shoulder, must instead be
arms, thus accommodating the display of the gut as the anatomy
of a half man.

As we've seen, Bosch was a keen portraitist of cripples (see fig-
ure 1.6).[61] Several of these Boschian bodies feature amputated
legs, or legs withered, broken, deformed, or unusable. Arms are
instead used for locomotion by means of vernacular prostheses:
canes, crutches, footed grips, sledges, and such. The peg is an
image of the leg. It is equipment in the form of an effigy. The pro-
totype it represents is that of a whole person, which is the type
from which the cripple as anomaly deviates. Fitted to the cripple's
specific disabilities and capabilities, and embodying his or her
special cunning or making do, the pegs and crutches serve to

broadcast to healthy observers the veracity of the cripple's malady. They are also images of artifice and of the capacity to make images that function like their prototype, hence their fascination for Bosch, whose special skill is to rig together plausible monstrosities. As a peculiar class of things, prostheses come imaginatively to *our* aid as we work out the sort of man the monster in the drawing is: a gigantic cripple using two boats to make his arms work as legs. As we can with all such determinations, we can run with it until it runs out. Forgetting that ships can't be shoes, we marvel at how like a muscular shoulder that shoulder seems, how weirdly but appropriately knee-like its elbow! Eventually, though, the monster everywhere exceeds any singular description. Although in other works Bosch shows bodies spilling their guts, this cavity, by way of a multiplying set of resemblances, becomes part of different aspects — a tavern or brothel, a broken egg, the hollow of a tree — long before we puzzle over its (vanishing) aspect as gut. A gut feeling remains nonetheless as a secondary association within a new partial synthesis of what the monster is. Before turning to these alternative aspects, I would like to pause at Bosch's anthropomorphism.

To speak of a grotesque body would be redundant.[62] Instead of a closed, discrete thing (the *res* as extensive *corpus* within an extended surround), we have a broken container for other bodies that, eating, drinking, and whoring, enact *their* open corporeality. Note also how, when we attend to the Treeman's dark hollow, the enclosing oval loses its three-dimensional shape, confounding any physical or metaphysical identification of space with *matter*.[63] As several commentators have observed, the interior scene reflects a popular image of hell as a tavern, of taverns as hell, and of both hell and taverns as hollow vessels called "nobis jugs," from the French *en âbis*.[64] In that abysmal jug, then, the revelers fill their guts at the point where the framing monster would empty itself.

Face and ass bend round toward each other, but instead of con-
necting, the involution opens lewdly its aperture. Bosch sum-
mons a host of obscene associations here. In Dutch, a tree hollow
is commonly called an *aarsgat* (arsehole).[65] Witches and Jews were
accused of kissing the ass of cursed beasts, either the devil in the
case of witches or a giant pig — the *Judensau* — in the case of Jews.[66]
The confrontation of eye and anus is a feature of allegories of
Vanity. In *The Garden of Earthly Delights*, a naked woman receives
this punishment in hell, where she sees her face (and that of a
demon) reflected in the convex mirror of a tree monster's but-
tocks (figure 1.12). More diagrammatically, a woodcut illustration
for *Ritter vom Turn* shows a primping noblewoman receiving a
ghastly admonishment. Instead of beholding her face in the mir-
ror, she discovers a reflection of the devil's behind (figure 1.13).[67]
The devil himself stands with his eye at the scene's constructed
vanishing point, and therefore aligned with our own gaze. The
collapse of the body and objects occurs in a story about the cor-
ruption of body and world. Entered sodomitically, the repellent
object dissolves into an emblem of the world as corrupt, dark,
empty, and abject.[68]

In visualizing an argument against the visible world, Bosch
revives an ancient theodicy. Codified in Augustine's doctrine of
sin as nonbeing and ontological aversion, the Christian symbolism
of evil used and repudiated images for its expression.[69] In the edi-
fying literature of the Middle Ages, the devil appears in every pos-
sible monstrous and beautiful guise, mutating effortlessly from
one to the another. According to Caesarius of Heisterbach, demons
in human form cannot be observed from behind; since they have
no backs, and are hollow inside, they always withdraw from us by
walking backward.[70] It is this hidden, negative, and empty world
that Bosch allows us to see, either through the positive example of
the hermit saints, who themselves turn away from the world to

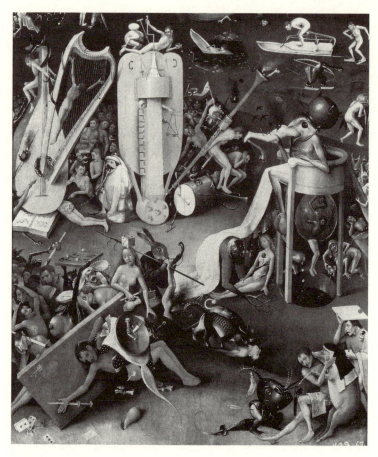

Figure 1.12. Detail of "Vain Woman," from Hieronymus Bosch, *The Garden of Earthly Delights*, "Hell" panel. Prado, Madrid.

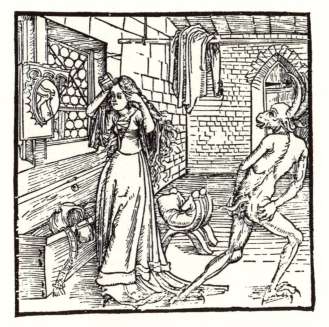

Figure 1.13. Attributed to Albrecht Dürer, *Vanity and the Devil*, woodcut illustration from *Ritter vom Turn* (Basel: Michael Furter, 1493).

the truth of an invisible God, or through the emblem of world as *nothingness*, hay.[71] As a visual ontology, Bosch's drawing posits "the thing" negatively, within the Judeo-Christian metaphysics of the world as idol.[72]

This story repeats itself in each of the monster's aspects. Like the aspect "man," each grasps only partially the whole — this repeated failure being the moralizing index of the object's corruption. Thus the prefix "tree" of the conventional title *Treeman* goes some way toward organizing the whole into a thing. "Tree" is beautifully rendered in its (or rather their) erratic extension from the boats, up through the pod-like torso to the upper branches that mingle, plausibly, with the quotidian tree on the shore to the left. Bosch excels at selectively affirming our belief in the trees' treeness. He interprets their trunks as tunnels of access: we can see how the revelers might have reached their table by climbing up inside their hollows. He imagines just how branches might grow through a decaying body, pod, or shell over time. With his delicate quill (probably made of a hen's feather), he elaborates, and invites us to observe, the impossible zones of *material* transition where tree is no longer tree but part of a rock, a skeleton, a bird's wing, indeed where the form we still read as tree cannot materially be a tree. These metamorphoses, which the Treeman veritably consists of, depend on the medium of drawing, and on Bosch's skill in it. Consistency is a sleight of hand: busying his pen on details, the artist conjures some *thing* that causes us to miss the large-scale shift accomplished elsewhere, or that performed right under our nose. The whole — the object as tree — remains open or incomplete, being replaced, before we know it, by some other unfinished totality such as man. And that incompleteness belongs to a pessimistic narrative, here of the dead tree as symbol of evil and death, antithetical to the Tree of Life.

There are other wholes that the Treeman partially is or resem-

bles. It is an egg, but one that, instead of being the emblem of pri-
mal existential closure, is open and dead. In this decay, it reveals a
cadaverous inside that associates it abjectly with its mother: the
carcass of a goose or duck, perhaps even of the hen whose feather,
inked and wielded by Bosch, brought it into view.[73] It is also, and
perhaps most plausibly, a boat, or a raft floated on two boats.
Grasped as such, the monster becomes a sort of constructed mon-
strosity in the manner of Bruegel's carnival confections, where
even the most improbable thing could just possibly be the prod-
uct of crude, rustic artifice. Needless to say, even that reading col-
lapses, since the little crafts are too small to carry their loads and
their divergent courses (shown by the angle between their prows)
mock all thoughts of maritime motion. Bracketing off this and
other embellishments, one scholar proposed that Bosch records
an actual miscarried, limbless fetus of the type teratologists termed
"amelia"[74] — so exact are Bosch's fantasies.[75] In the end, though,
Bosch's monster isn't similar *to* anything; it's just *similar*, an image
"degree zero."[76]

Equipment Failure

"When we discover its unusability," wrote Heidegger, "the thing
becomes conspicuous."[77] Bosch's thing is unusable, and hence con-
spicuous, both because it escapes a referential structure of what
it is (let alone what it might be for) and because it consists of things
that are, in a spectacular manner, "improperly adapted for their
specific use." According to Heidegger, it is as equipment that the
objective environment encounters us. Involved in everyday actions
(for example, as the hammer the shoemaker reaches for), equip-
ment stands unperceived but ready at hand until the moment when
it breaks, at which point it becomes an "object" in a strict sense and
can be explored theoretically. "Tools turn out to be damaged, their
material unsuitable," notes Heidegger at a critical moment in

Being and Time, when world announces its existence in broken hammers and missing nails. Certainly the Treeman obstinately "liegt nur da — ": something with this anomalous appearance and without the consistent intentionality of things at hand. In contrast to Heidegger, however, who recovers *Sein* by way of broken tools, Bosch makes equipment failure disclose *Schein* — the world global deception. Guevara, whose father acquired several paintings directly from Bosch, admitted that the artist "painted strange figures, but he did so only because he wanted to portray scenes of hell, and for that subject matter it was necessary to depict devils and imagine them in unusual compositions."[78] To unpack the condition of Bosch's landscapes as hellscapes would involve a thematic analysis of his allegories of world. At present, I will pursue this theme by attending to the misused equipment that the Treeman is partly built of. By way of the monstrosity's rigging, we will proceed to analysis of Bosch's drawing as *made* thing.

Like so many of the artist's creations, the Treeman features everyday products in absurd combinations. It is a telltale sign of an authentic drawing by Bosch that such objects seem somehow carefully observed, even when they cannot be, since there is no real-world prototype for them.[79] One intuits that the artist, while depicting them, imagined both how their forms would have worked physically as bodies and what space those bodies would occupy. The realism of Bosch's study sheet in Berlin of two monsters depends on at least three mutually supportive illusions (figure 1.14).[80] First, the artist fashions his monsters as *organisms*. The cat-bird-tortoise on the right looks like an autonomously functioning three-dimensional entity, with all parts and organs fitted together as the "instrument" (*organon*, in Greek) of its existence. The monster's outline broadcasts an inner anatomy such that, able to distinguish from the contorted, half-concealed shapes the specific mobilities of neck, shoulder, elbow, and wrist, we can imagine

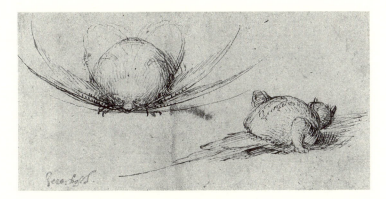

Figure 1.14. Hieronymus Bosch, *Two Monsters*, pen and ink. Staatliche Museen zu Berlin, Kupferstichkabinett, KdZ 550 recto, Berlin.

just how this creature stands and walks. Second, Bosch makes this volumetric creature seem to stand in a world. In the Berlin drawing, the surrounding space is less definite than in the *Treeman*. Yet it is implied by the lines suggesting shadows cast by the beast. Darkest under the head and tail, but reaching forward almost to the sheet's right edge, this superb bit of hatching establishes a fictive ground wholly disjoined from the picture plane on which the beast is sketched. Third, the beast captured in the drawing seems itself intent on capturing its prey. Gazing with unseen eyes toward the left along a line oblique to its body, it draws us who stand unseen behind it into its virtual world.

Bosch's monsters seem like three-dimensional entities, even if we see only one view of them. In this, they differ from monsters made by imitators. Depicting another image, Bosch's followers produce oddly flat beasts (see figure 1.10). Yet it is the master's capacity for imaginative manipulation (akin to Heideggerian *Umsicht* as opposed to *Sicht*) that makes possible the combinations that his disciples slavishly copy. By engaging with how a thing is put together, Bosch can rebuild it as he wishes, constructing especially those places of improbable but somehow visibly plausible attachment whereof his hybrids consist.

All the early commentators on Bosch emphasize these attachments as his principal skill. Guevara compared them to the comic genre of antique painting known as *grylloi*; in 1605, José de Sigüenza, the librarian at El Escorial, associated them with a "macaronic" style of poetry and art;[81] and in other Spanish texts, it gets its own term: *disparates*.[82] According to the sixteenth-century mathematician Girolamo Cardano, you can tell a real from a fake mermaid by examining her joints.[83] With the Treeman, the trunks of the trees seem genuinely to stand in boats because Bosch has been able to draw the vessels around them as if his pen built them plank by plank. Bosch makes *exact fantasies*.

Depicting a thing is not quite the same as making one, though. While the boats evince a boat-wright's know-how, they remain, in Bosch, views of a boat. We can observe this distinction in the transition between the egg, pod, or jug of the Treeman's torso and the backward-turned head, at the feathery, bark-like, rocky "shoulder." Simultaneously animal, vegetable, and mineral, this is the quintessence of Boschian *disparates*: unpairable parts joined by a materially ambiguous joint. It might seem that whereas traditional crafts grasp for and directly shape things, the arts of painting and drawing only copy their appearance. Observed in the motion of depicting one thing, however, Bosch's quill makes marks that, by a combination of chance and projective imagination, jump-start the portrayal of some other thing, which engenders new marks and new references. Instead of copying nature's products (*mimesis*), such an art imitated nature's own productivity (*poiesis*); this had long been Renaissance humanism's standard argument for the supremacy of painting and poetry.[84] How might we understand such labor from the perspective of the craft tradition to which Bosch belonged?

Early Netherlandish painters excelled in making visually consistent images.[85] Not only do the things depicted in their pictures form a robust structural whole; that whole is fitted to the world in which those pictures originally stood, so that looking at them feels like gazing through an open window into another real world. This consistency depends, paradoxically, on the presence of objects that seem accidental to the scene: a crumpled pillow, a clay pitcher, a sunlit orange. None of these are necessary to the subject matter.[86] Yet adhering to the picture's consistent system of space and light, and corresponding to the randomness of the world in which the picture finds itself, these everyday things strengthen the illusion that what the picture shows is real.

Bosch came of age around 1475, at the moment when this

technology climaxed in the art of masters like Dieric Bouts and Hugo van der Goes. And in his own strange way, he continued to render objects with a trompe l'oeil veracity. Placing them in impossible settings, however, and welding them, chimerically, to radically different objects, Bosch lets ordinary things rupture the consistency of the painted world. As his earliest admirers knew, this was partly because Bosch paints the world's vain "contingency" as something that *is* but could be *otherwise*, or could equally well not exist at all. And he contrasts this contingency with metaphysically and formally necessary structures, with diagrammatic orders distinct from the accidents they frame. The circular format of his *Seven Deadly Sins* inscribes the errancy of everyday actions and objects into the higher consistency of "last things."

Working within a native craft famously skilled in the imitation of nature, Bosch pursues the unreal and impossible — all that is "against nature." His things are deceptions; their closest counterparts are perhaps the charms of witchcraft, which affect their prototype through similarity and contact.[87] Bosch paints these in such a way as to make his viewer uncertain about what they see. For example, is the tulip cut from the patient's head in *Cure of Folly* an allegorical symbol that the artist has introduced into the genre scene (via the Dutch proverbial association of "tulip" with "fool"), or has the artist borrowed it from allegorical plays depicting such foolish cures? Is it the quack's own prop, like the palmed bits of bloody meat that shaman-doctors "extract" from a sufferer's maladies? Or is it evidence of some genuine devilry practiced by the quack? Bosch breeds uncertainty by the way he applies paint. His brushwork is loose and visible, as if sketched in pigment, and his colors are motley, mingling reds with greens, blues with oranges — techniques alien to mainstream Netherlandish painting, which excelled in meticulous finish and brilliant local

color.[88] By these means, Bosch renders entities materially ambivalent, allowing them to "be" different objects and different orders of objects: allegorical requisites, theatrical props, magic tricks, or diabolical deceptions. He returns us to an animistic condition where things talk in proverbs, since they may be demonically possessed. The Dutch word for proverbs, *spreekworden*, literally means "words that talk."

Bosch can depict animistic things without quite claiming that his pictures are magically possessed, however. Let me clarify this disclaimer. The uneasy relation in his art between talisman and painting is entirely foreign to Bruegel, who, like an ethnographer, represents native folkways and vernacular effigies from outside, as primitive other to his global perspective and realistic style.[89] Bosch takes vernacular craft goods in hand and "circumspects" them. He even learns from them the technology of their sublimation, for throwing jugs and sketching views both involve shaping an empty space, a hollow, a hole, a whole, a hell.[90] But then he also breaks them so that, now "just lying there" in the space shaped by his depictions, they show themselves (in Heidegger's words) as a "thing with this or that outward appearance in its handiness." In *The Treeman*, we observe this view of vernacular equipment, where, having broken crafts goods to make a monster, Bosch rigs together with *his* equipment — the pen — a plausible craft. The ropes that fix the boats' prows to the trees, the line between the crescent-moon flag and the ladder, the carefully balanced disk and jug: these are a draftsman's tricks for equipping objects to be perceived as such, objects tossed before us, plausible even when broken down.

Rigging fixes the monster's parts into a whole and that whole into an embracing space. Improvised and imposed from without, it lays bare the disparity between form and matter, the one consistent, the other not. Rigging also stands in an analogy to

proverbs, which, forging connections between words and things, similarly improvise links among monstrous parts. And proverbial associations do tie together Bosch's monster. Figures climb up a "ladder" (in Dutch, *ladder* or *leer*), which rises from a "jug," or *kan*. Spoken out loud, as *de leer komt uit de kan*, this combination potentially states that the revelers in the hollow get "learning," or *leer*, from drink.[91]

Embellishing the things brought together in the monster (each of which embellished something before it), the depicted ropes *think the thing in place*, rather as fifteenth-century book illuminators endeavored to stitch the viewpoints of spectator and reader by fictively pinning their figures to the vellum surface or by roping the text to the scene around it (figure 1.15).[92] Set in motion, this thinking also reactively conjures a space where such equipment makes sense, not on a page but in a world. Yet the outlines of the monster retain their pleasurable aspect as lines made by a quill; the pen connects parts as would the rope it playfully draws.[93] Bosch's artistic means, the mobility of his imagination, and the object that results are plaited into a single thread.

Hell as a Collection

No matter how anomalous or outsize his Treeman seems to be, Bosch insists on placing it in a world. The natural setting is structured to surround. Land encompasses the Treeman and the sea. It is the inverse of the world on the outer shutters of the *Garden* (figure 1.16). There, a disk of the inhabited earth surrounded by the deep and enclosed in a reflective cosmic sphere; here, earth-embraced water that contains the world's ruined empty sphere. In the drawing, the landscape that unfolds to the horizon is one of Bosch's most precocious achievements. Such a vast, sketchy panorama of the Dutch countryside prefigures the art of Bruegel, Hendrik Goltzius, Hercules Seghers, and Rembrandt. But this worldview encircles a

Figure 1.15. *Scenes from the Passion*, page from *Book of Hours*. MS E. XIV Tesoro, National Library, Madrid.

Figure 1.16. Hieronymus Bosch, *The Garden of Earthly Delights*, closed state. Prado, Madrid.

symbol *of* world that turns the image inside out. Polyglot emblem of vanity, of the thing as no-thing, the Treeman looks back toward us. This rearward glance, akin to Saint Anthony's, has led some scholars to identify the monster as Bosch. That huge face that twists round under the spiked board, they argue, is a self-portrait, and the brothel scene unfolds in his body.[94] Although the face very loosely resembles posthumous portraits of Bosch, the Treeman, whomever it looks like, closes round on itself to behold not us but its missing body.[95]

Even as he places his monster within an art-historical *terra nova*, Bosch also snatches it from us, by putting in our way, just lying there, the world-subverting emblem of its emptiness, where outside and inside, front and back, object and self, mingle uncannily. The image of the thing as that which surrounds and is surrounded is expressed by a motif occurring (twice) in *The Treeman* and in Bosch's two other autonomous drawings.[96] Whatever its symbolism, the image of the owl mobbed by birds has the structure of a trap. The owl functions as decoy to capture smaller prey. It is an emblem of Bosch's art, which again and again styles itself as a trap luring viewers with pleasurable curiosities.

To the ambivalent object, world is all marginal decor. Turned in on itself as if averse to its own display, this margin also engenders the thing that Bosch himself produces. In *The Treeman*, he shapes a deep view by framing the object with elements that displace the material limits of the image to the represented limits of a view: the overgrown tree stump at the base; along the right edge, the owl on the shore; along the left, the Claudian tree and cliff. Land surrounds the image in the same way it encloses the water where the Treeman floats. While these internal frames may seem natural to us, used, as we are, to the autonomous tableau, they were not so for artists of Bosch's time, and especially not for painters engaged in drawing. Signaling composition

as a self-enclosed whole, these frames make the sketch into an autonomous artwork even if the objects the drawing features subvert such closure.

Before Bosch, drawings formed part of the *painter's* equipment. They were tools, not works, helping variously to record a likeness, to plan a composition, to copy for reuse in another picture, to indicate to clients what they could expect, and so on. Now, for perhaps the first time north of the Alps, the drawing has become, through the way it represents its own closure, a finished thing to be sold and collected.[97] A print after Bosch's drawing vividly represents how, with his pen, Bosch also launched this monstrous thing, the Treeman, as an anomalous work, *The Treeman* (see figure 1.11). The anonymous engraver has added an audience on the right and a set of producers below: a painter with palette and brushes, an astrologer with almanac and tools, and between them a third figure holding a fox. What the artist reports, the astronomer interprets and prognosticates; classed along with heavenly portents as omens, monsters were believed to have been created to foreshadow disaster, hence their etymological derivation from *monstrare*, meaning "to show." This trio invites us to contemplate not just the monster but Bosch's remarkable image of it, now shaped to our gaze through the round format.

Georg Simmel wrote that with "the possibility of desire" goes "the possibility of objects of desire." "The object thus formed, which is characterized by its *separation* from the subject, who at the same time establishes it, and seeks to overcome it, by his desire: that object is for us a value."[98] The engraved *Treeman* evidences the desires that fueled its production. By its time, most autograph works by Bosch had entered princely collections, where they were the objects of intense fascination and envy. Guevara warned that already in Bosch's time spuriously signed forgeries of his work abounded; these were "smoked in chimneys to give them the

63

appearance of age."[99] And there exist several Boschian paintings executed on top of earlier (non-Boschian) compositions, perhaps to simulate antiquity.[100] Paul Vandenbroeck has chronicled the steps taken by the duke of Alba to secure for himself *The Garden of Earthly Delights*.[101] In 1567, he machinated its seizure from William of Orange, who had inherited it from Henry III of Nassau. Timing suggests that the momentous summons against the prince of Orange was prompted by Alba's craving for a Bosch. William's concierge refused to surrender the picture, suffering unspeakable tortures as a result; the report of these shows the *Garden*'s "Hell" panel in a new light.

In engraving *The Treeman*, the copyist must have had Bosch's original sheet before him; his purpose was to publish that coveted sketch itself and not just what it depicts. The public and the producers are shown standing on the shore, on an elevation signaling contemplation or "theory," from the Greek *theoros*, meaning "spectator." For them, the monstrosity is the paradigm of an exotic "view."[102] As such, it stands opposed to their lifeworld and to the elemental things they, opening their harbor to strange arrivals, leave behind. Beached in a northern European harbor like some bizarre shipment from afar, the copy of Bosch's monster — itself a fantasy of nothingness — demonstrates the new magic of commodities. Though made, exchanged, and coveted by persons, the thing as "work of art" floats before us, more animate than ever before.

Let me close by observing the mysterious third figure on the shore. On the evidence of clothing, and despite the beard, scholars have identified her as the artist's wife.[103] In my view, she is a he, and specifically a poet or fabulist, hence the fox, stock character in this tradition. Sigüenza associated the artist with a writer "who called himself Aesop," and to his later admirers Bosch was Aesop-like in his having a hot line to popular ethical wisdom. In the thinking of Renaissance humanists, *fabulae* rendered truth

under a disguise. Sandwiched between the artist and the astron-
omer, this emblematic third figure indicates what Bosch's work
would become: a telling fable. Framed by a scenography of its
future reception, *The Treeman* reveals how the making of fictions
comes from the imagination of demons, and how from depictions
of hell comes a painting of everyday life.

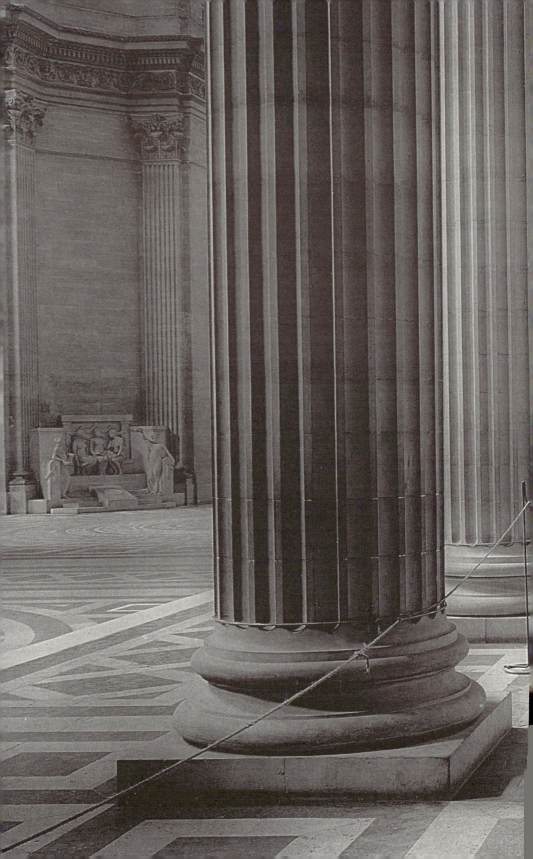

CHAPTER TWO

The Freestanding Column
in Eighteenth-Century
Religious Architecture

Antoine Picon

On the Explanation of Architectonic Devices

Is it possible to give a cultural explanation of architectonic devices such as Greek trabeation or the Gothic vault and its flying buttresses?[1] During the second half of the eighteenth century, at a time when the emergent history of architecture began to pay close attention to these devices, several authors posited a close connection with the civilizations that had created them. In his 1758 *Ruines des plus beaux monuments de la Grèce*, Julien David Le Roy explained, for instance, that Greek temples, with their columns and lintels, were the expression of the "general system" that the Greeks had followed in the sciences and the arts.[2] How exactly this "general system" was organized and, above all, its relationship to trabeation remained, however, obscure for Le Roy.

Obsessed with race, believed to ground the quest for a truly "organic art," nineteenth-century theorists like Eugène-Emmanuel Viollet-le-Duc tried to relate architectonic devices to the geniuses of the people who had given birth to them. In his *Entretiens sur l'architecture* (1863–1872), Viollet-le-Duc explained, for instance, that Greek trabeated temples bore the mark of Greek natural taste and reason.[3] However, race and its characteristics constituted perhaps too far-fetched an explanation. Despite his

conviction that architectonic devices and structures in general originated from racial predispositions, Viollet-le-Duc himself used this kind of explanation with relative parsimony because of its distance from principles of construction.

The major problem in the cultural explanation of architectonic devices lies in the difficulty of finding truly convincing mediations between culture, or at least what can be ascertained about it, and the thing itself. Yet the assumption that these devices are culturally determined is almost unavoidable, given that the recognition of an assemblage of architectural parts as a significant and coherent architectonic device presupposes an education of the mind and eye. To consider the association between a freestanding column and a lintel as the basis of Greek architecture, a consideration already present in Vitruvius's *Ten Books on Architecture*, means that such an association is permeated with cultural meaning. Let us note in passing that these meanings may very well belong to the culture of the distant observer of a given architecture rather than to the culture of its producers. On the one hand, we can be sure, because of Vitruvius and his close relation to the Greek tradition, that trabeation was significant for the builders of the Parthenon. On the other hand, our conventional interpretation of the Gothic, based on the association among the lancet arch, the ribbed vault, and the flying buttress, has probably more to do with late-eighteenth- and nineteenth-century interpretations of its structural characteristics than with the way in which the master builders of the Middle Ages conceived their work.

Erwin Panofsky was well aware of this pitfall when he proposed his daring explanation of the relation between Gothic architecture and medieval philosophy. Published in 1951, *Gothic Architecture and Scholasticism* remains a provocative attempt to relate patterns of thought to architectonic principles.[4] Instead of referring to general features of medieval society, such as its beliefs, its

class structure, or its scientific and technological achievements, Panofsky concentrated on the Scholastic techniques of exposition for philosophical arguments, on their modus operandi as exemplified in works like Saint Thomas Aquinas's *Summa theologiae*. He then asserted analogies between these techniques and the structural and spatial divisions that ruled Gothic architecture. Panofsky's analysis was based on the assumption, developed in his *Abbot Suger on the Abbey Church of Saint-Denis and Its Art Treasures*, that scholars influenced religious architecture through the careful programming of its major characteristics.[5] In order to realize his program, Panofsky displaced the argument by focusing on general stylistic issues rather than solely on the structural dimension. But he remained faithful to the equivalence between style and architectonics earlier postulated by theorists, from Le Roy to Viollet-le-Duc.

In France, Panofsky's work found an enthusiastic supporter in the sociologist Pierre Bourdieu. Bourdieu not only translated and published *Gothic Architecture and Scholasticism*, as well as extracts from *Abbot Suger on the Abbey Church of Saint-Denis and Its Art Treasures*. He also gave his own version of Panofsky's approach in an extended postface.[6] According to Bourdieu, Panofsky's work ranked among the most daring challenges ever issued against positivism: "Mr. Erwin Panofsky shows that culture is not only a common code, nor simply a common repertory of shared problems, but rather a set of fundamental schemes, assimilated beforehand, from which are generated, according to an art of invention similar to musical composition, an infinity of peculiar schemes, directly applied to specific situations." Panofsky's method appeared to Bourdieu all the more remarkable because seemingly consistent with his own concept of "habitus," namely, a tendency to reason and act governed both by the social and cultural position of the actor and to a certain degree by the actor's individual traits.

Although seductive, Panofsky's approach as revisited by Bour-
dieu presupposes a greater degree of unity in the work of art
and architecture than is often the case in practice. In this essay, I
would like to deal with a case study that is far less coherent, at both
a stylistic and a technical level. The use of the freestanding column
in French eighteenth-century religious buildings is certainly not
comparable to Gothic architecture, although one of its sources
was the desire to emulate Gothic structural lightness. But first, this
very desire implied the reinterpretation of past architectonic
models. In the eighteenth century, trabeation could by no means
appear as a direct and naive expression of the prevailing conditions
of the era. The best proof of this is that the device was highly con-
troversial at the time. Subsequent historians of art and architec-
ture, who have never considered this moment as describable in
terms of style, with the civilizational connotations usually attached
to that term, have provided yet further proof. Eighteenth-century
freestanding columns, in contrast to their Greek ancestors, are
neither synonymous with an easily identifiable architectural style
nor structurally sound, at least by the standards of a contemporary
architect or engineer. The lintels they support carry not relatively
light wooden beams, as in Greek temples, but massive stone vaults
exerting oblique stresses not easily dealt with by slender vertical
members. Traditional from the Renaissance on, massive piers and
arcades were much more appropriate for such a load. Furthermore,
the lintels themselves, because of their span, were built with
voussoirs instead of as monoliths. Such a solution is at odds with
contemporary structural wisdom insofar as it creates, once again,
stresses in unwanted directions.

That eighteenth-century freestanding columns cannot be con-
sidered in stylistic terms does not mean they were not intimately
linked to the culture of their period — on the contrary. As we will
see, it is even possible to relate the columns to the modus oper-

andi of Enlightenment philosophy, namely, the so-called analytic method that philosophers like Condillac, Condorcet, and the Idéologues placed at the core of human reason. The churches that were built using trabeation are certainly not the logical outcome of a timeless structural rationality. Their structural contradictions make them even more interesting for the historian intent on situating objects within a complex maze of determinations. These churches do "talk," but they talk at different and sometimes discrepant levels. One reason for these discrepancies was the growing tension between the artistic and the technical dimension of the architectural discipline that marks the second half of the eighteenth century. The use of freestanding columns and lintels allegedly echoed Greek elegance while retaining Gothic structural lightness.

Historians of architecture have often emphasized the links between eighteenth-century experimentation with the freestanding column and the subsequent development of structural thought. Here I shall argue that controversies over the freestanding column led to the emergence of the modern notion of structure *tout court*, a notion that would inform early experiments in iron construction. With this, the genealogies that have often been mobilized to explain the evolutions of artifacts are remote indeed. Still more remote is the process of "concretization," described by the French philosopher Gilbert Simondon in terms of a gradual convergence between the parts of a technological artifact and its corresponding functions.[7] Instead of seeing a logical convergence between parts and functions, we are confronted with an experimental process, a process that led to a dead end from a purely constructional point of view but that would play a decisive role in altering the framework within which the general relations between architecture and construction could be envisaged.

Deprived of notions such as style, sound structural justification,

and technological genealogy, one is confronted with a very different vision of culture from the one implicit in Bourdieu's reading of Panofsky. Instead of being a coherent whole, culture resembles a somewhat labyrinthine reality, a reality based on complex interfaces, on overlaps, and on short circuits rather than on the harmonious development of "a set of fundamental schemes, assimilated beforehand." In such a reality, social imagination plays a key role, imagination being taken here not as a coherent set of representations but rather, following Cornelius Castoriadis's characterization, as the frame of thought that "enables in a given society the coexistence of the apparently most heterogeneous things, acts, and individuals."[8] Imagination is ultimately not about coherence but about the possibility of articulating heterogeneous parts and levels, both for theoretical and for practical purposes. Associations of that type are often called chimeras. With their freestanding columns and their massive vaults, with their contradictory references to Greek and Gothic, eighteenth-century churches are indeed chimeras. Many things that talk, in architecture as in other domains, have something chimerical about them.

Freestanding Columns: From the Colonnade of the Louvre to the Panthéon

Until the late seventeenth century, freestanding columns were rare in French architecture. With its gigantic Corinthian order, the colonnade of the Louvre inaugurated a new period marked by a series of monumental buildings making use of trabeation, culminating in Jacques-Germain Soufflot's church of Sainte-Geneviève, renamed the Panthéon during the French Revolution.

The principle of the colonnade was formulated in 1668 by a committee composed of the painter Charles Le Brun, the architect Louis Le Vau, and the savant Claude Perrault in order to replace the design produced in 1666 for the Louvre by the Roman artist

Giovanni Lorenzo Bernini.[9] Whereas Bernini had proposed a facade with pilasters, according to the manner used for Italian palaces, Le Brun, Le Vau, and Perrault decided to create a peristyle with freestanding columns. Nationalist concerns were surely present in their decision. The new facade of the Louvre was to emulate the Greco-Roman peristyles at a scale yet unheard of, thus demonstrating the superiority of French architecture over not only its coeval European rivals but also its antique models.

Although the exact author of the scheme is difficult to ascertain, Perrault, who had been commissioned by the French state to do a new translation of Vitruvius, certainly played an important role in the affair. The general appearance of the colonnade was very close to the engravings he was commissioning at the same time for his translation. Besides this connection between his interpretation of Greco-Roman architecture and the choices made for the Louvre, his essential contribution to the further definition of the colonnade and its construction staked his claim as the true author of the building.

From a structural point of view, the new facade of the Louvre was disconcerting (figure 2.1). It looked like a giant Greco-Roman peristyle, but it was based on entirely different construction principles because of its size. In order to span the broad intercolumniations, the lintels were composed of voussoirs instead of the monoliths that the ancients had used for their temples. Such a device transformed them into flat vaults exerting horizontal thrusts. Above all, the entire construction was reinforced with iron (figure 2.2). Iron tie-rods were, for instance, used to counterbalance the thrust of the voussoirs, while horizontal X-braces helped to stabilize the ceilings of the peristyle. Vertical iron ties reinforced even the columns.[10]

Such an extensive use of iron was quite unusual at the time. It gave the colonnade an experimental character, further enhanced

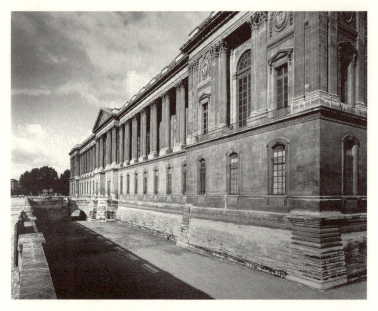

Figure 2.1. The Colonnade of the Louvre, general view. © Centre des Monuments Nationaux, Paris. Photograph by C. Rose.

Figure 2.2. Reinforcements of the Colonnade after Pierre Patte, *Mémoires sur les objets les plus importants de l'Architecture*, 1769. Courtesy of the author.

by impressive feats like the use of two huge monoliths, each measuring more than 50 feet, to cover the pediment of the central pavilion. A special machine had to be designed to transport them and put them in place. In the second edition of his translation of Vitruvius, published in 1684, Perrault publicized this achievement.

The most decisive feature of the colonnade was probably the discrepancy between its exterior and its inner organization, as well as the eclecticism of its stylistic references. The use of iron implied a divorce between appearance and building techniques. Moreover, while the colonnade presented itself as the heir of the Greco-Roman peristyles, there was something Gothic about its slender proportions. These discrepancies jeopardized the Vitruvian notion of solidity that had prevailed since the Renaissance in architecture and engineering. Solidity in the Vitruvian sense was based on the accordance between the interior reality of a construction and the impression conveyed by its exterior. To count as solid, a monument not only had to be well built; it also had to look reassuringly stable. Hence the disconcerting judgment customarily passed on Gothic cathedrals: they were not usually deemed solid, although they had stood for centuries, because their proportions were too daring to convey a true impression of stability. With its hidden reinforcements and its Gothic connotations, the colonnade flirted with precariousness.

Despite its controversial character, the Louvre's peristyle soon became a major point of reference for religious architecture. In a project for the reconstruction of the Parisian abbey Sainte-Geneviève, Claude Perrault was among the first to envisage replacing the massive pillars in use since the Renaissance by slender columns similar to those of the colonnade (figure 2.3).[11] In his project, the columns carried an entablature instead of arches. The resemblance to the colonnade was striking. In a commentary written in 1697, Claude's brother, Charles Perrault, stressed the

Figure 2.3. Claude Perrault, project for the reconstruction of the abbey
Sainte-Geneviève in Paris, circa 1680, cross-section on the nave, Bibliothèque
Sainte-Geneviève.

similarity. Supporting the heavy stone vaults of the church was, however, a challenge. In his memoir, Charles stated that iron reinforcement would provide the columns and lintels with the necessary strength.

Throughout the eighteenth century, the colonnade remained influential. A series of churches was built using trabeation in a way reminiscent of its layout. In addition to the chapel of Versailles by Jules Hardouin-Mansart and Robert de Cotte, the chapel of the palace of Lunéville, built in the 1720s by Germain Boffrand, was among the first examples of the new type of construction. Around 1755, Saint-Vaast in Arras used freestanding columns on an even larger scale (figure 2.4). Later came, among others, the church of the Madeleine in Rouen, by Jean-Baptiste Le Brument, and the cathedral of Rennes, by Mathurin Crucy.[12] Scale was indeed important in the affair, as if the architects were trying to set a record. Etienne-Louis Boullée's famous proposal for a gigantic cathedral was typical in that respect. More generally, churches with freestanding columns, like the colonnade, usually were something of an experiment.

This experimental character was not only a matter of isolated vertical supports and the size of the construction. Churches with freestanding columns were also built with complex iron reinforcements. Moreover, in their attempts to cope with the oblique thrusts exerted by the vaults, thrusts for which slender supports were not wholly adequate, at least in theory, the architects revived a typically Gothic feature: the flying buttress.

These features were present, for instance, in the most famous church with freestanding columns, the new church of the abbey Sainte-Geneviève, begun in 1754 by Jacques-Germain Soufflot.[13] Later known as the Panthéon, the church made spectacular use of freestanding columns, from its portico to its nave. The portico columns were especially remarkable. Even taller than those of the

Figure 2.4. Pierre Contant d'Ivry, Saint-Vaast in Arras. © Centre des Monuments Nationaux, Paris.

colonnade, these columns set a new record in the race toward gigantism. To make its daring proportions viable, Sainte-Geneviève's lintels and nave were reinforced with iron, while flying buttresses, hidden behind the exterior walls, were meant to take part of the vault thrusts.

A desire to reconcile Greco-Roman architectonic and ornamental features with Gothic constructive ingenuity permeated the churches with freestanding columns. This desire was especially pronounced with Sainte-Geneviève, and Soufflot told one of his assistants that his intention was to reconcile Greek elegance with Gothic lightness (figure 2.5).[14] Such a reconciliation was clearly imbued with political meaning. During the second half of the eighteenth century, in architecture as in other domains, from furniture to fashion, the Greek reference was synonymous with a quest for a new visual clarity that would convey the enlightened aspirations of the reign of Louis XV, breaking with the unbridled fantasy of the rococo.

Soufflot's patron, Marigny, brother of the Marquise de Pompadour and appointed through her influence to the post of superintendent of royal constructions, was among the chief proponents of the new trend. Visits during his formative years to the Greek temples of Paestum in the company of Soufflot and Charles-Nicolas Cochin had left a great impression on Marigny's mind. To be Greek meant for him to merge the founding principles of the French absolute monarchy with the civic and aesthetic values of the ancients. In a period marked by the emergence of ideals of individual and economic freedom, this merging was highly desirable for the administrative and financial elite who wanted to reform the French status quo.[15]

The Gothic reference was as political as the Greek. It conveyed ideas of continuity between the past and the present of the French nation. From the end of the seventeenth century on, a

Figure 2.5. Jacques Germain Soufflot, Sainte-Geneviève, now the Panthéon, general view of the nave. © Centre des Monuments Nationaux, Paris.

renewed interest in Gothic architecture had been growing. Gothic ornamentation was still dubbed grotesque, but Gothic monuments were at the same time more and more frequently interpreted as an authentic expression of French artistic genius. Gothic proportions and slenderness were praised by authors like François Blondel, the first director of the Academy of Architecture, and Michel de Frémin, a lawyer and builder. This context explains the choice made in the 1720s to complete the cathedral of Orléans with a facade in the Gothic style.[16]

Related to both the Greek and the Gothic, associated with themes such as visual clarity, lightness, and economy of material, freestanding columns and their lintels were thus permeated with a complex of aesthetic and political meanings. The colonnade of the Louvre was among the main beneficiaries of this situation. Besides its possible Greek and Gothic interpretations, the peristyle was a symbol of Louis XIV's reign, the prestige of which haunted the contemporaries of Louis XV and Louis XVI, as shown by the history that Voltaire devoted to it. This helps to explain the great attention paid to the colonnade when its construction was resumed at the beginning of the 1750s under the supervision of Soufflot. The task was Soufflot's first major commission. From the colonnade of the Louvre to the Panthéon, the freestanding column was one of the key features of eighteenth-century French monumental architecture.

Theorizing Trabeation

The importance of freestanding columns and trabeation is further revealed by a series of theoretical writings dealing with religious architecture and its evolution. In his *Mémoires critiques d'architecture* of 1702, Michel de Frémin praised Gothic churches for their slender supports that contrasted so sharply with the heavy pillars of Renaissance and seventeenth-century religious buildings.[17]

Frémin was also full of admiration for the flying buttresses that enabled their columns to carry only part of the load of the vaults. Next came the abbot Jean-Louis de Cordemoy and his *Nouveau Traité de toute l'architecture* (1706). Cordemoy was even more critical than his predecessor of the architecture of his time, to which he opposed the beauty of ancient churches and the majesty of the Louvre. "I would indeed consider a church in the manner of the peristyle of the entrance of the Louvre . . . as the most beautiful thing in the world," declared Cordemoy, who saw the freestanding column as the true basis of religious architecture.[18] As the historian of architecture Robin Middleton has noted, Cordemoy's proposals were "surprisingly Greek."[19] Thus Cordemoy was among the first to theorize the Greco-Gothic ideal that would culminate in Soufflot's Sainte-Geneviève.

Throughout the eighteenth century, various other authors wrote on similar issues. None was as influential as the Jesuit Marc Antoine Laugier with his *Essai sur l'architecture* (1753) (figure 2.6). More ambitious than his forerunners, Laugier tried to justify his preference for churches with freestanding columns in a way that reveals what was at stake far better than the still-confused explanations given by Frémin or Cordemoy. His starting point was the assumption that architecture had to be founded on utility, that essential notion of eighteenth-century philosophy and political theory. "Utility circumscribes everything. In a few centuries' time it will set bounds to experimental physics, as it is about to do to geometry," wrote Denis Diderot in his 1754 *Pensées sur l'interprétation de la nature*.[20] For an architectural discipline still imbued with Vitruvian principles that gave precedence to ornament over utilitarian concerns such as disposition or construction, this assumption indeed marked an important shift. Although Laugier made no direct reference to them, two factors at least played a role in this evolution. The first was the gradual replacement of

Figure 2.6. Marc Antoine Laugier, *Essai sur l'architecture* (Paris, 1753; new edition Paris: Duchesne, 1755), frontispiece. Courtesy of the author.

traditional monarchical values by a growing concern for individual and public welfare. Architecture was summoned to participate in the quest for the common good. The example set by engineers, whose projects seemed to epitomize this quest, was another powerful factor. The French engineering profession was developing rapidly in the mid-eighteenth century, and utility was among its fundamental claims.[21]

But how was architecture, as an art, supposed to be useful? Churches in particular seemed to answer spiritual needs that had nothing to do with ordinary utilitarian concerns. To take up the challenge, Laugier used a typically eighteenth-century literary device of projecting his reader toward the origin of man and society. Architecture at the origin was useful because its function was to shelter man. According to Laugier, this function was first carried out through the construction of primitive huts. Primitive huts, he supposed, were made of wood, with four tree trunks linked by horizontal branches supporting a double-pitched roof.[22]

This archetype was meant as a model to which architecture should cling in order to avoid unnecessary fantasies and sophistication. The Greek temple was seen as its direct translation into stone. Applied to churches, such a model justified the freestanding column and its lintel, interpreted as a transposition of the primitive tree trunks and branches. The vaults, however, set limits to this interpretation. To justify the discrepancy between the archetype and its modern version, Laugier, like Cordemoy, referred to the Greco-Gothic ideal, Greek authenticity and correctness tempered with Gothic lightness.[23]

To a contemporary architect or engineer, the justification from Laugier may seem strange at first, since the reference to the primitive hut was counterbalanced by a radical change in the way the building behaved. Indeed, one passed from the Greek stack of monoliths to a much more complex system in which the thrusts

exerted by vaults were transferred to flying buttresses. The architect Charles-François Viel later characterized this move as opposing the "direct forces of tradition" to the "indirect forces" on which monuments like Soufflot's Sainte-Geneviève were based.[24]

The ambiguity of the justification is in itself an incentive to dig further in order to understand the fascination with the freestanding column and the lintel. Laugier's origin story is in this respect revealing. To an eighteenth-century mind, the origin did not necessarily have a historical status. It had more to do with the idea of a rational reconstruction of the conditions of a given feature's emergence and development than with the description of an actual situation. From this perspective, the primitive hut could well be a mere fiction. This fiction promoted an interpretation of architecture as a system whose elements were clearly distinguished from one another: the vertical supports, the horizontal beams, the roof. Unlike Renaissance and seventeenth-century churches, in which the various parts — pillars, arches, and vaults — interpenetrated one another as segments of a continuum, the primitive hut appeared as an assemblage of discrete elements. To eighteenth-century eyes, the logic of assemblage was the only true common denominator between the Greek and the Gothic. Like the Greek temple, the allegedly direct transposition of the primitive hut, the Gothic cathedral was interpreted by its admirers as an articulated system, with its slender columns, its vaults, and its flying buttresses. In a letter written in support of Soufflot, whose design for Sainte-Geneviève had been criticized as unsound by the architect Pierre Patte, the Ponts et Chaussées engineer Jean-Rodolphe Perronet related it to Gothic churches, the organization of which he compared to the human skeleton, the epitome of an articulated system.[25]

A quest for architectonic clarity permeated the *Essai sur l'architecture*. The same quest was present in the churches with free-

standing columns. It had to do with the analytic attitude in domains ranging from philosophy and the sciences to the arts. Analysis had first been promoted as an attitude and as a method by sensationalist philosophy. Its first object was to understand how complex judgments and discourse were the outcome of primitive sensations through a process of gradual abstraction. Primitive sensations were thus interpreted as elements whose combinations gave birth to thought and language. From that stage, it was tempting to generalize by assuming that the various sciences and arts were nothing but combinations of elements. Condillac had such a generalization in mind when he stated that "analysis is the entire decomposition of an object and the arranging of its components so that generation becomes at the same time easy and understandable."[26] The Idéologue Dominique Joseph Garat would define "analysis" as "the method of the human mind" in his lectures at the Ecole Normale during the Revolution.[27]

From the analysis of the human mind to the other sciences and arts, the path was easy to follow if one could identify their fundamental elements (figure 2.7). This perspective was implicit in some of Jean Le Rond d'Alembert's writings such as his article "Eléments des sciences" for the Encyclopédie and his Essai sur les éléments de philosophie.[28] Applied to the mechanical arts, analysis, or the systematic decomposition of machines and processes into elementary parts and operations, seemed to point the way to improvement and rationalization. This perspective was well expressed by Diderot in his Encyclopédie article "Stocking [Bas]," in which he analyzed a knitting-machine and the way it operated.[29] Indeed, this analytic perspective permeated the entire Encyclopédie and its descriptions of the arts and crafts.[30]

The same analytic attitude was present among engineers and designers. Eighteenth-century engineers often conceived their projects as combinations of elementary parts and their realization

Figure 2.7. Pierre François Lancelin, *Introduction à l'Analyse des Sciences* (Paris, 1801), analytical expression of complex ideas. Courtesy of the author.

as sequences that should ideally approximate a chain of manufac-
turing operations.[31] In its own way, Laugier's interpretation of
churches with freestanding columns was also analytic, since the
evocation of the primitive hut as an assemblage and the reinter-
pretation of religious architecture as a transposition of this assem-
blage were equivalent to "the entire decomposition of an object
and the arranging of its components so that generation becomes
at the same time easy and understandable."

In this process of decomposition followed by generation, or
rather rearrangement, the utility of architecture was twofold.
The physical utility of architecture was linked to its function as a
shelter. But there was also a moral lesson to be drawn from the
contemplation of its origin and the complexity of its modern
transposition. With their Gothic connotations, churches with
freestanding columns portrayed human evolution, from primitive
needs to the subtleties of civilization. Reconciling Greek elegance
with Gothic lightness was thus saturated with a moral value, as a
reflection on the history of man and the meaning of progress.
Later in the century, the so-called revolutionary architects Eti-
enne-Louis Boullée and Claude-Nicolas Ledoux further pursued
this moral mission with architectural productions that pointed
both to the origin and elementary spatial sensation and to the
more refined sphere of language and symbolism.[32]

With the analytic character of churches with freestanding col-
umns and its philosophical component, we are close to Panofsky's
type of interpretation. However, this analytic character does not
fully account for the power of the Greco-Gothic ideal. Other fac-
tors also contributed to the desire for greater architectonic clarity
and structural lightness.

Greater visibility of the main altar was another goal invoked
by theorists, from Frémin and Cordemoy to Laugier. Why this
was desirable may seem obvious at first, especially given the

church affiliations of the last two. But the greater visibility of the altar was not the only consequence of replacing massive pillars by slender columns. The crowd attending the church also became more visible. In this respect, the evolution of religious architecture was analogous to transformations in other fields, such as the theater. Eighteenth-century French theater architecture was marked by a series of experiments tending toward a compromise between the Italian model, with its loges, and the antique organization with its tiers. Loges were in accordance with the hierarchical nature of the ancien régime society. However, they were synonymous with visual barriers that deprived the public of the pleasure of seeing each other without obstacle, a pleasure clearly in play in Greek and Roman theaters — hence the desire to reach a compromise between the Greek or Roman organization and the modern Italian one. Proposals were made by authors like Charles-Nicolas Cochin and Pierre Patte.[33] Their underlying concern was especially clear in the commentary written by Ledoux on the theater he had built in Besançon. Illustrated by a famous engraving of an eye in which the theater room was reflected, the text emphasized the importance of the public.[34] According to the architect, the gathering of the people was as important as what was taking place on the stage. The same was probably true of the churches with freestanding columns built in the last decades of the eighteenth century, a time when the people gradually came to be seen as the only source of true political legitimacy. Despite their religious function, these churches were part of the trend often described as the "secularization" of French society, a trend that would ultimately be one of the causes of the Revolution. In this perspective, the transformation of Sainte-Geneviève into a secular pantheon devoted to the cult of civil heroes like Voltaire and Rousseau was consistent with the character imparted to the building from the start.

Figure 2.8. Sainte-Geneviève, now the Pantheon, view of the freestanding columns. © Centre des Monuments Nationaux, Paris.

In addition to visibility, mobility was at stake. This dimension was conveyed by the theorist Julien David Le Roy in another treatise devoted to churches with freestanding columns: his 1764 *Histoire de la disposition et des formes différentes que les chrétiens ont données à leurs temples, depuis le règne de Constantin le Grand jusqu'à nous* asks: What is the nature of the aesthetic pleasure we derive from colonnades? His answer was that, unlike most architectural devices, colonnades gave a pleasure that was not static but dynamic, linked to the changing perspectives offered by the lines of columns like trees in a forest.[35] It followed that churches with freestanding columns invited their visitors to move. Thus they were reviving the patterns initially associated with basilicas, originally meeting places, in Antiquity (figure 2.8).

Implying mobility, their aesthetics was well in accordance with the emphasis at the time on movement and circulation. As historians have repeatedly pointed out, eighteenth-century culture privileged movement over immobility. Movement was seen as healthy and productive, immobility as dangerous and sterile. This obsession with mobility permeated urban policies. It explains the general concern with the renewal of air and water in urban districts, as well as the accent put on the commercial needs of cities.[36] Mobility was vital both in the natural and in the human world; it extended even to the political and moral sphere. Goods and men but also ideas had to circulate.

In the engineering world, the new type of bridge conceived by designers like Louis de Régemortes, Jean Hupeau, and Perronet was one sign of the importance attributed to movement.[37] Its function was to establish communication and to promote exchange between cities and provinces. Features like its thin piers and surbase arches were meant to improve the flow of water as well as the circulation on its deck. Revealingly, these features were often compared with the Gothic system. Perronet declared, for instance,

that modern bridges, because of their slender proportions, were "like Gothic churches that would necessarily collapse if one of their pillars gave way."[38] An engineer like Perronet also had in mind the analogy between bridges and churches with freestanding columns. Thin piers were analogous to columns, while surbase arches bore some resemblance to lintels made of voussoirs. The analogy could be carried further, since the piers, because of their thinness, could not take the entire thrust of the arches. The force exerted by the latter was actually transmitted to the abutments, at both ends. Abutments were thus structural equivalents to the flying buttresses of a church like Sainte-Geneviève. This set of analogies helped drive Perronet to envisage the replacement of bridge piers by rows of columns, as if a bridge were a trabeated structure that emerged from water. In one of his memoirs on bridge building, he went so far as to suggest that modern bridges were based on a trabeated archetype similar to Laugier's primitive hut.[39] In this context, it is no surprise that Charles François Viel condemned churches with freestanding columns and modern bridges because of their use of "indirect forces" in the same breath.

In the engineers' case, the evolution of bridge design was linked to a broader change in technological efficiency.[40] Like the architects, seventeenth-century engineers usually reasoned in terms of order and proportion. Like architectural beauty, technological efficiency was a matter of order and proportion between the parts and the whole of a machine, or between causes and effects. It was a static quality related to the belief in an ordered universe, which was in many ways comparable to a grand edifice. Hence theorists were fascinated by the proportions given by God to the Temple of Jerusalem, which were supposed to embody the ultimate knowledge about the creation.[41] Gradually abandoning this belief, eighteenth-century designers interpreted efficiency as an outcome of the movement, flow, and circulation that animated

both nature and society. Being efficient became synonymous with being in accordance with natural and social dynamism. The new bridges built by engineers embodied this new conception.

During the second half of the eighteenth century, the meaning imparted to trabeation extended far beyond its mere architectural impact. Besides their philosophical connotations, the freestanding column and its lintel, like their engineering counterparts, the thin pier and the surbase arch, were related to a series of themes, from visibility to mobility, themes that resonated with cultural and political factors such as the gradual secularization of society and the evolution of technological efficiency. Although interconnected, these themes and factors cannot be described as a logical system akin to the Scholastic modus operandi. They appear, rather, as the expression of the various directions taken by the social imagination of eighteenth-century France, directions neither entirely convergent nor totally divergent.

The Emergence of Modern Structural Thought

Churches with freestanding columns sparked fierce debates on the soundness of their design. Like modern bridges, they were indeed daring constructions. Their proportions challenged the rules that had been taken for granted by the Vitruvian tradition. Sainte-Geneviève was, for instance, criticized in the early 1770s by the architect Pierre Patte, who found the pillars that supported its cupola too thin. Later, during the Revolution, the building was again the subject of a polemic opposing various architects and engineers.[42] Structural problems had begun to appear for reasons still discussed today. The compression of the soil played a role, but so did the way stones were dressed. Many changes were made in Soufflot's initial design, but the Panthéon has remained until today a somewhat problematic building.

These problems fostered reflection on the behavior of

construction. Following Robin Middleton's study of Cordemoy and Laugier, the historian of architecture Kenneth Frampton has argued that they initiated the modernist "tectonic" ideal.[43] I would like to go a step further by showing that they played a crucial role in the emergence of modern structural thought. The point is not an obvious one to make, since historians of architecture and construction usually take structure as granted by nature, as if deciphering the organization of a building into structural and nonstructural parts were unavoidable. This prejudice is reinforced by the fact that we can always retrospectively analyze past constructions, like Filippo Brunelleschi's famous cupola, as structural achievements. In fact, until the eighteenth century, at least in France, a structural attitude was hard to identify not only among architects, but also among engineers.

One reason for this is that our notion of structure is based on the possibility of a discrepancy between the exterior appearance and the internal organization of a building. Although early-modern architects and engineers often cheated in their realizations, using, for instance, hidden wood beams and even iron cramps to reinforce them, these practices were considered minor deviations from the rules of architecture and engineering. Within the Vitruvian framework, these rules postulated a profound harmony between exterior and interior. Moreover, the Vitruvian-based theories of architecture and engineering did not recognize a hierarchical order between what we now call structural and nonstructural parts. Ornament in particular was deemed as essential as pillars, arches, and vaults. The determination of the line of the volute of the Ionic capital was, for instance, a fundamental topic in the eyes of theorists.[44] In this context, a structural reading of buildings was of no real interest.

Another way to reveal the complexity and cultural character of the notion of structure is to examine what was later to become

a structure for an architect or an engineer. Everything in the world has an organization. A heap of sand or a pile of wood is, for example, a structure; in recent decades, physicists have become increasingly interested in the way sand piles up. But for architects or engineers, a heap of sand is not usually considered a structure. In their eyes, structure is synonymous with a certain range of choices. It does not cover all the configurations made possible by nature. Structure is usually synonymous with an inspiration taken from nature, but it is based on some kind of selection among natural configurations. A structure presupposes a degree of visual complexity that disqualifies the heap of sand as structural for the architect or the engineer. Too complex a device can also be considered an aberration, since it seems to run counter to structural rationality. Structure is actually a compromise, a socially shaped compromise, between the simple and the complex, the natural and the artificial.

Following the colonnade of the Louvre, churches with free-standing columns were based on a profound discrepancy between their exterior and their inner organization, their Greek or Roman appearance and the hidden iron cramps and ties. This discrepancy was further reinforced by the claim to be both Gothic and Greek, the Gothic covering what was soon to become the structural organization, the Greek being more ornamental. From a purely aesthetic standpoint, this gap implied two different kinds of beauty. Whereas the Greek reference pointed to the traditional Vitruvian values of harmony between the parts and the whole, as well as to the refinement and delicacy of the ornaments, its Gothic counterpart had to do with lightness, a lightness so extreme that it conveyed ideas of daring and even danger. Perronet's remark that Gothic churches would collapse were only one of their pillars to break must be placed in that perspective. In the late eighteenth century, the challenging nature of some constructions would be

interpreted as sublime. Structure emerged under the aegis of sublimity, a sublimity both physically evident, since one could not but be struck by the height of the vaults and the slenderness of the vertical supports, and technologically concealed, since neither the iron cramps nor the flying buttresses could be seen by the spectator. This mixture of evidence and concealment still characterizes many structural achievements today. Facing a structure, we can easily appreciate the performance, but it is usually more difficult to decipher how it actually works.

Because of the slenderness of their columns, churches with freestanding columns had to be built with special care, from the foundation to the top: hence a special concern with the links between the various parts of the construction, between the columns and the lintels, the vaults, the walls, and the flying buttresses. Constructions like Sainte-Geneviève were not just articulated systems. Like skeletons, they were meant as systems in which each part was supposed to contribute directly toward the stability of the whole. By the end of the seventeenth century, a heated debate had opposed physicians and anatomists on the question as to whether or not nature had put unnecessary parts in animals.[45] Churches with freestanding columns were clearly looking for an organization with no superfluous members.

From the start, the use of freestanding columns was permeated by organicist references. This influence was evident in Claude Perrault, who was both a physician and an architect. In his writings, the term "structure" was used to designate the intricate organization of an organ or a whole body. During the second half of the eighteenth century, the organicist references were still more evident, since physicians were becoming increasingly concerned with urban and architectural problems. They played, for instance, a crucial role in the decision to displace cemeteries outside cities and in the construction of new hospitals.[46]

Among these organicist references, the circulation of blood and other fluids was especially prominent. Churches with free-standing columns were based on the circulation of forces, on their partial derivation toward the periphery of the building. At a time when fundamental notions of mechanics, such as force and work, remained unclear, especially for practitioners, the exact nature of these forces was defined empirically.[47] Loads circulated like a fluid, the properties of which were yet to be understood. Architectural parts that conducted the loads were like arteries, drains, or pipes. These hydrodynamic connotations durably impressed the builders' imaginations. This intellectual context may account for the decision taken some decades later by Augustin-Louis Cauchy, who had been trained as a Ponts et Chaussées engineer, to use Leonhard Euler's approach of hydrodynamics to define stress and to organize the theory of elasticity.[48]

The modern notion of structure emerged at the meeting point of various factors, as a culturally constructed compromise between the natural and the artificial, the visible and the invisible, the stable and the risky. It appeared synonymous with an internal circulation, the characteristics of which still had to be investigated. Meanwhile, various life forms provided provisional models for it. Besides the circulation of blood, trade on roads and canals was a possible model. The emergence of structural thought was contemporaneous with the development of economics. Both belonged to a world in which static organization, from the assemblage of architectonic parts to the layout of territorial infrastructures, mattered only insofar as it enabled circulation to take place.

Along with the various cultural factors I have been reviewing throughout this essay, a disposition to treat dynamic phenomena through static organization should also be mentioned.[49] Analysis, as Condillac conceived it, was no more than a way to describe as a static set of genealogical relations the dynamic process through

which elementary sensations combined to give birth to complex thoughts. Similarly, churches with freestanding columns were immobile monuments celebrating movement and fluidity. How not to be reminded of Joseph-Louis Lagrange's turning dynamics into statics in his *Mécanique analytique* (1788)? The suggestive power of architecture often stems from its capacity to translate into visual metaphors cultural trends of that type.

The Symbolic Alternative

By the end of the eighteenth century, in the eyes of many the freestanding column had acquired a structural status. This status implied consequences that were devastating for the unity of architectural design, since the structural and the ornamental levels were becoming distinct problems, a split that prefigured the divorce between science and technology, on the one hand, and between art and architecture, on the other. Throughout the nineteenth century, rationalists like Viollet-le-Duc lamented this divorce. Some of its damaging consequences, at least from the architect's point of view, were already detectable on the eve of the nineteenth century. The anxiety it generated may explain the investigation of an alternative, a purely symbolic one, by authors like Jean-Louis Viel de Saint-Meaux.

In his *Lettres sur l'architecture des anciens et celle des modernes* (1787), Viel de Saint-Meaux proposed another origin for the freestanding column: the monoliths that the ancients erected in order to symbolize the rhythms of the universe, the cycle of seasons, and the fecundity of the earth: "One can consider these very stones as the mothers of sciences and arts; they bore the first hieroglyphs, or representative signs, signs to which we owe the origin of painting and language."[50] Through this symbolic function, the divorce between the structural and the ornamental was to be avoided, for these stones also represented load and structural

behavior, although this meaning was second to the celebration of cosmic rhythms.

A symbolic dimension had been present in Laugier's writings, since the freestanding column pointed to the origin while enabling the spectator to measure the long distance between the fulfillment of primitive needs and the present state of civilization. But the symbol was not foundational. What mattered above all was the structural role of the column in relation to the lintel and the roof. With his theory, Viel de Saint-Meaux reversed the respective importance of symbolism and structural function.

Architecture is probably not a discipline in the ordinary academic sense, but a tradition based on the periodic reinterpretation of the past. Although most historians of architecture neglect the cultural factors reviewed here, factors that explain the eighteenth-century use of freestanding columns, the episode is nonetheless held to be a major turning point in architectural theory and design. Although Sainte-Geneviève and the other churches with freestanding columns had no posterity in the nineteenth century, they are often mentioned as important steps leading to modern architecture. The split between structure and ornament, as well as the tension between a structural and a symbolic interpretation of architecture, certainly plays a role in the affair, especially with historians like Joseph Rykwert and Alberto Pérez-Gómez, who defend the symbolic dimension of architecture against the alleged threat of science and technology.[51] Unveiling some of the cultural factors that may account for the structural use of freestanding columns and revealing the role played by social imagination in the emergence of structural thought might present an alternative in a prolonged battle that has often prevented seeing architectural things as they really are, that is to say, as far less univocally determined, as far less coherent than what the historian or the philosopher would like them to be.

Staging an Empire

M. Norton Wise and Elaine M. Wise

Palimpsest

"History unrolls the palimpsest of mental evolution," says the *Oxford English Dictionary*.[1] Although the metaphor derives from the canonical palimpsest of a parchment subjected to writing and writing over, it is appropriate for other objects whose form and meaning result from a history of shaping and reshaping, such as rocks subjected to the forces of fire and water. A curious "thing" of this sort sits in the Havel River near Potsdam (figure 3.1). It is the Pfaueninsel (Peacock Island), on the surface of which, between 1793 and 1830, successive visions of romantic isolation, imperial fantasy, and industrial and colonial development left their impression as formations in the landscape. The island might be thought of simply as a place, a destination for a weekend excursion from Berlin. It becomes an eloquent thing when it is seen to carry multiple layers of meanings, meanings that have been built into it and that can still speak to those who reflect on its history. In fact, the palimpsest of the Pfaueninsel has been sufficiently fascinating that for a century and a half it has attracted both popular and professional historians of all sorts, meriting even a literary visit by Theodor Fontane and a place in Alexander von Humboldt's *Kosmos*.

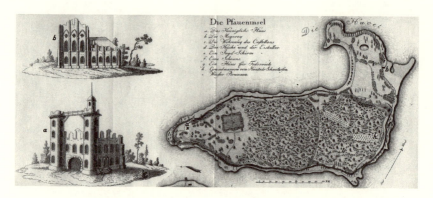

Figure 3.1. *Die Pfaueninsel*, drawing by L. Humbert, engraved by Ludwig Schmidt (1798), in *Der königliche neue Garten an der heiligen See, und die Pfauen-Insel bey Potsdam* (Potsdam: Horvath, 1802; repr. Potsdam: Märkische Verlags- und Druck-Ges., 1991), pocket foldout.

Humboldt, whose significance for the Pfaueninsel we will sug-
gest was ever present, even in his near-total absence, will serve
here to place the island in a perspective somewhat different from
that which has been usual, taking us away from the excellent stud-
ies of the buildings, plants, animals, and residents that have al-
ready been written — and on which our interpretation relies — to
what lay behind and around its multiple re-presentations.[2] We are
treating a period when Prussia was passing through some of the
most formative moments of its political economy: Stein-Harden-
berg reforms, *Befreiungskrieg*, and entry into the modern econ-
omy of industry and empire. We will indicate how these events
left their marks on the Pfaueninsel as a series of stage settings
where visions of colonial empire were enacted. In this palimpsest
of stagings and restagings, the earlier visions remained visible in
the later, but under partial erasure and carrying newly inflected
meanings. Five settings will emerge.

Paradise

When Friedrich Wilhelm II acquired the Pfaueninsel in 1793, it
already carried an aura of mystery. Its owner in the late seven-
teenth century had been the (al)chemist Johann Kunckel, whose
smoking ovens and secret operations lent a suspect quality to his
private domain. He did pursue alchemical secrets, but more di-
rectly important to his patron, the Great Elector Friedrich Wil-
helm of Brandenburg, was his production of many kinds of glass,
especially a unique ruby glass that brought high prices throughout
Europe.[3] Still, the alchemist image remained attached to the foun-
dation stones of his burned-out workshop forever afterward (fig-
ure 3.1h). The mystical and Rosicrucian attachments of the new
royal owner did nothing to erase it. Friedrich Wilhelm II and his
consort Wilhelmine Enke (raised to Countess Lichtenau) con-
ceived the Pfaueninsel quite literally as a stage set, in two senses.

From a distance, it was to provide a prospect, a vista on another world, to be seen from the Marmorpalais in the Neue Garten. For that purpose, they had built on one end of the island a small palace in the form of a ruined Roman villa and on the other end, as a visual pendant, a dairy done as a Gothic ruin (figure 3.1a and b). The structures were even built like stage sets, with the siding of the palace walls consisting of painted boards sprinkled with sand to look like stone and with the Gothic pilasters and arches of the dairy done as appliqués made of painted fieldstones.[4]

As an actual destination for short trips up the Havel River, however, the island and its ruins took on a different function. They provided the setting for the illegitimate royal couple's idylls, in which peacocks wandering among the ruins figured the island as a romantic paradise, to which the pair sailed on the sprawling Havel River as though on an ocean voyage (figure 3.2a and b). Accordingly, for the interiors of their very livable theatrical buildings, they employed the best of local woodworkers and painters to produce fine dining halls and more intimate bedrooms and parlors. Several such rooms in the palace feature exotic wallpapers with Asian and tropical motifs. Most notable for the theme of paradise is the Tahiti Room (*Otaheitisches Kabinett*), which recalled the colonial expeditionary voyages of Captain Cook, so popularly described in the account of Georg Forster, who accompanied Cook as a draftsman and naturalist on his second trip around the world in 1772–1775.[5]

The Tahiti Room was painted and papered to mimic a bamboo hut. On the walls hung pictures of scenes from the Havel landscape, painted as though in the tropics. In one, the voyage to Tahiti was presented as the voyage to the Pfaueninsel, as the viewer in the palace "hut" looked past the leaves of banana palms to see the palace itself on a nearby tropical island (figure 3.2b).[6] In this first incarnation of the Pfaueninsel as a stage for royal imagining,

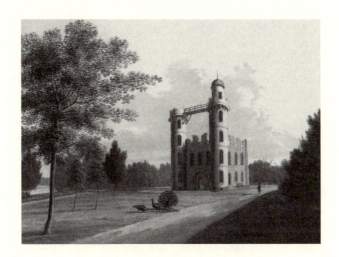

Figure 3.2a. Wilhelm Barth, *Das Königliche Schloss auf der Pfaueninsel*, ca. 1805, Staatliche Museen zu Berlin – Preussischer Kulturbesitz, Kupferstichkabinett, KdZ 26563; 3.2b. Peter Ludwig Lütke, *Ansicht der Pfaueninsel*, 1795, on the wall of the Tahiti Room, in Georg Poensgen, *Die Pfaueninsel* (Berlin: Hollerbaum und Schmidt, 1934), fig. 1.

it had none of the attributes of economic reality that it would soon acquire. It called up a world of dreams, whether of nostalgia for the decayed remains of Roman and medieval life or an idyllic future on a South Sea island. The king and his consort, however, had little time to develop these fantasies, because he died in 1797.

Model Farm

Under the new king and his immensely popular queen, Luise, the Pfaueninsel soon took on a new staging. It served no longer as a romantic destination to which the couple could escape from the realities of court, for Luise did not particularly care for it. Their favorite escape was Paretz, down the Havel River from Potsdam, where they sought the simple life among the villagers and in their *ferme ornée*, somewhat like Marie-Antoinette's Petite Trianon at Versailles. But these nostalgic references soon lost their viability in the nineteenth century. The French Revolution and subsequent rule of Napoleon deeply threatened the external security and internal stability of Prussia. In response both to the promises of political and economic freedom and to the threats of revolution at home and French domination from abroad, a strong reform movement had developed in Prussia even before the turn of the century, since identified with the names Karl vom und zum Stein and Karl August von Hardenberg. We will focus here on Hardenberg, since his activities were most important for the Pfaueninsel.

Most immediately, in 1804 he brought the agricultural reformer Albrecht Daniel Thaer from Hannover to Prussia to lead a program of agricultural modernization. Hardenberg himself had in 1781 left the administrative service of the duchy of Hannover (an English possession until Napoleon's victory in 1803) to find a more fruitful setting for his reforming ambition, first in Braunschweig and then from 1790 in Prussia. In 1802, he visited Thaer in the town of Celle and came away much impressed. There Thaer

avidly carried out agricultural experiments on his small farm and founded an agricultural school while maintaining a medical practice. Appropriately, he held the title personal physician to George III, called "Farmer George" for his promotion of agriculture.[7]

Without actually visiting England, Thaer had studied everything available in print on the diverse methods practiced there, especially Arthur Young's *Course of Experimental Agriculture* of 1770, with respect to crop rotation and fertilization. Having tested and adapted these methods to local conditions, Thaer promoted their adoption in a three-volume work on this "enlightened" and "scientific" agriculture: *Einleitung zur Kenntnis der englischen Landwirthschaft und ihrer neueren praktischen und theoretischen Fortschritte, in Rücksicht auf Vervollkommnung deutscher Landwirthschaft für denkende Landwirthe und Cammeralisten* (Introduction to knowledge of English agriculture and its recent practical and theoretical advances, in consideration of the perfection of German agriculture, for reasoning agriculturalists and cameralists). "Theoretical" meant to Thaer the attempt to supply principles on which rational practices could be understood and improved. Antoine-Laurent Lavoisier's new chemistry, with its emphasis on analysis and synthesis of elementary components — oxygen, hydrogen, nitrogen, and carbon — provided the best available foundation.[8]

Already in 1798, when Thaer sent a copy of the first volume to Friedrich Wilhelm III, the king responded that he was "convinced of the advantages of English agriculture" and would give Thaer's book the attention it deserved. Thus he and Hardenberg were happy to provide Thaer with funds for a full-size demonstration farm and a new agricultural school in Möglin, east of Berlin. Thaer would also become a professor at the new Berlin University, inspired and organized by Wilhelm von Humboldt, brother of Alexander, when it opened in 1810.[9]

In addition, Thaer's "scientific" methods were embodied in a model farm on the Pfaueninsel, where agriculturalists and other visitors could witness firsthand the results of employing the English system to maintain the productivity of the soil. On six different fields, slightly variable schemes of crop rotation were originally planned over seven years, 1805–1811, using rye, hay, barley, clover, oats, and heavily fertilized potatoes (promoted by Thaer and a mainstay of the industrial revolution in Germany). Figure 3.3, from 1810, shows how the model farm was plowed into the soil of the island, leaving only the large old oaks of the existing forest.[10] The table at top left gives a new rotation scheme for 1810–1816. The court gardener J.A.F. Fintelmann, responsible for the Pfaueninsel from 1804, drew up the system in an elegant depiction meant for public display, mixing the technical aspects with the continuing attractions of the palace, dairy, and a new Cavalier House (guest house) built in 1803–1804.

The model farm was thus conjoined with the existing imagery of Gothic and Roman ruins and island paradise in what became a typical interweaving of romantic and utilitarian ideals during the reform period. The ground itself speaks here of a distinct historical turn, from a longing for the past to anticipation of a modernized future. Thaer was one of those who promoted Enlightenment in the German lands through the English concept of the landscape garden as an "ornamented farm," an epitome for uniting the useful with the beautiful without suggesting the precious form of Marie-Antoinette's *ferme ornée*. Even Goethe in 1824 celebrated Thaer's vision in a poem for the fiftieth anniversary of his doctoral degree.[11]

It was on the Pfaueninsel on May 2, 1810, that Hardenberg met secretly with Friedrich Wilhelm III and Queen Luise to present his plans for a complete revamping of the king's administration and the finances of the state. The possibility for such drastic action derived from the crisis brought on in the aftermath

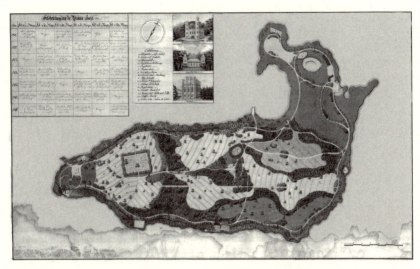

Figure 3.3. J.A.F. Fintelmann, Pfaueninsel, 1810, Verwaltung der Staatlichen Schlösser und Gärten Pfaueninsel, in Michael Seiler, *Pfaueninsel, Berlin*, (Tübingen: Wasmuth, 1993), p. 17.

of Napoleon's crushing defeat of the Prussian army at Jena in 1806. Early in 1810, Napoleon demanded that Prussia either pay the impossibly exorbitant "war contributions" that he had levied or forfeit a province, implicitly Silesia, with its lucrative mines. In this crisis, the queen and her trusted Hardenberg, rather than the ministry of Karl vom Stein zum Altenstein, represented the political backbone of the state. As the new chancellor, Hardenberg, in order to meet Napoleon's demands, pushed through basic reforms of the political economy: peasant ownership of land as well as freedom from hereditary dues; restructuring of the state bank and the state trading corporation (*Seehandlung*) to promote private and public enterprise; restructuring and extension of taxation to fund the bank's activities; secularization of church lands; and so on. At the time, Hardenberg presented his reforms within a principled liberal framework and the ideal of individual freedom: "The new system, the only one on which prosperity can be grounded, rests on the premise that every citizen of the state, personally free, can also freely develop and employ his capacities." The new system was to be based on equality before the law and freedom of trade and industry.[12]

Another transformation requires incorporation with this one, in the imagined reference to the voyage to the island empire. If the former owners had imagined themselves voyaging to Tahiti with Captain Cook, the new monarchs acquired an additional point of exotic reference in the scientific travels of Alexander von Humboldt through the Spanish colonies in South America and Mexico (1799–1804). Humboldt's fame had spread throughout Europe even before he returned, especially through letters published in Paris and in Berlin, where his reports of tropical jungles, towering mountains, wild animals, and native peoples appeared regularly in the *Neue Berlinische Monatsschrift* and where he was called by the king to full membership in the Prussian Academy of Sciences.

Although he would spend the next two decades in Paris, he came to what he regarded as the depressing backwater of Berlin late in 1805 to acknowledge his selection and to promote his views of natural science, characterized as much by the aesthetics of nature as by physical measurements. The events surrounding the defeat at Jena in 1806 and the subsequent French occupation of Berlin kept him for two years in the city of his birth, where he wrote his immensely popular *Views of Nature* (*Ansichten der Natur*, 1808). The great traveler was as sought after for salons and dinner parties as he was for scientific gatherings. Humboldt's breadth and depth of knowledge, coupled with his famed capacity to talk interestingly and at length on any subject, greatly impressed the conversationally impaired Friedrich Wilhelm III, who acquired a lifelong affection for the cosmopolitan scientist. He made him his chamberlain, with a yearly stipend of twenty-five hundred talers, while allowing him to return to Paris to publish his findings.[13]

We might imagine Humboldt telling of the grandeur and beauty of the New World, or perhaps of the courageous Indian girl who stabbed an attacking crocodile in the eye with her knife until it let go of her arm, nearly severed below the shoulder.[14] But we should also think of accounts of gold and silver mining in Mexico, of agriculture, world trade routes, and Spanish colonial administration, for, prior to becoming the most famous scientific traveler of all time, Humboldt had been a Hardenberg man, concerned with transforming the economic and political condition of Prussia. To capture this coalescence of Humboldt's ideals for the political economy with his aesthetics of nature, Michael Dettelbach has employed the term "aesthetic empire."[15] It can serve as well for the successive stagings of the Pfaueninsel under Friedrich Wilhelm III and Hardenberg's administrators, for the island maintained reference to Humboldt even as the political reality increasingly violated the Humboldtian ideal of freedom.

111

Of most immediate relevance, Humboldt had published in 1793 a long series of aphorisms, on the chemical physiology of plants, promoting Lavoisier's new oxygen chemistry with respect to his own experiments on accelerated germination and growth, treating oxygen as the principle of vital force (*Lebenskraft*). In a manner characteristic of classical romanticism, Humboldt referred these and other recent discoveries in chemistry and technology to ancient sources: Aristotle, Cicero, and Pliny. The aphorisms quickly became required reading for agriculturalists. Among them was Thaer, whose discussion of the *Lebenskraft* within a Lavoisieran framework follows Humboldt's general scheme.[16] Thus Thaer's recruitment by Hardenberg and his model farm on the Pfaueninsel were more directly connected to Humboldt than one might otherwise suppose.

Already at the age of twenty, Humboldt, accompanying Georg Forster himself, had traveled for three months in 1790 to the Low Countries, England, and France. From up close they observed political developments in Paris and London, which confirmed Humboldt's sympathies for the ideals of the Revolution.[17] The trip prefigured the career path that Humboldt envisaged for himself in the economic administration of Prussia, one that would allow him the freedom he prized above all else for self-development (*Bildung*) through travel and science (*Wissenschaft*). Within two years, he would become *Oberbergmeister* in the newly annexed territories of Ansbach-Bayreuth, where Hardenberg acted as plenipotentiary. There Hardenberg first began to implement his ideas for economic and political reform of all of Prussia. He appointed Humboldt, only twenty-three years old, to head his Department of Mining, Manufacture, and Commerce (*Bergwerks-, Manufaktur-, und Kommerzdepartement*).[18]

At the same time, Humboldt participated in the famous Jena circle of Goethe, Schiller, Wilhelm von Humboldt, and others. To

a considerable extent, Alexander's "aesthetic empire" was a shared commodity among them. In their different ways, they all articulated visions of a new German identity in aesthetic terms, projecting it onto the vitality and organic unity of nature, typically through classical Greek writings. But Humboldt brought to the romantic ideal a thorough commitment to the latest analytic techniques of French chemistry and physics and to the precision instruments on which that analysis depended.[19] It is important explicitly to recognize that Humboldt's unification of measurement with beauty, of administration with romanticism, was not so easily purchased in Jena. In a letter to their common friend the poet Gottfried Körner, Schiller had damned Humboldt's South American project even before it began. He saw in Alexander:

> a poverty of the senses, which for the subject he treats is the worst malady. It is the naked, tailoring intellect [*schneidende Verstand*], which wants to have nature — always ungraspable and in her every detail venerable and unfathomable — shamelessly measured out and, with an impudence that I cannot grasp, makes its formulas, which are often only empty words and always only narrow concepts, into her measure.[20]

Only by doing considerable violence to Schiller's aesthetics of nature did Alexander co-opt his language of tranquillity (*Ruhe*) to characterize his own *Views of Nature*.[21] Humboldt's primary goal in South America and Mexico was to integrate all the major domains of natural history — botany, zoology, mineralogy, meteorology — through a physical description of the landscape, using precise geographic and topographic mapping as the foundation. But at the same time, he sought the determinants of the political economy. This goal is most clearly shown in his *Political Essay on the Kingdom of New Spain* (1808–1812, French; 1809–1814, German).[22] The

essay reproduces on a grand scale Humboldt's job description under Hardenberg in Ansbach-Bayreuth, extending his purview to all aspects of the landscape and its resources as they affected the present and future economic and political situation of Mexico. To represent the totality as an integral system, Humboldt employed his famous vertical profiles of the landscape, the "physiognomic" projections. One such projection, along the route from Acapulco on the west coast, up through Mexico City, and down to Veracruz on the east coast, allowed Humboldt to capture the primary determinants of transportation and commerce between the capital and the two ports through which all trade with the rest of the world passed (figure 3.4a). Such physiognomic silhouettes functioned much like the methods of physiognomic analysis of human character in Johann Kaspar Lavater's *Physiognomische Fragmente zur Beförderung der Menschenkenntnis und Menschenliebe* (Physiognomic fragments, to advance the knowledge and love of mankind), illustrated by Humboldt's early drawing teacher, Daniel Chodowiecki.[23]

For Humboldt, physiognomy provided a means of interpreting the full diversity and complexity of a landscape, showing at a glance such things as why the agriculture in different regions of Mexico depended much more on the dramatic changes in elevation across the country than on changes in latitude. He summarized:

> The physiognomy of a country, the grouping of its mountains, the breadth of its plateaus, and their elevation, which determines their temperature, everything that belongs to the structure of the globe, stands in intimate connection with the advances of the population and with the well-being of the inhabitants. Unmistakable is the influence of the external formation of the earth's surface on agriculture,...on the facilitation of domestic commerce, on military defense and the external security of the colony![24]

114

In views like this, Friedrich Wilhelm III could perhaps see a new Humboldtian physiognomy for the Pfaueninsel, beginning with the possibilities for agricultural development in Prussia, as explored on Thaer's model farm. Certainly Hardenberg's young reformers, who would soon reconstitute the island, could see clearly the significance of physiognomy. The Pfaueninsel would become one of many landscapes into which they projected their ideals for a modernized Prussia, as "aesthetic empire." Humboldt's vision took a grandly iconic form in his *Atlas géographique et physique du nouveau continent* (1814), which extended the material of the *Political Essay on the Kingdom of New Spain* to Central and South America. Its frontispiece shows a kneeling Aztec prince being raised up by Athena (wisdom) and Hermes (communication), with the pyramid of Cholula in the background before the great mountain Popocatépetl near Mexico City (figure 3.4b). The drawing originally bore the title "America, Raised from Its Ruins by Industry and Commerce." Without losing this economic message, Humboldt gave it a characteristic classical gloss with a quotation from Pliny the Younger, thereby translating the fruits of modern Europe into original Greek inventions and into Humboldt's own ideals for Prussia: "Humanitas. Literae. Fruges," or, in neo-humanist German, "Bildung, Wissenschaft, Ackerbau [agriculture]."[25]

English Garden with Menagerie
In 1814, the Pfaueninsel began to receive a new formation, although from a considerable distance and as yet with no visible impression. In late March, delegations and troops from Prussia, Russia, Austria, and Britain entered Paris to negotiate the Peace of Paris, ending the Napoleonic Wars and, for Prussia, the war of independence (*Befreiungskrieg*). The events brought together again for an intense two-month period Friedrich Wilhelm III,

Figure 3.4a (*above*). "Tableau physique de la Nouvelle Espagne," in Alexander von Humboldt, *Atlas géographique et physique du royaume de la Nouvelle-Espagne* (*Mexico Atlas*) (Paris: Schoell, 1811), pls. 12 and 13; 3.4b (*below*). "Humanitas. Literæ. Fruges," drawing by François Gérard, engraving by Barthélemy Roger, frontispiece in Alexander von Humboldt, *Atlas géographique et physique du nouveau continent* (Paris, 1814–1834). Photo courtesy of Staatsbibliothek zu Berlin – Preussischer Kulturbesitz, Abteilung Historische Drucke.

Chancellor Hardenberg, and the Humboldt brothers, as Wilhelm was serving in Hardenberg's administration and Alexander was drawn in as liaison between French and Prussian interests. The king insisted that Alexander, who moved through Parisian society like no other German, accompany him everywhere, guiding him personally through the attractions of Paris, easing social relations wherever they went, and reading to him when he was indisposed. One such outing took them to the Jardin des Plantes, where the king found new scope not only for what his Pfaueninsel might become botanically but for his personal love of animals, for the Jardin des Plantes included an exotic menagerie among its wonders. Both the flora and the fauna made lasting impressions on the king. Of course the garden and the neighboring Musée d'Histoire Naturelle were also the natural home in Paris for Humboldt's extensive South American collections, for the continuing publication of which Humboldt now extracted the remarkable sum of twenty-four thousand talers from the king.[26] So we should recognize in this Parisian moment, in the midst of Prussia's triumphant visit to the capital of its oppressor, a critical juncture for the future of the Pfaueninsel, where Humboldtian travel and science would continue to merge with royal display. At the same time, however, this moment represented the high point of Hardenberg's effective rule of Prussia. The entry into Paris marked his elevation to princely status as Fürst von Hardenberg with a gift from the king of estates east of Berlin, renamed Neu-Hardenberg.

If Humboldt had expected to stay in Paris when the Prussian delegation left, he was disappointed, for the king now required that he accompany them to London to continue his role as personal companion and liaison, in this case with the prince regent, soon to be George IV. One outcome of the trip was an elaborate gift from the prince regent to Friedrich Wilhelm, a miniature frigate, probably about 50 feet long, three-masted, outfitted with

cannon, full rigging, and sails, and destined for the Pfaueninsel.[27] In full sail on the Havel, it made an impressive sight (figure 3.5). Inevitably, the gift of the frigate symbolized the role of British naval power in the alliance against Napoleon. Equally inevitably, it recalled the naval voyages that established and maintained the British colonial empire. In one sense, therefore, the use of the frigate for the royal family's outings to the Pfaueninsel figured their trip even more strongly than previously as an allegorical voyage with Captain Cook to Tahiti. But that image had acquired the more immediate overlay of Humboldt's voyages, which so strongly conjoined the exotic with economic imperatives. The frigate suggests related changes.

With the allied victory over Napoleon, Prussia turned sharply from France toward England for its models of economic power and political freedom. One highly visible aspect of that turn was the refashioning of royal gardens and parks. Formerly done in the "absolutist" French style of the seventeenth and eighteenth centuries, as in the geometrically arranged promenades of the Tiergarten in Berlin and the mimicry of Versailles at Sanssouci in Potsdam, they began now to be reworked in the naturalistic style of English landscape gardens. Natural shapes replaced the rigors of geometry as winding paths replaced straight avenues, variety in color and texture replaced regimented rows of sharply pruned trees and shrubs, and free-form meadows appeared where mowed lawns had been. Although aspects of the English style already existed at places like the Pfaueninsel, it had taken on a new significance in Prussia following the war of independence, also called the war of freedom (*Freiheitskrieg*) by citizens who saw it as opening a new era of political liberalism.

At the same time, Hardenberg and his administration won financial freedom for their modernizing regime. Money was available for both state and personal projects, including Hardenberg's

Figure 3.5. Frigate *Royal Louise* under full sail (having replaced original frigate in 1832), in Wilfried M. Heidemann, "Royal Louise: Die Fregatte vor der Pfaueninsel," *Mitteilungen des Vereins für die Geschichte Berlins* 82 (1986), p. 415.

development of his own landscape gardens at Glienicke, just down the Havel River from the Pfaueninsel, and at Neu-Hardenberg. Crucial for the development of both his own gardens and the Pfaueninsel was Hardenberg's policy of recruiting bright, ambitious, and politically liberal young men — similar to the Humboldt brothers a generation earlier but often from the middle class, like Thaer — to serve throughout the expanding ranks of his administration. One such activist was the landscape architect Peter Joseph Lenné, brought from the Rhineland in 1816. The product of a long line of court gardeners in Cologne, Lenné was already known as a reformer in garden design. His first projects in Berlin included the full-scale development of the Pfaueninsel as an English garden and the similar transformation of Hardenberg's estates.

Hardenberg's gardening initiative carried all the usual symbolism of naturalistic freedom in the postwar period, but it also embodied the promotion of agricultural and industrial development. He integrated into his garden landscape at Glienicke a brick and tile manufactory employing over sixty workers. It was located not far from his *Lustgarten* (pleasure garden, intended to delight the senses with flowers, lawns, and an occasional classical ruin), which he equipped with a horse-powered treadmill to pump water from the Havel River to irrigate the garden and to supply several fountains. The system featured the latest in experimental technology, including cast-zinc pipe (which soon corroded).[28] This attempt to integrate industrial development into a garden landscape represents in microcosm Hardenberg's policy for all of Prussia. Again he had acquired a dynamic young administrator who in 1818 would take charge of a grand program of industrial advancement, Peter C.W. Beuth, who will appear below.

Finally, and equally characteristic of Hardenberg's ideals, was a classicizing renovation of the existing house at Glienicke, carried out by a third great reformer of the period and an intimate of

120

Beuth's, the architect Karl Friedrich Schinkel, who had entered the administration with strong support from Queen Luise and Wilhelm von Humboldt as well as Beuth. On the Pfaueninsel, Schinkel would soon be involved in all the major building projects from 1816 to 1830. Lenné, Beuth, and Schinkel may be seen as three visionary agents in the practical and symbolic expression of the policies developed under Hardenberg's administration, and it was their work that spoke so eloquently to the public who would later visit the reconstituted Pfaueninsel in droves, up to six thousand in a single day, according to one account.[29]

Although from a slightly later period, the plan of figure 3.6 shows immediately how Lenné reshaped the island as a complete English garden. Gone are the sharply outlined fields, replaced by meadows gradually merging with woods; the straight "road" down the length of the island has become a vista through verdant meadows; and curving paths allow visitors strolling freely to discover the rich diversity of plants and views that the garden offers.

Into this arcadian landscape came a somewhat disruptive element through the king's desire to incorporate exotic animals, like those Humboldt had shown him at the Jardin des Plantes. Gradually, as aristocrats, wealthy entrepreneurs, and consular officials in other lands contributed gifts of animals, a menagerie grew up of considerable size, beginning originally with unusual varieties of farm animals (geese, ducks, sheep, goats, pigs, cows) and wild birds (storks, owls, eagles) and continuing with more exotic species (kangaroos, apes, a wolf, Brazilian coatis). By 1820, many of these animals had been housed in a hodgepodge of cages near the palace, disturbing both the tranquillity and the concept of the English garden. That untenable situation, along with the new trees and shrubs themselves, would introduce a new period of development.[30]

Figure 3.6. J.A.F. Fintelmann, "Situations-Plan der Königl. Pfauen-Insel," 1828, Verwaltung der Staatlichen Schlösser und Gärten, Berlin, Plankammer 1906.

A Steam-Powered Garden

If Hardenberg's young administrators had already begun their work on the Pfaueninsel by 1816, their hopes for uniting nature with industry in the Prussian landscape nevertheless got as slow a start in royal display as they did in more practical terms. The problem lay in the backward state of Prussian machine production and machine use in comparison to Britain, especially in relation to steam engines. When in 1812 the Hardenberg administration began a concerted program to stimulate native engine production in Berlin, there existed only one engine in the city, a little three-horsepower machine at the Royal China Factory. They advertised to Berlin manufacturers, "The deficient condition in which our factories find themselves with respect to motive power has induced us to set up a model of how, with the help of a steam engine purposefully arranged, a greater effect can be produced with lower costs." They proposed to supply three machines at the cost of the state, two to be given free to local manufacturers to replace their horse-powered alternatives and one to be set up as a model for instruction of the public at the Royal Iron Foundry (Königliche Eisengiesserei). After some difficulties with a supplier, they had two engines built at the Royal Iron Foundry by an untested mechanic from Westphalia. In 1815, he had two engines ready. One functioned so infrequently that it had to be replaced by an import from London; the other had just about enough power to move itself for ten minutes, independent of working machinery, before it stopped. An ultimately more successful strategy involved sending bright young machine builders like F.A.J. Egells to England in 1821 to learn to design and build engines from existing masters. But that route took time; Egells would not produce his first working engine until 1825.[31] It was into this vacuum that Peter Beuth moved with his inexhaustible store of energy and ideas and his constant collaboration with Schinkel, aiming always

at an elevated aesthetics of the machine age built on classical forms and ideals.[32]

Beuth had joined the Prussian service in 1809 and soon became what Caroline von Humboldt (Wilhelm's wife) called "a great protégé" of Hardenberg's, as *Obersteuerrat* in the Finance Ministry of his new government.[33] Within the Section for Trade and Industry, Beuth joined the Commission for Reform of Taxation and Industry, but little could actually be done to reform industry until after the war, during which he fought in the cavalry of Adolf von Lützow's *Freikorps* and won the iron cross. He used his time while quartered in 1814 in Liège, Belgium, to study machine production at the large factory of the Englishmen James, John, and William Cockerill. On his return, Beuth was elevated to *vortragender Rat* in the Section for Trade and Industry, under G. J. C. Kunth, former tutor of the Humboldt brothers, collaborator with Stein and Wilhelm von Humboldt in the first reform period (1807–1809), and now Hardenberg's main adviser (*Staatsrat*) on technological development. In his new position, Beuth brought the Cockerills to Berlin to establish a plant for woolen manufacture and machine building. Opening in 1815, it soon became a major supplier of machines for the textile industry. Their offerings included steam engines from a new plant near Liège, built according to designs and fabrication techniques brought from England.[34] From 1818, now as head of the Section for Trade and Industry, Beuth put state sponsorship of industrial development on a new track, establishing by 1821 the Industrial Institute (Gewerbe Institut) to nurture future entrepreneurs and the Union for the Advancement of Industry (Verein zur Beförderung des Gewerbefleisses) to publicize technical developments and promote interaction among mechanics, instrument makers, technologists, factory owners, and state administrators.

Thus a new technological era was dawning in Prussia; with it came new opportunities for garden building on the banks of the

Havel and for projecting Prussia's movement into the future through royal display. Already in 1819, Lenné had begun collaborating with the Englishman John Barnett Humphrey, who was trying to establish a steamship company on the Havel. They proposed, on economic and aesthetic grounds, to install a steam engine at Sanssouci to irrigate a part of the gardens that Lenné was redesigning in the English style and finally to set in motion the fountains that Friedrich II (the Great), in his attempt to rival Versailles, had sought to supply using windmills. The estimated cost of 11,500 talers seemed at the time poor economy to Friedrich Wilhelm III. Still Lenné and Humphrey did not give up their promotion of engines but shifted their aim to the Pfaueninsel, where lack of water presented problems for the animals, for a new rose garden, and for other plantings.[35] Early in 1823, Lenné included an engine as the foundation of a major building project to secure the garden's integrity. The moment had arrived for engines in Lenné's English gardens, and the Cockerills were there to meet the need. They quickly proposed an appropriate engine costing forty-five hundred talers.[36]

In the spring of 1824, the king finally approved detailed plans for the entire project, plus a Gothic facade and renovation of the Cavalier House by Schinkel, for a total cost of over forty-three thousand talers. Approved also was an enhanced Cockerill engine for six thousand talers, capable of raising 3,000 cubic feet of water per hour to a height of 84 feet. In addition to filling a 6,600-cubic-foot-reservoir 53 feet above the Havel River on the highest point of the island, it could have pumped the water considerably higher to supply a fountain from a second reservoir (never built) in the tower of the Cavalier House. The total cost for the engine installation alone, including its house (with an apartment for a mechanic) and the reservoir came to over 10,000 talers. To cap the production, a 20-foot fountain, cast at the

ironworks of the prominent Abraham Mendelssohn-Bartholdy, was installed in the reservoir. Designed as a Roman candelabrum, it spilled the entire flow of water from the engine over two successive dishes to form a shimmering sculpture among the trees (figure 3.7a).[37]

Within two years, many of the other structures were complete, along with 4,300 feet of buried clay pipe, supplied by another leading Berlin industrialist, T.C. Feilner, to distribute water to the sensitive flora and fauna of the island. The rather elegant buildings for the animals were placed almost invisibly near the center of the island on both sides of the main axis of view from the palace (figure 3.6). They included a two-staged tower for waterfowl in a large pond (figure 3.7b), supplied by a stream through the woods from the reservoir, and (in 1830) a llama house, built in the fashionable Italianate villa style of the Schinkel school (figure 3.7c), including another fountain, also supplied from the reservoir.[38]

Thus the pumping engine on the Pfaueninsel impressed on its staging a dramatically new formation. If empire in a British sense had already been present in the miniature frigate decorating its shoreline and in the English garden itself, the entire display of colonial flora and fauna on the island now depended on an engine of English design, supplied through a transplanted English machine-building company. Even the master mechanic Franciscus Joseph Friedrich, who with Humphrey installed the engine and maintained it for many years, came as part of the Cockerills' proposal for this imported English system. Friedrich had mastered his trade while working at the new Cockerill plant in Berlin for seven years (1815–1822).

But there was also something distinctly un-English about the entire scene, for landscape gardens in England typically did not employ engines. More generally and more importantly, the arti-

fices that maintained the naturalistic scenery in English gardens were never supposed to be noticed. In contrast, the new technology on the Pfaueninsel explicitly called attention to itself. Even if visitors standing before the great fountain failed to see the smoke rising from the chimney in the background (figure 3.7d), they could not have missed the thumping pulse of the engine, whose continuous operation maintained the fountain's cascading showers. Further, an English landscape garden should not have featured a fountain at the top of a wooded hill, where no water could naturally emerge. Its very existence in this location invoked the engine. We should recognize, therefore, that the engine was part of the display and that it called up a new era in Prussian economic modernization, one that the Hardenberg administration had tried hard to promote but that was only gradually becoming naturalized in the landscape. As such, the engine in operation was a spectacle to be seen and admired.

Thus the engine house, under the care of Joseph Friedrich and his wife, Elisabeth, became a destination in itself, partly because Elisabeth acquired a certain fame for supplying to properly respectful guests the only refreshments obtainable on the island, accompanied by wit and charm, and partly because one could visit the working engine and study the source of its power.[39] Friedrich's contract explicitly required that he keep the entire house, and especially the rooms for the engine, in a clean and orderly condition because the "aristocratic and royal gentlemen will often want to watch the machine working or to visit it with invited guests." As one visitor narrated his experience of 1828 in a novelistic account:

> We inspected the machine from front and back, as if we had wanted to remake it at home, but at the end as at the beginning we knew no more than that it was made of iron.... To set water in motion by fire

Figure 3.7a. Fountain, authors' photo; 3.7b. Waterfowl House from Seiler,
Pfaueninsel, Berlin, p. 21; 3.7c. Llama House, by Albert Dietrich Schadow, 1830, in
Archetechtonisches Skizzenbuch (Berlin: Ernst und Korn, 1852–86), no. 54,
p. 2; 3.7d. chimney of engine house, authors' photo.

was at the beginning of the second quarter of the nineteenth century the highest creation of art, but it will probably not long remain so.[40]

Clearly the engine was envisaged from the outset as an integral part of the stage setting on the Pfaueninsel. In this respect, the multitalented Friedrich was the ideal man for the job. Before coming to the Pfaueninsel, he had spent the years 1822–1824 directing construction of the stage machinery for a popular new theater on Alexanderplatz (Königstädtisches Theater) whose director intended its technical capacities to exceed those of the higher-class Königliche Schauspielhaus on the Gendarmenmarkt in the center of town.[41] In a strong sense, Friedrich continued in this role on the Pfaueninsel, managing the stage machinery for an aesthetic empire.

That the engine should be seen as part of the aesthetics of the presentation, rather than merely a useful tool for moving water, became a matter for philosophical reflection in the lectures on aesthetics of the famed theologian Friedrich Schleiermacher at Berlin University in 1832–1833. For Schleiermacher, the question of what should count as fine art in a landscape garden turned on freedom, on whether it expressed the "free productivity" of human activity without compromising the natural forces of vegetative life. On the one hand, the architectural geometry of the earlier French style displayed the aggressive "power of man over nature," forcing it into shapes contrary to life. On the other hand, a garden that merely reproduced nature itself without expressing human activity would be no art at all. True art required that the free productivity of mankind simultaneously free the forces of vegetative life, thereby setting a strict limit on human artifice. As in architecture, where no structure could be pushed further than the "feeling of security" would allow (see Antoine Picon, this volume), in the landscape garden, for Schleiermacher, the "security

of vegetative life" stabilized the relation between pleasure in nat-
ural life and pleasure in power over nature. Here the engine on the
Pfaueninsel found its proper place within the aesthetics of the gar-
den as the comforting expression of security in what would other-
wise have seemed an unnatural landscape.

> It is difficult to think of a beautiful garden without water, because
> then the totality seems to come out of nowhere. Vegetation built
> up and enhanced by human activity beyond the usual measure [...]
> requires also a higher measure of moisture, and for that a sufficient
> security must be present. The beautiful gardens of the Pfaueninsel
> near Potsdam, being an island, are surrounded by water, and yet they
> have attained their full perfection only through artificial irrigation,
> supplied by a special machine. In this, what is sufficient for main-
> taining vegetative life in its heightened condition [maintaining its
> security] reveals itself, and where it is lacking, one will in no way be
> able to bring this life to any perfection.

Therefore, far from suggesting that the engine should be hidden,
producing the deceptive sense of the garden as a "work of nature
produced by man," Schleiermacher's principle of security required
the visibility of the engine, so that the steam-powered garden
would give the impression of a work of nature "enabled by human
activity." Here was a principle for integrating the romantic garden
with the modern machine. It suggests how Johann Gottfried
Schadow, director of the Academy of Art in Berlin, understood
the engine when he visited it in 1825 with a company of academy
artists and reported: "Through the power of water transformed
into steam, refreshment and nourishment come from afar in
trickles and streams to the beautiful plants of the island, and arti-
ficial fountains will be magic to see."[42]

During the 1820s, the island empire continued to gain in

depth of reference. Just as the engine derived from and symbolized Prussia's incipient entry into the industrial marketplace, the continuing acquisition of animals and plants derived from and symbolized Prussia's expanding involvement in colonial trade. Since 1810, Hardenberg had relied on Christian Rother in the Finance Ministry as his most trusted ally in reforming state finances and as head of the Königliche Preussische Seehandlung (Royal Prussian Maritime Company). Established in 1772, the Seehandlung was a combined state and private corporation that centrally managed and promoted domestic and foreign trade. In 1820, under Rother's direction, it became an independent financial and trading institute of the state and rapidly developed financial, manufacturing, machine-building, and trading installations throughout Prussia and abroad. Rother had his eye on the English and hoped even to mimic their profits in the China trade.[43]

With its expanding international reach, the Seehandlung offered opportunities for the king to develop his menagerie on the Pfaueninsel into a world-class attraction. He put in charge of the project Heinrich Lichtenstein, a traveling *Naturforscher* like Humboldt, and a Humboldt correspondent, who had spent the years 1804–1806 in avid natural-history research in the Dutch Cape Colony, published as *Reisen im südlichen Afrika* (1810–1811). Lichtenstein became professor of zoology at Berlin University in 1811 and soon thereafter a member of the Academy of Sciences. It was at his instigation that Wilhelm von Humboldt, no doubt with Alexander's advice, had included a zoological museum in the plans for Berlin University in 1810. And it was with Lichtenstein that Alexander would organize a famous meeting of the Verein Naturforscher und Ärzte in Berlin in 1828.[44] Although Humboldt himself contributed directly to the king's menagerie only the huge bones of a whale, in 1821, his descriptions and depictions of South American animals, perhaps especially the apes and a great condor,

certainly helped to inform Lichtenstein's recommendations. Their actual realization involved such things as having a Seehandlung ship collect animals in Brazil in 1822, including a gray ape, five parrots, and nine other birds. Acquisitions from Africa, India, and the Philippines followed, including, in 1831, a lion from Senegal, accompanied by two apes and an anteater. Many more animals came as gifts or purchases from other European and British menageries, themselves the result of colonial trade.[45] This presence behind the scenes of the Seehandlung suggests an analogy: just as domestic machine building and industrialization supported colonial trade, the steam engine, in microcosm, supported the "colonial" menagerie on the Pfaueninsel.

The Seehandlung's activities extended to one of the more remarkable personages on the Pfaueninsel, the Sandwich Islander (Hawaiian) Harry Maitey, later christened Heinrich Wilhelm Maitey.[46] Maitey had arrived in the new Prussian port Swinemünde in 1824 on the frigate *Mentor*, the first ship in the service of Prussia to sail around the world or to exploit opportunities for worldwide trade. Loaded with linen and other Prussian goods, the *Mentor* sailed westward around South America to Valparaiso, Chile, where its Prussian cargo was sold. Crossing the Pacific, it stopped in Hawaii (discovered for England by Captain Cook in 1779) to take on fresh water — and Maitey, who requested passage — before continuing to Canton to spend two months acquiring new cargo, consisting largely of tea, silk, porcelain, paintings, and curios. Upon reaching Berlin, having sailed around Africa, these goods of the China trade and of other ports along the route were exhibited at the Seehandlung's offices.

Although no naturalist had accompanied the *Mentor*, it brought back specimens for the university's mineralogical and zoological museums, plus objects for an expected ethnographic museum: from Chile, a dancing dress made from bear intestines; and from

Hawaii, fans made of peacock feathers, helmets of reeds, and various fishing and household items. All of this was very much in the Humboldtian spirit. The daily *Vossische Zeitung*, however, reporting on "Our China Traveler," indulged in some highly anti-Humboldtian colonial prejudices. They may serve to remind us that the Prussian regime had by then taken a distinctly reactionary turn, usually referred to as the Karlsbad Decrees of 1819, when personal freedoms were sharply curtailed and Wilhelm von Humboldt's vehement protests to Hardenberg resulted in his forced resignation from the Ministry of Culture. The liberal Schleiermacher, with Enlightenment ideals ringing through his entire philosophy, found himself threatened with dismissal from the university for his politics, with Hardenberg and Altenstein as his persecutors.[47] The climate for pursuing universal human values had clouded substantially. The *Vossische Zeitung* perhaps reflected this deteriorating atmosphere when it observed, ostensibly in admiration of Chinese works of art, that "through interaction with the English," Chinese craftsmen had "become acquainted with pleasing forms, so that one now finds in China nothing improperly formed except the Chinese themselves." The paper suggested that Maitey might appropriately serve as the caretaker for the future ethnographic museum (figure 3.8).[48]

During its voyage, the *Mentor* had changed status from a ship chartered by the Seehandlung to one that it owned. As a consequence, Maitey became the direct responsibility of Friedrich Wilhelm III, who had no idea what to do with him, largely because of his heathen status. In effect, he became the ward of the Seehandlung and its director, Christian Rother, who undertook to educate him for his required conversion to Christianity. Meanwhile, Maitey lived rather luxuriously with the Rother family, dressing in the finest clothes and serving at meals and dinner parties, where guests enjoyed his exotic presence and rewarded him with tips.

Figure 3.8. "Maitey," Dr. Ehrhardt (brother-in-law of Rother), in Caesar von der Ahé, "Der Hawaianer auf der Pfaueninsel," *Potsdamer Jahresschau* (1933), p. 21.

Maitey began to attend school in 1826, at about age eighteen, but acquiring sufficient German for his Christian education proved a considerable problem, so Rother brought in his friend Wilhelm von Humboldt, who was then studying South Sea languages. Maitey, however, was of more value to Humboldt's linguistic studies than Humboldt was to Maitey's German. Only after painful separation from the Rother family, more intensive schooling, and a change of pastors was Maitey confirmed in 1830 and transferred to the king's household, thence to the Pfaueninsel.

On the island, Maitey joined a small colony of similarly curious residents. Two Prussian giants, the 8-foot-tall Carl Friedrich Licht and his somewhat shorter brother Johann Ehrenreich Licht, came to the Pfaueninsel in 1822 at the ages of twenty-four and eighteen. Johann became a palace servant and lived nearby at Nikolskoe with his family, while Carl lived on the island. Both died in 1834. Also arriving in 1822 were the sibling dwarfs Christian Friedrich and Maria Dorothea Strackon, about 2.5 feet tall, aged nineteen and sixteen. Christian did odd jobs on the island and sometimes exercised his training as a tailor to make clothes for Carl Licht, while Maria became a palace servant. Both worked on the island until they died in 1837 and 1878, respectively.[49]

For some visitors, these "extremes of humanity" were as interesting as the animals. When Schadow and his company of artists visited the island in 1825, they took the measurements of Carl the giant and traced the outline of his hand, remarking on the abnormal relation between its length and its breadth. Had they come two years later, they might have reported on the black African named Karl Ferdinand Theobald Itissa, who arrived in 1827. Schadow included Maitey in a later collection of comparative human measurements: "The broad cheekbones occur also among us, and although his skull is smaller, this is hidden by the heavy thick hair. What differentiates him somewhat is the dark skin

color. He seems unsuited for a more refined mental formation [*Geistesbildung*]."[50] Maitey and the others constituted something like a living anthropological museum, complementing the menagerie, albeit in a domestic environment. Before long, Maitey would marry the daughter of the animal keeper, with the dwarfs in attendance, and set up household in the nearby village at Glienicke.

In brief, Maitey's story shows how Prussia's aspirations for colonial trade through the Seehandlung brought a real South Sea islander to embellish its aesthetic empire. But this enhanced staging has a final nuance. Maitey came to the Pfaueninsel as assistant to the master mechanic Friedrich, who added to Maitey's existing skill in carving some significant training in carpentry and metalwork. It was apparently Maitey who kept the engine in shining condition and demonstrated the marvels of its operation to many of its admirers.[51] Here the colonial exotic doubled the industrial exotic in a remarkable evocation of Prussia's aims for a modernized political economy.

Empire as Opera

When Maitey joined the little steam-powered empire in 1830, it was already in the process of acquiring a new focal point for tropical imagination, a tall glass building called the Palmenhaus, home to a collection of tropical plants that soon expanded like the menagerie. Like much else on the island, the Palmenhaus got there as an offshoot of more general state interests, realized by appeal to the personal tastes of Friedrich Wilhelm III. Altenstein, now the minister of culture, was responsible for all state educational institutions, among them the museums for zoology, mineralogy, and ethnography, which he had already seen benefiting from colonial trade. But he also had responsibility for the Botanical Gardens. Thus when Altenstein got word that one of the largest collections of palms in Europe was available for purchase, he realized that the

large sum required might be obtained for the Pfaueninsel, if not for the Botanical Gardens directly, and there serve as a kind of nursery.[52]

With approval from the king, and with Alexander von Humboldt's approval of recommended enhancements, Altenstein set in motion the purchase of the collection of Monsieur Fulchiron near Paris, for a total cost of over 15,500 talers. Still resonant in these projects were Humboldt's words of 1807 describing the plants of the tropical lowlands, where "nature has developed the most magnificent forms and has united them in the most beautiful groups. Here is the region of the palms and banana plants." But in 1827 Humboldt himself had returned to Berlin on the king's orders and with an increased salary of five thousand talers to take up his position as chamberlain, spending several hours a day in personal attendance on the king and accompanying him wherever he traveled. And it was in 1827–1828 that Humboldt presented the public lectures at the university and the Singakademie that made him a sensation in Berlin society and further developed the popular fascination for the exotic plants, animals, peoples, and physical geography of distant lands.[53]

Humboldt also had regular contact with Schinkel, a close family friend who had remodeled the family estate at Tegel for Wilhelm von Humboldt several years earlier, in an explicit attempt to integrate architecture and landscape, and now joined Alexander in his most immediate projects. Schinkel built the small house, free of iron, for Humboldt's magnetic observations in the large garden of Abraham Mendelssohn-Bartholdy. He also designed the scenery for a celebratory evening that Humboldt organized for the 1828 meeting of the Verein Naturforscher und Ärtze. For the occasion, held in one of Schinkel's greatest buildings, the Schauspielhaus, he adapted his earlier Queen-of-the-Night scene in Mozart's opera *The Magic Flute* (1816). The names of Germanic

scientists, from Copernicus and Kepler to Euler, Kant, and Werner, now adorned the heavens above Zoroaster's temple.[54] Schinkel's designs for other scenes in *The Magic Flute*, featuring lush tropical growth and volcanic mountains, apparently also derived in part from Humboldt's *Vues des Cordillères* of 1810, as did his scenery for other operas: *Athalia* (1817), *Fernand Cortez* (1818), *Armida* (1820).[55]

The evocative presentation of tropical vegetation in a theatrical setting also characterizes Schinkel's much more elaborate work on the Pfaueninsel. To house the large palms, up to 18 feet tall and 4 feet in circumference, scheduled to arrive in 1830, Schinkel conceived a structure that would recall the exotic regions from which they might have come and that evoked fantasies associated with those regions. Fortuitously, the crown prince had acquired through a Hamburg dealer early in 1829 an unusual Indian pagoda that he hoped to install on the island. In a burst of creative integration, Schinkel was able to meld the palms and the pagoda with another set of references that anyone in Berlin society would recognize: an adaptation of Thomas Moore's popular lyric romance *Lalla Rookh*, which had been converted into a musical performance of 1821 at the royal palace in Berlin, with music by Gaspare Spontini and "living pictures" by Schinkel; and the subsequent Spontini opera *Nurmahal*, with Schinkel's scenery.

The musical adaptation of *Lalla Rookh* gives a highly compressed version of the journey of the beautiful princess Lalla Rookh from Delhi to Kashmir to meet for the first time her betrothed, Prince Aliris. Disguised as a minstrel, Aliris accompanies her on the trip, singing a series of tales of love and loyalty to explore her affections, with the predictable result that their love has blossomed well before he appears in the finale as the prince himself. Schinkel animated the songs of their romance with a dozen rapidly changing *lebende Bilder* (living pictures). These were

effectively stage sets, consisting of large diorama-like paintings of Oriental scenes, produced in the stage-scenery workshop of Carl Wilhelm Gropius, in front of which the "actors" were arranged in still-life poses, as though part of the pictures, with careful lighting and framing to produce a deceptively realistic impression (figure 3.9).[56]

The cast of characters for the entire production consisted of 168 princes, dukes, and other aristocrats from the court, administration, and military, including even Hardenberg and his wife. It had been conceived to celebrate the presence in Berlin of Grand Duke Nicholas (soon Tsar Nicholas I) and Grand Duchess Charlotte (the king's daughter), who played the lead roles of Aliris and Lalla Rookh. The audience, on the other hand, consisted of three thousand invited guests, intended to represent all classes. Everyone enjoyed the spectacle. Their pleasure, however, should not obscure the festival's state purpose: it celebrated the Prussian-Russian alliance following the war of independence and its expected continuation. In retrospect, furthermore, it would be hard to find a more potent symbol of the newly reestablished regime of authoritarian government than the sharp division between the aristocratic actors and their mostly middle-class audience, whose hopes for personal freedom and constitutional government had been so recently compromised by the Karlsbad Decrees. Now, in a fairy-tale romance, the court was acting out for the middle-class audience whatever fantasies of love, freedom, and paradise they might entertain, renewing the celebrations of absolute power of Baroque courts.

The great success of the multimedia performance of *Lalla Rookh* led Spontini to develop a part of it, the story of Nurmahal and the festival of roses, into the full opera *Nurmahal*. Schinkel's designs for the scenery clearly derived in part from his earlier Humboldtian-inspired opera scenes and *Lalla Rookh*. Michael

Figure 3.9. "Nurmahal und ein Genius," one of Schinkel's living pictures, drawn by Wilhelm Hensel (1821), *Die Lebenden Bilder und pantomimischen Darstellungen bei dem Festspiel Lalla Rukh* (Berlin: Wittich, 1823), pt. 2, pl. 3. Photo courtesy of Staatsbibliothek zu Berlin – Preussischer Kulturbesitz, Abteilung Historische Drucke.

Seiler has shown how Schinkel drew on earlier images from En-
glish books on Indian architecture and gardens and on the *Nurma-
hal* designs while conceiving the Palmenhaus. The final plans, as
drawn up by A.D. Schadow, carried an expected cost of fifty-two
thousand talers.[57]

The impression the *Palmenhaus* made on its many visitors ex-
ceeded even that of its operatic predecessors. Alexander von Hum-
boldt later described the effect in his *Kosmos*:

> When one looks down from the high balcony on the fullness of reed-
> like and treelike palms in the bright midday sun, he is for a moment
> completely deceived as to where he is. One thinks that he sees in the
> tropical climate itself, from the top of a hill, a small palm grove.
> Admittedly, one misses the view of the deep blue sky and the greater
> intensity of light; nevertheless, the imagination is here more active,
> the illusion greater, than with the most perfect painting. One at-
> taches to every plant form the wonder of a distant world.[58]

Despite his wonder, however, Humboldt notices how the ines-
capable impression of artificial nurture in a greenhouse disturbs
the effect. He takes the opportunity to express his reservations, in
the form of an ode to freedom, reminiscent of Schleiermacher's
views on the art of landscape gardening. As he and his Jena friends
had always done, Humboldt uses nature as an aesthetic stand-in
for society, with obvious political implications:

> Complete nurture and freedom are inseparable ideas in nature also;
> and for the avid, well-traveled botanist, the dried plants of a herbar-
> ium, if they were collected from the Cordilleras of South America or
> the plains of India, often have more value than looking at the same
> type of plant taken from a European greenhouse. The domestication
> [*Cultur*] eradicates something from the original natural character

[*Natur-Charakter*]: it disturbs, through constricted organization, the free development of the parts.[59]

Interestingly, in Humboldt's view, it was the Eastern peoples — Semitic, Indian, Iranian, Chinese, and Japanese — who had earliest and most completely developed concepts that were now as necessary for landscape gardening as for botany: "feeling for nature" and for the "physiognomy of plants" (the multiplicity and diversity of forms in a region) had characterized their image of an "earthly paradise." Ancient Chinese gardens, stretching for miles, came closest to the sense of natural freedom of the present "English parks." A Chinese writer had expressed their function: "to compensate a person for everything that takes him away from life in free nature, his true and favorite abode." Thus the art of composing a garden consisted in uniting serene views, lush growth, shadows, loneliness, and calm so as to deceive the senses. "Diversity, which is the prime virtue of the free landscape," should be sought in all things. "All symmetry is tiring; surfeit and boredom are produced in gardens in which every layout betrays coercion and artistry."[60] It would appear that Humboldt's ideal of naturalistic freedom was as problematically represented in the tropical climate of the Palmenhaus as it was in the political climate of *Vormärz* Prussia. Nevertheless, in the Palmenhaus, the Pfaueninsel reached the high point of its eloquence. To fix its magic in historical memory, Friedrich Wilhelm III commissioned Karl Blechen in 1832 to represent it in oils (color plate II).

Blechen's paintings were as successful as the building itself, perhaps especially because of their implied reference to *Lalla Rookh* and *Nurmahal* through the enchanting presence of Indian women, clad in colorful silks and seductively reclining on Oriental carpets with musical instruments.[61] The scenes immediately recall Schinkel's original *lebende Bilder*, with their Humboldtian

background of tropical foliage and mountains, and the music that accompanied them (figure 3.9). A reporter at the 1834 academy exhibition described his response to Blechen's paintings: "The innocent abundance and tenderness and the dreamlike fascination of Oriental vegetation come over me. The artist has perfected this effect through the delicate poetic figures.... I have seen the Palmenhaus many times; I see it again here exactly, but as though translated from words into music."[62] Though the Palmenhaus burned to the ground in 1880, Blechen's paintings continue to speak of the aesthetic empire it once embellished.

Reflection

The palimpsest of successive stagings that constituted the Pfaueninsel in the 1830s unrolled the history of its physical presence — vegetation, vistas, buildings, engine, fountains, animals, and people — through which it spoke to its visitors. These things could speak because they had been "socialized" through the history of their appearance there. We have stressed the history of industry and commerce during and after the reform period as something any perceptive Berliner could have seen and heard there. That is, the island spoke not so much as a bounded and isolated object as through the ways in which its components and their interrelationships spoke of a larger world in which they acquired their meaning. For that reason, it has been important to keep always before us the Humboldtian projects that attached at so many points to the shaping of the island. Humboldt serves to remind us of the island's connections to people and events far outside its bounds that gave to its physical form the languages that different visitors could understand in its presence.

What has been said of the moors of Yorkshire in England could be said of the Pfaueninsel: "Edges of Moors are an archaeological palimpsest of superimposed field systems, a record of

centuries of endeavour and failure."[63] A visitor to the island today will still find such records. Some are subtle — a field of Thaer's model farm is now a sun-tanning meadow; of the llama house only a squirt of a fountain remains; a few carved stones mark the Palmenhaus — but many are more prominent: palace, dairy, English park, engine house, and fountain. These remainders of the various stagings that the ground has supported and rejected continue to constitute the Pfaueninsel as the unique thing that it is.

A Science Whose Business Is Bursting: Soap Bubbles as Commodities in Classical Physics

Simon Schaffer

> These experiments lie very closely on that ill-defined border-line which separates scientific work from scientific play, but I trust that the beautiful way in which they illustrate the action of certain forces may be sufficient excuse for my showing members of the Physical Society what cannot fail to remind some of them of their nursery days.
>
> — Charles Vernon Boys, "Experiments with Soap-Bubbles," Physical Society, April 14, 1888

How Commodities Speak

Scientists at work and at play devise techniques that fix transient phenomena as defined things. Study of such things shows the art in their fixations. Here the thing is a soap bubble, long involved in the domestic and commercial system of hygiene and purity, in the artistic and moral system of innocence and transience, and in the scientific and demonstrative system of short-range forces and luminous colors. During the final decades of the nineteenth century, work on soap bubbles brought these systems into close contact. A notable point of intersection was classical physics, its arts

147

those of the laboratory and lecture theater as well as the studio, the salon, and the billboard. This science's eloquent objects, soap bubbles included, were often commercial commodities. When he analyzed the "language of commodities" in Victorian Britain, Karl Marx reckoned "the products of men's hands" had begun to "appear as autonomous figures endowed with a life of their own." Marx mocked any who sought a "chemical substance" corresponding to things' innate exchange value: "Listen how those commodities speak through the mouth of the economist." A few years later, the London chemist William Crookes prefaced his new edition of Michael Faraday's highly popular lectures, *The Chemical History of a Candle*, with such a ventriloquist's fantasy: "The huge wax candle on the glittering altar, the range of gas lamps in our streets, all have their stories to tell. All, if they could speak (and after their own manner they can), might warm our hearts in telling, how they have ministered to man's comfort, love of home, toil and devotion."[1] Commodities such as gas, wax, and soap acquired special life stories in the period of high capitalism. They showed up in many scientific sites, especially those of public physics. Art stabilized mutable materials as examples of scientific principles. Time-lapse photography and cinematography were both mobilized in the cause. Indeed, the nineteenth-century development of machinery to make fixed images mobile was rather a speciality of those physicists who worked most on the behavior of bubbles. The art and physics of soap films culminated in films of soap.

Physicists sought to make big, stable, visible bubbles out of liquid soaps, among the era's most important new commodities. The commodification of soap involved transformations of women's work, imperial commerce, and crises of labor. Soap mattered in contemporary public art, both through the iconography of the bubble canonized in the Western tradition in maxims of *vanitas*

and innocence and through the newfangled enterprise of mass advertising. Though the episodes treated here are mainly set in London, with an apt Parisian coda, soap physics and its markets were global. "There were to be soap wars as fierce as the Crimean War," writes Asa Briggs in his history of Victorian things. "Both the cult of domesticity and the new imperialism found in soap an exemplary mediating form," argues Anne McClintock in her study of race, colonialism, and sexuality in that period.[2] This essay explores one moment when physicists turned a commonplace commercial entity into a representative thing that fitted the laws of their world. John Austin once notoriously remarked that the world of sense might be imagined to be made up of "moderate-sized specimens of dry goods," and, though smaller and wetter, soap bubbles in their commodity form fit this picture. It is by appropriating such particularities that the sciences demonstrate their grip and give voice to the idiosyncrasies of their production.[3]

The Soap Business

A very rapid expansion in soap production and sales was one of the more dramatic phenomena of late-nineteenth-century British market capitalism. Urban soap boilers extracted hard fats from tallow or bone grease, then mixed them with potash. Manufacture and consumption of washing soap, and wax candles the shops also produced, had been pervasive if small-scale artisanal and domestic concerns. British soap consumption was barely 25,000 tons in 1801; by 1861, following repeal of the soap excise, production had reached more than 100,000 tons. Empire, energy, and engineering were decisive. As in other capital-intensive Victorian systems, production relied on high-pressure steam engineering (to run the boilers) and chemical technology (involving the precision laboratory analysis of fatty acids and glycerin as well as mass production

of solid caustic alkali). The eminent German chemist Justus von Liebig's *Familiar Letters on Chemistry* was read as a manifesto:

> The quantity of soap consumed by a nation would be no inaccurate measure whereby to estimate its wealth and civilisation. Of two countries with an equal amount of population, the wealthiest and most highly civilised will consume the greatest weight of soap. This consumption does not subserve sensual gratification, nor depend upon fashion, but upon the feeling of the beauty, comfort, and welfare attendant upon cleanliness; and a regard to this feeling is coincident with wealth and civilisation.

In emulation of these views, the London commercial journalist George Dodd introduced polite readers to a vast soap works on the Thames where steam engines and chemical laboratories had just been installed to mass-produce their favoured homely product: "If cleanliness is next to godliness, we ought to have very pleasant thoughts while passing between these walls of soap."[4]

There were immediate linkages with other industrial sectors. The Solvay process accelerated alkali production after 1863; in the same year, with Alfred Nobel's development of nitroglycerin, soap makers could play their loyal part in the explosives industries. Equally important was the mid-nineteenth-century imperial exploitation of colonial plantations. Cultivation of western African oil palms and South Pacific copra by transported and indentured workforces in new colonies gave metropolitan industrialists profitable sources of fat. Palm-oil soaps had long been used in western and central African cultures: "the Africans use this oil in cookery," Dodd explained, "and for anointing the body, but when imported into England it is used in soap making." African oils now became signs of and commodities in European imperial economies. Dodd wrote:

The use of this oil in soap is a matter of almost as much importance to the philanthropist and the statesman as to the soap-manufacturer. The latter looks at it merely as a good and cheap ingredient; the philanthropist may view it in respect to its African origin as a powerful instrument in the abolition of the traffic in slaves; the statesman may feel that it secures our manufacturers a lucrative barter trade free from the fiscal regulations which impede our commerce with old states.

The "lucrative" trade boomed. From 1880, Britain led the way in the production of elegant bathrooms well equipped with soaps. The first branded soap was put on sale in 1884. In 1891, more than 250,000 tons of soap were sold in Britain, a doubling in consumption per head in three decades.[5]

If the material components of this new mass commodity relied on long-range intensified communication networks, so did its consumption. Soap's consumers were formed through the distinctive late Victorian combination of scientific authority, respectable domesticity, and mass advertising. Scientific expertise advertised itself through bold institutions, often more newsworthy for their ambitions than for their efficacy, as chaotic London programs for water surveillance showed in the 1870s and 1880s. Liebig's hygiene cult and his zymotic theory of disease were but parts of a general concern with pathogens and putrefaction. Public scientists such as Thomas Huxley and his ally John Tyndall lectured their flocks on the germ theory of disease, the pathologies of dirt, and the virtues of antisepsis and rational domesticity. Huxley's evolutionist sermons appealed to the transient beauties of bubbles: "The man of science knows that...there is not a rainbow glint on a bubble which is other than a necessary consequence of the ascertained laws of nature, and that with sufficient knowledge of the conditions, competent physico-mathematical skill could

account for, and indeed predict, every one of these 'chance' events." Tyndall used lectures at the Royal Institution and experiments in Turkish baths to show how dust, dirt, and soap obeyed the laws of material science. Scientific confidence in law-like ephemera, directed against spontaneous generation and putrefaction, soon turned into campaigns for universal soap.[6]

In ways familiar to the anthropology of pollution, the fight for soap helped define social and natural hierarchies in the same detergent gesture. In his epochal report on proletarian sanitation, the philosophical radical Edwin Chadwick paused to recommend that waste steam from factories be used to clean the workforce before insisting that "sound morality and refinement in manners and health are not long found co-existent with filthy habits among any class." Charles Kingsley's *Water-Babies* (1863), inspired by moral ecology, Christian socialism, and Liebig's sewerage chemistry, was a familiar version of this soapy reverie. "If they work very hard and wash very hard, their brains may grow bigger," Kingsley moralized. At last his well-washed hero became "a great man of science, and can plan railroads and steam-engines and electric telegraphs and rifled guns and knows everything about everything."[7] Of all soap's phenomena, suds were especially important in the great sanitary war and its laborious obsessions. The great socialist suffragette Hannah Mitchell, growing up on a Derbyshire farm in the 1870s before she fled its crushing exploitation, recalled that her mother's "love of cleanliness" was "carried to the point of absurdity, as for instance when she used her left-over soap suds on washing days to scrub and wash the pigs." Manifestos for new automatic washing machines, commercially adopted in Britain from the 1870s, explained the contrast between hard labor and effortless bubbles: "Other inventors have tried to succeed by imitating the common process of washing by rubbing, pressure or friction; in our machines the clothes are alternately in steam and

in suds; the former opens the fibres and the latter removes the dirt." Commodity culture embodied scientific, virtuous, efficient, healthy life in soap bubbles.[8]

Bubbles as an Artistic Commodity

"Any fool can make soap, it takes a clever man to sell it." So wrote Thomas Barratt, head of A. & F. Pears Ltd., one of the capital's major soap firms. His principal competitor, the ingenious Lancashire entrepreneur William Lever, explained the physics of soap salesmanship in the 1880s: "Mr Lever has always viewed advertising as a reserve of energy. The cost of advertising can only be paid for by increased sales, if increased sales result, and it may be viewed as a storage battery upon which in a time of stress drafts might be made for a limited period." Lever's and Barratt's "cleverness" lay mainly in mass advertising. From his headquarters at Port Sunlight near Liverpool, Lever spent almost two million pounds in the two decades after 1890 on advertisements to link happiness, prophylaxis, and Sunlight bars. Barratt raised his company's publicity budget from barely £100 annually to almost £130,000. He offered to buy the back page of the national census form, recruited endorsements from eminent chemists, took out advertisements even in such sober organs as Norman Lockyer's *Nature*, and, notoriously, recruited the work of the nation's most celebrated artists (figure 4.1).[9]

Barratt's principal target was the wealthy London painter John Everett Millais. Their relation is not best understood as that between heartless commerce and misty artistry. Rather, their deal embodied the metropolitan art world's culture of capitalism, imperialism, and print technology. The later Victorian growth of illustrated magazines and powerful print sellers was decisive for the emergence of "artistic advertising."[10] In the 1880s, Millais was earning almost forty thousand pounds each year, his works

AWARDED THE HIGHEST HONOURS.

Diplomas, Gold Medals, and Special Certificates of Merit, at all the great Exhibitions of the World, from the FIRST Great Exhibition of 1851 down to the LAST at Paris in 1889.

Is bought to-day by everybody, and has maintained its reputation as the best of all Toilet Soaps for more than One Hundred Years.

The following Evidence is Indisputable:

DR. REDWOOD, Ph.D., F.C.S., F.I.C.,

Professor of Chemistry and Pharmacy to the Pharmaceutical Society of Great Britain.

" My analytical and practical experience of Pears' Soap now extends over a very lengthened period—nearly fifty years—during which time

I have never come across another Toilet Soap which so closely realizes my ideal of perfection.

Its purity is such that it may be used with perfect confidence upon the tenderest and most sensitive skin —EVEN THAT OF A NEW-BORN BABE."

PEARS' SOAP represents a Century's Experience of the most successful achievements in the Art and Craft of Fine Soap Making.

Printed by RICHARD CLAY AND SONS, LIMITED, at 7 and 8 Bread Street Hill, Queen Victoria Street, in the City of London, and Published by MACMILLAN AND CO., at 29 Bedford Street, Strand, London, W.C., and 112 Fourth Avenue, New York.—THURSDAY, December 4, 1890.

Figure 4.1. "Awarded the Highest Honours," *Nature*, Dec. 4, 1890, p. xl.
By permission of the University Library, Cambridge.

distributed lithographically in editions of up to sixty thousand copies via magazines such as the *Graphic* and the *Illustrated London News*. His sentimental imagery traveled throughout the empire. In 1885, he became the first British artist created baronet.[11] In January 1886, Millais was honored with a one-man show at the Grosvenor Gallery in Mayfair, around the corner from the Royal Institution. Previous such shows at Coutts Lindsay's gallery had been devoted to past masters of British art: Sir Joshua Reynolds (1884) and Thomas Gainsborough (1885). The obvious inference, that Millais now belonged in the national pantheon, was not missed. Nor was the Grosvenor merely an aesthetic haven. By 1886, Lindsay had hired the young electrical engineer Sebastian de Ferranti to set up an electric lighting system centered on the Grosvenor to distribute power across much of west London. Millais's paintings found themselves at the hub of a new technical network of artistic and industrial London, "one ever green oasis standing boldly out in the midst of a dismal waste," in the words of one entranced engineering journalist.[12]

As soon as Millais's Grosvenor Gallery show closed in early 1886, a neighboring Bond Street dealer, Arthur Tooth, displayed the artist's latest product, *A Child's World*. The painting showed Millais's five-year-old grandson, William James, dressed fashionably in Gainsborough velvet, gazing awestruck at a large soap bubble. The sitter would eventually grow to distinction as an admiral and Tory member of Parliament. The image had an even more global future, perhaps the most widely seen work of any British artist. Millais sold it for the 1887 Christmas number of the *Illustrated London News*. Even before this mass distribution, Barratt had been to Tooth's gallery and bought the copyright for the spectacular price of £2,200. Barratt explained to Millais "the advantage which it was possible for the large advertiser to lend to Art." Millais reportedly agreed to "paint as many pictures for advertisement

as you like to give me commissions for." Barratt skillfully retitled the piece — *Bubbles* — then spent £17,500 on making the print and £30,000 on the subsequent publicity campaign, eventually mass-marketing the image with a bar of Pears's soap inserted in one corner in engravings, posters, jigsaw puzzles, and postcards (figure 4.2). *Bubbles* became the best-known artistic commodity of the age. It was on display at the Paris Exhibition of 1889, Millais reassuring the exhibition commissioners that its commercial use had not damaged its status as fine art. Skeptics vented their spleen on "the soap business" and its destruction of innocence. Millais riposted that "thousands of poor people" could thus gain access to the heights of artistry. In the end, many of his paintings joined the world of the soap business alongside other Pre-Raphaelite masterpieces at Lever's splendid gallery at Port Sunlight.[13]

Bubbles was made and lived in an era of high capitalism, linked with consumption and cleanliness, empire and innocence. Pears distributed Willie James's portrait alongside those of white children, black men, victorious colonial troops, "the formula of British conquest." The firm's advertisements juxtaposed Liebig's slogans about soap and civilization with images of savagery reclaimed by Britain's cleansing commodities. Commerce, war, civilization, and morality all helped turn bubbles into valuable things.[14] Bubbles thus became the stock-in-trade of a science of ephemera. Their meanings had for centuries perversely included those of both childish innocence and inevitable death, emblems of coming into being and passing away. So alongside the work required to stabilize bubbles' existence was that needed to stabilize their sense. Soap bubbles could be balloons, lenses, or toys, offering occasions for sciences to show their artfulness in mundane things.[15] Such mundane moments were commonly apocryphal elements of the cult of scientific genius and its sudden insights. Bubbles were to be to optics what apples had allegedly

Figure 4.2. 'The sweetest picture post card yet produced," ca. 1900. By permission of the British Library (X.415/5590).

been to gravitation. Both Robert Hooke (in 1672) and Isaac Newton (in 1704), deity of the genius cult, had long before reported their own investigations of the dioptrics of soap bubbles, and especially of the strange black spots produced as bubbles thinned.[16] It became possible, in the wake of Netherlandish proverbial imagery of cherubic bubble blowers and of such masterpieces as Jean-Baptiste Chardin's *Soap Bubbles* (1733), then to invent genial natural, philosophical images of soap and light. Exemplary was an earlier nineteenth-century work, *Newton Discovers the Refraction of Light*, by the Bolognese designer Filippo Pelagio Palagi (figure 4.3). The artist domesticated his subject, surrounding the Cambridge recluse with a family, especially a blond child innocently playing with soapy globes to capture the light shining into the study through an illuminated window. The contrast between pensive natural philosopher (immured by his texts and his optical equipment) and carefree child (with nurse and soap dish) was telling. The result of the foreground encounter (the discovery of refraction) was already there as a background commodity (the reflecting telescope). Palagi's subsequent labors won him plaudits, not least when he displayed his works at the Crystal Palace in 1851.[17]

The linkage between bubbles' optics and bubbly innocence stayed common in later nineteenth-century imagery, reinforced by Millais and Barratt's global enterprise. At the World's Columbian Exposition in Chicago (1893), the Paris-based artist Elizabeth Jane Gardner scored a hit with her *Soap Bubbles*, children playing at a window with pipes and soap. It was soon bought by Millais's erstwhile agent Arthur Tooth. The catalog explained that "the iridescent effects on the bubble and the clever work which reproduced the reflection on a window in the rear were the attractive features of the canvas. So strong is the influence of truth on the people." But "truth" in bubble optics was a contested commodity. Millais himself had sometimes been victimized by literal-minded

Figure 4.3. Filippo Pelagio Palagi, *Newton Discovers the Refraction of Light*, 1827, oil painting, 167 x 216 cm. Pinacoteca Tosio Martinengo, Brescia. By permission of the Direzione dei Musei Civici d'Arte e Storia di Brescia. Bubbles are to optics what apples are to gravity: Newton is shown at his desk working on optics when, turning, he sees to his surprise a boy making soap bubbles in which colors are made by refraction of light rays. The woman is described as Newton's sister.

scientists, especially with respect to his understanding of the order of colors. In 1856, he was peremptorily and expensively ordered to repaint an evocative (but optically incorrect) rainbow so that it better conformed to the scientific principles of Newtonian refraction. This episode then became a test case in the campaign mounted from the 1870s in *Nature* by Norman Lockyer to make popular art subservient to the purposes of public scientific optics. Emulating Huxley's lectures on law and chance, Lockyer moaned about the scientific ignorance of Millais and his ilk: "There seems to be a sort of notion that there are no laws underlying the phenomena of air and sky and sea, that the order of colours in a rainbow depends on the play of blind chance." Lockyer and his allies treated the play of light, air, and water as a crucial site where their laws ran. In this light, Millais's *Bubbles* appeared when rational understanding of the world of commodities might be linked with the artful control of transient geometry, force, and color.[18]

"Platonic Suds": The Origins of Microphysics

"The wonder and admiration so beautifully portrayed by Millais in a picture, copies of which, thanks to modern advertising enterprise, some of you may possibly have seen, will, I hope, in no way fall away in consequence of these lectures: I think you will find that it will grow as your knowledge of the subject increases." This was how Charles Vernon Boys, metropolitan master of soap physics, started his popular lectures at the very end of 1889. For several years, the show of soap science relied on the ubiquity of bubbles and their markets, while soap bubbles were represented as luminous tokens of underlying natural laws. Homely phenomena such as bubbles were shown by demonstrators to be uncanny; strange sparks, drops, and jets were domesticated. The day Millais's show at the Grosvenor closed in January 1886, audiences

around the corner at the Royal Institution were treated to a stunning show of soap bubbles and liquid drops. The lecturer was Sir William Thomson, already for forty years natural-philosophy professor at Glasgow and doyen of classical physics. His theme was "capillary attraction." When soap bubbles were on the point of bursting, as Hooke and Newton had reported, it was possible to see a black film, which Thomson estimated to be about 12 micromillimeters thick, since the destructive interference of incident light must then correspond to a half-wavelength path difference. This film's behavior could only be explained by a continuous gravitational force and intensely dense molecules. "May we not go farther," Thomson asked, and assume a Newtonian force "continuously from the millionth of a micro-millimeter to the distance of the remotest star or remotest piece of matter in the universe"? Thus Thomson took his audience from soap to the most distant star. To calculate the behavior of real bubbles was beyond exact analysis, so he recruited his former student the engineer John Perry to draw capillary surfaces of revolution based on the gravitational theory (figure 4.4). Thomson showed them on lantern slides at the Royal Institution, then had them engraved for Lockyer's *Nature* as publicity stunts. To dramatize the ways in which Perry's curves would change under the surface-tension forces that governed expanding bubbles, Thomson drew chalk lines on a large rubber sheet, then had a lab assistant pour in water from above as the artificial drop slowly expanded. This technique was common in Thomson's Glasgow physics classes. He suspended his big bubble from the roof of the Royal Institution's lecture theater. Vibrations of the water-filled rubber sheet showed Thomson's theory in play, "which culminated when finally the elastic film gave way and the drop burst over the lecture table splashing the nearer members of the fashionably attired audience." Surface tension, soapy water, rubber sheets, and artful

Figure 4.4. William Thomson, "Capillary attraction," in *Popular Lectures and Addresses*, 3 vols. (London: Macmillan, 1891), vol. 1, p. 34, fig. 10. By permission of the Syndics of Cambridge University Library. Diagrams drawn by John Perry in the Glasgow University natural philosophy laboratory for Thomson's investigation of the surfaces of drops in capillary tubes, then shown by Thomson at the Royal Institution on January 29, 1886, and published in *Nature* in July 1886.

dramaturgy all taught the grip of physics' understanding of cos-
mic forces. Soon Lockyer published this lecture in his magazine,
then encouraged Thomson to release it as the first volume of his
successful *Popular Lectures and Addresses.*[19]

By the end of the 1880s, soap bubbles and films had preoccu-
pied the Glasgow natural philosopher for several decades. Bub-
bles' dimensions, colors, and oscillations held clues to the basic
structures of matter. Thomson and his allies had precedents for
their ingenious combinations of "popular" bubbles and micro-
physical models. Just over a century after Newton's *Opticks*, pop-
ular natural-philosophy texts extracted serious lessons about light
and force from ephemeral bubbles. Characteristic was *Philosophy
in Sport Made Science in Earnest*, first issued in 1827 by the Mayfair
medic John Paris with delightful illustrations by the cartoonist
George Cruikshank and a fulsome dedication to Paris's friend
Michael Faraday. In Paris's book, tyros were instructed with little
more than tobacco pipes and common soap. But from the 1840s,
experimenters' techniques became more sophisticated, their
commodities carefully prescribed, and their inferences ambitious.
Decisive were the projects of the Belgian experimenter Joseph
Plateau and the British response to his remarkable work. Plateau
cared how things looked. He lost his sight in the early 1840s after
more than a decade's work on persistence of vision. Plateau's
family and assistants then collaborated with the blind Ghent pro-
fessor in precisely tracing the motions of soap, oil, and other flu-
ids. Plateau pursued two techniques for managing bubbles and
films. A mass of oil suspended in a mixture of alcohol and water
of identical density could show what happened in the absence of
net gravitational force. Alternatively, by mastering the vagaries of
commercial glycerin and determining the best mixture of shop
soap with water, Plateau's collaborators could blow long-lived
bubbles and films, then manipulate them with wire frames of

varying shapes. Plateau at last began to tame bubbles' behavior. He showed that perfect spheres were the preferred equilibrium shape and that in soap films three surfaces always met along a curved edge at angles of 120 degrees, or else four curves would meet at a vertex at just under 109 degrees. Plateau sought to hitch his team's elegant tricks to suggestive cosmic lessons.[20]

The British proved especially receptive. Plateau explained how his spinning drops could imitate Saturn's rings by successively depositing circular laminae. The Cambridge professor James Challis arranged the translation of this unctuous model in a widely read London journal in 1846, then joined Thomson in setting the problem of the planet's rings for Cambridge mathematics students in 1855. This challenge was met by the young James Clerk Maxwell in 1857 and launched new work on modeling fluid stability. Others, such as the Edinburgh journalist Robert Chambers, found Plateau's models evidence for the nebular hypothesis of cosmic evolution. "The dew-drop is, in physics, the picture of a world," the Scottish evolutionist told his readers in 1845. "We are prepared in some measure to hear of a Belgian professor imitating the supposed formation and arrangement of a solar system on the table of a lecture room! The experiments were first conducted by Professor Plateau of Ghent, and afterwards repeated by our own Dr Faraday."[21] Faraday was particularly enthusiastic about Plateau's techniques. He exhibited the Belgian's soap films and spinning drops in his Mayfair lectures and visited London friends to display his new skills. "What a beautiful and wonderful thing a soap bubble is." In his Royal Institution Christmas lectures of 1849, soon published to acclaim in *The Chemical History of a Candle*, Faraday showed his rapt audiences gas balloons made by blowing soap bubbles in hydrogen to dramatize the behavior of fluids. "We have a perfect right to take toys and make them into philosophy, inasmuch as nowadays we are turning philosophy into

toys." After further discussions with Plateau about bubble technique, Faraday turned these public tricks into backstage methods of showing the diamagnetic behavior of gases. The puzzle was to contain gas samples in magnetic fields without disturbing the fields. Plateau's bubbles proved invaluable. Faraday did laboratory experiments with fresh soapsuds (old suds proved too stringy), blown through thin glass tubes to capture different gases and then track their motions in strong fields. "It was easy to make soap bubbles, beautiful in form, and very mobile in a pendulous fashion." In an 1868 eulogy, his successor Tyndall recalled how Faraday "suddenly rose from his bubbles of oxygen and nitrogen to the Earth itself. Newton's observations on soap bubbles were often referred to by Faraday; his delight in a soap bubble was like that of a boy, and he often introduced them into his lectures."[22]

The combination of childlike enthusiasm and sober microphysics became ever more important in bubbles' experimental career. Just as Faraday turned soap bubbles into clues to magnetic matter, Maxwell used Plateau's techniques to model innovative statistical mechanics, first as a Cambridge wrangler analyzing Saturn's rings, then professorially as exemplars of microphysical energy distribution. He got his Scottish natural-philosophy classes to replicate Plateau's oil-drop experiments and discussed them with William Thomson. By 1862, Maxwell had started to learn Plateau's recipes for long-lived bubbles: "I have been brewing Platonic suds." In temporary retirement in the late 1860s, he designed an ingenious microscope to measure the surface tension of liquids in response to Plateau's group's estimates of capillary surfaces: "I shall also try soap bubbles to test the effect of the soap." When Plateau at last published a compilation of his essays on soap bubbles and hydrostatics in 1873, Maxwell back in Cambridge reviewed it in *Nature*: "Can the poetry of bubbles survive this?" The review started with an evocation of soap bubbles as signs of

vanity and innocence, explained that such eloquent things were "phenomena on the careful study of which depends much of our future progress in the knowledge of the constitution of bodies," then brilliantly summarized how energetics explained bubbles' behavior. Maxwell reinforced these lessons in his widely read article on capillarity in the *Encyclopaedia Britannica* in 1876. This text provided Thomson with crucial data on the rubbery tension within soap films and a possible graphical solution to problems of bubble shape and capillary surfaces.[23]

The importance of the link between public play and microphysics became evident throughout British public science. The new physics professor at Leeds, Arthur Rücker, turned Plateau's bubbles into effective show. In November 1875, he delivered a successful discourse on soap bubbles as part of a series of "science lectures for the people." Following Plateau's recipe, "a large bubble was speedily blown and it showed the usual beautiful colours. This and the succeeding experiments were dexterously and successfully performed and were much applauded." Rücker made himself an expert on deriving microphysical principles from "the short but brilliant life of a bubble." By the summer of 1877, he had prepared studies of Newton's black soap film, using Plateau's glycerin as his chemical of choice and applying sensitive galvanometers across the films to measure their thickness as about 12 micromillimeters, Thomson's favored number in his own lectures. Rücker's skills won him the physics chair at South Kensington's new Royal College of Science in 1886 and the Royal Society's Royal Medal in 1891. Further work on limiting dimensions of soap films proved decisive for British physicists' measures of the smallest dimensions of molecules, thus the components of the optical ether.[24]

A Physicist Takes a Bath

Thomson had once boldly identified the ether that carried light waves with the airy matter with which soap bubbles were made. Soap bubbles were reckoned both a model and an effect of nature's fundamental substance. The Glasgow professor told his students in the autumn of 1852 that the interference colors of thin soap films demonstrated the rarity of this airy matter, much finer grained than one wavelength of light. But during the 1860s, Maxwellian thermal kinetics suggested air must be much coarser grained than luminiferous ether — the two substances were now judged similar, not the same. In 1870, Thomson therefore sent an essay to Lockyer's *Nature*, using data on capillary attraction and the colors of thin soap films to estimate molecular size as roughly one thousand for each light wavelength. This made it very unlikely that air molecules were the same as the components of a luminiferous ether. In early 1883, in a painstakingly prepared lecture at the Royal Institution, Thomson gave a manifesto for a new research program, beginning with Newton's original description of interference in soap films and Rücker's electrical data on their thickness. As he prepared the Mayfair talk, Thomson asked his friend the Cambridge optical expert George Stokes for "any knowledge or views as to the black hole-like spots which we see in soap bubbles and films before they break." Thomson and Stokes agreed these spots showed soap films were heterogeneous, "somewhat like soft phlegm." A decidedly Archimedean moment convinced Thomson that soap mixtures held the clue to the puzzle of how light could be reflected and refracted by spinning fine-grained molecules:

> Yesterday morning [10 January 1883] in my bath (hot Loch Katrine water) I saw quite decidedly something that I did not expect: a very faint image of a candle from a seemingly *black* hole in a soap film

between my hands. I could distinguish no colour, but the seemingly unchanged tint of the candle flame itself. The image seemed as from a perfectly smooth surface. The film round the seeming hole was very streaky.

Just over three weeks later, Thomson projected images of these "seeming" soap colors onto a large screen for his London audience. "Philosophers old and young, who occupy themselves with soap-bubbles, have one of the most interesting subjects of physical science to admire. Blow a soap-bubble and look at it — you may study all your life, perhaps, and still learn lessons in physical science from it."[25]

In this public physics, experience of commodities such as jelly, rubber, glass, and soap was decisive. At the limits of its mastery, in cases such as the medium of light or the microphysics of the ether, display proved invaluable. In October 1884, Thomson lectured at Johns Hopkins University in Baltimore to a more specialist audience of eminent physicists such as Lord Rayleigh, Henry Rowland, and Abraham Michelson on the relationship between molecular dynamics and the continuous ether. He used these Baltimore lectures to explore "the natural history of the luminiferous ether" and show how to "get into the notion that the molecule must be soft and that there must be an enormous mass in its interior. I have no more doubt that something of the kind is true than I have of my own existence." Once again, measures of the optics and dynamics of soap bubbles furnished his best evidence for the size of these molecules, though he did not choose to shower his prestigious audience with water from a model droplet suspended above their heads. Nevertheless, work on editing the Baltimore lectures, a summary of Thomson's vision of classical physics' tasks, was entirely consonant with his histrionics in London's West End. The physics of soap bubbles helped demonstrate that the laws of mole-

cular dynamics could fix the transient phenomena of everyday things.[26]

In the autumn of 1887, Thomson began what he called an "utterly frothy" inquiry as part of his work editing the Baltimore lectures. To explain light propagation through crystals, it had become important to describe how to divide space into cells of minimum surface area. "The problem is solved in foam," Thomson realized. Plateau had shown that bubbles under surface tension were spherical because such a shape enclosed a given volume with minimum area. When complex wire structures were dipped in soapy foam, the Belgian reported, surfaces appeared "as if by magic," which solved problems of minimal area. What of a mass of bubbles such as that imagined by Thomson's microphysics? Plateau urged that "even though everything seems to be at random, such foam must obey the same laws" as simple bubbles. Thomson agreed with this legalization of foam behavior. He explained that "the solution is interestingly seen in the multitude of film-enclosed cells obtained by blowing air through a tube into the middle of a soap-solution in a large open vessel." Thomson made clay models of these "tetrakaidekahedra" for show in Edinburgh and elsewhere, complex structures with six square and eight hexagonal faces, exactly represented in his soap solutions.[27] These models would by 1917 provide the great Scottish polymath D'Arcy Wentworth Thompson with evidence for underlying geometries of organic forms. Meanwhile, the combination of making models for show and trying soap bubbles at home gave Thomson hints to the ideal structure of such extrema. In the autumn of 1887, while Thomson was drafting his essays on tetra-kaidekahedra, his sister Elizabeth would come into the great man's study to watch soap bubbles being blown with a tobacco pipe then captured in wire frames and dutifully read him edifying extracts from Tory speeches against Irish home rule to pass the

time. His niece Agnes happily recalled Thomson and his assistant at home in their Ayrshire retreat

> blowing soap-bubbles at the top of the stairs, and watching them with their lovely colours float gently down, even if we did not know that by studying them he was hoping to be able to discover something of the ether spreading through space, which he believed to be the medium for the transmission of light, that with his marvellous measuring instrument he had measured the film and found it to be one twenty-millionth of a millimetre thick, and that the questions involved in the seemingly simple operation of blowing bubbles were amongst nature's greatest enigmas.[28]

Bubble Cinematography

Physicists such as Thomson and Maxwell started with familiar domestic phenomena, then analyzed these transient effects for clues to underlying structure. By the early 1890s, this enterprise seems to have taken over much of British public science.

At a Mutual Improvement Society in a Liverpool suburb in the autumn of 1890, a loyal audience braved bad weather to join in "bubble blowing" under the guidance of a local industrial chemist, Thomas Williams (figure 4.5). He recommended buying Plateau's glycerin and distilled water from the shop, but oleate of soda should be made at home: "I admit this is not a compliment to manufacturing chemists." Like many lecturers, Williams explained how childish play could become mature understanding through "a training to the eye," and that the heroes of Victorian science had thus imposed stable laws on transient commodities. Faraday did not "dwell on the weakness of the soap bubble. No, he dwelt on its strength and the powerful attraction of particle for particle the water composing it possesses."[29] Yet while the theme of underlying strength and scientific order stayed a commonplace

Figure 4.5. Thomas Williams, "A Dissertation on Bubbles," in *Soap Bubbles* (Liverpool: Journal of Commerce, 1890), frontispiece. By permission of the British Library (8708.i.25.[8]).

of lecturers' work with bubbles and films, the new decade witnessed a significant inflection in their artful manipulations. A novel concern of their work was the possibility of fixing new kinds of mobile phenomena in photographs and image machines which could themselves become commodities. During the 1890s, scientists began to design machines that could reproduce transience, and so capture the playful kinematics of drops and films.

These machines had first been devised by the protagonists of nineteenth-century soap science. In mid-1825, the London scientific popularizer John Paris had accompanied his work on soap bubbles in *Philosophy in Sport Made Science in Earnest* with a "thaumatrope," a simple spinning disk that could produce splendidly shifting images. From 1828, at the start of his work on persistence of vision, Plateau devised an "anorthoscope," which used a rotating anamorphic image behind a slotted disk to turn a moving image into a seemingly stable picture. Paris's friend and neighbor Faraday soon devised a similarly toothed spinning setup, which he showed at the Royal Institution in late 1830. Plateau was concerned that Faraday seemed unaware of his own project and by 1832 constructed the earliest version of a "phenakistiscope," which required the observer to gaze into a mirror, in front of which a complex of toothed disks and successive images of slowly changing form would be spun. Even blindness did not halt Plateau's campaigns for better mechanical production of movement. By mid-century, such machines, shown in music halls and scientific lecture theaters, had become indispensable commodities throughout Europe. In the 1860s, Maxwell adapted the so-called wheel of life, a sequence of pictures on a removable strip of paper inside a regularly slotted cylinder, for lecture performances on the movement of his vortex rings. Just as they started work on capillary force and surface tension, Maxwell told Thomson he had made a wheel of life to illustrate "a fountain throwing off drops

which change colour as they pass through the rainbow positions." These devices have typically been treated as part of the archaeology of cinema. Artful assemblages of screens, cog-wheels, lenses, mirrors, and lamps were supposed to turn fixed objects into moving images and fickle crowds into disciplined spectators. The image machines found their most common English home in such scientific theaters as the Royal Polytechnic Institution, the Royal Institution, and the London Institution, headquarters of profitable philosophical sermonizing. What mattered in the public science of bubbles and drops was the capacity of such machines to master transience.[30]

The protagonist of the new cinematography of soap bubbles and drops in the 1890s was Charles Vernon Boys, physicist at the Royal College of Science in South Kensington from 1881. Boys was trained by the expert teacher Frederick Guthrie in the mid-1870s, just when Plateau's soap statics became celebrated. From 1886, Boys was joined at the college by Rücker, already an adept of bubbles and foams. Boys's most famous student, H.G. Wells, un-impressed by his skill as an instructor, nevertheless recalled his "manipulative skill and ingenuity with soap bubbles. Boys shot across my mind with a disconcerting suggestion that there was a whole dazzling universe of ideas for which I did not possess the key." The imagery of artful wizardry and dazzling speed was apt. Boys mastered the physics of spiderwebs and bicycles. He made astonishingly fine wires by firing molten quartz from crossbows in heroic experiments to redetermine the gravitational constant with torsion balances. He was viewed as a "conjuror" by students and audiences. "Some of his devices were very artistic," they recalled. Boys would lasso pedestrians with huge smoke rings pumped out of his lab windows on Exhibition Road. He became the long-serving master of ceremonies for fashionable soirees held at the Royal Society to entertain the beau monde with up-to-date scientific

tricks. In the spring of 1888, under Guthrie's sponsorship, Boys launched his career as a soap scientist with a clever lecture at London's Physical Society. He acknowledged the link between "nursery" games and high-class physics. He refined the techniques of Plateau with wire frames and of Faraday with gas-filled bubbles to show metropolitan physicists the best ways of demonstrating surface tension, capillarity, and the optical principles of colored rings as bubbles came into contact or apparently miraculously passed through each other without bursting. His reputation as the wizard of bubbles and droplets was quickly established.[31]

Over the New Year holiday of 1890, Boys turned this reputation to good effect in three lectures on soap bubbles at the London Institution in Finsbury Square, the City equivalent of the West End's more prestigious Royal Institution. He proposed modifying the techniques of Plateau, Faraday, and Guthrie to show how surface tension worked during the "growth and formation of a drop." The successful lectures were soon published in the Romance of Science series sponsored by the Society for Promoting Christian Knowledge: "books which will show that science has for the masses as great interest and more edification than romances of the day." Successive editions offered consumers' guides to soap products. Common yellow soap was better than anything fancier, whose olive-oil base was often fatally mixed with cottonseed. British oleate of soda was useless. Instead, experimenters were counseled to order Berlin alkali. Boys played out standard soap dramas. He reworked Faraday's games with gas-filled soap bubbles moving between the poles of strong electromagnets to show how "slightly stable bubbles may be used to detect forces which would not be noticed in a bubble of more stable form." Thomson's moist show with rubber bags was repeated, then extended to reveal how even nursery rhymes could be realized with experimental art. Boys quoted Edward Lear's famous

nonsense verse about sailors who "went to sea in a sieve" (figure 4.6). The surface tension of a soap film stretched across a perforated wire gauze could indeed produce a skin well capable of floating if the sieve were large enough and the water smooth. "This experiment also illustrates how difficult it is to write real and perfect nonsense."[32]

What especially impressed Boys's audience was his novel use of image machines to show the kinematics of bubbles and drops. An important colleague in this innovative project was Lord Rayleigh, appointed in the spring of 1887 to succeed Tyndall as natural-philosophy professor at the Royal Institution. Master of precision physics and equipped with a fine domestic laboratory and support staff on his estate in rural Essex, Rayleigh had already published a startling essay on the order of colors in thin films and soap bubbles. In the summer before Boys's show, Thomson asked Rayleigh about the dynamics of soap-film shapes: "Soap proves much more that is very curious. See how a circle of oil, Plateau's oil, acquires a dimple which curves to the side, breaks the edge, and leaves a horseshoe which quickly rounds itself into a fresh curve, which again gets a dimple and a hole. I don't understand this." Rayleigh suspected these "curiosities" must depend on surface impurities in soap and that spark photographic methods could capture their motions. So in late 1889, he began examining how clean water jets and soap solutions coalesced when shot close by charged sealing wax, thus how surface forces might change suddenly when camphor, oil, or other surfactants were added to normal Plateau solutions. He decided atmospheric layers of carbonic acid were responsible for the size and lifetime of soap films. Thomson persuaded friends in the Edinburgh physics laboratory led by Peter Guthrie Tait to reproduce these experiments, using the speed of ripples generated by tuning forks across soapy solutions to assess liquids' surface tension. The Scottish experimenters understood

Figure 4.6. Charles Vernon Boys, *Soap Bubbles and the Forces Which Mould Them* (London: SPCK, 1890), fig. 6. By permission of the Syndics of Cambridge University Library. In his children's lectures at the London Institution over New Year 1890, Boys explained how to make a sieve float by using water's surface tension.

the difference between the standing waves they could master, easy to photograph, and the jets and droplets "made by Lord Rayleigh, who photographs a moving stream in a small fraction of a second."[33]

Inspired by Boys's success in early 1890, Rayleigh a few months later delivered talks at both the Royal Society and the Royal Institution on his image machinery. He explained the need to examine "the properties of the liquid surface immediately after its formation" and how he made ten-second photographic exposures of his liquid-jet images on gelatin under the illumination of candle flame behind ground glass. His most startling conclusion, he told his genteel audience, was that "foaming liquids are essentially impure — in fact, dirty. Pure liquids will not foam" because of differences in surface tension. How to demonstrate this evanescent phenomenon in a theater? "This may seem an impossible feat, but there is really no difficulty about it, all that is necessary is to observe a jet of the substance in question issuing from an orifice." So with projectors and screens he could fix the moment when soapy jets transformed into droplets over periods of less than $\frac{1}{100}$ of a second. Evanescent films were a mark of purity. The longevity of Plateau's films became a mark of their mixture with pollutants. All this, Rayleigh and his allies began to realize, demanded mastery of the new image machines.[34]

From Bubbles via Bullets to Battleships

In the year between their London lectures and publication, Boys and Rayleigh pursued work with image machines and transient drops and jets. Rayleigh's stories about impure surface layers in commercial soap films were somewhat controversial. Stokes wrote from Cambridge questioning his claims about surface-tension variations. Thomson, in contrast, asked Rayleigh for permission to add the essays on surface impurities to a new edition of his *Popular Lectures and Addresses* on capillarity and soap. Boys was

even more enthusiastic. In May 1890, he returned to the Physical Society with new photographs of soap-drop formation. "Under ordinary circumstances a drop of water is so small that the formation of the neck and separation of the drop are too rapid for it to be possible to follow the process by the eye." How to fix these ephemera? Boys explained how Rayleigh had started trying oscillating sparks from discharging capacitors to capture the transformation of falling jets into drops. But "the value of this method of observing the movements of rapidly moving bodies loses its practical value because the spark is alight during a large proportion of the time of each oscillation, so that it is by no means an instantaneous phenomenon." Boys reckoned he'd solved the puzzle of fixing a clear image of acidulated drops by putting a spinning grooved disk in front of a mirror between the spark and the jet, as in Plateau's phenakistiscopes. Boys then showed the London physicists a sequence of droplet images taken at twenty per second with $1/800$-second exposures pasted onto a cardboard disk: "When the cardboard is made to rotate in front of a looking-glass, the original experiment is again perfectly presented, and all the features are evident without using these objectionable liquids." He printed this "thaumatrope" image of a falling drop in the endpapers of his lectures, so his audiences could reproduce the original trial (figure 4.7). New photographs were offered his many readers. "I would suggest that those who have the advantage of beautiful surroundings might find it interesting to photograph them as presented in a bubble." He gave instructions on how to arrange camera, landscape, and gas-filled bubbles to make "a kind of dreamland portrait taken by reflection from the evanescent surfaces of a simple soap-bubble."[35]

Rayleigh presented similar images at the Leeds meeting of the British Association in the summer of 1890. He was less celebratory than Boys, cautioning that spark photos of jets turning into

Figure 4.7. Charles Vernon Boys, "Thaumatrope for showing the formation and oscillation of drops," in "Notes on Photographs of Rapidly Moving Objects and on the Oscillating Electric Spark," *Philosophical Magazine* 30 (1890), p. 251, fig. 2. By permission of the British Library (PQ PP-E[82]). On May 2, 1890, Boys lectured at the Physical Society on his methods for photographing drop formation. He also showed this optical device, with forty-three separate photographs of a falling drop pasted onto a cardboard disc and spun in front of a mirror. The thaumatrope was then printed on the back cover of the first (1890) edition of *Soap Bubbles and the Forces Which Mould Them*.

droplets were shadows and that though ground glass would im-
prove pictures' tone, light would be lost. "The degree of in-
stantaneity required depends upon circumstances. In some cases
the outlines would have lost their sharpness had the exposure
exceeded $\frac{1}{10000}$ second." So Rayleigh resumed his experiments on
surface pollutants' effects on the life of soap bubbles and drops,
aiming to render them things that could be captured by his image
machines. On vacation after the Leeds meeting, he took tobacco
pipes on walks along Highland streams, blowing vast bubbles
from their surface foam. "These bubbles behaved like soap, and
not, as had been rather expected, like saponine," the material of
mass-marketed bubble toys. Rayleigh composed long essays on
surface tension, reexamined Rücker's data on the thinness of the
"black of soap-films," and had decided by the end of 1890 that
he could offer his public authoritative photographs of drop and
bubble formation.[36] His February 1891 performance at the Royal
Institution marked a further stage in the use of image machinery.
For the first time, he used streams of bubbles to make apparent
the astonishing speeds of his spark photographs. "For some time
it has been my ambition to photograph a soap bubble in the act of
breaking" (figure 4.8). He showed the effect of dropping alcohol-
soaked shot through soap films. He set up an electrical circuit
so the shot dropped just as the condenser sparked. "This work
proved more difficult than I had expected, and the evidence of our
photographs supplies the explanation, namely that the rupture of
the film is an extraordinarily rapid operation," which he esti-
mated as $\frac{1}{300}$ of a second, just beyond the scope of his current
apparatus.[37]

Boys took up this challenge. The use of falling shot at once
suggested a solution. In July 1890, *Nature* carried the first British
reports of Viennese work by Ernst Mach and his team on the
spark photography of fast projectiles and condensation waves in

Figure 4.8. Lord Rayleigh, photograph of breaking soap film, in "Some Applications of Photography," *Proceedings of the Royal Institution* 13 (1891), pl. 2, fig. 7. By permission of the University Library, Cambridge. "Everyone knows that if you blow a soap bubble it breaks – generally before you wish. The process of breaking is exceedingly rapid, and difficult to trace by the unaided eye. For some time it has been my ambition to photograph a soap bubble in the act of breaking." Using alcohol-soaked shot and a high-speed spark apparatus, Rayleigh was able to show photographs of a breaking soap film at the Royal Institution on February 6, 1891.

air. "The ground has been well-prepared for sets of systematic experiments made with useful forms of projectiles fired with various muzzle velocities." Boys incorporated these image techniques in his soap-bubble fixations. He photographed breaking soap films by piercing them with "a minute electric spark," "then a twenty-thousandth of a second or more later letting off the spark by the light of which it was taken. My electrical arrangements were akin to those by which I photographed bullets in their flight in one thirteen-millionth of a second, but my optical arrangements were similar to Lord Rayleigh's." Boys's enterprise with soap and bullets took him beyond the limits of Rayleigh's machinery, as these amazing numbers were supposed to demonstrate. So at the British Association meeting in Edinburgh in the summer of 1892, Boys took over Tait's professorial drawing room to show flash photos of bullets and bursting bubbles. He started with one of Rayleigh's spark images of a bursting bubble, its edge traveling at approximately 30 miles an hour. Then he switched to the photographs of bullets and their shock waves sent to London by Mach, and finished with graphic details of his new laboratory setup in South Kensington, where very fast spinning mirrors and high-powered Wimshurst machines had at last enabled him to master these transient phenomena. "I wish to conclude with a series of photographs which show how completely the method is under control, how information of a kind that might seem to be outside the reach of experiment may be obtained from the electric spark photograph, and how phenomena of an unexpected nature are liable to appear." Boys's efforts, starting with bursting bubbles and culminating in exploding shells and high-powered rifles, were reiterated in private discussions during the early 1890s with military ballistics experts on improved rifle design and better projectile systems. "If, as in other subjects, the first wish of the experimentalist is to see what he is doing, then in these cases surely, where

in general people would not think of attempting to look with their natural eyes, it may be worth while to take advantage of this electro-photographic eye." [38]

Work with bursting bubbles, exploding bullets, and high-speed sparks offered new eyes to a scientific culture entertained by the microphysics of ether and air, games with soap and suds, and the military-imperial implications of precision ballistics. Image machinery helped the commodification of entertainment and the physicists' campaign to fix transient things. In the autumn of 1894, the first kinetoscope parlors opened in London, boasting peep shows of films running at roughly forty frames per second viewed through magnifying lenses. Robert Paul, a clever electrical engineer from John Perry's Finsbury Technical College, began making these devices in London during 1895, then teamed up with Boys's former student H.G. Wells to patent "a novel form of exhibition whereby the spectators have presented to their view scenes which are supposed to occur in the future or the past, while they are given the sensation of voyaging upon a machine through time." The experience of time travel might become a viable commodity. In early 1896, Paul was showing his newfangled film projectors at Finsbury Technical College, then prestigiously at the Royal Institution. One publicist reckoned that "the fact that the display was given before one of the foremost scientific bodies in the world stamped it as being a development of signal importance." Paul's "animatograph" was a key agent in making cinematography part of the public market. When George Stokes, authority on fluid resistance, asked Boys for his images of supersonic bullets, the London experimenter sent prints of his "animatograph film" of explosions and projectile paths. The combination of cinematography and spark photography proved invaluable for the new physics of bursting and explosion. [39]

Another of Stokes's clients, Arthur Worthington, pushed the projects of Boys and Rayleigh to their iconic and military conclu-

sion. His interest in the shape of drops began early, when in 1875 his Rugby school friend Hugh Newall tried dropping ink onto sooty glass dishes and Worthington found more elaborate splash shapes using mercury. This childlike passion stayed important as he pursued maturer research. Worthington trained at Manchester, Oxford, and for a year in Hermann von Helmholtz's prestigious new physics institute in Berlin. During the 1880s, he became a science teacher in a Bristol school, read Plateau's work on bubbles, and attended Stokes's Cambridge lectures on fluid mechanics. He began researching bubble formation and asked Stokes for help on how best to pursue these trials professionally and to design better lecture experiments with soap droplets. Stokes commented on Worthington's early efforts to correct classical bubble theory using up-to-date Maxwellian energetics. At last the passionate schoolmaster became physics professor at the Royal Naval Engineering College in Devonport, whence he commuted to London to learn graphic techniques from his friend Rücker, then helped out Boys's lecture performances of 1889–1890 with drawings of bubble shapes on rubber sheets. Worthington was not yet master of the art of fixing images of this extraordinarily rapid phenomenon. He failed to photograph his youthful experiences with ink and mercury droplets. New soap techniques and spark discharges practiced in London helped him out. He trained himself to draw what he could see as droplets fell onto glass sheets illuminated by discharge from an induction coil. To act as a "natural historian of drops," he found, "some judgment is required in selecting a consecutive series of drawings of each stage...it is impossible to put together the drawings so as to tell a consecutive story without being guided by some theory." So Worthington concentrated on making a representative image of splashes and drops from the startlingly lit impacts he repeatedly watched in his naval workshop (figure 4.9). "The mind of the observer is filled

Figure 4.9. A.M. Worthington, "The splash of a drop followed in detail by instantaneous illumination," in "The Splash of a Drop and Allied Phenomena," *Proceedings of the Royal Institution* 14 (1894), pl. 7. By permission of the University Library, Cambridge. On May 18, 1894, at the Royal Institution, Worthington showed his drawings of "ideal splashes" made using rapid illumination of falling water droplets. "Such is the history of the building of bubbles which big raindrops leave on the smooth water of a lake, or pond, or puddle."

with an ideal splash — an *autosplash* — whose perfection may never be realized." In the spring of 1894, he came up to lecture at the Royal Institution on these ideal splashes. Worthington started to use Boys's and Rayleigh's techniques, with sparks drawn quickly from condensers rather than powerful induction coils. He did show his Mayfair audience a few blurred photographs, but for Worthington skilled judgment and theoretically informed drafts-manship were for the moment more reliable resources to fix the transience of drop shapes.[40]

Worthington shared with Thomson, Boys, and Rayleigh a wish to convince audiences that even in such seemingly random phe-nomena as drops and bubbles "we have to deal with an exquisitely regulated phenomenon." In 1895, he published his drop drawings in the same popular series, Romance of Science, as Boys's lectures on soap bubbles. He and his senior colleagues insisted the laws of energetics dictated the most variable shapes of these transient phenomena. Just as Thomson again lectured in Oxford on his clever models of the close stacking of molecules in seemingly chaotic foams and films, Worthington extended work on imaging drops and bubbles to reveal their "orderly and inevitable" behav-ior. "In these days of kinematographs and snapshot cameras it might seem an easy matter to follow even a splashing drop." It wasn't. At last, he managed to master the cinematographic tech-nologies to make these structures visible. By adapting the setup Boys used for bursting bubbles and spinning bullets, Worthington produced reliably repeatable illuminations from his condenser discharges of less than three millionths of a second. From 1897, he gradually released his new images to the public, first at the Royal Society, then through *Pearson's Magazine*, and eventually in a stunning book of photographs, *A Study of Splashes*. *Pearson's* was a populist journal devoted to astonishing its audience with up-to-date technology and imperial values. The magazine printed

Worthington's images alongside articles on dynamite factories, military uniforms, and the virtues of industry and cleanliness. Physicists made this connection, too. Boys had worked out how to use techniques for imaging bubbles to analyze military ballistics and show the laws they obeyed. As the military scientist Worthington closed his study of splashes, he, too, explained the advances of cinematography, how image machines had let "the student of hydrodynamics" realize the microphysical laws of fluid motion, and, as frontispiece and punch line, displayed "the splash of a projectile on striking the steel armour-plate of a battleship" (figure 4.10). The slippage from soapsuds to dreadnoughts via the law-like behavior of domestic commodities was complete.[41]

Conclusion: A Science Whose Business Is Bursting
Bubbles' aura as commodity was both fluid and useful to fix. In many late-nineteenth-century milieus, from theaters and laboratories to galleries and schoolrooms, the workings of suds, drops, and jets were made into transiently stabilized images of underlying principles. These manipulations mattered because their lessons and images could travel. Just as the Grosvenor Gallery and Pears's publicity helped Millais's visions journey overseas to colonized Africa or to belle epoque France, translations of British physics helped its materials abroad. Classical soap physics was taken as exemplary of the marketing of public science even, and perhaps especially, where its authority was most in question. In 1892 Boys's *Soap Bubbles* appeared in French translation by the standards physicist and future Nobel laureate Charles Guillaume. Thomson's *Popular Lectures and Addresses* was released in Paris the following year. Both texts were avidly read there by an impoverished young Breton writer desperately seeking entrance to the Ecole Normale Supérieure while penning strange literary essays for the capital's magazines. Alfred Jarry well understood the aims

Figure 4.10. Arthur Worthington, "Permanent Splashes," in *A Study of Splashes* (London: Longmans, 1908), frontispiece. As the frontispiece and conclusion of his study of liquid splashes, Worthington published these photographs of the result of a projectile hitting the steel armor plate of a battleship.

of classroom physics. In his Rennes lycée in 1888–1891, he pilloried his hapless physics teacher Hébert, transforming him eventually into a bestial figure, Ubu, whose violent artlessness challenged academic good order. Once in Paris, Jarry used his school experiences to formulate 'pataphysique, roughly to be translated as "not your physics," which he defined as "a science invented by ourselves and whose business is bursting." This new science made its appearance through Ubu in Jarry's very first article for the *Echo de Paris* in April 1893. He devoured works of Boys on bubbles, Thomson on the ether, and H.G. Wells on time machines. Struck by cinematography, new technological projects and Boys's provocative lesson that it was difficult "to write real and perfect nonsense," Jarry began to compose an entire treatise on the "science … whose business is bursting." In a cleverly titled section, "Ethernity," he imagined sending Thomson "telepathic letters" about the space-filling luminiferous ether, the vibrations of tuning forks, and the age of the sun. Jarry finished the work early in 1898, failed to get it published, and resignedly issued extracts in the *Mercure de France* in May of that year. He started with an essay dedicated "to my learned friend C.V. Boys," which explained how "capillarity, surface tension, weightless membranes," and, "more generally, the elastic skin which is water's epidermis" would allow his hero to build a boat 12 meters long made of a sieve kept afloat with a film of "250,000 drops of castor oil."[42]

Thus on both sides of the Channel, bubble markets were mixed up with mass science. An entire history of soap bubbles and their commodification could well be produced for the French as for the Anglo-Saxon tradition. It would include the eminent nineteenth-century chemist of candles and soap Michel-Eugène Chevreul and the caricaturist Grandville, whom Walter Benjamin perceptively described as "giving the entire universe the character of a commodity" and whose publications he labeled "the sybilline books

of advertising." In 1844, Grandville's *Another World* showed the secret of celestial mechanics: an aged wizard blows astronomical systems out of soap bubbles. Following Plateau, such bubbles were the stock-in-trade of popular Francophone physics, as in the best-selling *Monde Physique* (Physical world, 1882) of the fiercely republican scientist Amédée Guillemin (figure 4.11). These were important sources for Jarry's visions. It has been urged that in his writings on 'pataphysique, Jarry focused on the disquieting strangeness of physics, as though sifting the marginally entertaining from an otherwise sober enterprise. Not so. "I am of the opinion that one could reduce considerably the complexity of this luminiferous ether," he accurately paraphrased Thomson, "by substituting various systems of circulation of liquids of infinite volume through perforations in infinitely small solids." The science whose business is bursting perceptively reworked the premises of classical physics and its arts, seeing in a bubble "a globe through whose transparency the outlines of the universe appeared gigantically enlarged."[43]

In the hands of late-nineteenth-century physicists and entrepreneurs, the ephemeral bubble became a stock object of engineering, image making, and commerce. Techniques that could turn seemingly transient and unstable things into fixed and stable commodities were essential components in market capitalism. The same entrepreneurs who so admired cherubic bubble blowers were masters of the art of inventory investment, storing and preserving mutable things to make them valuable goods. This was a vital link between the warehouse and the cabinet. The tradition lived on, in powerful form, in the classical physics of bubbles, with its image machines and its science of bursting. Thus its master, Charles Vernon Boys, could offer his audience a history lesson on serious games with soap:

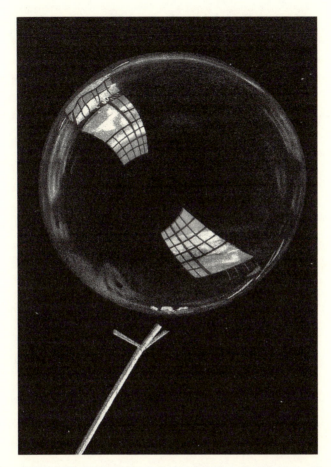

Figure 4.11. Amédée Guillemin, "La bulle de savon," in *Le Monde physique*, 2 vols. (Paris: Hachette, 1882), vol. 2, p. 298, pl. 6. By permission of the British Library (8705.f.28). "Who among us in his childhood has not amused himself with a pipe of straw and soap and water in blowing and throwing into the air bubbles of the most perfect form and the most delicate and varied colors?" Guillemin, leading secularist scientific popularizer of the Third Republic, already made this image the frontispiece of his *Phénomènes de physique* (1868), then republished in England by Lockyer as *Forces of Nature* (1872). The image represents the moment at which black spots appear on the bubble's surface just before it bursts.

I must ask you whether that admiration and wonder which we all feel when we play with soap bubbles has been destroyed, or whether now that you know more about them it is not increased. I hope you will all agree with me that the actions upon which such common and everyday phenomena as drops and bubbles depend, actions which have occupied the attention of the greatest philosophers since the time of Newton to the present day, are not so trivial as to be unworthy of the attention of ordinary people like ourselves.[44]

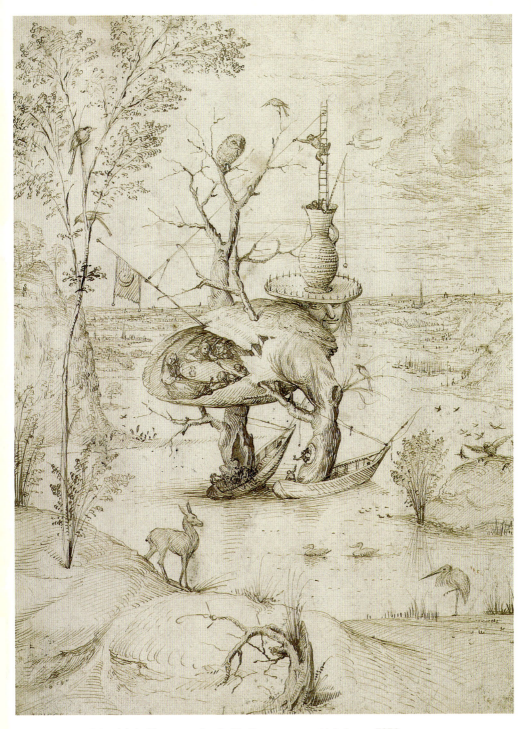

Color plate I. Hieronymus Bosch, *The Treeman*, pen and ink. Inv. nr. 7876, Albertina, Vienna.

Color plate II. Karl Blechen, *Das Innere des Palmenhauses*, 1832–1834, one of a pair. Inv. nr. GK I 5054, Staatliche Schlösser und Gärten, Potsdam-Sanssouci.

Color plate III. *Iris versicolor* L., glass model by Rudolph Blaschka, 1896. Botanical Museum of Harvard University. Courtesy of The President and Fellows of Harvard College. Photograph by Hillel Burger.

Color plate IV. Wax model of roses by John and Horatio Mintorn. Courtesy of the Royal Botanic Gardens, Kew.

Color plate VI. *Lathyrus magellanicus (Papilionaceae)* as shown at the French millennial exhibition in Avignon, glass model by Leopold and Rudolph Blaschka, Botanical Museum of Harvard University. Courtesy of The President and Fellows of Harvard College. Photograph by Hillel Burger.

Color plate V. *Cyanea capillata*, glass model by Leopold and Rudolph Blaschka, 1884. Courtesy of the Museum für Naturkunde der Humboldt-Universität, Berlin.

Color plate VII. Jackson Pollock, *Totem Lesson 2*, 1945, oil on canvas, 6 ft. x 60 in. (182.8 x 152.4 cm). National Gallery of Australia, Canberra. © 2003 The Pollock-Krasner Foundation / Artist Rights Society (ARS), New York.

Color plate VIII. Jackson Pollock, *Mural*, 1943, and 8b, detail, oil on canvas,
97¼ x 238 in. University of Iowa Museum of Art, Gift of Peggy Guggenheim.
© 2003 The Pollock-Krasner Foundation / Artist Rights Society (ARS), New York.

Color plate IX. George Grosz, *Tatlinistischer Planriss: Brillantenschieber im Café Kaiserhof*, collage and watercolor, 1920. Courtesy of the VG Bild-Kunst.

Res Ipsa Loquitur

Joel Snyder

Introduction

A Russian archaeologist friend once took the time to describe
to me the relations between the discipline of archaeology in the
USSR and the Soviet state security apparatus in the difficult days
of the late 1940s: a large team of archaeologists in Siberia discov-
ered the foundation of an ancient church dating back nearly a
thousand years to the origins of Christianity in Siberia. In a com-
partment at the deepest level of the foundation, they uncovered
a tomb, replete with bones that were identified via a partially
effaced inscription as those of a bishop. The archaeologists imme-
diately divided into two groups, one claiming the bones were
those of the region's first bishop, Saint Cyril the Lame, and the
other opting for the second bishop, Saint Demetrius the Martyr.
The debate grew heated, and finally the leader of the expedition
decided to pack the bones carefully and ship them to the best
forensic laboratory in the Soviet Union, the NKVD Laboratories
in Moscow. The large crate was sent to Moscow with a note:
"Comrades, can you determine if the enclosed are the bones
of St. Cyril the Lame, or St. Dmitri the Martyr?" Nearly six
months later, the chief of the expedition received a large envelope
from NKVD headquarters. When he opened it, he found a letter

cushioned by a large amount of white powder. The letter was direct and brief: "Comrade, we have finally made the identification you requested last summer; it is definitely Cyril." Delighted by the response but mystified by the lack of details concerning the method of identification, the director sent a brief inquiring telegram to the NKVD: "How do you know?" A responding telegram from the laboratory arrived a week later with a two-word response: "He confessed."

Granting a voice to inanimate things can strike us as torturing, perhaps even violating language. Some philosophers — I am thinking in particular of Saint Thomas Aquinas — locate the distinction between things and persons in what they take to be the unique human capacity to use language. Beings are human, according to Saint Thomas, if and only if they have the capacity to talk (and not merely to make sounds, like those made by macaques or cardinals). Every other kind of thing is not a human being. This neat division between persons and things is conditioned on a conception of language as more than a collection of sounds made in accordance with rules, although systems of syntax, semantics, and pragmatics are obviously at the heart of language.

In the past 125 years, inventors have produced a variety of machines that seem to talk — Edison's phonograph, the Dictaphone, tape recorders, the "talking pictures" — but these don't really talk; they play back what once were called "transcriptions" of human speech. These may be things that make intelligible human sounds, but they are not talking machines. It would be misleading to think of them as capable of repeating what we say.

At the outset of part 1 of *Philosophical Investigations,* Ludwig Wittgenstein asks us to "conceive...a complete primitive language game" consisting of only four words — "block," "pillar," "slab," "beam" — played by a builder and his assistant. We are to

imagine that in the course of their work, the builder calls out a word and the assistant brings the designated material. One of Wittgenstein's goals in this section is to show us that if we take the exercise seriously, we cannot, in fact, conceive of human beings whose entire language is limited in this way; the game he asks us to imagine can only be played by beings who already possess a language. We are supposed to wonder how, for example, the players could have learned only these four words and no others. From whom could they have learned them? How does language acquisition work, and what are the conditions of playing a language game? There have been times when perfectly pragmatic, not particularly poetic people have granted things the ability to talk, and not just a few words, but language as we use it. At such times, they are acting under compulsion; something about the way in which they think about some subject forces them to concede to things the capacity to talk. There was a time in the United States when lawyers inclined their ears and heard photographs talk. I will return later to the issue of photographs that talk.

Mechanical Copies of Nature

Published accounts of the invention of the daguerreotype — a process for making pictures described by the authors of the articles as wonderful, magical drawings or engravings — began to appear in popular journals in France, England, and the United States in February 1839, a few months before specimen daguerreotypes were finally made available for unrestricted display in Paris and the first details of the procedure were made public. These reports, based primarily on hearsay, described difficult-to-imagine marvels, "incredible" pictures that were hidden from the view of the writers. Despite the absence of direct evidence, the authors described things they had not seen and simultaneously attempted to locate daguerreotypy within the customary

vocabulary and categorical schemes routinely used by picture makers and critics of visual art.

In one of the earliest reports, an unnamed contributor to the *Spectator* published an article "gleaned principally from fragments of the report of M. Arago [to the French Academy of Sciences], quoted in the communications of the foreign correspondents of the *Athenaeum* and the *Literary Gazette,* and partly from private information":

> An invention has recently been made public in Paris that seems more like some marvel of a fairy tale or delusion of necromancy than a practical reality: it amounts to nothing less than making light produce permanent pictures, and engrave them at the same time, in the course of a few minutes. The thing seems incredible, and, but for indisputable evidence, we should not at first hearing believe it; it is, however, a fact: the process and its results have been witnessed by M. Arago, who reported upon its merits to the Academy of Science.[1]

What interests me particularly about this article is the way in which the correspondent, who refers to the daguerreotype as "a discovery the most remarkable in the history of art," begins by figuring the process as a means of enabling nature to "reflect and engrave her own face though but as 'in a glass, darkly,' and engraving it too, that we may have copies of it!" and then moves, I almost want to say "naturally," to characterize daguerreotypy as "mechanical":[2]

> This looks like superseding Art altogether; for what painter can hope to contend with Nature in accuracy or rapidity of production? But Nature has only become the handmaid to Art, not her mistress. Painters need not despair; their Labors will be as much in request as ever, but in a higher field: the finer qualities of taste and invention will be called into action more powerfully; and the mechanical

process will be only abridged and rendered more perfect. What chemistry is to manufactures and the useful arts, this discovery will be to the fine art; improving and facilitating the production, and lessening the labor of the producer; not superseding his skill, but assisting and stimulating it.[3]

The placement of daguerreotypy (and, a bit later, photography as a whole) within the realm of the mechanical has dominated discussions of photography from the beginning. What has been overlooked, however, is that the term "mechanical" had long been entrenched in the curricula of art academies and schools, was constantly referenced in artists' practice itself, and was standard fare in the discourse of art criticism. What interests me particularly, however, is the way in which the specific qualities identified by the term "mechanical" — those features that the word was meant to isolate and underscore — shift over time, for these alterations of meaning affect, in different ways, the sense of the general claim that photography is a mechanical method of depiction. I have no interest in correcting the historical record or in denying (or affirming, for that matter) the mechanical character of photography. What I would like to achieve is some clarity about the range of possible meanings of "mechanical" at various moments in the nineteenth century. A generalized, one-size-fits-all account of "mechanical" will only block an understanding of why, for example, the introduction of photographs as evidence was often challenged (at times successfully) in American courts of the 1860s and 1870s. Each side in these contests insisted on the mechanical character of photography but, arguing from this premise, reached opposing conclusions. I will return to this problem in the next section.

A significant portion of the *Spectator* article is aimed at "calming the apprehensions of the more humble class of artists," fears

rooted in persistent rumors emanating from Paris that the da-
guerreotype would drive them out of business. But in addressing
this pressing concern, the author adopts terms from the vocabu-
lary of a centuries-long discussion among painters and critics
regarding the distinction between copying and inventing and from
a more recent debate about the aesthetic implications of using aids
to drawing — simple items like the Claude glass (a small slightly
convex, darkly tinted mirror), plane mirrors, prisms, and more
complex aids such as the recently invented diagraph or the ancient
camera obscura. The term "mechanical" is used in the journal
report in a way that echoes its use in then contemporary art prac-
tice, pedagogy, and criticism: it functions as a foil for artistic inven-
tion. When the author states, "the mechanical process will be only
abridged and rendered more perfect," he is referring not to the
perfection of daguerreotypes but to an improvement of the man-
ual skills of those artists who will study and copy them. "Mechani-
cal dexterity" — skill of hand — is a necessary (but by itself an
insufficient) condition for the production of art. Daguerreotypes
will provide artists with model copies that can in turn be copied
by hand (thus compressing the labor involved in copying directly
from nature), freeing them to concentrate on invention (or allow-
ing them to become better copyists). The author of the *Spectator*
report is not breaking new ground in underscoring the importance
and yet devaluing the mechanical aspect of painting; he follows
an old distinction, popularized by Sir Joshua Reynolds (one that
became canonical in the United Kingdom) in his *Discourses on Art,*
between the mechanical and the intellectual/imaginative compo-
nents of painting. This is a use of the term "mechanical" that,
though now nearly obsolete, was in widespread use (and not only
in the context of painting and drawing) well into the late nine-
teenth century. In this sense, the term "mechanical" is synony-
mous with "manual" (or, at times, "corporeal"). The mechanical

trades were the manual trades, and a mechanic was not someone who worked on machines but someone who earned his living by the skill of his hands or simply through bodily labor.

Reynolds's *Discourses on Art* can usefully be understood as a series of lectures aimed at distinguishing the mechanical element of painting from its peculiarly artistic component. In the hands of an ungifted painter, the mechanisms of painting amount to little more than the ability to repeat the rules of correct drawing through the disciplining of the hand and the education of the eye, each achieved by the endless, monotonous, step-and-repeat operations involved in the copying of plaster casts, engravings, paintings, and human models.[4] The results of mechanical drawing are pictures precisely representing the details of their subjects in all their particularity.

In discourse 1, Reynolds criticizes student artists who concentrate on developing "a lively, and what is called a masterly, handling of the chalk or pencil.... Whilst boys, they are arrived at their utmost perfection; they have taken the shadow for the substance; and make the mechanical felicity, the chief excellence of the art, which is only an ornament."[5] The concluding discourse opens with the following lines:

> It has been my uniform endeavor, since I first addressed you from this place, to impress you strongly with one ruling idea. I wished you to be persuaded, that success in your art depends almost entirely on your own industry; but the industry which I principally recommended, is not the industry of the HANDS, but of the MIND. As our art is not a divine gift, so neither is it a mechanical trade.[6]

As Reynolds has it, mechanical work in drawing and painting is always the activity of copying, whether the subject copied is a painting by an acknowledged master, a figure, or even a landscape.[7]

A copy is an exact and precise representation of its model; the copy contains no new ideas; it is governed by the rules of mechanical work embodied in the hands and eyes of its maker. "Mechanical," then, applies both to the qualities of a picture (its precise delineation of the subject in all its particularity) and to the skills of hand that produced it.

To call daguerreotypes mechanical is to say they are correct, particular, and precise in their details; it is to qualify them as copies of some thing or group of things. The machinery of photographic production is in no way central to this use of "mechanical."[8]

For the author of the *Spectator* report, the differences between mechanical copies executed by hand and those done by means of the daguerreotype process are, nonetheless, remarkable. Daguerreotypes of stationary objects under proper conditions of light and in the appropriate weather can provide "accuracy of form and perspective, a minuteness of detail, and a force and breadth of light and shade, that artists may imitate but cannot equal." The superiority of daguerreotypes to copying by hand — "the precision and accuracy of their effects — is explained by the author's unsupported and, to me, somewhat mysterious claim that no "painter can hope to contend with Nature in accuracy" or in the speed of production.[9]

It might seem, then, that the excellence of the daguerreotype, in respect to accuracy and precision of detail, is a direct result of the chemical, "self-operating" character of the process, but the author allows that these pictures are not always mechanical copies — things or persons in motion may be "imperfectly represented" — even though the process is always self-operating:

> As it is the continued stream of light that acts upon the metal, fixed objects only can be delineated: "the foliage of trees," again to quote M. Arago, "from its always being more or less agitated by the air, is

often but imperfectly represented. In one of the views, a horse is faithfully portrayed except the head, which the animal had never ceased moving: in another, decrotteur (shoe-black), all but the arms which were never still."[10]

It is stunning that the written reports of the first exhibitions of daguerreotypes, in July 1839, and, a month later, of the official announcement of the details of the process did not significantly differ from earlier articles based entirely on hearsay. Daguerreotypes continued to be modeled on copy engravings or drawings, and the process remained characterized as mechanical; it is figured in the *Spectator* article as an engraving made by nature of her own face, so "that we may have copies of it."[11] Daguerreotypes are copies of nature, but all well-made copies are mechanical. The agent in daguerreotypy is nature figured as a mechanically dexterous engraver, and the skill is the production of a mechanically engraved plate.

This explanation seems clearly metaphoric, but the terms are drawn from the practices of picture makers and are not deployed as substitutes for material explanations based on the machinery of the camera and the natural laws of chemistry and optics. This reliance on the vocabulary of pictorial practice is a persistent if not pervasive feature of photographic literature from the moment of invention until well into the 1870s. For example, W.H.F. Talbot dubbed his first invention "Photogenic Drawing," and his second "the Calotype Process of Photogenic Drawing," and figured his camera negatives as copies and his prints as copies of copies, and titled his first book illustrated by photographs *The Pencil of Nature*. Photography continued to be figured as a means of making drawings well into the 1870s, but it was obvious to anyone who reviewed the process that the photographer was not the delineator. Writers on photography (including photographers themselves)

produced a charming account of the process in which there was a curious division of labor between the photographer and the sun: the photographer's job was to prepare the sensitive materials (and this could be done well or poorly), but it was sunlight that drew the picture. And it was an easy step to move from this distribution of tasks to the personification of the sun as artist and from this figure to the idea that the sun was both observer and depicter (figure 5.1).

I have been suggesting that the characterization of the daguerreotype as "mechanical" can be seen as an extension of the vocabulary of artistic education and practice, in which manual dexterity, as it related to copying, was portrayed as mechanical and was opposed to the intellectual or imaginative component of visual artistry. The claims, made from 1839 through the late 1850s, about the mechanical character of daguerreotypy and then of photography need to be understood as attempts to assimilate photographic production into the habits of artists and illustrators, regarding the production of pictorial copies (and specifically not in respect to the production of art).

By the late 1850s, the products of photography had lost most of their tinge of the "prodigious" and had come increasingly to be viewed as commodities — the useful products of commerce, technology, and science. This relatively rapid passage from prodigy to something not out of the ordinary is a striking feature of what we now think of as modernity, but equally arresting are the terms in which photographs were transformed from precious fairy-tale marvels into just one among many kinds of things produced for a rapidly expanding popular culture. The change in response to photographs — their exit from the realm of the extraordinary and entry into the world of the everyday — was achieved through the rapid commercialization of photography and the proliferation of photographs throughout Western societies.[12]

Figure 5.1. Advertisement for the studio of Southworth and Hawes, Boston, 1854.

The discovery in 1840 of means to "accelerate" daguerreotype plates led immediately to daguerreotype portraiture and the establishment of portrait studios for the taking of "likenesses." The demand for cameras, improved lenses, and the various raw material of daguerreotypy led in turn to the formation of networks of manufacturers who produced thousands of items sold centrally through photographic supply houses.[13] By the 1850s, the wet-plate collodion process, a variation of Talbot's calotype process, had overtaken the daguerreotype, and paper prints had come to dominate photographic production. Photographs were assigned comfortable, unremarkable places in the home: on the mantelpiece; behind frames on living room walls; in parlors, where they were kept in family albums; and in wooden boxes that sat beside stereopticons. Photographers' practices were shaped primarily by sales to the aspiring middle and established upper classes, through the production of portraits for clients who were often subjected to steep climbs to the sky-lit top floors of photographic studios and through the manufacture of immense collections of stereographic cards that gave a glimpse of distant cities, exotic worlds, and natural wonders, illustrated the course of empire, and often provided models of bourgeois modes of dress or home furnishings for those who aimed at acceptability in middle-class society. The history of photographic practice began with the annual production of relatively small numbers of daguerreotype plates and paper prints (in the early 1840s), but by the 1850s photography was becoming an industry of large and small studios (some of which flourished while others remained in a perpetual state of near bankruptcy), photographic publishing houses, supply houses, trade journals, and tens of thousands of low-wage photographic-print makers, mostly women and children, on both sides of the Atlantic. The division of labor in large firms was rigid: there were darkroom assistants, camera operators, negative "doctors," print

exposers, print processors, and print mounters, in addition to managers, accountants, and the entrepreneur, whose name was embossed under each finished print. In small studios, one or two people handled all these operations. Photography was primarily a picture-making business aimed at maximizing profits and was hardly engaged with issues that preoccupied painters and graphic artists. Whereas some of the first generation had notions of pictorial effect that, when successfully imitated, brought their pictures into conformity with those of skilled artisans in the older graphic media, the following generation was devoted to establishing the differences between photographs and handmade pictures. Starting in the 1850s, photographers adopted means of imparting a high gloss to the surface of their prints (and this gloss increased dazzlingly in the decades that followed) to maximize the articulation of details carried in the negatives and to increase the overall contrast of the pictures, but also to give them the look of mass-produced, machined products. These prints, with their "inhuman finish," were nonetheless made painstakingly and entirely by hand.

Although photographs had achieved remarkable currency by the late 1850s, there seem to have been no attempts to provide positive analyses of the new picture-making medium. Discussions of photography continued to be framed in terms of the comparison to handmade pictures in words drawn from the vocabulary of the pictorial arts. In the spring of 1857, Lady Elizabeth Eastlake, an occasional writer on the subject of art and the wife of Sir Charles Eastlake, president of the Royal Academy, addressed the subject of photography in an essay published in the *Quarterly Review*. "Our chief object at present," she wrote, "is to investigate the connection of photography with art — to decide how far the sun may be considered an artist, and to what branch of imitation his powers are best adapted."[14]

The very success of photography, the exponential increase in the number of photographs produced annually, provoked Eastlake into fashioning an argument directed against the increasing tendency (among the unschooled, or the anesthetic) to confuse photographs with works of art. "[Photography] is made for the present age," she writes, "in which the desire for art resides in a small minority, but the craving, or rather necessity, for cheap, prompt, and correct facts in the public at large."[15] Photography's popularity with the broad public and its appeal as an avocation even to the well educated and well heeled required a blocking maneuver, one that would permit the classification of photographs as pictures while preventing, once and for all, their celebration as works of art.

Eastlake's subtle and complex argument rests on her characterization of visual art as being carefully coordinated with "our experience of Nature."[16] A work of art represents the imaginatively constructed experience of an artist and is addressed to an audience responsive to such depictions. Eastlake assumes that the properties of vision — the ways in which things appear to a sensitive viewer — constitute something like the conditions of visual art. Although photography can, like painting, delineate nature, it cannot produce pictures that accord with "our experience of Nature."

This separation of photography from art requires a doubling of terms: for example, there is truth-to-nature (facts) and truth-to-nature-as-experienced-by-an-artist (art), and the gap between the two is unbridgeable. Photography can produce "cheap, prompt, and correct facts," but photographs cannot be works of art: "Correctness of drawing, truth of detail, and absence of convention, the best characteristics of photography, are qualities of no common kind, but the student who issues from the academy with these in his grasp stands, nevertheless, but on the threshold of art." This is, of course, a restatement of Reynolds's position on the relation of mechanical skills to the production of art. But in this context, it is

more than a simple iteration; it underscores the difficulty of sepa-
rating claims about the mechanical (machine) character of pho-
tographs from those concerning the mechanical qualities of copies
in general (whether produced by hand or by machine), and East-
lake herself has difficulty keeping the two separate:

> Far from holding up the mirror to nature, which is an assertion usu-
> ally as triumphant as it is erroneous, [photography] holds up that
> which, however beautiful, ingenious, and valuable in powers of
> reflection, is yet subject to certain distortions and deficiencies for
> which there is no remedy. The science therefore which has devel-
> oped the resources of photography, has but more glaringly betrayed
> its defects. For the more perfect you render an imperfect machine
> the more must its imperfections come to light: it is superfluous
> therefore to ask whether Art has been benefited, where Nature, its
> only source and model, has been but more accurately falsified. If the
> photograph in its early and imperfect scientific state was more con-
> sonant to our feelings for art, it is because, as far as it went, it was
> more true to our experience of Nature.[17]

The "distortions and deficiencies" Eastlake mentions relate to the
harsh contrast of many photographic prints and to a peculiarity
of the photographic processes then in use, which were primarily
sensitive to blue radiation and, as a consequence, failed to register
the equivalent monochrome values of all other colors. One result
of this spectral insensitivity is that in order to provide a robust
exposure of a green landscape, cloud-filled blue skies must be
massively overexposed and appear, therefore, as blank white areas
in the finished print.[18] Eastlake might have added that the blond
hair of a subject sitting for his photographic portrait fails to have
any effect on the plate and appears, consequently, as a black mass
in the final print and that red freckles register as black dots. These

constitute distortions and defects in Eastlake's view because they are at odds with "our experience of Nature" and with the ways in which painters represent these experiences.

Eastlake locates the distinction between the mechanical and the artistic aspects of painting in the "free-will" of the painter — in the artist's power of selection and rejection, emphasis, deletion, and so on. The distinction is again between copying and interpreting. But photography does not permit interpretation; it demands "obedience to the machine."[19] And so the machinery of photographic production functions as a foil for artistic production. A work of art is "the marriage of [the artist's] mind with the object before him," it is "half stamped with his own features, half with those of Nature," while photography is capable of nothing more than "literal, unreasoning imitation." Because of its dependence on machinery, photography cannot be used to produce art; its value to society is that it is the "sworn witness of everything presented to her view." The realm of photography is the domain of the mechanical, and the virtues of the machine are not human virtues. Machines are incapable of having experiences and so cannot represent them; what they can do is passively copy nature, but these copies, though faithful to nature as it is, are not true to nature as experienced.[20] This double characterization of photography as mechanical — in its apparatus and materials and in the way its products look (they look like copies of their subjects) — is further complicated by Eastlake's understanding of "obedience to the machine." It would be wrong, for instance, to conclude that because photography is mechanical (in the sense of its reliance on machinery), it is therefore predictable, its results automatic or inevitable. One important and overlooked feature of Eastlake's account is her emphasis on the mysterious unreliability of photography. Despite the best efforts of photographers, the processes can fail completely and unaccountably:

You go out on a beautifully clear day, not a breath stirring, chemicals in order, and lights and shadows in perfection; but something in the air is absent, or present, or indolent, or restless, and you return in the evening only to develop a set of blanks. The next day is cloudy and breezy, your chemicals are neglected, yourself disheartened, hope is gone, and with it the needful care; but here again something in the air is favorable, and in the silence and darkness of your chamber pictures are summoned from the vasty deep which at once obliterate all thought of failure. Happy the photographer who knows what is his enemy, or what is his friend; but in either case it is too often "something," he can't tell what; and all the certainty that the best of experience attains is, that you are dealing with one of those subtle agencies which, though Ariel-like it will serve you bravely, will never be taught implicitly to obey.[21]

Here Eastlake repeats the endless complaints of legions of photographers whose manuals were filled with long sections dealing with unaccountable failures of the process, sections that carried titles like "Manipulation Miseries." Photography seems to have its own Cartesian demon, its own spirit inexplicably toying with the rules of the craft, or abandoning them altogether. Eastlake is faithful to the complaints of photographers and to their capitulation to "those subtle agencies" that often confound explanation and make remedial action impossible. Her invocation of Ariel, Prospero's faithful but willful spirit, is itself confounding: Ariel serves bravely but "will never be taught ... to obey." And yet photographers, who are subject to similar willful agencies, are in Eastlake's account thoroughly constrained by "obedience to the machine." It seems that the machinery of photography must be obeyed even though it is often disobedient, subject to chaotic, unknowable forces.

Nonetheless, it might seem that Eastlake's views, to the extent

they place emphasis on the machinery of photography, are more or less in compliance with more modern accounts of photography that aim at explaining photographic picture making by reducing it to a series of cause-and-effect operations said to be at the core of photographic production. But while she does invoke "obedience to the machine" to describe what cannot be done with photography, she does not locate depictive agency in the apparatus and materials of the process, or in the relations between them and the things represented in photographs. The machinery does not delineate the picture and neither does the photographer. The pictorial agent in photography is the sun: "Before [the invention of photography] little was the existence of a power, availing itself of the eye of the sun both to discern and to execute, suspected by the world."

The recurrent declarations that the sun, not the photographer or the sensitized materials, is the pictorial agent in the production of photographs can (and often does) strike modern readers as little more than a quaint way of saying the obvious: photographs are produced by the action of light. But the repeated identification of the sun as the depictive power in photography and the steadfast refusal to grant pictorial agency to the photographer suggest that the persistence of (what is often taken to be no more than) a figure of speech is easier to dismiss than to explain. The problem originates in the perfectly justifiable expectation that a picture of any kind must be drawn or sketched. But where is the depictive power to be located in photography? What (or who) draws the picture? As Eastlake describes the process, it is the job of the photographer to produce the photosensitive materials and to allow light into the camera, but it is the task of the sun to *draw* the picture.

Eastlake oscillates between two distinct ideas of the mechanical in order to explain why photographs cannot be works of art,

but she is unable to maintain a clear distinction between a sun-drawn copy and one made by hand. Near the end of the essay, she says:

> For everything which Art, so-called, has hitherto been the means but not the end, photography is the allotted agent — for all that requires *mere manual correctness, and mere manual slavery,* without any employment of the artistic feeling, she is the proper and therefore the perfect medium.[22]

Throughout the first three decades of its practice, photography was thought to be inescapably integumental; capable only of producing copy pictures of the immediately visible, first surfaces of things; it was constrained to deal with the superficial. For all the claims that photographs were mechanical in either sense — as precise, accurate copies of the visible, or as the products of machines — photographers routinely complained about sitters who abhorred their portraits and refused to pay for them, and sitters, for their part, criticized photographers for failing to provide accurate likenesses of them or their families. Police chiefs in New York and London complained about the relative uselessness of pictures in rogues' galleries as aids in the identification of suspected felons; geologists groused about the failure of photographs to mark distinctions between reddish and yellow-brown strata in rock samples photographed in the field; and the staffs of American geological expeditions grumbled about the uselessness of photography for topographical work. The rage photographers felt at times with the perversity of their materials was neatly summed up in the title of an article published in 1865 in a popular American photographic journal: "The Total Depravity and Gymnastics of Inanimate Things Photographic."[23]

Talking Pictures

It is difficult to know whether or not the personification of the sun as the delineator of photographs was intended by writers like East-lake to be taken seriously as an explanation of photographic representation, but this way of explaining photographic origination raised questions in American courts of law in the 1860s and early 1870s about how photographs could function as legal evidence. During that time, attempts to enter photographs into evidence resulted in challenges to their admissibility by opposing counsel. The possibility of changing the status of, say, a portrait photograph from a picture made for personal use to one that could provide public testimony required reconsidering commonly held opinions about the nature of photographic representation — opinions that were oppositional and fragmentary.

Photographs received sparing use in courts of law in France, Germany, England, and the United States starting in the late 1850s, often for the purpose of identifying claimants as the rightful heirs to estates but also for verifying the authenticity of signatures.

In a famous American case, the *Howland Will* Case (1870), in which the plaintiff (successfully) used photographically copied specimens of a signature as the foundation of his case, the defense attorney demanded to know how a photograph could serve as evidence at all. In his concluding summary statement, he dangled a photograph in front of the jury and exclaimed: "It is nothing but hearsay of the sun."[24] By granting the photograph the power of speech, the lawyer was simultaneously denying its admissibility as evidence: hearsay is inadmissible as evidence in courts of law in the United States.[25] The photograph talked, but, according to the outraged lawyer, its talk did not satisfy the rules of court-sanctioned speech. What it did provide was secondhand testimony, from the point of view of the law, mere chatter — talk about talk, the reliability of which is indeterminate

In what way is a photographic portrait, or a photographic copy of a signature, comparable to gossip? The lawyer's complaint about the photograph of the signature is contingent on the supposition that a photograph repeats what the sun says. This complies with one old legal formulation of hearsay: the photograph is "a statement made out of court by someone who is not the original source [that is, someone who is a nonparty witness], offered for the truth of the matter asserted." The idea, then, is that the sun witnesses a signature and makes an assertion about it (the photograph *is* the statement) *out of court*, and accordingly the statement is necessarily inadmissible. A photograph stands to the facts it asserts in the way a hearsay report stands to the claims of a person who has no place as a witness in a legal action. Everything here turns on the allocation of a witnessing capacity to the sun and on its ability to make assertions. But the sun only makes out-of-court statements, which by the rules governing hearsay cannot be subjected to tests in court. Moreover, the lawyer could allow for the possibility that the photograph in question was thoroughly accurate, just as it is possible that other forms of hearsay might accurately repeat a secondhand report and that *that* report might itself be an accurate account of a matter of alleged fact before the court. The problem is that there is no way to test the reliability of the photographic "statement" because there is no way to cross-examine the photographic picture drawer.

This discussion may seem like a great amount of fuss to make over an innocent figure of speech, but there were real issues here concerning a mismatch between photographic pictures regarded as reports or testimony and the confining, either/or character of a legal system entirely dependent on the distinction between direct evidence and hearsay testimony. But there is another question as well: What was it about the notions of photography then in circulation that ruled out the photographer as the picture maker? Why

was it that the sun or nature or, as we will see in a moment, the apparatus and materials of photography — why were they routinely figured as the depictive agents and not the photographer? But for the habit of identifying photographic agency with, say, the sun, photographs could not have been considered hearsay. Sketches or diagrams made by hand could be and often were offered in evidence without objection; cross-examining the picture maker could test their reliability.

The theory of those lawyers who argued against the admissibility of photographs requires the sun to be granted the ability to make intelligible statements (in the form of photographs). But whenever the sun speaks, it does so out of court, and accordingly its assertions are inadmissible as evidence. *Res ipsa loquitur*, yes — but never in court. This is functionally equivalent to ruling that photographs are inherently unreliable.[26]

Unanimity about the legal standing of photographs in American courts was not achieved until the 1880s, and objections to their admission as evidence prior to that decade were hit-and-miss affairs — they were effective in some courts and failed in others. Photography, when addressed in general terms, was, in some way, an unsettling, troubling thing despite its quotidian status. The persistent identification of the sun as the photographic agent and its recurrent personification, its ability to talk, are one index of the difficulty people, even relatively sophisticated lawyers, had with the subject.

Arguments favoring the admissibility of photographs as legal evidence were predicated on the special relations photographs were said to have with the things we see. Prior to the late 1870s, photographs were rarely thought of as capable of revealing "hidden" aspects of things, or of providing evidence of matters invisible to the eye. Photographs submitted as potential evidence in courts of law were understood by those who presented them to

216

be pictures representing what anyone might have seen when looking at the object or person depicted at the time of the photographic exposure. Studio-made family-album portraits were used, for example, to assist in the identification of persons who claimed to be the long-absent but rightful inheritors of large estates. The belief in a special relation of photographs to the visible world provided the crucial premise for arguments favoring the admission of photographs into evidence.

In 1869, a lawyer practicing in upstate New York, who identified himself with the initials J.A.J., published an essay in which he addressed the issue of the admissibility of photographic evidence, denying that photographs should be treated as hearsay and arguing in favor of admitting them as direct evidence — in fact, as the strongest form of direct evidence. He wrote:

> Is a photograph, considered as a narration or delineation of facts, a piece of hearsay, or of original and direct, evidence...? In identifying a person a witness is produced and required to compare the person presented for identification with him with whom he is sought to be identified, as the latter remains pictured in the witness's mind; that is, with the conception or image of him existing in his "mind's eye." So, if the identification be of one physical object or place with another; the same act of comparison of the thing presented with a mere mental image or idea of it, is required of the witness.... The testimony of a witness comparing a person present with the remembered image of a person absent, is, in all its parts, original evidence. Ought we then to rank as secondary evidence either of the three elements of the process of identifying a person by his photograph, which follow, namely, 1. The establishment by proof of the genuineness of the photograph; 2. The statement or narration of facts made, if I may so say, *by the picture itself*; and, 3. The comparison, by witnesses, or by a jury directly, of the person offering himself, with that picture....

At first view, doubtless, a photograph seems a mere piece of hearsay evidence. It is what the witness vouching for its genuineness says, the photographic apparatus, acting in conjunction with sunlight and chemical reagents at the time of taking it, affirmed to be an accurate likeness of the person who sat for it. It differs from hearsay, however, in one essential particular; it is wholly free from the infirmity which causes the rejection of hearsay evidence, namely, the uncertainty whether or not it is an exact repetition of what was said by him whose testimony is repeated by the witness. In the picture we have before us, at the trial, precisely what the apparatus did say. Its language is repeated to us, syllable for syllable....

If I am correct in this, a photograph proved to be that of a person absent is that person himself, precisely as he exists in that article of vision — is, therefore, direct and original evidence of the kind of man he was. So, of the photographic likeness of any natural object or place. When shown to be the photograph of the place or object, it is original — that is, legally speaking, the best — evidence of its features and relations; as much so as the testimony of a witness speaking from memory of the same features and relations.[27]

J.A.J.'s argument begins with a psychological account of the way in which a witness routinely identifies people. The idea here is that every act of visual identification requires the comparison of what we see with a recalled mental image; recognition is based on matching what we see against a remembered image. J.A.J. then turns to the issue of the veracity of photographs and argues that the agents in photography — sunlight, chemical reagents, and the photographic apparatus (the photographer still remains out of the picture, as it were) — speak and speak truthfully. This formulation is then condensed: "In the picture we have before us, at the trial, precisely what the apparatus did say. Its language is repeated to us, syllable for syllable." And suddenly we have a chorus of things that

218

talk — light, chemicals, cameras, and the photograph itself — all of which do so, presumably, in unison and, perhaps, in harmony.

The final move in J.A.J.'s argument is to insist on the special relation of photograph to vision: "[A] photograph proved to be that of a person absent is that person himself, *precisely as he exists in the article of vision.*" Photographs can talk in court because they not only tell the truth but tell it better than eyewitnesses, who must rely on evanescent mental images in order to make identifications. J.A.J. does not explicitly invoke the camera-eye analogy, but his identification of the photographic portrait with the subject as he is seen recalls the old claims about photographs as mechanical copies of nature carefully observed. He may, in fact, be invoking the camera-eye analogy because it was very much in the air at the time, thanks to the speculation of Heinrich Kuehne in 1868 that the last thing seen by a person at the moment of death is impressed photographically on the retina and might be retrieved via chemical means.[28]

A judge of the Texas Appellate Court in an 1877 ruling relied explicitly on the camera-eye analogy in his opinion favoring the admissibility of photographs into evidence by arguing that all witnesses at all times have necessarily based their testimony on photographs:

> Every object seen with the natural eye is only seen because photographed on the retina. In life the impression is transitory; it is only when death is at hand that it remains permanently fixed on the retina. Thus we are secure in asserting that no witness ever swore to a thing seen by him, without swearing from a photograph. What we call sight is but the impression made on the mind through the retina of the eye, which is nature's camera.[29]

According to the judge, the photographic character of vision itself justifies, as nothing else could, the introduction of photographs

into evidence. He effectively converts photographs into eyewitness testimony (the relation is symmetrical: eyewitness testimony is based on photographs). This alignment of photography with vision was possible only as long as photographs could plausibly be construed as limited to the realm of the visible. With the advent of highly photosensitive emulsions and instantaneous exposures (which were soon brought to the attention of the public), it would no longer be possible to view photography as corroborating vision, as limited solely to the realm of the visible.

It might seem that an understanding of vision as being of the nature of a photograph would bring an end to all the talk about talking things — sun, apparatus, chemicals, photographs — and in a way it did. But it did not put an end to the linguistic character of photographs. The appellate judge continues:

> Science has discovered that a perfect photograph of an object, reflected in the eye of one dying, remains fixed on the retina after death. (See recent experiments stated by Dr. Vogel in the May number, 1877 of *Philadelphia Photographic Journal* [*sic*: the *Philadelphia Photographer*].) Take the case of a murder committed on the highway: on the eye of the victim is fixed the perfect likeness of a human face. Would this court exclude the knowledge of that fact from the jury on the trial of the man against whom the glazed eye of the murdered man thus bore testimony? In other words, would a living eyewitness, whose memory only preserved the fleeting photograph of the deed, be heard, and the permanent photograph on the dead man's eye be excluded? We submit that the eye of the dead man would furnish the best evidence that the accused was there when the deed was committed, for it would bear a fact, needing no effect of memory to preserve it. It would not be parol evidence [akin to hearsay] based on uncertain memory, but the handwriting of nature, preserved by nature's camera.[30]

The judge relieved photographs of the capacity to speak, but their value as legal testimony continued to be contingent on their ability to communicate by way of language. Photographs lost their voice but achieved the status of truthful texts. And so photographs were transformed into legal documents by achieving the status of writing.

The Glass Flowers

Lorraine Daston

My father used to say,
"Superior people never make long visits,
have to be shown Longfellow's grave
or the glass flowers at Harvard.
Self-reliant like the cat —
that takes its prey to privacy,
the mouse's limp tail hanging like a shoelace from its
mouth —
they sometimes enjoy solitude,
and can be robbed of speech
by speech which has delighted them.
The deepest feeling always shows itself in silence;
not in silence, but restraint."
— Marianne Moore, "Silence"

Introduction: *Making Things Talk*

They seem wholly unremarkable at first glance: a stem of Alpine toadflax (*Thesium alpinum*) with tiny white flowers; a pine tree branch (*Pinus rigida*) with straggling needles and mottled bark; an iris (*Iris versicolor*) of deep violet, some of its blossoms already withered (color plate III). It could be a miscellaneous collection

223

of freshly gathered botanical specimens, displayed for some ec-
centric reason under glass. But there is nothing fresh, nothing
even vegetable, about these plants. And they are not just under
glass; they are made of glass. It is the triple triumph of art over
nature that annually draws over a hundred thousand visitors to
the Ware Collection of Blaschka Glass Models of Plants — or the
Glass Flowers, as they are known far and wide, in poems and nov-
els as well as tourist guides — at the Harvard Museum of Natural
History in Cambridge, Massachusetts. First, there is the triumph
of all artistic naturalism, the successful deception of the senses:
these glass models are more lifelike than the most painstaking
Dutch still life. Second, there is the triumph of enduring art over
ephemeral nature: it is the essence of the beauty of flowers to be
fleeting, but the blue delphinium blossom, even the half-yellowed
leaf, are frozen in time, like an insect in amber. Finally, there is
the triumph of form over matter, of artistry over the resistance of
natural materials: the sheer unsuitability of hard, brittle glass to
mimic the delicate fronds, soft petals, veined leaves, fleshy fruits,
and thready roots of plants turns these models into wonders.
What would be ordinary in nature becomes extraordinary in art.

The collection of 847 life-size models of over 750 species and
varieties of plants is unique in the world, the work of two Dresden
craftsmen, Leopold Blaschka (1822–1895) and his son Rudolph
Blaschka (1857–1939), who in 1890 signed a contract with the
Harvard botanist George Lincoln Goodale "to make glass models
of plants, flowers, and botanical details, for Harvard University in
Cambridge, Massachusetts, exclusively and to engage in the manu-
facture of no other glass models" for the annual sum of eighty-
eight hundred marks over ten years.[1] Ultimately, the Blaschkas
(after Leopold's death in 1895, Rudolph alone) labored for some
fifty years (1886–1936) to produce the Harvard collection, which
was financed by Elizabeth C. Ware and her daughter Mary Lee

Ware in memory of Dr. Charles Eliot Ware, Harvard class of 1834.[2] Mary Lee Ware had attended Professor Goodale's botany lectures and over the years befriended the Blaschkas, visiting them at their workshop-home in Hosterwitz, near Dresden.[3] Over decades — before and after the First World War, during the hyperinflation of the early 1920s, after Adolf Hitler's rise to power in 1933 — the Glass Flowers made their well-packed way from Hosterwitz in Saxony to Cambridge, Massachusetts, financed by the ever-loyal and ever-generous Miss Ware.

What kind of things are the Glass Flowers? Much of their fascination derives from their unclassifiability — itself a paradox, since they were made and are still displayed in order to demonstrate post-Darwinian phylogenetic botanical classification.[4] They are at once undeniably artificial and flawlessly natural, in the tradition of mimesis that extends back to Pliny's story of the competition between Zeuxis and Parrhasius and includes not only illusionistic painting but also reptiles cast in bronze, Palissy ware, and automata.[5] In all these simulacra, artifice severs the usual connections between form and matter: the curtain Zeuxis attempts to draw is made of paint, not fabric; the innards of the Vaucanson automaton are made of metal and leather, not flesh and blood; the petals and leaves of the Glass Flowers are made of glass, not cellulose and chlorophyll. Matter does not matter. The naturalism is only skin-deep, an effect of pure appearances. Though the actual deception of appearance taken for reality lasts only for a moment, the pleasure of potential deception lingers long.[6]

But the Glass Flowers were intended to have a closer connection with nature than these other delightful counterfeits. The botanists who commissioned them and the artisans who fashioned them described them from the outset as "scientific models" to be used for botanical instruction along the most advanced lines, as these were conceived at the turn of the twentieth century. Under

this description, the verisimilitude that is called illusionism in art becomes scientific accuracy. Yet once again the classificatory label hangs askew. Most scientific models aim to lay bare the essential principles according to which this or that domain of phenomena operate: an orrery shows the arrangement of planetary orbits in the solar system but does not look like the solar system; the hydraulic model of supply and demand does not look like the market.[7] Metaphorically, one might say these models are anatomical, penetrating beneath appearances, whereas the Glass Flowers remain gloriously epidermal.

The Glass Flowers were not the only such "epidermal" models made in the late nineteenth century; scientists also ordered scores of exact replicas of, for example, embryos and sponges.[8] But even circa 1900, there was something distinctly odd about botanists' indulging in this taste for appearances exquisitely mimicked. Since the illustrated herbals of the mid-sixteenth century, botanists had striven to represent the species type of plants in the images that accompanied their verbal descriptions. These illustrations were usually composites drawn from several exemplars of the same species, so as to capture the characteristic aspects of the plant by filtering out idiosyncratic details that could hinder identification of a specimen in the field. As the German botanist Matthias Jacob Schleiden preached in his influential 1842 textbook, the goal of both observation and drawing in scientific botany was to fuse particular facts and visual impressions about plants into a "perfect and complete view [*Anschauung*]," to know what to overlook.[9] In collaboration with the illustrator Isaac Sprague, the Harvard botanist Asa Gray (Goodale's immediate predecessor) attempted to represent not just a species but an entire genus by a single image in his *Genera of the Plants of the United States* (1848–1849) (figure 6.1).[10] Hence nineteenth-century botanists were skeptical about image-making procedures like

ANEMONE.

Figure 6.1. *Anemone pennsylvanica*, for the genus *Anemone*, order *Ranunculaceae*, from Asa Gray, *Genera florae Americae borealiorientalis illustrata. The Genera of the Plants of the United States Illustrated by Figures and Analyses from Nature by Isaac Sprague*, 2 vols. (Boston: J. Munroe and Company, 1848–1949), vol. 1, pl. 4.

the *Naturabdruck*, in which plants left imprints on specially pre-
pared paper, and the photograph, both of which registered the
specifics of the individual plant at the expense of the general
type.[11] Latter-day botanists seem embarrassed by the collection,
which is too faithful to misleading appearances even — perhaps
especially — to teach students how to pick out the essential mor-
phology of plants.[12] Wherein lay, then, the scientific utility of the
meticulously detailed Glass Flowers, with their yellowed leaves
and wilted blossoms?

Although botanists now shrug their shoulders over the Glass
Flowers, the models are not friendless. To send a note of inquiry
concerning the Blaschka models (including those of marine inver-
tebrates made before they embarked on the Glass Flowers) is to
become quickly enmeshed in an international network of high
connectivity. Start at any one node, and you are very soon linked
up to other aficionados. The models inspire the kind of keen inter-
est that solidifies far-flung devotees into what the critic Miguel
Tamen has called "formal and informal societies of friends of
interpretable objects."[13] The objects in question may be novels by
Samuel Richardson, agates, Byzantine icons, or ancient Etruscans
— anything or anyone who cannot speak for itself, thereby inviting
representation by those who can speak and to whom the objects
matter. The capacity to call such a society of friends into existence
is as much a part of a thing's thingness, of its reverberations in the
world, as its material properties like weight and chemical compo-
sition. As Tamen points out, a society of friends acts to keep its
favored objects visible — for example, in museum displays rather
than in museum attics — and in extreme cases, as in the Byzantine
dispute over iconoclasm, to keep them in existence, to protect
them from willful or careless destruction. It is perhaps unlikely
that someone (an iconoclastic botanist?) will take a baseball bat to
the Glass Flowers, but, given their fragility, extraordinary mea-

sures must be taken just to preserve them from everyday acci-
dents. The models are rarely allowed to travel, and then only a
very few of them, once transported by hearse and now in custom-
made crates filled with space-age contoured foam (figure 6.2).
Befriending the Glass Flowers can be a strenuous and costly busi-
ness, demanding the mastery of an arcane body of knowledge,
huge shipping budgets, and a delicacy of touch that at times rivals
that of the Blaschkas themselves.[14] Sometimes friendship can
border on monomania, as when a Harvard professor of botany re-
acted to the bombing of Pearl Harbor in 1941 by suggesting that
"[Harvard] Museums must begin to think in terms of permanent
bomb-proof quarters for their irreparable treasures of which the
Blaschka Collection, the only collection of its kind in existence, is
certainly one."[15]

As the phrase suggests, friends of interpretable objects don't
just guard the objects singled out for care; they attach meanings to
them. In the case of the Glass Flowers, these interpretations are
very thick indeed. Historians write about when and how and why
the Blaschkas made the models; chemists analyze their structure
and composition; connoisseurs of glassware remark on the sub-
tleties of style and technique; poets enlist them to evoke the pun-
gency of a certain time and place; artists juxtapose them with
scenes of war as symbols of the all too easily shattered; visitors to
exhibitions express their fascination and enthusiasm in on-line
articles.[16] In this essay, I shall contribute to none of these readings,
although I have profited from all of them. My curiosity about the
Glass Flowers veers off in another direction: What is it about the
Glass Flowers that wins them friends, that turns them into things
that talk? What makes an object irresistibly interpretable? Another
way of putting these questions is to recall the original meaning
of "amateur" (*aficionado, amatore, Liebhaber*), which had nothing
to do with lack of training and competence — quite the contrary.

Figure 6.2. Curatorial associate Susan Rossi-Wilcox attaches individually cut foam supports to the model of *Panicum xanthophysum*, which will then be packed in a series of foam-lined boxes and a wooden crate for travel from the French millennial exhibition in Avignon back to the Botanical Museum at Harvard University. Courtesy of Susan Rossi-Wilcox.

Amateurs expertly cultivated their subjects out of affinity rather than utility, for love rather than money. My quarry here is the ways in which the Glass Flowers attracted amateurs in the root sense of the word — scientists, patrons, curators, museumgoers, the Blaschkas themselves — and the sources of these affinities. But the Glass Flowers aroused antipathies as well as sympathies, made enemies as well as friends. Things can be made to talk out of hatred as well as love. The very virtuosity and accuracy that won the Glass Flowers so many admirers also sowed suspicions in some quarters that they were unscientific, even antiscientific. The gradual transformation of the "Glass Models" into the "Glass Flowers" charts their migration from scientific tool to virtuoso craftsmanship, and with it the ups and downs of the uneasy relationship between botany and beauty.

Glass

One of the most improbable features of the Glass Flowers is their glassiness. Brittle, hard, colorless, smooth — there could hardly be a more counterintuitive choice of a medium for representing the pliant, richly textured, and brilliantly colored vegetable kingdom. Moreover, there was a tradition dating back to at least the eighteenth century of making artificial flowers out of the more malleable materials wax and silk; the nineteenth-century Mintorn models, still preserved at the Royal Botanic Garden in Kew, show the high degree of verisimilitude attainable in wax (color plate IV).[17] Wax can be easily tinted in nuanced shades; the correspondence between Rudolph Blaschka and the Harvard botanists was, in contrast, full of the vexations of finding the right pigments and getting them to bond to the glass: "You know the artistic result however you would be surprised if knowing at all the immense difficulty we had to struggle against when trying to copy the natural shades and textures. There were moments in which we were

231

exceedingly tired of the whole matter."[18] The arguments made in favor of glass over wax models — greater longevity — sound more implausible still, considering the precautions that must be taken simply to move one of the glass models from one case to another.[19]

The Blaschkas had in fact first made a name in scientific modeling by supplying natural history museums and university institutes with glass models of other organisms not easily preserved. Many collections throughout the world still own a few examples of the exquisite Blaschka models of marine invertebrates (color plage V).[20] Like the Glass Flowers, the models of jellyfish and sea anemones fascinate by their beauty and verisimilitude. But they do not evoke the same wonder. The transparent delicacy of nature in this case comes too close to that of glass; there is a more obvious connection between medium and subject matter, which is probably why zoologists like Ernst Haeckel and Franz Eilhard Schulze turned to glassworkers like the Blaschkas to stock their natural history museums in the first place. Leopold Blaschka himself seems to have hit upon the idea for the models when jellyfish observed at sea during an Atlantic crossing in 1853 reminded him of the glass worked by generations of Blaschkas in Bohemia. Years later, in an 1880 lecture titled "Hydroidquallen oder Craspedoten," presented to the local scientific society of Dresden, Rudolph Blaschka reported how his father had taken a particular interest in the jellyfish netted by the sailors, "because of their glassy appearance."[21] By 1871, Leopold Blaschka's catalog had come to offer three hundred models of aquatic organisms; in 1888, catalogs advertised some seven hundred models, sold to universities and museums throughout Europe and the United States.[22]

The Blaschkas' route to plant models was considerably more circuitous, through jewelry making, prostheses (glass eyes), and horticulture rather than through scientific botany. Leopold Blaschka had studied gem cutting; the family workshop in Bohemia had

already established a reputation in the late eighteenth century for high-quality glass paste gems and beads. Starting in the 1860s, he had fabricated floral brooches and earrings from glass. His first glass models of plants were commissioned and exhibited by Prince Camille de Rohan, founder of the Bohemian Society for the Promotion of the Garden Trade, and were mostly of orchids, the most luxurious and precious of cultivated flowers.[23] The Blaschkas, father and son, were to use jewelry-making techniques throughout their careers in fashioning both their zoological and their botanical models.[24] Medieval naturalists had often likened the beauties of flowers to those of gemstones; in the work of the Blaschkas, this analogy became strangely literal. Parts of the glass models — leaves, petals, tentacles — were strung on wires like beads in a necklace.

Since the mid-seventeenth century, the depiction of flowers, insects, and other *naturalia* for the purposes of natural history illustration had been closely intertwined with images of the same objects made for the luxury trades: embroidery, porcelain painting, interior decoration, silk weaving. An illustrator and an artisan were often one and the same person.[25] In their own minds at least, the Blaschkas continued this conflation of scientific representation and the decorative arts. One of Leopold Blaschka's earliest catalogs for the models of marine animals advertised them as "decorations for elegant rooms";[26] although later catalogs were pitched to scientific institutions, Rudolph Blaschka still remembered the marine models decades later as "a beautiful show."[27] Haeckel, who was one of the earliest and best customers for the zoological models and who lent the Blaschkas books from his library, surely influenced the symmetrical, sinuous forms of the models of sea anemones and medusae. In his *Monographie der Medusen* (1881), Haeckel had emphasized the "geometric basic form [*Grundform*]" of the organisms, and the magnificent lithographs (partly drawn

233

by Haeckel himself, with the help of the artist Adolf Giltsch) served as the basis of some of the Blaschka models (figure 6.3). The manner in which the Blaschkas made some of their earliest models would have emphasized symmetry out of practical necessity as well as aesthetic preference and zoological principle. Relying heavily on the already stylized illustrations of marine organisms in Haeckel and especially in Philip Henry Gosse's *A Naturalist's Rambles on the Devonshire Coast* (1853), the Blaschkas made their own reverse drawings of these to serve as preparatory material for the "back" of their three-dimensional models (figure 6.4).[28] There would, however, have been other sources for the Blaschkas' artful compositions: especially celebrated works of natural history illustration, such as John James Audubon's "magnificent" *Birds of North America* (1831–1838), which Rudolph Blaschka recalled having admired around 1875 in the library of the Academia Leopoldina-Carolina in Dresden.[29]

Words as well as images linked the Blaschkas' models to their glassy medium, and both models and medium to Leopold Blaschka's first métier as jewelry maker. In his descriptions of aquatic organisms, Gosse often compared them to jewels or glass: the tadpole of the *Amaroucium proliferum* reminded him of "a brilliant little ruby"; he christened a newly discovered medusa species the "Glassy Aequorea" and described it as "without a trace of colour ... [yet] exquisitely beautiful."[30] In a report on medusae to the Dresden scientific society Isis, Rudolph Blaschka remarked on how their "delicate, glass-like colors enhanced the elegance of their appearance."[31] The associations with the glitter of glass and gemstones, expressed in language equally precious, persisted long after the Blaschkas had abandoned models of jellyfish and polyps for those of orchids and Virginia creepers. Even the humblest weed modeled by the Blaschkas "has in its center lovely urns or caskets or basket shaped receptacles of purest crystalline texture,

234

PECTANTHIS ASTEROIDES.

Figure 6.3. *Pectanthis asteroides*, from Ernst Haeckel, *Monographie der Medusen* (Jena: Gustav Fischer, 1881), table VII. Courtesy of the Staats- und Universitäts-bibliothek Göttingen.

Figure 6.4. *Aequorea Vitrina*, from Philip Henry Gosse, *A Naturalist's Rambles on the Devonshire Coast* (London: John Van Voorst, 1853), pl. XXIII.

heaped high with tiny amber-colored or golden eggs of the pollen dust," rhapsodized an 1894 report in a trade magazine on the Ware Collection at Harvard's University Museum.[32] Just as the art of the maker of paste jewelry lay in disguising glass as gemstones, so the art of the Blaschka models consisted in counterfeiting flora and fauna out of glass yet somehow still evoking a scene from the Arabian Nights of treasures gleaming from richly worked caskets.

If the decorative associations of *naturalia* like flowers and shimmering, delicate marine organisms were strong and ubiquitous, reinforced by the Blaschka family experience designing costume jewelry, there was nonetheless something remarkable about their almost mystical allegiance to glass. Glass had been the medium of the Blaschka family for generations in their native Bohemia, whose glassworks had by the seventeenth century surpassed those of Venice to dominate the world market;[33] Leopold Blaschka once told Goodale that the only way to become an accomplished glassworker was to have a father, a grandfather, a great-grandfather with the same skills and tastes.[34] When Rudolph finally married in 1911, he and his bride spent their honeymoon in northeastern Bohemia, where he "had the splendid chance to see yet the building of the 200 years old glass-factory called, Zenker-Hütte where my great-grandfather was master about 130 to 150 years ago."[35] Leopold and especially Rudolph pored over chemical treatises, experimented with pigments and enamels, conducted field research (Rudolph made one field trip to the Adriatic to study marine animals in situ and two botanical collecting expeditions in 1892 and 1895 to North America), made microscopic studies of plant organs, and joined the local natural history society.[36] Whereas Leopold was described in the Dresden city tax records and the rolls of the Isis natural history society simply as a "Glasskünstler," Rudolph was designated by the same society by the more specialized title

"naturwiss.[entschaftlicher] Modelleur." Yet the Blaschkas remained craftsmen, and their medium remained glass.

If anything, the long years of work on the Glass Flowers deepened this identity as artisans and this identification with glass. It is possible to see the Blaschka workshop as becoming more scientific over the course of decades, especially once Rudolph continued alone after his father's death: whereas only a minority of the marine models had been prepared from nature studies,[37] most of the models for the Glass Flowers came from plants cultivated in the Royal Gardens at Pillnitz or in the Blaschkas' own garden at Hosterwitz, dried specimens sent by the Harvard botanists, or sketches made by Rudolph during his collecting expeditions. In later letters to his Cambridge correspondents, Rudolph fretted about the possible errors introduced by substituting cultivated for wild plant varieties, vividly recalled the habitus of plants he had seen on his North American collecting expeditions, and rejected illustrations in favor of his own microscopic investigations of plant anatomy.[38]

Yet the development in the artisanal direction was equally strong, to the point of willed anachronism. Whereas the early Blaschka models had made heavy use of commercially prepared glass and pigments, both the correspondence and the chemical analyses indicate that the later models were fabricated almost entirely from scratch in the Hosterwitz workshop.[39] When Goodale had first visited the Blaschka workshop in late 1889, he had found the worktable cluttered with "rods and tubes of glass, and blocks of colored glass," which surviving ledger books show to have been ordered in bulk from commercial suppliers.[40] But when Mary Ware visited in 1928, Rudolph made most of the glass and all of the pigments by himself:

One change in the character of his [Rudolph Blaschka's] work and, consequently, in the time necessary to accomplish results since I was

238

last here is very noteworthy. At that time, he bought most of his glass and was just beginning to make some, and his finish was in paint. Now he *himself* makes a large part of the glass and all the enamels, which he powders to use as paint.... He has dozens and dozens of little bottles with colored powders and little boxes labeled with colored enamels that he makes himself, and powders for paint.[41]

Rudolph railed against customers who "want me to do lots as a factory of a hundred workmen" when he was trying single-handedly "to contrive new methods in apparatus, coloring, preparing of enamels, etc."[42] Unbendingly committed to glass as a modeling medium with which "to reproduce the infinite variety of shade and texture, the often unattainable beauty of nature," and freed from the vicissitudes of the market by Harvard's unflagging demand for ever more models, Rudolph turned his back on the industrial products his father had used routinely and became an artisan of an almost archaic stamp.[43] By 1906, after nearly twenty years of making models exclusively for Harvard, Rudolph had taken to describing his labors as his "life work," in pointed contrast to a "business."[44]

Work

There was something magnificently mad about this commitment to glass. Not only did the tendrils and buds, the pistils and stamens, the bark and fruits all have to be molded by hand out of heated glass; the brittle models then had to be transported from Dresden to Cambridge. In feats of packing that almost rivaled the artistry of the models themselves, each tiny glass part was wired to the base of a firm cardboard box, then cushioned with tissue paper; surrounded by packing straw, the covered boxes were next packed in a large wooden crate; the crate was then packed in more straw and swaddled with burlap.[45] The love of glass exacted infinite

pains, as well as virtuoso tact, and not only from the makers of the Glass Flowers. The Glass Flowers did more than crystallize labor; they multiplied it. Everyone who came into contact with them — the model makers, the curators, the botanists — added their mite of care and concentration to the horde. By a peculiar kind of contagion, the Glass Flowers obliged those who dealt with them to assume the laborious, detail-obsessed attitudes and gestures of their makers. The steady hands and dexterity of Louis Bierweiler, who cared for the models at the Harvard Botanical Museum for sixty-three years (1901–1964), became, for example, a local legend in their own right.[46] A moment's indifference, inattention, or clumsiness in packing and unpacking, mounting and dismounting, even inspecting and drawing a Blaschka model (don't sneeze) could have irreparable consequences. Work was as much a part of the essence of the Glass Flowers as glass.

It was a peculiar kind of work, to be sure. Not backbreaking but painstaking, it was the work of delicate gestures, strained eyesight, focused attention, and, above all, vast patience. Nothing infuriated the Blaschkas more than the rumors (still rife) that they were in the exclusive possession of "secrets" that allowed them to produce the Glass Flowers effortlessly. Responding to an American newspaper report that the Glass Flowers were made by "certain secrets of moulding and annealing," Rudolph Blaschka insisted:

> The technical part of this work is only depending from the technical experience, above all from the skill and energy of hands and strain of eyes, and rarely there will be any other work which is so exclusively dependent from pains and succeeding as this. At first a man must be initiated into the technical rules of this profession, it may be called trade, art or science. After this the struggle of life commands: Help yourself! If steadiness, enthusiasm and ambition are present, the

young man is getting skilled. These rules have been taught to me by my father 38 years ago, just as they were taught to him by his father.[47]

Mother as well as father contributed to the abilities that made the Glass Flowers possible, with her "remarkable eyes which enable us to see the tiniest details with the unaided eye"; models that the Harvard botanists examined with a magnifying glass were made by the Blaschka family by eye alone.[48] A single model might cost as much as seven weeks' work. After his father died, Rudolph worked alone, without an assistant, and sometimes longed to rest, envying "such vacations as the Professors and students enjoy every year."[49] Yet though the work was unrelenting, it was not joyless. Rudolph also wrote of his "passionate love of this work and study of nature," and in the cold, hungry days following Germany's defeat in the First World War, he "rejoiced at getting young again in this work" provided by Harvard's continuing orders for models.[50]

Although the Blaschkas were incensed by the talk of craft secrets that seemed to tar them with the brush of charlatanism, the fabrication of the Glass Flowers impressed even those who observed it firsthand as mysterious. But these were mysteries as measured against the standards of late-nineteenth-century factory production rather than tricks of the trade. Almost every account of the Glass Flowers, official and unofficial, emphasized that they were handiwork, not machine-made: "All the modelling has been done by their own hands, a marvelous example of concentrated and conscientious effort."[51] Moreover, each model was unique and made by the Blaschkas themselves, who refused all assistance as insufficiently qualified — an apprentice would only "bungle and spoil things."[52] The terms of Harvard's contract with the Blaschkas were monopolistic, preventing even the Blaschkas from replicating

their own models for other customers (who would come calling in Hosterwitz from time to time in the person of professors from German universities seeking models for their own museums).[53] After his father's death, Rudolph gradually withdrew still further from the imperatives of industrial and commercial production, making rather than buying his own materials, refusing to be rushed by Harvard's anxious inquiries as to when the models would be ready, and rarely venturing out of his own garden, much less to nearby Dresden. He became an autarkic recluse who occasionally deigned to receive visitors — a *Geheimrat* from a Berlin museum, the queen of Saxony and her ladies, Professor Goodale and Miss Ware — drawn to his workshop by the mysteries of his craftsmanship.

These visitors left as baffled as they came, even if they were permitted to watch him at work. Goodale, his wife and son Francis, and Ware spent a sweltering August afternoon in 1899 at Hosterwitz watching Rudolph make various leaves and flowers and quizzing him about his methods. In a detailed letter to the chemist Charles W. Eliot, then president of Harvard, Goodale described how red-and-orange flames were used to color the glass, how even at 95 degrees Fahrenheit all doors and windows were kept closed, lest the slightest breeze make "the perfectly steady point of the flame" flicker, how the glass did not fracture when cooled. But all he was able to report about the actual making of the models was the bare act of creation: "Under his hands the flowers were created and nothing more marvellous has ever been seen by any of us."[54] It was the inscrutability of skill and sensory acuity (a small flower made by Blaschka's naked eye could only be inspected by the onlookers with a powerful lens), coupled with modes of production that were at once ante- and anti-industrial, that fed the legends about the Glass Flowers. The mythology of the Glass Flowers developed in explicit counterpoint to the modern factory:

242

In the time of the Middle Ages almost all trades or handicrafts had their mysteries.... It is very different now. If you visit the great factories, the proprietor or the foreman will show you how the complicated machinery works.... Still, some of the secrets of the handicraft remain and one of the most interesting of these is the wonderful art of the Blaschkas, which no other worker in glass has been able to learn or in any way imitate.[55]

In the age of mechanical reproduction and mass markets, the Glass Flowers were nonreplicable objects made by hand and from scratch by noninterchangeable laborers for a single customer.

It was perhaps this cult of work conceived as close observation, delicate manual skills, and taking pains that drew Goodale to the Blaschkas in the late 1880s. There was otherwise apparently very little to connect his brand of microscope-centered analytic botany with the mimetic naturalism of the Blaschka models. Goodale belonged to the generation of botanists who, following mostly German examples, turned from the external morphology to the internal physiology of plants and who worked mostly in a laboratory with a microscope rather than in the field or herbarium.[56] In his 1885 textbook on physiological botany, the illustrations were spare and schematic and mostly depicted microscopic sections of plant tissue (figure 6.5). An 1879 text on common plants prepared for Boston schoolteachers described the flower as "a complicated mechanism made up of simple parts" and illustrated the point with a gear-like diagram of a standard blossom (figure 6.6).[57] Yet Goodale was ferocious on the subject of first-hand, help-yourself observation of live plant specimens:

The teaching which is advised in this course of botanical lessons is based upon the belief that the pupil must earn his facts; that, in general, facts which a pupil may acquire for himself are to be placed

243

131

Figure 6.5. Magnified *Orchis maculata* pollen mass, from George Lincoln Goodale, *Physiological Botany: Outlines of the Histology of Phaenogamous Plants* (New York: Ivison, Blakeman, Taylor, and Company, 1885), p. 171.

Figure 6.6. Schematic blossom diagram, from George Lincoln Goodale, *Concerning a Few Common Plants*, 2nd ed. (Boston Society of Natural History, 1886), p. 43.

within his reach, but not in his hands. He must make some exertion to get knowledge, in order that it may become his. But in what way can a pupil be led to exert himself? Certainly not by having every thing done for him.[58]

It was pernicious to provide pupils with an analytic classificatory key before they had made a personal investigation of plant morphology with minimal aid from the teacher; good botanical illustrations had their place but "must never be used to the exclusion of fresh specimens or well-preserved dry ones."[59] Goodale's creed of the "wholesome painstaking" also extended to more advanced students. The best tools could be the simplest, provided they were deployed with sufficient dexterity: "Sharp, delicate needles, by which the parts may be separated by teasing, are often better than any cutting instruments."[60] Training in the modern botany of the microscope was a discipline for the hands as well as for the mind and eye.

This insistence on self-sufficient observation and manual skill, combined with a climate that precluded botanical fieldwork for a good part of the academic year, may have been what dispatched Goodale to Dresden to visit the Blaschkas, although he had not seen their earlier botanical models, burned in a fire in Liège and never commercially advertised. As first director of the Harvard Botanical Museum, however, Goodale would certainly have seen the Blaschka models of marine invertebrates, which were energetically advertised and marketed all over the world, in the neighboring Museum of Comparative Zoology founded by Louis Agassiz.[61] Although botanical illustrations, especially those of physiological botany, tended toward skeletal line drawings, Goodale's pedagogical ethos of strenuous observation required representations of an entirely different kind. If the plants themselves were not available, students would have to train their powers of attentive comparison

and judgment on replicas indistinguishable from the originals. Goodale hoped that the Blaschkas would create a perpetual garden, always in bloom, with which to instruct Harvard students in the specialized botanical ways of seeing and analyzing plants. Even settled, snowbound botanists — Cambridge was notorious for its long winters — could sharpen their eyes and memories on the Blaschkas' perfect replicas of plants year-round. The Glass Flowers were perhaps the culminating example of the nineteenth-century museum director's burning ambition to move nature indoors (figure 6.7).

Accuracy

In J.G. Ballard's short story "The Garden of Time," a garden of glassy flowers preserves the last refuge of an aristocratic couple against oncoming hordes until the final blossom has been plucked.[62] Similarly, the Blaschka glass models were intended to hold the forces of corruption and decay at bay, overcoming the imperfections of plants dried and flattened in a herbarium or bloated and bleached in alcohol. They would form a timeless garden. But a garden for whom, and for what use? By the time Goodale died in 1923, the answer had become clear: for the edification of the general public who came by the thousands each year to visit the Ware Collection, Harvard's most popular attraction by far. The Glass Models had definitively become the Glass Flowers. The answer around 1900 was, however, more ambiguous, as ambiguous as the declared mission of university museums, which were meant to serve simultaneously the interests of scientific research and public education.[63] The Ware Collection was originally conceived as much as a collection of scientific models as a magnet for crowds and donors. Goodale unabashedly exploited this magnetism for all it was worth, as when he sent off selected models as part of the Harvard display to the World Exposition in Paris (1900), in the

Figure 6.7. Display of Ware Collection of Glass Models in 1931 at the Botanical Museum of Harvard University. Courtesy of Harvard University Archives.

hopes that "some of the home-sick Americans in Paris may think very kindly of Harvard, if our exhibit there is a taking one."[64] Yet his assertion of the scientific utility of the Ware Collection was equally emphatic, albeit scientific, more particularly botanical, in a sense that was already disappearing when the models were commissioned. Central to this understanding were morphology, the science of appearances, and the ability to fuse vision and judgment into a single trained faculty for making sense of the pied variety of organic forms.

Goodale consistently described the Glass Flowers as models or "illustrations of types of the great classes and the subordinate groups of plants" or even as an "authoritative cabinet of type-specimens."[65] This usage is doubly perplexing. First, type specimens were usually individual plants, preserved in a herbarium, upon which the original identification of a species had been made and which served as the ultimate reference for all further description and classification. In rare cases in which such a specimen was unavailable or difficult to preserve, an illustration might serve as the type specimen, as in the case of Pierre-Joseph Redouté's celebrated images of the Liliaceae family.[66] But this would not have been the case for any of the species represented by the Blaschka models; nor is there any evidence that the models were ever used in this capacity. Second, the models were *too* accurate to be typical in the then-accepted botanical sense of representing an ideal that displayed the characteristic features of a plant genus or species, without any individuating peculiarities. In his influential *Phytographie* (1880), the Swiss botanist Alphonse de Candolle distinguished sharply between an "authentic specimen" (*échantillon authentique*) and "material representations of the true ideal type [*type idéal véritable*]"; only the latter had any taxonomic legitimacy.[67] Goodale followed this view in his own introductory botany lectures, describing the "type-flower" as an "approximation

248

towards perfection," and as director of Harvard's Botanical Garden, where he favored "types for the use of students instead of simple curiosities or specimens for horticultural exhibitions."[68]

How, then, were the Blaschka models to serve as "types"? Their accuracy was breathtaking, even supererogatory. The Harvard botanist Walter Deane undertook to examine the cluster of about twenty-five hundred to three thousand tiny flowers of the model of an angelica (*Aralia spinosa*) blossom with a lens and found each and every one of them to have "its five petals and five alternating stamens with long filaments."[69] It was a banality, repeated ad nauseam, that "as in Nature, no two flowers or leaves of a single plant are exactly the same, so in the glass reproduction every minute variation is followed with the greatest fidelity."[70] It is precisely in this hypertrophied accuracy that their value as models must be sought, despite the tension with prevailing notions of botanical types. Goodale intended them to be "exact fac-similes of certain typical plants," in three dimensions, and neither "conventionalized nor exaggerated," as in the case of two-dimensional illustrations. The eye of the fledgling botanist would thereby be trained in Goodale's version of morphology, "the detection of all disguises which conceal [the] identity of [the] plant," without the lazy trot of an already idealized illustration. The Glass Flowers forced students to "earn their facts" — or types — but without wetting their feet. Hence Goodale could recommend a visit to the Ware Collection in place of expeditions to gather wildflowers for Boston school classes or suggest that "excellent photographs of [models of] the principal types of flowering plants" be used for botanical instruction rather than photographs of the plants themselves.[71] The uncanny accuracy of the Glass Flowers liberated the botanist from real flowers while preserving all the features required to master morphology by the arduous, self-sufficient methods Goodale preached. The handicraft methods of the artisans

converged with nature's own, and made nature superfluous: "Their [the Blaschkas'] models are the living plants, and every flower has its separate pattern no two being exactly alike. They are not all cast in one mold."[72] The models did not simply represent nature; they replaced it.

It was partly these almost blasphemous pretensions of the Glass Flowers that excited the enmity of other botanists, among them Goodale's colleague William G. Farlow. In an 1889 letter to his former student Roland Thaxter, Farlow recounted how he had poured cold water on a Boston lady who "told me she could not imagine anything so beautiful as the models. I ventured to ask whether she did not think the plants themselves were beautiful."[73] It was no accident that Farlow and Thaxter were cryptogamists, specialists in nonflowering plants like ferns and mosses that reproduced by spores, as opposed to the flowering phanerogams that had previously dominated botany and were the chief subject matter of the Blaschka models. For Farlow and Thaxter, the Glass Flowers symbolized what they disdainfully called "Oh! *My!*" botany, at once flashy and phanerogamist. When Goodale objected to an expedition to Jamaica to gather cryptogam specimens, Thaxter was indignant: "What are glass models of phaenogams or other apparatus for hoodwinking a credulous Plutocracy as compared with the treasures we should bring to light."[74] The cryptogamists were not only envious and resentful of the funds and space lavished on the phanerogams (maddeningly apostrophized in textbooks as "the higher plants"); they were contemptuous of what they viewed to be the vulgar sensationalism of flowering plants, and the attention attracted by the Glass Flowers only deepened their antipathy. Their disdain extended to colleagues as well as to Boston grandes dames and hoi polloi. Farlow expressed relief when the Visiting Committee to the Harvard Department of Botany in 1891 "did not 'enthuse' much over the glass flowers";

he was worried that President Eliot, though a chemist, "has no real conception of botany as a science and is apt to be taken in with sensational things — as glass flowers."[75] In fact, Rudolph Blaschka had made models of cryptogams, which were to have been exhibited at the Paris Exposition, but these were at first withheld because of doubts expressed (by Farlow?) about their accuracy, and then definitively withdrawn by Blaschka himself. As Goodale explained to Eliot, "All of them are made of *clear* [glass] and do *not* represent or illustrate the peculiar Blaschka methods."[76] Those methods depended for their effect on a definition of accuracy restricted to the forms and colors of visible surfaces, best appreciated in plant parts evolved to be gaudily manifest, namely flowers.

The issues that divided the admirers and detractors of the Glass Flowers did not reduce in any simple way to popular versus scientific botany: both sides had embraced the laboratory and the microscope; both mounted museum displays; both lectured to lay audiences — though Goodale certainly outstripped Farlow as a fund-raiser.[77] Nor was the bone of contention whether botany would continue to be a "science of beauty"; fern fanciers and other cryptogamists were quite capable of going into aesthetic raptures over their specimens.[78] Rather, it was the *kind* of beauty that was at stake: showy appearances versus hidden mechanisms, a distinction with affinities too close for comfort to that between vulgarity and refinement, or between phenomena and noumena. The very word "phanerogam" derives from the Greek word *phaneros*, meaning "visible, apparent"; in this sense, flowering plants were literally sensational, phenomena ("appearances") in the root sense of the word. The art and accuracy of the models lay in the perfect simulation of appearances of the kind of plants in which the organs of botanical interest coincided with the focus of public fascination — the flowers. As the reproductive organs and essential

classificatory features of an enormous plant taxon, flowers had commanded scientific attention since Linnaeus. Yet when the Glass Models definitively became the Glass Flowers, they ceased to be scientific. Post-Darwinian phylogenetic approaches suggested that cryptogams were the most ancient plant phylum; Goodale himself had noted a trend by 1918 toward "the study of the lower instead of the higher or flowering plants, these latter being treated merely as members in a long series, and with scant consideration."[79] But the rivalry between cryptogamists and phanerogamists was not simply a matter of who could boast greater antiquity for their plants. In addition to their feminine, decorative associations (already well established in Linnaeus's time), flowers had come to symbolize the exoteric, the superficial, the epistemologically shallow, and the screamingly obvious. They lacked the depth and difficulty, the "restraint" of Marianne Moore's poem, that signed taste and truth.

Conclusion: The Perfect Copy

Although Goodale and his contemporaries admired the Glass Flowers as marvels of both science and art, they are by now outcasts in both domains. Neither botanists nor artists value extreme mimesis; on the contrary, they are discomfited by it. For the botanists, the models are too detailed to highlight the taxonomic characteristics of the plants; for the artists, meticulous verisimilitude and mismatch of form to medium signal kitsch. Connoisseurs of glassware appreciate the technical achievements of the Blaschka models, but as an artisanal dead end that inspired no styles or schools. Insofar as poets and artists have invoked the Glass Flowers, it is as metaphors that point beyond the things themselves. The fact that thousands of tourists come to gawk at the models every year does not improve their standing in the Republic of Letters. Superior people do not visit the Glass Flowers.

Yet the Glass Flowers are capable of mustering passionate supporters, not all of whom have a professional interest in the history of botany or glassworks. Their qualities as simulacra cannot be the whole explanation; equally exact floral models in wax have failed to attract anything like the following enjoyed by the Glass Flowers. I have suggested that certain other aspects of the Blaschka models — the quixotic dedication to the medium of glass and the painstaking efforts they at once embody and propagate — may rescue them from dusty silence and turn them into things that talk. Doubtless there are other aspects of their communicativeness. They have in common with other hallowed things a kind of real presence. Pilgrims make long, arduous journeys to see relics close-up; scholars and art lovers go to considerable expense and trouble to visit archives and museums where they can behold objects firsthand; friends of the great sequoias are not content with Sierra Club photographs. The same holds for the Glass Flowers, but for reasons that are more difficult to explain. Relics exert their virtue only close-up, often by touch; a slide of a Cézanne does not do justice to the details of brush stroke and paint modeling; you cannot smell a sequoia photograph or be dwarfed by it. But the Glass Flowers were never meant to be smelled or touched or even peered at too closely. They are pure appearance, and for pure appearance a good photograph, itself pure appearance, ought to suffice. Why, then, do they exude and demand real presence?

In the past century or so, a very few of the Glass Flowers have been allowed to travel, most recently to exhibitions in New York (1976) and Avignon (2000), where they are displayed singly, like framed paintings by illustrious artists (color plate VI). But the curious museumgoer must travel to Cambridge to see the collection in its entirety, spread out in rigid fragility in a room with warnings about setting off dangerous vibrations. It is not just the hold-your-breath fragility of the Glass Flowers that necessitates a

253

trip to see them in three dimensions. Although they are represen-
tations themselves, they defy representation. A photograph of the
glass model of a daylily or a strawberry plant looks exactly like a
photograph of the daylily or strawberry plant in your garden. The
Glass Flowers are perfect copies, but for just that reason they are
not perfect plants. One of the daylilies has begun to shrivel; there
is a fungus nibbling at the strawberry leaf. The wonder of the
Glass Flowers is not the idealized beauty of the finest botanical
illustrations, or that of the prizewinning garden overflowing with
a plenitude of vegetable colors and shapes, or even that of the
consummate illusion of naturalistic art. It is the wonder of the
copy that itself cannot be copied, which somehow is more au-
thentic than the original.

Figure 7.1. Herman Rorshach, *Rorshach*-Test (Bern, Schwitzerland: Verlag Hans Huber AG, 1921, 1948, 1994).

Image of Self

Peter Galison

In a brown cardboard box come ten cards, printed in Bern, Switzerland. Verlag Hans Huber is so concerned about the quality of their reproduction that it will only use the same antique printing presses that stamped out the first edition of the cards in 1921. And it won't print at all if the humidity and temperature do not match the secret instructions that have been passed down over generations. You will be instantly sued for unauthorized duplication of the cards, and psychologists around the world stand vigilant, ready to pounce on wrongful distribution or even casual public display of the images. At the same time this box of plates may well be the most studied object of the last hundred years: several *million* people have not only examined them but recorded the innermost details of what they saw. What are these cards? To answer (or even not to answer) is to present yourself. Just insofar as these cards are described, they describe the describer. Not only do these objects talk back, they immediately double the observer's language with a response that pins the speaker on a psychogrammatic map. These are the cards of the Rorschach test; and they don't mind sending you home, to the clinic, or to prison.

I am concerned here neither with the vast reception history of the method nor with the broader history of psychological testing.

257

Instead, my aim is to treat these cards as a technology of the self, that is, as highly refined apparatuses for defining, in fine and in large, the nature of "interior life." The goal is to approach the Rorschach test as a material, procedural system — a far less ideal version of Foucault's *souci de soi*.

The argument proceeds in three steps. First, an analysis of the examination logic of nineteenth-century inkblots provides a ground conception of the self against which Rorschach's very different understanding of 1917–1921 is thrown into relief. Late-nineteenth-century inkblot tests served to assess the power of a specific mental faculty, the imagination, in precise analogy with memory or computational tests. Second, we turn to Hermann Rorschach's specific location within the clinical-experimental setting of early-twentieth-century Swiss psychiatry. More specifically, our attention will focus on the material and abstract apparatus that Rorschach built as a "neutral" probe of an inner life that he refused to divide into segregated faculties at all. Instead, Rorschach designed his test to probe *perception* (not, in the first instance, the particular faculty of imagination). Perception mingled affect and cognition in ways that dramatically departed from the older notion of isolated mental functions: depression can matter as much as a capable imagination. Rorschach believed that only a maximally *objective* stimulus, one that appeared utterly removed from human intentionality, could reveal the purely *subjective* nature of the response. That search for an objective measure of an individual's (or group's) characteristic mode of perception drove his insistence on "neutral," "chance," or "unintentional" visual forms: only the purest of "chance" images could surface the inner, structuring forms of perception. Finally, in the third part of the argument, I want to widen the inquiry to address head-on the complex link between subjective and objective conceptions of the self that makes the Rorschach test possible. In the world of

Rorschach's inkblots, subjects make objects, of course: "I see a woman," "I see a wolf's head." But objects also make subjects: "depressive," "schizophrenic." Properly understood, the now-canonical Rorschach test system measures but also reinforces a particular (and specifically modern) integrated, interior self.

Inkblot Imagination

When the French psychometrician Alfred Binet wanted to characterize individual psychology in 1895, he divided his arsenal of tests into (he was French) ten faculties. Each domain merited its own distinct probe:

1. memory
2. nature of mental images
3. imagination
4. attention
5. faculty of comprehension
6. suggestibility
7. aesthetic sentiment
8. moral sentiments
9. muscular force and force of the will
10. dexterity and coup d'oeil

Memory, for example, could be gauged by a subject's ability to reproduce a complex geometric form. Among these various individuated items was number three — the imagination. According to Binet, imagination came in two flavors: involuntary and voluntary. Literary and musical creations were quintessentially voluntary forms of imagination; other, more associative skills were involuntary. However partitioned, imagination had its own test, one that probed it exclusively:

Let there be a spot of ink with a bizarre contour on a white sheet; to some this view will say nothing; to others who have a vivid imagination of the eye (Leonardo da Vinci, for example) the little spot of ink appears full of figures, in which one notes the type and number, without pushing, of course, experience to that kind of hypothesis that the English love to provoke with their crystal vision.[1]

(Leonardo's cameo appearance here is an echo of the often-repeated stories of his use of cracks, ashes, and other "chance" images as an exercise and provocation in visual imagination.)

E.A. Kirkpatrick in the United States had similar goals in his studies of 1900: like Binet, he aimed for a battery of tests, each measuring a specific ability. To test for certain hand-eye and low-level arithmetical skills, young children were asked to count as high as they could in ten seconds, or to sort twenty-five cards into four piles, or to distribute cards according to a letter written on them. Among these timed, order-following quizzes came the ink-blot test, which was Kirkpatrick's key to the imagination. To Kirkpatrick's surprise, first-graders handily beat older children. In part, he attributed the six-year-olds' "supremacy" to the directness of their reports. It seemed that older children framed their identifications with a cautionary "it is somewhat like" or "it looks a little like" before identifying the blot with "a dog" or "a cloud." Nothing in this interpretative hesitation by the older schoolchildren particularly intrigued the psychologist except (as Kirkpatrick put it) the signal that cautiousness seemed to heighten with age. Underlying Kirkpatrick's (and Binet's) test procedure was a picture of the self as an aggregate of "powers." Kirkpatrick wrote: "I would suggest that it is desirable to have tests of such a nature that they can be taken by children as well as adults, that they shall be such that all persons tested will have had about equal opportunity for the exercise of the power tested."[2]

In Britain, as in France and the United States, educational psy-chologists enthusiastically measured the associational capabilities of their charges. At the Women's Education Department of the University College of South Wales and Monmouthshire, Cicely J. Parsons sorted schoolchildren's inkblot responses into animals, humans, toys, and other commonplace objects. Miss Parsons, as she signed her articles, was not so riveted by the quantitative production-control ethos that absorbed her stopwatch-wielding American colleagues. Instead, she and others hoped to sort her re-spondents into bins of reproductive and productive imagination, categories made popular by William Wordsworth and Samuel Taylor Coleridge.[3] (Taylorist foreman-psychologists to the west of the Atlantic; rewarmed Romantic women's education to the east.)

Details change, but the widespread nineteenth-century use of inkblots in England, the United States, and the Continent all had roughly the same goal: use subject responses to ink blots to classify and grade the imagination. George Dearborn at Harvard shared this ambition:

> To "see things" in the ever-changing outlines of summer clouds or among the flames and embers of a fire, has doubtless in all ages been to imaginative men a source of entertainment and delight.... For the purposes of studying the reproductive imaginations of men and women, the psychologist might well desire to take the clouds into his control and bid them serve him; but they are far beyond him and will not for a moment stay.
>
> To reproduce, then, under applicable and controllable conditions these familiar studies of human fancy, the following simple means have been adopted, and they constitute the complete apparatus, sim-ple enough, of the investigation. Chance blots of ink, made by press-ing gently with the finger a drop of common writing fluid between two squares of paper, furnished all the variety of outline imaginable.

Key to understanding Dearborn's project are his instructions. It is only in the micro-application of these procedures, applied over and over, that one can see just what, statutorily, found its way to the record. In particular, the rules of inkblot engagement *removed* precisely what has become "obvious" through nearly a century of Rorschach procedures. Dearborn's mandate to the subject was to

> look at the blot-card always right-side up, turning neither the card, nor the head; to try to employ the whole character if possible, not allowing it to separate into parts while being observed; not to be too particular to get a perfectly fitting object in mind, but to tap at the moment of the consciousness of the first suggested image; to react by a sharp tap as promptly as possible; to report each concrete object suggested as concisely as possible, with any suggested general action of the same, and especially, only such details as occurred before reaction by the tap.[4]

As we will see, *every* element of Dearborn's protocol clashed with the corresponding component of Rorschach's. Whereas Dearborn demanded a rigid orientation of the card, Rorschach specified that subjects could turn the card any way they liked. Whereas Dearborn insisted on the outright deletion of fractional or detailed images, Rorschach taught that the test attributed particular importance to the number and percentage of partial objects seen. Whereas Dearborn asked his emissaries not to be "too particular" about the fit of the inkblot object to the mind's eye of the subject, Rorschach put great weight on the "fit" of the form, as reflected in his scoring nomenclature (F+ = good fit); (F− = poor fit). Finally, whereas Dearborn requested a concise report, Rorschach wanted a great many other aspects of the client's report, including affect, hesitation, and revision.

Perhaps most striking in Rorschach's version of the inkblot

exercise was the division of the test into four highly choreographed phases. The first was "Response." Instructions to the subject were stark, and the directions systematically violated all the strictures imposed by imagination-driven technologies of the self. Sitting next to the subject, the examiner positions himself so that the cards and the subject's gestures toward the cards are clearly visible: "The subject is given one plate after the other and asked, 'What might this be?' He holds the plate in his hand and may turn it about as much as he likes."[5] In Rorschach's test, it is imperative that the patient *not* be given any instructions about what to see or how much (or how little) of the image to report. There was no time limit or race to completion, and the subjects were not to be told *anything* about the number or kind of responses desired. Coercion had to be avoided at all costs — with the caveat that the plates should not be viewed from too great a distance. From afar, plate 1 was often seen as a fox, a relatively rare response in the "normal" (arm's reach) viewing position. It is worth attending to the current doyen of Rorschach, John Exner, instructing on how to handle a subject's questions about the response. Essentially, the examiner (E) should speak without saying anything, presenting the subject (S) with a studied calm that put the card in the light of apparently unmediated presence:

S: Can I turn it?

E: It's up to you.

S: Should I try to use all of it?

E: Whatever you like. Different people see different things.

S: Do you want me to show you where I see it?

E: If you like. (It is probably best at this point to avoid any mention of the Inquiry.)

S: Should I just use my imagination?

E: Yes, just tell me what you see. (It is more appropriate to use the

word see rather than reminds you of to questions of this sort, stress-
ing perception rather than association.)
S: (After giving a response) Is that the kind of thing you want?
E: Yes, just whatever it looks like to you.
S: Is that the right answer?
E: There are all sorts of answers.
S: Does it look like that to you?
E: Oh, I can see a lot of things.[6]

The pursuit of detail takes place in a second, "Inquiry" phase,
after the subject has completed the raw identification of the
"Response." As in the response phase, while the subject speaks,
the examiner helps the cards to respond (by studiously not help-
ing). "Now we are going to go back through [the cards]," the
examiner instructs. "It won't take long. I want you to help me see
what you saw. I'm going to read what you said, and then I want
you to show me where on the blot you saw it." While probing for
elaboration of the original response, it is Rorschach axiomatic
that no *new* information emerge during the inquiry. If the exam-
iner suspects that the subject is introducing a new interpretation
during the inquiry, the examiner should record but not score the
comment. Here is an Inquiry exemplar, written in the agreed-on
shorthand of the trade:

Response:	Inquiry:
S: I supp this cb a wm in the cntr	E: And then u said supp this cb a wm in the cntr
	S: Yeah, c here (outlines), her shape. & she's got her hands up lik she's waving or sthg

The examiner then sketches the outlines of the waving woman on
a workbook template. It is widely recognized among examiners

264

that distinguishing "new" from "original" material requires skill and training — and the examiner's ability (when appropriate) to disqualify his own questions as leading.

"Scoring" is the third, highly regimented phase of the process. Rorschach divided the scoring process into an evaluation of four axes that crudely might be summarized in four questions: How many responses? Are the answers linked to form or color? Is the figure construed from parts of the images or the whole? What does the subject see? In addressing these questions, the examiner uses a set of codes: Codes of structure include W (whole), D (detail), C (color), M (movement), F (form), and a host of complex combinations and subdivisions. Alongside these are codes of content: A (animal), H (human), and numerous others. So a "butterfly" in plate 1 would be given by WF+A to designate a whole-plate image, of good form, of an animal. "Two angels with streaming robes floating in the air" seen in the same plate would yield DM+H, that is, a detail-based answer, well-specified form, human kinesthesia (motion), with a whole-human form: DMF+H. There are certainly subtleties in ascertaining border cases where motion (kinesthetic response) might or might not be judged present. For example, the simple report "this is an airplane flying" might well be rated without movement, while "a clown precariously balanced on a chair" would count as M. From these raw response encodings, a host of quantitative measures can be computed, numbers of individual responses — for example, percentage of A (animal) images — or more complicated ratios, such as the very important ratio of form-dominated color responses to color-dominated form responses.

But by and large the hardest part comes in the fourth, and final, phase — "Interpretation." Though the interpretative project has been extended to an extraordinary number of other domains, including patterns of self-perception and styles of ideation, the core

interpretative idea was and remains what Rorschach called the "experience type" (*Erlebnistyp*). Specifically, Rorschach set up an opposition between a framing pattern of experience that is intense in attachments and rich in inner life, on the one side, and one that was more extensive, outwardly directed, and impulsive in affect, on the other. By studying the articulation and maintenance of these *types*, we can begin to sketch the contours of a new self, one very different from the aggregate faculty-self of the mid- to late nineteenth century. But before entering into that discussion, it is worth pausing (all too briefly) to locate Rorschach himself at that evanescent crossing point of Swiss psychoanalysis, sociology, psychometrics, and physiological psychology.

Territory of the Test

Not a great deal is known about Rorschach; there is little doubt that the historian of the unconscious Henri Ellenberger produced one of the best, admiring articles about the master of the inkblot. Intriguingly, Ellenberger has three origin stories. The first is a kind of fate-by-name: it seems that young Rorschach (*sans blague*) actually carried the nickname "Klex" as a child, after the inkblot parlor game that he apparently so loved. Justinus Kerner had popularized the genre with his inkblot plates accompanying his lugubrious 1857 book of poetry (*Klecksographien*). *Klecksen* means "to daub," and mediocre paintings were often known as *Kleckse*, *Kleckserei*.[7] Ellenberger's second origin story takes place at the height of Rorschach's medical training in Zurich and Neuchâtel (he graduated in 1906). It seems that the inkblot emerged as if in a dream, in Rorschach's reporting a dream after viewing the autopsy of a human brain:

> The dissecting of the brain interested me particularly, and I joined to it all kinds of reflections about the localization and the cutting up of

the soul. The deceased had been an apoplectic; the brain was cut in transverse slices. The following night I had a dream in which I felt my own brain was being cut in transverse slices. One slice after another was cut off from the mass of the hemispheres and fell forward, exactly as it had happened at the autopsy. These bodily sensations (I lack a more precise designation) were very clear, and the memory of that dream is even now fairly vivid.[8]

Rorschach used this dream in two related ways, both connected to the third origin story having to do with Rorschach's genial appropriation of local intellectual resources. The dream featured prominently in his doctoral work "On Reflex-Hallucinations and Kindred Manifestations" (November 1912), in which he addressed the problem of how hallucinatory experiences could exist when they corresponded to physiologically impossible states. Written in the framework of Eugen Bleuler's associationism, Rorschach's paper was also tied to the experiments of a rather odd Norwegian psychologist who explored the ways in which constrained physical states induced movement in dreams. (He tied up sleeping students.) Over the next decade, Rorschach returned again and again to this reciprocal relation between external and internal motility.

In Carl Jung's orbit, the purely physiological and ideational were never enough by themselves. By 1911, Rorschach had, on one side, begun linking his work on hallucinations to symbolism. On the other, he had launched a program of experimentation, allowing patients not only to paint but also to free-associate both to paintings and to inkblots (on the model of and comparison with Jung's word-association test).[9] During the years after 1911, he analyzed artwork for its inner meanings, as in his "Analytic Remarks on the Painting of a Schizophrenic," where the artist-patient gave all the Last Supper diners the long hair typical of women except Judas. Rorschach took his research out of the clinic

too: as in his sociopsychological examination of Johannes Bing-geli's *Waldbruderschaft*, a Swiss cult in which Binggeli taught the initiated that his penis was sacred and worthy of adoration. These inquiries led Rorschach to a cultural psycho-geography in an effort to understand the schizophrenic cult leader as a type pref-erentially arising on the disputed boundaries between the racial groups of Switzerland.[10]

From 1915 to 1922 (the period in which he wrote *Psychodiag-nostik*), Rorschach worked at the Heil- und-Pflege-Anstalt in Herisau, the cantonal asylum of Appenzell (eastern, German-speaking Switzerland). All around in this period there were psy-chological studies of image associations, but one could not be ignored. A Polish student of Bleuler (Rorschach's own adviser), Szymon Hens, had experimented on inkblots (still as a test of imagination but now administered to mentally ill as well as nor-mal patients), work he completed for his doctoral thesis in 1917.[11] Jolted in part by Hens's thesis publication, Rorschach returned to his old investigations of 1911 and tried to organize a psychoanalyt-ical society that would eschew the parochial views of any single approach.

Rorschach's search for neutrality marks his work from his the-oretical aims and his efforts to found an ecumenical society to the detailed design of his "random" images.[12] In part, that hunt for neutrality issued from the Swiss psychologists' precarious location between the larger schools of Austria, Germany, and France. Even within Switzerland, Rorschach seems always aware of the power-ful gravitational forces pulling the field toward such figures as Eugen Bleuler, Carl Jung, and Ludwig Binswanger. This search for autonomy (intellectual and epistemic) dominated Rorschach's 1919–1921 correspondence with Walter Morgenthaler, his friend and former senior colleague from his stint at the Waldau Mental Hospital (summer 1914 – October 1915). Immediately on leaving

Waldau, Rorschach became head doctor at the institute and asylum of Herisau in the canton of Appenzell; in Herisau, from 1919 to 1921 he fought a pitched battle to bring his blots into print. Throughout, Morgenthaler remained both a sympathetic mentor and a go-between in the publishing process. (Morgenthaler himself was then in the midst of an effort to publish a work at the boundary of art and psychiatry on the art-brut painter and convicted schizophrenic child molester Adolf Wölfli.) Like Rorschach, Morgenthaler desperately sought a neutral methodological ground on which to locate this boundary work between art and psychiatry. In fact, the senior psychologist told Rorschach that he hesitated to join the Psychoanalytic Society (of which Rorschach was slated to be vice president) because he feared that the organization would fall sway to a parochial orientation. Morgenthaler wrote:

> What has kept me away until now, and still does, is the fear of having to adopt a single orientation and losing the freedom to take individual positions regarding different problems and findings, as I do now. In my opinion, Freudian theories have grown out of their early stage when they did need to be cared for and discussed within special societies. Freudian theory has fully permeated psychology and psychopathology and has become, particularly for me, one method of psychotherapy among all the others.[13]

Maintaining neutrality was essential, Rorschach agreed, but "in the present union there is no danger that the spirit of bondage will penetrate. Even if Freud here and there appears with an all too papal nimbus, the danger of becoming a hierarchy can best be avoided if people come together who interact and have a sense for various viewpoints."[14]

As for the blots, Rorschach insisted that the printer (Ernst Bircher) produce them with a uniformity and accuracy that would

avoid any deviations; Morgenthaler was a consultant and go-between on these publishing plans. "If he makes difficulties about the blots, then the matter is finished," Rorschach insisted in January 1920 to Morgenthaler, "because the special publication makes sense to me only if really all of the blots are genuinely reproduced as much as possible, so that the total represents a test apparatus."[15] As became clear, Rorschach not only considered the uniformity of the prints to be significant; he also had inscribed in the plates themselves a very specific notion of color, symmetry, size, and density. Late in March 1920, Rorschach related his printing woes to Morgenthaler, citing the contract, which specified the reproduction of ten colored blots: "Of these blots, 5 are black, 2 are black/red, 1 has 3 colors, 1 has 4 colors, and 1 has 8 colors. [The contract must] indicate that the reproduction of plates be *true to the original plates*: size, number of colors, etc. have to correspond to the original plates. Otherwise, naturally, the whole has no meaning."[16]

Every aspect of the plates had to be purged of manifest allusion to extraneous bits of visual culture. Otherwise patients — especially ill ones — would latch on to some perceived referential bit of the plate even before engaging with the image. Rorschach explained to Morgenthaler on April 18, 1921:

Eventually, I will put a note on the blots folder describing how they can be glued on fabric.... As you will see, it is preferable that the picture is not bordered by the canvas (fabric) and instead gets glued on it so that the fabric should be no more than 3 mm over the border of the blot. When there is a darker border, especially if it is on the surface, it induces some depressed patients to have the impression that it is a "death announcement." And this diminishes further their already feeble ability to associate.[17]

It was not that Rorschach wanted to preempt the depressed patient from lugubrious associations; open-ended association was, after all, the entire goal of the enterprise. Instead, the "death announcement" frame would, in Rorschach's view, so deepen the depressed subject's state that the poor soul would be voided of the little free energy he possessed, making it impossible to see the blot *as* anything at all. Association would fail. And the cards — all the cards — would become nothing but incapacitating harbingers of death.

Not only did these cards talk; they did so in virtue of their form and color down to the smallest detail. If the blots suggested even a shard of human design, certain patients would seize on that fragment, losing their own ability to speak from within. For this reason, nothing was more important to Rorschach than creating and reproducing cards that would register as undesigned designs, unpainted paintings: "[I]f the small printed border is not sufficiently precise on some of the blots [after cutting the sheets] or still partly visible here and there after pasting, the blot could still leave visible a small bit of intentionality [*Absichtlichkeit*], and there are [schizophrenics who] react very negatively to the tiniest bit of intentionality."[18] In order for the subject to speak, the card, and the card's author, had to find a perfect silence. This meant that every blot must be produced with exquisite care. Demanding fine adjustments even at galley-proof stage, Rorschach insisted with regard to one card that "the light tones, especially in the upper right, must be darker so that the color looks somewhat flatter."[19] Unintentional arbitrary form would emerge only by the extraordinary exertion of a determined and fully intentional design: an exquisite art of artlessness.

Even the title of Rorschach's book became a matter of contested neutrality. Morgenthaler pleaded with his young colleague to find something less modest — and frankly less unappetizing —

than "Method and Results of a Perceptual-Diagnostic Experiment (Interpretation of Arbitrary Forms)." What about "PSYCHODI-AGNOSTIK"? Morgenthaler asked. Rorschach demurred, saying he was determined to emphasize the limited scope of the test and wanted a title that would not, by its use of German or philological invocations, "sound strange as almost to be mystical." He believed that a kind of positivist equipoise could be maintained in a system of neutral, associational diagnostics. This minimalism would protect the work from the overbearing claims of more ambitious projects:

> Expressions such as "Psychodiagnostik"... go too far. I don't want to give the impression that one can make general psychograms with the experiment, and in that context I have tried to put the brakes on that idea in several places in the text. Perhaps later, when there is a norm created through controlled investigations, such an expression can be used. For now, though, it strikes me as too pompous.

Morgenthaler pleaded for the ambitious title, promising Rorschach he could display his modesty through the subtitle; in the midst of "these bad times" no one in his or her right mind would shell out twenty or thirty Swiss francs or a hundred German deutschemarks for "A Perceptual-Diagnostic Experiment." Rorschach "unhappily" ceded. *Psychodiagnostik* rolled off the press in 1921.[20]

Rorschach's neutralist inclinations were lost on no one. Some praised the scientific character that abstemiousness gave his work, while others found that his atheoretical approach limited the work. The phenomenological psychiatrist Ludwig Binswanger, for example, wrote Rorschach in January 1922 first to praise the work as a natural science of emotional life and to characterize it in psychoanalytic terms. The anal-erotic character (according to Binswanger) registers certain sensations; those sensations (in Rorschach's language, the particular pairing of movement and color

sensations with an *Erlebnistyp*) could be further pursued as characterological features. But at the same time, Binswanger rejected Rorschach's reliance on association psychology and urged the young researcher to avail himself of the tradition of work issuing from Edmund Husserl (work, it should be said, that Binswanger had done much to promote). Indeed, Binswanger reminded young Rorschach that he had once confessed to Binswanger his desire to escape his "scientific autism" (*wissenschaftliche Autismus*). Rorschach deferentially replied that he knew it was high time to produce a theoretical gloss of his experiments and that he recognized the limitations of associationist psychology. Yet he admitted to a frustrated confusion about where to look for theoretical backing.[21]

Scientific autism notwithstanding, Rorschach's determined neutrality was key to the test's success. Freudians could use it; so could Jungians. Binswanger clearly saw uses for the new tool, as did Bleuler. In fact, just this flatness, this *dis*-association of the procedure from any "sectarian" school, blocks attempts to single out any one "origin" of the test. One of Rorschach's colleagues had previously written a paper comparing the ascription of meaning in the divination of water with the Jung word-association test. Surely that could be considered a "root." Another published on "unconscious picture riddles in the normal," letting patients associate, scribble, and find shapes.[22] That, too, could be a source. Rorschach's wife later recalled the pensive reverie into which her husband fell when they read together the passage (in a biography of Leonardo) about the images to be found in stones, cracks, ashes, and dying embers.[23] There was Bleuler's associationist psychology to reckon with (through which Rorschach was trained), as well as Hens's "formless picture" tests of visual-imaginative power in children, adults and the mentally ill. In the background, too, lurks the art of Rorschach's father, not to speak of Rorschach's own childhood fascination with Klexographie and the uses he made of

it (and the art-psychiatric link) in his earlier psychological studies. While it may be a useful project to try to attach coefficients of importance to each of these "origins," that project is not mine.

Instead, the crucial point is that the confluence of experimental associationist psychology, therapeutic use of pictures, and psychoanalytic notions of projection, introjection, and free association were, during the second decade of the twentieth century, more intensely studied in the three major clinics of Switzerland than anywhere else. The search for neutrality — Rorschach and his Swiss colleagues' hunt for an *überparteilich* epistemic stance — signaled an attempt to avoid the often bitter and parochial psychiatric battles that divided the profession. One could follow those internecine struggles into a comparative "reception history" of the Rorschach test, examining its changing status and use throughout Europe and the United States while attending to its differential acceptance among the various psychiatric schools. Here I will follow the neutrality question in another direction — with the goal of using inkblots to unravel the complex relation among subjectivity, objectivity, and inner life.

Most urgently: What logic of the self did the test embody? To approach that question is to treat the technology of self — its measure through the Rorschach system — not so much as a world-historical unfolding of the ethics of selfhood (as Michel Foucault has argued). Nor is it to expand the techniques of the self to include more than classical ethics, also the practical dimension of classical logic and physics (as Pierre Hadot has suggested in his criticism of Foucault). Instead, I am here principally concerned with a kind of technique of the self that is more local, more material. It means following the micro-establishment of the self, not in the abstract but in the routinized procedure followed in thousands of ordinary tests. In turn, this requires treating the Rorschach test not just as a set of plates but as plates situated within a system of charts,

tables, and graphs, of scripted questions, calculated indexes, and downloadable computer programs. Only then is it possible to ask what this system of procedures presupposes about the status of the self it aims to assess.[24]

This takes us to our last goal: to specify that notion of self that fits the Rorschach measurement technology. After all, measuring instruments and the objects they study often enter together: scan the heavens through a radio telescope, and the sky-scape lights up one way; look through an optical scope, and very different elements become its major features. By a measurement technology, I do not mean something as general as any abstract procedure. I have in mind technology in a more ordinary sense: a technology of the self as a grubbier, saturating, hands-on affair mixing charts, hardware, and procedures the way so many other measurement routines do. Navigation, microscopy, carbon-14 dating — all marshal complex mixtures of electronics, reference guides, and bits of the physical world. The Rorschach, too, combined a heterogeneous set of inputs as it came to be regularized through the standardization of cards, sitting, lighting, timing, presentation, scoring, and analysis. But there is this difference: by its ubiquity, the Rorschach test *saturates* contemporary culture in a way that the electron microscope does not. When Andy Warhol produced his enormous Rorschach canvases, he could count on our recognizing the genre as he playfully subverted authorship, meaning, interpretation — even the idea of his own fixed and determinate self.

Interpreting Interpretation

There is more than just a difference in procedure between the imaginarium of the mid- to late nineteenth century and the interiorism of the early twentieth. At every moment, the Rorschach test presupposed a different ontology of the self from the faculties (or powers) assumed by a timed test of rapid association. Most

275

important, for Rorschach the imagination is *not* the principal object of inquiry, though he expected that his subjects might think so: "Almost all subjects regard the experiment as a test of imagination. This conception is so general that it becomes, practically, a condition of the experiment. Nevertheless, the interpretation of the figures actually has little to do with imagination, and it is unnecessary to consider imagination a prerequisite." It is true that the test aims to *test* imagination, but it does so among many other characteristics: "*The interpretation of the chance forms falls in the field of perception and apperception rather than imagination.*"[25]

This raises a point of immense theoretical interest to those of us conversing with talking things. For nearly a century, the great centerline of philosophy of science has been the demarcation of "seeing" from "seeing as." Fundamental to the Gestalt psychologists, this division shaped discussions throughout the long run of neo-Kantian philosophical psychology all the way from Ludwig Wittgenstein and Thomas Kuhn through recent work in the sociology of science. Rorschach's intervention demands that "seeing" and "seeing as" be taken not as fundamentally alternative relations of perceiver to perceptions but as limiting tints at the edges of a full-color spectrum. Indeed, the archive of Rorschach overflows with cases in which "interpretation" is an inappropriate characterization. Organic cases of mental illness, people with senile dementia, paretics, epileptics, schizophrenics, many manics, almost all feebleminded, and many normals are simply not aware of the assimilative effort that registers the *difference* between perception and "seeing as." That is, *laut* Rorschach, the effort of integration gives rise to the conscious recognition of "interpretation" as such. If the threshold for the registration of that assimilative work is high, the cards are "seen"; if the threshold is low, the subject becomes conscious of interpretation and the cards are "seen as." Pedants and depressives, for example,

characteristically find the cards uniformly "changed" or "strange." Both are acutely aware of the interpretative act, since the reporting effort immediately crosses the low threshold of awareness.

The crucial point: Rorschach concluded that *"the differences between perception and interpretation are dependent on individual factors, not on general ones; that there is no sharp delineation, but a gradual shifting of emphasis; and that interpretation may be called a special kind of perception."*[26] For brevity I use "apperception" as a shorthand for Rorschach's claim that perception relates to interpretation as genus to species. Setting aside for the moment the ultimate status of the Rorschach test (Is it "objective"?), it is possible to pursue some implications of this claim for apperception. First, it marks a shift in the logic of the self: *from* aggregate powers manipulating specific contents *to* a framing disposition in which experience is necessarily situated — self as form, not content. Second, using Foucault's language in a different context and now in ways that tie them together, it means that the functions of subjectivation (how subjects are formed) and objectivation (how objects are formed) enter at precisely the same moment. To describe the cards (on the outside) *is exactly* to say who you are (on the inside). Read one way, that link between perception and personality is a straight-ahead claim of psychometrics. But it is possible to take apperception in a different way, removed from the detailed and sometimes incompatible coding mechanisms of the various Rorschachian sects and their ferocious internecine battles. (School leaders Bruno Klopfer and Samuel Beck would not speak to each other.) Taking a more abstract and more historical perspective, one could say that the massive popularity of the Rorschach test over the course of the twentieth century signals (and conditions) a specific concept of self. That historical apperceptive self is picked out by its insistence on relations of depth and surface, inner and outer life, and the inseparability of ideation and affect.

The world of the apperceptive self is full of *very* talkative objects. In the late nineteenth century, a subject who sat mute before one of Professor Kirkpatrick's cards simply scored zero, not unlike a screw sorter incompetent to plunk a flat head into a different bin from a round head. In Rorschach's universe, the cards not only responded to every utterance; they had plenty to say if the subject remained silent or simply reported that there were two blobs of ink: "Occasionally neurotic subjects fail to answer; this is caused by inhibitions due to complexes." These complexes can be of various sorts, one of the most striking being the "color shock" that certain subjects exhibit when faced with several of the later cards. For example, in one case study one of Rorschach's subjects facing (color) plate 9 said, "I don't know, nothing much comes to me," to which Rorschach appended: "Suppression of color responses as expressed in color shock is a pathognomonic sign of neurotic repression of affect." Other kinds of subjects also occasionally refuse to answer; feebleminded hysterical subjects may not respond "because they are afraid they will give stupid answers; we deal with an 'intelligence complex.'" Schizophrenics ordinarily do not so much refuse *ab initio* to respond to color; instead, quite suddenly they refuse to carry on with responses at all.[27]

From Rorschach's time to the present, identifying schizophrenics has been an important goal of the test. In the last decades, this has meant tweaking the statistical package to maximize the overlap of schizophrenics diagnosed through the Rorschach test with individuals diagnosed through the checklist behavioral and affective criteria of *DSM-III* (the standard psychiatric guide). The Rorschach Schizophrenia Index formula is complex, involving the number of distorted forms and white spaces, along with the number of responses that exhibit extreme "dissociated, illogical, fluid, or circumstantial thinking":

"It's the destituteness of the world, evil and hollow"

"It's the universal hole of a female vagina"

"It looks like two men have raped some stones"

"It's a face with Cousteau's bra across the mouth"

"It looks like the double twin two peaks of Mt. Rushmore"[28]

According to the Rorschach bible (Exner's three-volume reference work), a score of 4 on the SCZI (Schizophrenia Index) is cautionary; at 6 or 7 the diagnosis begins to overlap almost entirely with one made according to *DSM-III*.

Although Rorschach wanted to diagnose pathology (and in various aspects of normal intelligence, affect and ideation), by far his greatest interest was in the axis separating kinesthetic responses suggesting human movement (M) and responses emphasizing color (C). A subject of "above average attainments" (university graduate, twenty-nine years old) had a very high level (97 percent) of highly resolved forms (F+); six movement-indicating responses; no pure-color responses; no responses first identified by form and then by color (FC); and only two responses that were in the first instance color-oriented, secondarily implicating form (CF). Schematizing hundreds of such particular cases, Rorschach laid out the two extrema as ideal types:

Kinaesthesias Predominant (Introversive)	Color Predominant (Extratensive)
More individualized intelligence	Stereotyped intelligence
Greater creative ability	More reproductive ability
More "inner life"	More "outward" life
Stable affective reactions	Labile affective reactions
Less adaptable to reality	More adaptable to reality
More intensive than extensive rapport	More extensive than intensive rapport
Measured, stable motility	Restless, labile motility
Awkwardness, clumsiness	Skill and adroitness[29]

Although Rorschach seems to have tried, in his prose, to re-
main clinically neutral between the two *Erlebnistypen*, his prefer-
ence for the human-kinesthetic "M type" is visible on just about
every page of his work. Introversion, as he calls it, is related to but
not quite the same as similar-sounding concepts that Freud and
Jung had advanced. For Freud, introversion was characterized by
the deflection of love from a real love object to an internal fantasy
world; at first, Jung generalized the notion but kept it pathologi-
cal: introversion was supposed to be the manifestation of an ex-
panded libido (the will in Arthur Schopenhauer's sense) redirected
from outside to inside in such a way that "the inner world gains in
(personal) reality to the same extent that the (universal) reality
loses in emphasis and determining power."[30] Subsequently, Jung
dropped the taint of pathology from introversion, but Rorschach
wanted to go further, raising the "introversive type" above the
normal to the top of the existential heap.

Similarly, Freud's notion of projection, used in 1895 and 1896
in a pathological setting, reenters as a "normal" aspect of the
psyche in the metapsychology of 1913 (*Totem and Taboo*). Freud
famously cast God as the psychological projection of the father;
beginning in 1939, it became increasingly common to refer to
the Rorschach test itself as projective (though Rorschach, who
had long since died, never used the term).[31] Now, while there are
clearly projective elements in Rorschach's conception, the under-
lying idea is actually more radical than that; it is that the axis
projection-perception, like the axis perception-interpretation, is
empirical. Be that as it may, in its manifold uses during the 1930s
and after, the test clearly became a useful phenomenological ac-
cessory for the psychoanalytic community.

This extrication of the test from the "sectarian" orientation of
Freud and Jung (or for that matter any other major school) is, I
believe, essential for understanding the extraordinary widespread

appropriation of the test. It meant that Rorschach could seize an already existing "market" for psychoanalytic reasoning about the unconscious (such as introjection, projection, and the detailed dynamics of symbolic representation). It fitted equally well with Jungian word-association tests and dovetailed neatly with Bleuler's associationism. But in borrowing from his own psychiatric training, Rorschach stripped away much Freudian psychoanalytic specificity: no ego, no id, no superego in their full theoretical configuration. This question of the uptake of Rorschach's test merits much greater consideration, but now back to the *Erlebnistyp*.

"Introversive" in Rorschach's terms meant having the ability to turn in toward oneself, not necessarily being fixed in a state of introversion. This ability to find emotional resources *within* defined the type. By contrast, the "C[olor] type," or "extratensive," experienced the world through an outer-directedness, a restless motility, and unstable affective reactions.[32] On the basis of the relative weight of M-type and C-type responses, the Rorschach test aimed (and aims) to display the balance between these two ideal types. Even so, the *Erlebnistyp* does *not* and should not reveal

> *what* [the subject] experiences, but, rather, *how* he experiences. We know many of the traits and characteristics with which he goes through life, be these of associative or emotional nature, or a mixture of the two. We do not know his experiences; we do know the apparatus with which he receives experiences of subjective or objective nature, and to which he subjects his experiences in assimilation of them.[33]

The *Erlebnistyp* is not a complete picture of the psyche (a psychogram); instead, the type shows how experiences are conditioned. It might be thought of as a psychological inflection of

neo-Kantianism extended to affect, with a slogan like this: there is perception, affect, or ideation outside these conditions of possible experience.

Unlike Kant's categories considered in their transcendental function, Rorschach's *Erlebnistyp* varies from individual to individual, over the course of a lifetime, and between racial and even sub-cantonal groups. Nonetheless, the variations fall within the space of Rorschach's parameters. Put another way (not Rorschach's): the human personality exists in an experiential type-space analogous to the three dimensions of form, movement, and color. Personality (*Charakter*) is neither determined by nor entirely immune to external experience. For example, important as it is, disciplined thinking is an acquired trait, and it shows up on the projective test in a statistical tendency to proceed in an orderly manner, for instance, from analysis of wholes to analysis of parts. *Charakter* (whether introversive or extratensive) is made up of the "inherent, primary qualities of the constitution."[34]

Because the inner characterological structure of the individual is a hybrid of exterior conditioning and intrinsic structure, Rorschach registers changes on many levels. Individual *mood* can shift the Rorschach registration: a transient depressed mood shoves a person toward the introversive end of the scale, a miniature version, so to speak, of clinical depression. Observing a subject over the course of a lifetime, Rorschach also saw characteristic flow of the young child from extratensive toward intratensive, then back out in later life toward extratensive. *Groups*, too, could bear their own statistical distribution of experience types. Early in his career, Rorschach explored what he considered characteristic differences between the extratensive Appenzeller of eastern Switzerland (whom he clearly disliked) and the introversive Bernese (with whom he identified). Schizophrenic Bernese fell more easily into a catatonic state, and their delusions were more florid, mythical, and isolated;

the Appenzeller usually manifested the disease through more conventional delusions without losing social contact.

When *Psychodiagnostik* appeared in 1921, Rorschach was ready to expand the study to racial contrasts, an enthusiasm that permeated testing of all sorts in the 1920s and remained a standard part of comparative anthropology well into the 1960s. Even disciplining experience could, within bounds, alter responses. The bureaucracy could clearly pull a person toward the repressed end of the spectrum, a circumstance that could either encourage certain tendencies or conflict badly with an already established personality. More generally, the manipulation of the outside ("fonction du réel") could alter the frame of experience: "Rhythmic, staccato speeches, 'worldly' music with powerful rhythms, rhythmic flag-waving, and in the center the bright red blouse of the old general. This is certainly no 'turning in on oneself.'"[35]

As the Rorschach system was modified into its canonical "comprehensive" form in the 1970s, 1980s, and 1990s, the *Erlebnistyp* became the "cornerstone" of evaluating decision-making patterns more generally. Introversives (high M) tended to prefer precise, uncomplicated logical systems, with all alternatives laid out in advance; extratensives (high C) mix thinking and feeling much more thoroughly, giving rise to more complex cognitive patterns and a greater inclination to reverse decisions. Too sharp a weighting on one side or the other correlated with inflexible problem solving.[36] That was not all. Over the decades, the number of variables increased enormously — not only vast compilations of plots exhibiting possible details and patterns for each card but new categories altogether. Textures and blends, among other variables, entered, along with a raft of specific ratios and clusters.

When I say the Rorschach test is a technology, I mean it. Testers have long been able to reach for the 741-page *Index of Rorschach Responses*, for example, and draw on the twenty-thousand

responses — sorted by keyword, content, and card segment — given by five hundred or so Johns Hopkins medical students during the 1950s.[37] A more up-to-date tool enters with the personal computer: costing about $595, a computer scorer will compile scores into various compilations, clusters, and statistical correlations and *interpret* the results following one of the standardized approaches.

Here is an excerpt from the advertised selling points of one popular routine:

- Unlimited-use software automatically generates an on-screen Structural Summary and Sequence of Scores, both of which can be printed.
- Professionally formatted narrative report provides interpretive hypotheses based on the individual's responses.
- If a Structural Summary report would not be valid due to a low number of responses, RIAP4 Plus will still generate the client's raw data and constellations, but without any ratios, percentages, or derivations.
- You have the option to select which sections of the report will be generated: Structural Summary, Sequence of Scores, and/or sections of the Interpretive Report.
- Memo fields facilitate recording of general notes to complement, refine, and personalize the interpretive report.[38]

To give an idea of the kind of interpretation that the automatic scorer produces (much shortened by me), here are a few excerpts. This is an automatically produced case file built on the record of a twenty-seven-year-old man tested in March 1999:

The following hypotheses are listed solely to provide an initial orientation to some of the data in this record. A full analysis of the data is

required to confirm or reject their validity. No summary or synopsis is intended.

He has an inflated sense of self-worth. Many psychological operations are used to protect and defend the ego. The person's style of coping with problems is extratensive. There are indications of affective distress relating to depressive features. Problems with interpersonal relationships or cognition are evident. He has problems with processing information. Considerable pessimistic or negative thinking is present. Problems involving the need for interpersonal closeness are likely. He is avoiding or being excessively cautious about emotionality....

Suicide Potential: → *The Rorschach indicates a* **very strong suicide risk**. The SCON [suicide constellation of statistical factors] at this level has a very small probability of error in predicting a fatal suicide attempt. **Take precautions!**

Endogenous Depression: A diagnosis of major affect disorder or dysthymic disorder should be considered, especially if the history is positive. However, this value of the DEPI [Depression Index] may falsely indicate depression, may simply indicate recurrent depressive features, or may detect precursors to depression not yet clinically evident. Psychosomatic or anxiety symptoms may express the underlying disruptive affect. Dysphoric ideation is likely. His underlying attitudes, expectations, and views of life and self may be pessimistic, negative, and self-defeating. His coping style suggests depressive symptoms of confused and constrained painful feelings, intellectualization, and devaluation of self-worth.

His strongly dysphoric thinking about himself and the world may be the result of very hurtful or damaging past experiences. His self-concept may include feelings of vulnerability, incompetence, or

inadequacy. His negative attitudes stem from early developmental experiences, are persistent, and resist change, making it hard for him to use simple support or consolation.[39]

Of course, the computer did not produce this evaluation on its own. Seventy-five years of psychiatry work, clinical observation, and experimental work lie behind this output. One sees traces of the original Rorschach language ("extratensive") in the report, but much else besides. Behind the computer program lay long years of statistical studies that were used in the creation of indexes (such as proclivity to attempt suicide, "SCON," and the degree of depression, "DEPI"), in the process of which the studies were cross-correlated back to other psychiatric theories and classifications. But the very existence (and popularity) of such "automatic" scoring mechanisms buttresses the experience of neutrality that Rorschach himself sought. Here, at last, was a routinized system of card deployment that at nearly every stage appeared to sidestep the immediate involvement of anyone but the subject. The patient looked at the blots and reported on what he saw, and the card machine then scored, evaluated, and located him in a complex space of forms of perception: "negative attitudes," "dysphoric thinking," "vulnerability," "resist[ance to] change," problems "processing information," low "self-worth," and, most menacing of all, in that dangerous corner of interpretation, a very likely candidate for suicide. The cards have spoken.

Subjects and Objects

Staring into the inkblot, we can begin to make out very different structures in its use. Since the time of Leonardo, "chance" images have held pride of place as exercises of the imagination, signs of provocation to the imaginative gift. Toward the end of the nineteenth century, inkblots found a special place in the examination

286

armamentarium: a faculty-specific test of the imagination along-side tests of the various other faculties. Because the test aimed to measure the *specific* power of the imagination, it reinforced the faculty-psychological concept of self. No better way to reinforce the reality of an object than to measure it, collate it, compare it, publish it — over and over. But a full-bore inquiry into the technology of self in the Binet era (up to and including Szymon Hens) would have to go much further than anything I have done here; it would take each of the "powers" (and its appropriate test) to track the history of its hypostatization. If we had such a history, it would constitute part of a technological history of the late-nineteenth-century aggregate self.

The Rorschach test presupposes a very different ontology of self. There is no atomistic separation between *any* of the faculties or powers. Take imagination. In Rorschach's inkblot world, imagination simply is not a well-defined *power*; nothing in the test presupposes an organ, so to speak, of imagination. Indeed, for Rorschach, imagination manifests itself in the experience frame of the introversive in a way very different from that of the extratensive. For the introversive, who perceives reality more clearly than the extratensive, there is a tone of pleasure to the interpretative act: interpretations are complicated, the task is a game. For the extratensive, there is little pleasure here — perhaps a triumph, because of the brilliance of a performance as received by others — because the extratensive (in the limiting case) may not even realize that he or she is interpreting; the act may more resemble confabulation.[40]

In general, cognitive features in the Rorschach system (such as the degree of rigidity in problem solving or the diversity of logical forms of argumentation) do *not* live separately from affective features (such as relation to other people, vigilance, or aggression). One might think here of similarly deflationary pictures of reason

287

in Friedrich Nietzsche or in Freud, Freud having famously remarked, "The ego is no longer master in its own house." But it was the Rorschach test in its multiplied, routinized form that *automated* this "X ray of the mind" in such a way that the mental powers and affective structures were fundamentally linked. I suspect that it is precisely this automaticity that makes displays like the RIAP4 Plus report I quoted so uncanny (in Stanley Cavell's sense of simulating the human). You say: I see these colors, these figures, these movements, these shadings. The card machine replies at the speed of computation: You are obsessive, isolated, disordered in your thinking, and should be placed under suicide watch.

Objectivity, as it was understood, demanded routinization. Routinization pulled intervention from observation and worked all out to make science into a machine. Not surprisingly, many psychologists pushed the test toward such a mechanical procedure, from precise reproduction of inkblots to detailed scoring manuals, from scripted inquiries to computed statistical summaries and automated interpretations. The apparatus of social-scientific objectivity entered again and again in the research of nearly a hundred years of Rorschach studies that have probed the validity and reliability of the test. Predictions are perhaps the clearest indicators of validity, and psychologists have duly pounced on them to study the correlation between Rorschach test results and such observables as future academic success, psychiatric consultation, or attempted suicide. But validity could be addressed in other ways too — for example, comparison of Rorschach results on color shock with physiological indicators such as skin conductivity as an indication of emotional distress. Experimenters have even tried administering the test with the subject under hypnosis or mood-altering drugs to see if the results altered in expected ways. Tests of reliability (robustness of the results) have been

undertaken by splitting the test in two parts, by retesting after thirty days, by having different judges match scores and interpretations from many different subjects.[41]

But behind this vast industry of validity and reliability assessments, behind the volumes of indexed responses and statistical compilations, lay a concept of a unified self with dynamic relationships among its various components: a self for which perception was always through an inseparable complex of reason and affect; an interior self for which it was appropriate to speak of private experience. Although present from the start of Rorschach's research around 1920, this "Rorschach self" (so to speak) crystallized around Lawrence K. Frank's identification of the test as *projective* in an extraordinarily influential article of 1939. From that point forward, the ontological structure of the self acquired a visual-physical representation that has been repeated ever since. Likening Rorschach tests to standard beams of X rays or polarized light, Frank contended that an "individual personality" resembled the sample probed by these beams. Suddenly he — and we — could imagine the self like a test object: "The subject ... is made to bend, deflect, distort, organize, or otherwise pattern part or all of the field in which it is placed." That deviation characterized the subject, be it a thick film of carbon fibers or the perceptual apparatus of a delusional schizophrenic. Frank wrote:

> We elicit a projection of the individual personality's *private world* because he has to organize the field, interpret the material and react affectively to it. [A] projection method for the study of personality involves the presentation of a stimulus-situation designed or chosen because it will mean to the subject, not what the experimenter has arbitrarily decided it should mean (as in most psychological experiments using standardized stimuli in order to be "objective"), but rather whatever it must mean to the personality

who gives it, or imposes upon it, his private, idiosyncratic meaning and organization.[42]

A personality "is the way an individual organizes and patterns life situations" and "structuralizes his life space"; it shapes the way the subject perceives cloud pictures, amorphous clay shapes, or music. As such, personality is a "process," not an entity or an "aggregate of traits, factors, or [a] static organization."[43] The contrast is stark: older Binet-style tests assumed the existence of a self *exactly* defined through such entities — an aggregate of fixed traits or powers.

Frank took the projective test to be modeled closely on recent developments in physics, chemistry, and biology. Physicists, he argued, had gone beyond the older, purely statistical methods (such as reading the temperature of a gas from a thermometer) by developing devices such as the cloud chamber and the Geiger counter that were capable of studying individual atomic processes and structures one by one. Now the Rorschach test promised to do just that for the individual psyche. It would be an X ray of the mind in the analogical sense that the individual's characteristic scattering (mode of perception) altered the "test beam" (inkblots) in measurable ways. In the field of meanings, symbols, and values, Rorschach's plates promised a glimpse into the complex internal dynamics of the self.

The World Is a Test

As the Rorschach came to be a diagnostic tool deployed in an ever-expanding number of contexts, its categories were naturalized. In the Second World War, the Americans adopted the test as a standard entry exam for many kinds of service. Germans used it to test for racial type in their racial settlement (and annihilation) in the conquered East. When the Nazi war criminals took the test

in their holding cells, the tests entered a long debate over the psychology and sociology of evil.[44] More proximately, Rorschach tests have had a long history in assisting counselors in their provision of career advice in schools and companies. And in the courts, the plates continued to figure in forensics, from custody battles to sex crimes. Beyond its practical uses, the inkblot system has become a symbolic technology; the locution "something is a 'Rorschach'" has by now been lodged in the everyday speech of all the European languages. Far more than the widely used thematic apperception test or the word-association test, the Rorschach is truly a *saturating technology*, one that, by its visual omnipresence, meanders through the rhetoric of literature, art, and politics. At that powerful intersection of the literal and the metaphoric, the Rorschach test reinforces our sense that there is a complementary relation between an objective, neutral "test pattern" of the original inkblot and the subjective distortion of that pattern by our internal patterns of perception. We have learned — in no small measure through this specific technology — to envision the self alternately as a filtered camera and as a powerful projector.

Of course, the Rorschach test did not rotate the self from aggregate to apperceptive all by itself. The late-nineteenth-century history of "inner life" is a vast subject, one that includes cultural and social changes across many domains; this was a period in which new forms of domestic architectural space, family dynamics, autobiographical narratives, mass media, and political culture all took hold. But within this broader shift, the Rorschach test has played a dual role: it both reflected this new interiority and, more actively, provided a powerful assessment procedure, a universally recognized visual sign, and a compelling central metaphor.

If technologies of the self like the Rorschach are to be addressed head-on, then their histories must enter *with* our accounts of

scientific epistemology. It is impossible to speak about the history of objectivity (the ideal of a world imagined without us) without bringing the assumed nature of subjectivity (as a distorting lens) into the picture. Conversely, no account of Rorschach subjectivity (how we characteristically perceive our world) would be possible without a concomitant characterization of objectivity (how the world is without that distortion). We therefore need a *joint* epistemic project addressing the historically changing and mutually conditioning relation of "inside" and "outside" knowledge.

In Rorschach's time, such a joint inquiry might begin by examining the precise inner state deemed appropriate for objective scientific work. A clue can be found in Rorschach's *Psychodiagnostik*, where he insisted, "Coartivity [constriction of affect] is necessary if there is to be talent in the field of systematic scientific endeavor. . . . Maximum coartation leads to empty formalism and schematisation."[45] Here is yet another example of Rorschach's deep-seated conviction that affect and reason are inseparably bound. Intriguingly, Rorschach's view that the ideal scientist avoids "maximum coartation" suggests a turning away from *both* an ideal of automatic representation (the pure rule-driven mechanical objectivity) *and* an entirely rigid and emotionally constricted self. Purely cognitive powers — such as rule following, memory, and computation — would seem to be inadequate for significant science. I suspect — though it would take much more to show it — that the early twentieth century marked a dramatic transition from the pair mechanical objectivity:aggregate self *to* judgmental objectivity:apperceptive self. One would then correlate this break with another, equally important development. In field after field, scientists after 1920 explicitly began decrying the sterility of "purely objective" images of natural-scientific objects. In magnetograms of the sun, in X rays of the skull, in electroencephalograms of the brain, and bubble-chamber pictures of particle

physics, experimenters demanded that images be modulated by *subjective* judgments.[46]

True, many Rorschach experimenters aimed to render their test more and more mechanical by employing computer programs, reference atlases, and untrained clerks. In this sense, the test was becoming a quintessential objective measure of the subjective frame of experience: an aporia of the subjective self. But just at the moment when the Rorschach system seemed to be tumbling toward a pure automaticity, many leading voices in the field protested against such rule-bound interpretation. Marguerite R. Hertz, one of the most respected Rorschach authorities, put it this way in her summary essay for the insistently lab- and statistically oriented book *Rorschach Science* (1962):

> The various studies based on short cuts and sign approaches cannot be considered clinically valid or acceptable. [When] patterns are applied mechanically ... all evaluation of the dynamics of personality is excluded. This is a distortion of the Rorschach method. Clinically, results are sterile.... Those who emasculate the method with the view to giving it to clerks to handle are doing much to keep the Rorschach from attaining full scientific status.[47]

In ways that remain underappreciated, *judgment* came to reign at the vital intersection of the subjective and the objective.

The Rorschach system functions at this intersection of self and world, subjectivity and objectivity. These ten cardboard plates remain a remarkable technology, reaching as they do into the domain of the objective by their unformed, chance images and at the same time into the very core of private desires. At every moment, these plates take what we say about them and speak back to us about our innermost selves, through specific results *and* through the saturating metaphor of a self that projects, distorts,

transmits. Rorschach himself suggested that the system he was proposing modeled perception in a way that was not restricted to inkblots. Back in 1921, he emphasized the significance of an individual's choice in painting (expressionism versus impressionism, for example) as revelatory, just as he saw significance in the highly abstract reaches of philosophical preferences (Nietzsche versus Schopenhauer versus Kant). Rorschach's world of objects — and in many ways it is ours — is populated by a noisy, ventriloquized crowd. So do tell: What do you prefer?

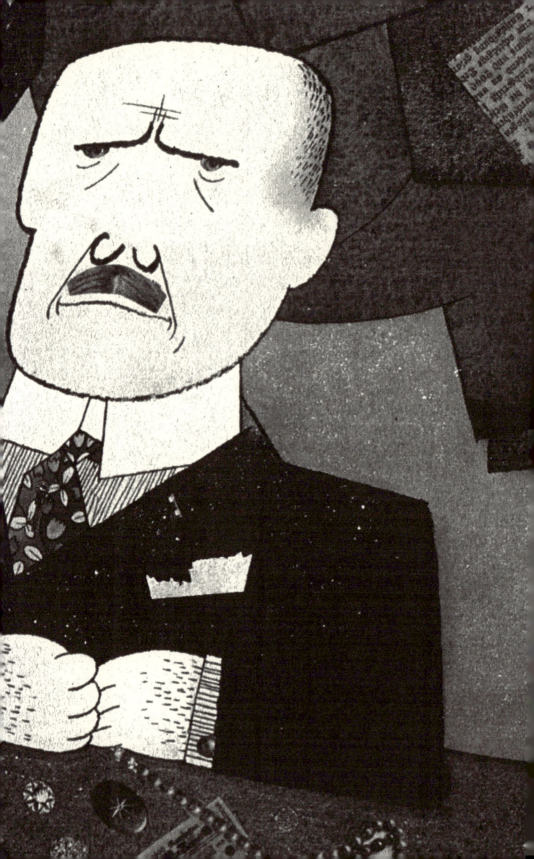

CHAPTER EIGHT

News, Paper, Scissors:

Clippings in the Sciences and

Arts Around 1920

Anke te Heesen

The agents of this account, an account of ways in which information was assembled and organized in early-twentieth-century arts and sciences, are widely familiar sorts of things: scissors, glue, and clippings. Most but not all of the clippings in question are from newspapers, and the majority of these newspaper clippings were cut and collected in the first decades of the last century. A longer history of the practice and the object of clipping has yet to be written in its entirety and would need to reach into present-day domestic culture. Everyone has a few newspaper clippings at home — reviews, reports, tips. Compiling newspaper clippings is a means of gathering and preserving information, whether one collects articles on Prozac, travel information, or reviews of a famous colleague's work. The Internet and its search and capture techniques (engines such as Google, techniques such as bookmarking) have begun to replace cutting practices. But the commands menu of the (word-processing) computer screen still contains traces of their history: one of the most familiar commands — cut and paste — is symbolized by scissors (cut) and a clipboard with a slip of paper (paste). Both command and icons were developed in 1970 at the Palo Alto Research Center, founded by Xerox Corporation,

and were later adopted by Steve Jobs, one of the founders of Apple, and developed for the Macintosh system.[1] From that time onward, the Mac visual-display unit (and recently Windows as well) simulated a desk complete with standard tools for textual work: scissors, folders, pages of text, empty sheets, pencils. The objects and processes to which these icons refer have an extensive history that goes well beyond the everyday practice of making newspaper clippings.

Since the Renaissance, "cutting and pasting" has been part and parcel of an active (philological) relation to a textual tradition. From humanistic literary working methods and notebooks to commonplace books and *Zettelkästen*, and from card-filing systems to digital data banks, traces of a long-standing history of cutting and pasting are in ample evidence. The invention of the printing press, as we know from Elizabeth Eisenstein and others, enabled such developments in the West.[2] Early bibliographies such as the one compiled by Konrad Gesner in mid-sixteenth-century Germany, and quotation systems, such as Daniel Georg Morhof's of the mid-seventeenth century, were developed in the face of progressively mounting literary production. Beginning in the later fifteenth century, a vast number of different techniques for working with reproducible texts and parts of texts, with notes, pictures, and quotations, were developed and perfected. While the ends and the products of cutting and pasting have changed over time, the practice itself has remained constant: pieces of a text or an image are isolated from a page by cutting them out, and these fragments are relocated (pasted) into a new context, whereby they may acquire a different meaning.

The invention of the printing press provided initial impetus, but improvements and technological developments have since generated new ways of cutting and pasting that are just beginning to be examined. Only in recent years have attempts been made to

look not only at how scientific thinking, for example, is produced but at the material practices involved as well. Note-taking practices, footnotes, marginalia, lists, indexes, and commonplace books have come into increasing focus.[3] Much remains to be said about the materiality of such notation systems, about paper and ways of working with it, about the history of the pencil or, indeed, the scissors. To understand paper as a thing, a three-dimensional object that we work with and that we not only read but handle, fold, glue, and cut as well, necessitates taking a closer look at the practices associated with it. Just as any thing shows new facets when viewed in the light of its technical and social functions, the history of those scraps of paper excerpted from newspapers and other publications and assembled in the form of collections is worthy of attention.

Numerous scientists, artists, and writers took part in collecting newspaper articles around 1900. A prime example of this is the huge clipping collection assembled by Franz Maria Feldhaus, a historian of technology and an information office employee. Starting in 1904, he collected everything available on the history of technology.[4] A fellow Berliner and brain anatomist, Oskar Vogt, compiled several newspaper-clipping collections through clipping services. The pathologist Rudolf Virchow had a less substantial newspaper-clipping collection, devoted to a single topic: he collected articles that included his name or the name of his museum. The novel *Berlin Alexanderplatz* (1929) by Alfred Döblin was written with extensive use of newspaper clippings, which the author pasted into his manuscript — a technique that, as he remembered it, he had derived from film-editing techniques and from the collages of the Dadaists.[5] The collages of Kurt Schwitters and Hannah Höch would be inconceivable without newspaper and journal cuttings.[6] One could go on and on, citing the *papiers collés* of the French Cubists, for example, or the role of newspaper

and typography for the Russian avant-garde or the art of the German Bauhaus.[7] Newspapers, their texts and their pictures, were primary materials of the arts and sciences around 1900.

This essay treats things that, in an obvious sense and by professional obligation, talk: newspaper clippings. It looks at how these things were produced — the technologies of clipping and pasting — and how they came to be reassembled in yet other forms that talk too: newspaper-clippings collections. One could account for cutting and pasting as an *Aufschreibesystem*, a network of techniques and institutions that enable a given culture to extract, store, or digest relevant data.[8] Clipped newspaper articles are certainly elements of a discourse network but might more precisely be thought of as a pasting network. Pasting, not writing, is the operative process for generating meaning. In this case, the key figures are not the typewriter or the gramophone, but a new, industrialized practice applied to paper. This practice created a new object around 1900: the newspaper clipping that came into focus for scientists and artists. In the following, I will explore the different meanings of these paper objects and the roles they played — within the scientific community, as a notation system; and within the artistic one, as montage and collage. In my examples, I will concentrate on Berlin around 1920. These talking things, as will become clear, cannot be understood without reference to the techniques by which they came into being. I argue that object and techniques of production — cutting, pasting, and collecting — are inseparably interwoven. Moreover, no such thing as a single newspaper clipping exists; clippings always exist in series and therefore form a collective singular. So while a newspaper clipping always talks, it talks in a different way when assembled in collections and other montages, as this article demonstrates.

Newspaper and Its Techniques

The history of the newspaper reaches back to the early seventeenth century, but its apex came with the industrialized nineteenth century, when newspapers were strongly connected with political and economic developments and with the market for information and newspaper production became a mass-market industry. At the end of the nineteenth century, 3,069 different newspapers were available for purchase in Germany. In 1914, there were 4,221 papers on the market. Internationalization and specialization of the content of the papers, as well as the acceleration of communications brought about by the telegraph and the train and technical inventions such as the rotation press (1872) and the typesetting machine (1884), were the catalysts for this enormous increase.[9] In Berlin, metropolis and imperial capital city, the *B.Z. am Mittag* (Berlin midday journal) was founded in 1904 and bore the motto "The Fastest Paper in the World." Newspaper kiosks had been set up by 1905, although Döblin's beaverheads — mobile newspaper boys — were spread out across the city even before then. For all their speed and ubiquity, newspapers were perceived as ephemeral, valuable for one day only. According to Eberhard Buchner, a figure about whom I will say more later: "The day before yesterday's newspaper was very interesting the day before yesterday, but today it is trash."[10] From descriptions by urban observers such as Walter Benjamin and Siegfried Kracauer, of Berlin and Paris, it is clear that newspapers were profoundly associated with urbanism, modernization, and internationalism; nondirectional perception; and film, movement, and speed. The modern, industrialized newspaper was a medium of its time.

The industrialized newspaper came to be used as a resource in a variety of ways, primary among them, for the purposes of this essay, as the material from which newspaper-clipping collections

were assembled. Recently scholars have suggested that with the new medium "the question was raised of how to tap the content of newspapers. The topical and potential coverage of the press turned the newspapers into an indispensable source for every political and public activity, as well as for many scientific issues. Together with the publications of indices of contents, clipping collections emerged as simple means for opening up newspapers."[11] Private collecting practices took hold, and to facilitate new modes of information gathering, "newspaper-clipping bureaus" or "press services" were established in increased numbers during the last two decades of the nineteenth century and thereafter. The agencies, which commanded a vast repertoire of titles, collected individual articles that they supplied to their customers on a weekly (subscription) basis. One anecdotal account of the origins of these bureaus holds that in 1879 in Paris, the young aristocrat François Auguste Comte de Chambure came to a startling realization: the mornings after art exhibitions, artists gathered eagerly around kiosks, scouring the various newspapers to find their names and notices of their works. This inspired Chambure to create an institution that specialized in the pre-selection of newspaper contents for clients, that would find names of politicians, artists, scientists, and writers on their behalf, and that would cut out relevant articles and deliver them in a timely manner. Chambure himself, in his history of the press, credits the "elegant solution" of this service to Alfred Chérié, writing that "an ingenious man ... conceived of an elegant solution in 1879, in founding l'*Argus de la presse*, which centralized all the publications in the world, by methodically abstracting and distributing to interested parties the articles that concerned and interested them."[12] This anecdote about the invention of clipping services is not the only one. There is a second *first* inventor: Henry Romeike:

The man who hit himself one day on his forehead came ... from Russia and was at the beginning an employee in Germany. Legend has it that the idea popped up when he saw a painter paying a lot of money for an old newspaper that mentioned an old exhibition of his. The first clipping office was founded in London. Still struck by his experience in Paris, he could ... convince a gentleman from a large newspaper-distribution company that his old newspapers were as valuable as gold. This was in 1881. Two years later, the house Romeike opened in New York.[13]

Whether in Paris, London, or New York, these "first bureaus" took root in big cities, metropolises, where customers for such services could be found. One common undercurrent among these origin narratives is the modern legend of the artist, a publicity-sensitive creature interested in his own media coverage. Another common thread is the modern and by now conventional history of the self-made man, who develops from an unknown apprentice to a prominent, experienced company owner capable of turning a profit from the waste of civilization. The clipping service is one foundation among many on which capitalist success stories were built.

While the origins of clipping bureaus were frequently, as in the Chambure account, traced to artistic interests, the actual operations of these businesses were nothing short of industrial. The model of serial production structured daily practice, and progress toward the end product — the cuttings — was optimized. In 1906, an Austrian journal reported on press services: "The discovery that here too division of labor was needed and that the materials contained in modern journals were extremely valuable created a peculiar industry that is only about thirty years old but that is already represented in nearly all civilized nations. We are talking about the newspaper-cutting industry."[14] Some commentaries —

such as the anonymous account "Herr der tausend Scheren" (1900) — represent the techniques and practices of the developing industry as a version of the work performed at telephone exchanges, where the archetypal "Fräulein vom Amt" processes modern technologies of communication. Clipping bureaus were populated largely, though not exclusively, by women with excellent memory skills, who scoured newspapers in search of relevant articles and notices:

> When they [the women in the clipping offices] lift their eyes from the newspaper, they look at a printed list of the names and topics they have to search for. All in all, one can count 7,000 names and topics.... Twice a day a bell rings, and a foreman enters the room and reads out loud new customers and subjects. The girls do not cut; they only mark with a pencil. Cutting is the job of the boys. At the end, a group of girls orders the cut clippings in compartments."[15]

What is also at stake here is a division of labor in reading practices. The production of the clipping is divided into several steps, fulfilled by girls, women, and boys. Reading a newspaper was automated in this (gendered) manner in order to produce clippings. The clippings were finally pasted onto preprinted slips of paper, which also contained the title of the newspaper, the date, and the name of the cutting service, and delivered weekly to customers. Agencies bore such names as Zeitblick: Akademisches Büro für Zeitungsausschnitte des Studentenwerks Berlin e.V. and Dr. Max Goldschmidt: Büro für Zeitungsausschnitte. Names like Argus de la Presse in Paris and Argus Suisse in Geneva reflect — much as the invocation of the female laborer's "Argus eyes" — the concern with perspicacity.

A press service functioned, according to contemporary accounts, "as a mediator between the press and those circles that

have to rely on the evaluation of their public appearance."[16] This "applied journalism" was commissioned by politicians and statistical bureaus, factory directors, and university professors. Evidently, the appeal of such services was widely felt — well beyond the circle of artists, writers, and scientists evoked earlier in this essay: "Besides the manufacturer of fluid air and artificial silk, the airplane technician demands news about the most recent problem child of humanity. A cloth manufacturer wants to know about engagements, a producer of children's food about births, a worker of gravestones about those whose last home he will design, and the writer wants to see reviews of his work."[17] The ways in which newspaper-clipping collections were used ranged from evaluation of products to evaluation of individuals and the identification of new markets. In order to provide for such a diverse clientele with varying interests, bureaus tended around 1900 to favor two search methods and two organizing categories. Searches were conducted according to key terms or entries referring to specific topics or events or according to names (of products or persons). Key terms had to be as precise as possible in order for the scanners — the women in the offices — to search properly and to maximize the results: it would have made no sense to search for a word like "bicycle," because it would garner too many hits. Going one step further, one might say that topics, products, and persons came into being, or were constructed, by clipping offices and newspaper-clipping collections. Isolating and extracting information allowed for it to be reassembled, and this reassemblage in many cases conferred consistency or identity on a subject. Paper individuals came, as we shall see in the final section of this essay, to be industrially produced serially. Another fine example of the ways in which a clipping collection shaped and substantiated new topics is offered by the collection of the Berlin physicist Ernst Gehrcke.

Relativity Theory: Gehrcke

Like many of the collectors mentioned so far, Ernst Gehrcke (1878–1960) lived in (and near) Berlin. He studied under Emil Warburg and was a member of the Physikalisch-Technische Reichs-anstalt (Imperial Institute for Physical-Technical Studies), where he became the director of the optical division in 1926. In addition to his works on interference microscopes and anode rays, he was known from 1911 on as an opponent of Albert Einstein and his theory of relativity. His opposition to Einstein took both public and private forms: he gave numerous lectures on the topic, published books, and assembled a significant newspaper-clipping collection, which he arranged in scrapbooks. My interest in Gehrcke is to show how these forms of exposition or argument were related, and especially to highlight the centrality of his clipping collection to his published opinions.

The numbering system of his clipping collection suggests that Gehrcke must originally have compiled at least twenty-one volumes, of which twelve remain.[18] Each volume is devoted to one or two calendar years, though the internal order is not entirely chronological. Rather, the clippings are arranged in the order in which Gehrcke obtained them from press services or collected them himself. All the materials assembled in the surviving twelve volumes revolve around a single theme: Albert Einstein and his theory of relativity. (The materials in the surviving volumes date for the most part to 1920 and 1921; though Gehrcke started collecting earlier, few early materials survive.)

Upon receipt or acquisition of materials (Gehrcke subscribed to Berlin press bureaus such as Adolf Schustermann, and clipped himself as well), he glued them to pieces of scrap paper (old proofs or endpapers of old journals) and bound them together in a scrapbook. Looking through these volumes, one is struck by how comprehensive his efforts were: he collected all available articles

regardless of redundancies in content, including identical sentences. One page contains eight cuttings, dated from November 4 to November 8, 1921, from different papers, among them the *Hannoversche Kurier*, the *Heidelberger Tageblatt, Jenaische Zeitung*, and *St. Galler Tageblatt* (figure 8.1). They all report the listing of Einstein for the Academy of Sciences in Paris, and note that he received eight votes but nonetheless was not elected. Gehrcke collected newspaper articles as well as pictures, photographs, and caricatures in journals such as *Die Gartenlaube* and *Die Woche*. These heavily illustrated journals were famous for their photographs (figure 8.2). Gehrcke was keen on cutting out pictures of the Einstein Tower in Potsdam, designed for observation purposes by the architect Erich Mendelsohn and completed in 1921. But sometimes the text accompanying the picture was mixed up with another event, so that — in the best photomontage manner of the 1920s — we see in the upper part of the page beside the Einstein Tower a prehistoric horse skeleton that had been found in nearby New Cologne, Berlin.

In 1920, in his *Die Relativitätstheorie eine wissenschaftliche Massensuggestion*, Gehrcke wrote: "The topic of the theory of relativity, specifically the controversy over its importance and its accuracy, has been trumpeted in every direction possible."[19] Relativity theory was widely familiar to (if not fully understood by) academics, teachers, middle-class housewives, publishers, and so on. The first important publication on relativity theory was published by Einstein in 1905.[20] But the high point of its public reception took place from 1919 to 1922.[21] These were the principal years during which Gehrcke collected his clippings. And the primary motivation for Gehrcke's collecting was to buttress his conviction that Einstein's theory of relativity was not all it was chalked up to be. The theory and the principle of relativity were, according to Gehrcke, only used in the press as catchphrases "that

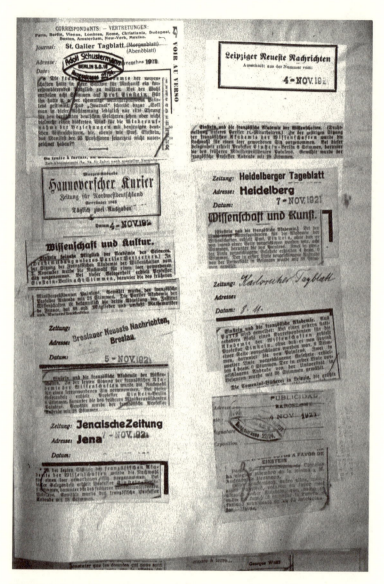

Figure 8.1. Page of Ernst Gehrcke's clipping collection, vol. 14, 1921. Courtesy of the Max Planck Institute for the History of Science Library, Berlin.

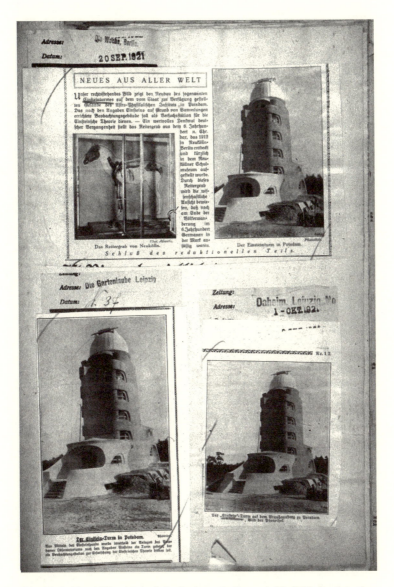

Figure 8.2. Page of Ernst Gehrcke's clipping collection, vol. 12, 1921. Courtesy of the Max Planck Institute for the History of Science Library, Berlin.

have the effect on the masses of making everyone believe that he has heard something familiar."[22] He wrote off the relativity of space and time as a flash in the pan, claiming that the public had heard only positive things about Einstein and his theory and therefore could not yet properly evaluate the information. "Thus has the theory of relativity grabbed the public's attention — by mass suggestion."[23] Four years later, in another book, Gehrcke stated more explicitly that he had earlier examined the physical and philosophical assumptions of relativity theory but now would be ready to look at its psychological impact more closely.[24] To do so, he consulted the most famous writings on mass psychology at the time, principally Gustave Le Bon's *Psychologie des foules*, first published in 1895.[25] The constitution of a mass depended, for Le Bon, on all the feelings and thoughts of individuals being oriented in the same direction, to the extent that no conscious personality remains.[26] Gehrcke wrote:

> Among the modern psychologists, it was LE BON who, concerning the psychology of the masses, declared that only excessive stimuli can arouse the masses. If in connection with the relativity theory of fixed stars, the sun, COPERNICUS, GALILEI, NEWTON, the daily press reports about receptions with presidents and kings . . . , then this news becomes for the masses excessive stimuli in the sense of LE BON; they are well adjusted to what the mass desires.[27]

While pointing to the role of mass media in the making of masses, Gehrcke also invoked the term "mass suggestion," citing the ethnographer and physician Otto Stoll: "It is very instructive to see that the suggestion — that is, the psychological compulsion in a form of a bias that is not objectively justified — finds its way even in those disciplines that are characterized by the capacity to work with numbers and formulas."[28] Gehrcke is not especially inter-

ested in a differentiated explanation of these phenomena, which were heavily discussed by cultural critics and psychologists alike at the time; rather, he takes up the catchphrases (thereby doing exactly what he criticizes) and applies them to the way newspapers reported on relativity theory. In describing how newspapers were reporting on the phenomenon, he aimed to demonstrate how their reports functioned as "Propagandamittel" while maintaining, sometimes explicitly, sometimes between the lines, that Einstein himself was responsible for the reporting.[29] What Gehrcke does not explicitly say at the end of his 1924 book, *Die Massensuggestion der Relativitätstheorie*, although it is clear from the way he refers to the work of psychologists and psychoanalysts, is that Einstein's theory is only acceptable to those who are not able to understand what Einstein is saying and who are susceptible to mass suggestion. In other words, to argue or even simply to be for Einstein and his sayings and writings is a form of mental illness.

"As early as 1912, I argued the position that the theory of relativity has a psychologically interesting side and had become mass suggestion. I also suggested this occasionally in publications."[30] In his 1924 book, Gehrcke set out to provide "documentary support" for this position. In the introduction to the book, he declares: "In what follows, I provide factual material about the mass phenomenon surrounding the theory of relativity." Of particular interest is the way in which he purports to support his claims. Gehrcke continues: "The support material is representative of my collection of over 5,000 newspaper clippings and newspaper articles."[31] It was plainly evident from these sources, Gehrcke maintained, how this theory had been forced on the public, though his sources required some defense. "I have become convinced, not without some reluctance, that it is better to show these proceedings and facts in the proper light than to ignore them, just because they are reflected by newspaper reports. As insubstantial as these

newspaper reports are, they make up, be they true or not, the strongest means of communicating this mass suggestion." Gehrcke's claim had a dual impact. First, he did not assume the truth of newspapers, but saw them as highly tendentious and potentially propagandistic material; he used them only to illustrate current popular discussions and fictions. Second, he did not share the fears and insecurities caused by or effected through accounts of relativity theory in academic journals and daily newspapers alike; as an expert, he was immune to this mass hysteria.[32]

Snippets of History, Snippets of Information

Rather than enter deeper into early-twentieth-century discussions about relativity theory or even mass psychology, I would like to come back to the cuttings and their function. Gehrcke, in the process of amassing his vast collection, referred to psychologists and journalists alike and culled materials from a variety of sources. In this respect, he adhered to the example set by Eberhard Buchner (1877–1933), whose work provided the model for Gehrcke's creation of a newspaper-clipping collection. "Eberhard Buchner's works," he wrote, "demonstrate how important reports from the daily papers are for judging the spirit of an era."[33] Buchner was a Berlin journalist and author who worked on a freelance basis and, through his collections of documents, achieved a certain importance, at least in the Berlin region. Buchner published many works on the history of newspapers, among them some volumes of the Documents of a Metropolis series (1904–1908), which were famous in Berlin at that time.[34]

In 1911, Buchner defined newspapers as "news items published in a businesslike manner or a collection of news items that are recorded under the immediate impression of the events and are designed for a large, usually unrestricted number of interested individuals." Although newspapers are only important for a

period of hours — "The day before yesterday's newspaper was very interesting the day before yesterday, but today it is trash" — only let readers glean impressions and perceptions, and did not allow objective reporting, they did provide "the most immediate and least retouched picture of the time." Buchner summarized his somewhat contradictory views as follows: the value of newspapers "is secondary or tertiary for the historical sphere; the most important contribution is in the realm of cultural history. A specialized study about the French Revolution provides a more exact and dependable orientation to events than the newspaper of those great years," but "a note of just a few lines often reveals more than a weighty tome." Citations from ephemeral, tendentious media such as newspapers proved particularly well suited for Buchner's purpose (and for cultural historical purposes as well), because they are the best source for determining the "mood of the time."[35]

While Buchner's first publications dealt with seventeenth- and eighteenth-century newspapers, several years later he published another series of newspaper documents, this time relating to the First World War.[36] In the preface, he wrote that he wanted not to write a history of the war but to give an immediate sense of what the war had been like. By his own account, "this position did not allow any distance from the topic."[37] Buchner's documents on the war were very well known in the 1920s, although he was not the only one who undertook such projects.

In his 1916 essay, "Collection and Use of the Newspaper," the Hessian archivist Ernst Goetz described how in various parts of Germany the so-called clipping procedure was used during the war as a type of reporting on the war itself. Indeed, war newspaper archives came to be established in Jena, Leipzig, and above all Darmstadt.[38] Clipped articles were at times copied and — as in Buchner's case — published as "documents on the war." History

313

comes into being through paper and storage.[39] And in this case, the materials and practices of history — paper (documentation) and storage (preservation) — took the ephemeral form of newspaper clippings. Material and storage alone are not sufficient, however; order is also required. Goetz therefore continues, in his 1916 essay:

> As little value as a single notice appears to have when viewed in isolation, it is important when compared with other clippings of a similar type from other small papers. If you cut out these specific notices from a series of newspapers from one and the same region and arrange them chronologically, a cultural historical image of tremendous richness results in the type of color that no researcher would willingly forgo.[40]

It is by virtue of serial ordering that the clipping becomes a source for cultural history. Only through chronological organization and serialization is the eventual completion of a biography or the history of a nation made possible. Or, as a newspaper expert put it in 1931: "The academic value of a collection of clippings sources is dependent, to a certain extent, on its completeness."[41]

The use of newspapers as historical sources was first publicly declared at the 1908 International Congress of Historians in Berlin, where the topic of ordered collections of newspapers and their potential utility was thoroughly discussed. Reports on the congress record:

> Newspapers contain "an astonishing richness, a great deal of raw gold that awaits the prospecting historical researcher [...]. And in a comprehensive manner, all the intellectual powers that determine the development of a culture are expressed in newspapers. In order to access the treasures hidden in the press, the collection of news-

papers and magazines has to be carried out with greater rigor and with a greater sense of purpose."[42]

These calls for methodological improvement reflect a sensitivity to the transitory nature of the medium. Scientists and historians of the time were equally concerned with the preservation of their sources, with fixing their observations and descriptions. Two developments played important roles here. First, the notion of a "cultural historical image" that could be spun of the "raw gold" offered by newspapers adhered to a model of writing cultural history that was already contested in the early twentieth century. The strategy of collecting material to produce a "picture of a time" was underpinned by the idea of the historian as a chronicler of his time, shoring up history against oblivion by means of detailed observations and reserves of material. A second, even more influential development was information technology. Strategies for organizing historical or cultural material were a hot topic in the early years of the century. Index cards were one available means, a means related to what the information management of that era called a dossier or file. To some contemporaries, such as the Belgian information organizer Paul Otlet, index cards represented a forward-looking system. Otlet described his vision in 1910 as follows: "Instead of an encyclopedia in a certain number of volumes, in the future there will be a hall in which original notes about each item are organized into files on slips of paper."[43]

The newspaper was not a durable medium, and while cultural critics viewed its ephemerality as a central problem, others tried to compensate for the compression and acceleration of time by means of ordering and collecting.[44] "Documentarists" such as Otlet stated that the newspaper was not the problem; the problem lay in how society dealt with it. In their opinion, civilization had reserved a place for the book in locations like libraries,

315

museums, and private bookshelves, but nothing for the medium of the newspaper. Clear prescriptions were offered by members of the circle around Wilhelm Ostwald, the chemist and chief architect of the German Industrial Standards' norms for paper.[45] One of his colleagues, Carl Friedrich Roth-Seefrid, stated in 1918 that (especially after the experience of the war) "through the careful selection of one's orientation material, and indeed from books and newspapers, one can gain a much better image of the world than had hitherto been possible."[46] The aim of such selection is to organize time and to enable a more refined level of reading and thinking: "Just as in the material world the tool is superior to the naked human and the machine to handicraft instruments, so too the big card-filing system is superior for intellectual work."[47] In contrast to those suspicious of newspapers, Roth-Seefrid was not concerned about the potential impact of the "new" medium on individuals' reading capacities; rather, he concentrated on new ways to enable the assimilation of the immense flow of printed announcements, communications, and information. His information technology offered strategies for disseminating, collecting, and ordering data from a medium such as newsprint, which would otherwise not have been manageable. Although Gehrcke's collecting techniques did not go so far, or were not as detailed as what Roth-Seefrid suggested, his cutting processes and collections, and the clipping services on which they depended, were intended to fulfill a utopian idea of a fully ordered archive containing every snippet of history and information.

Gehrcke knew the importance of newspaper clippings and created — along the lines later suggested by Robert Musil's *Nachlass zu Lebzeiten* — an image of Einstein with his clipping collection. Musil wrote in 1936: "The century that has invented the made-to-measure shoe out of ready-made parts and the ready-made suit for individual fitting also seems to create the poet out

of completed inner and outer parts."[48] The central question here
is how to combine the parts (of a person, of texts, and so on) to
form a whole, a complete and representative picture. The under-
lying principle, whether in the case of clippings or poems, is
clearly that of collage and montage.

Montage/Collage: Grosz

Around 1920, the artistic principles of collage and montage ani-
mated literature, painting, music, photography, and film equally.
Their lifeline extends into medical culture (in the discussion of
prostheses, for example) and technical and industrial arenas as
well. Whereas "collage" means "to glue" and implies handiwork,
"montage" has a much more industrial background; since the
Encyclopédie, it had been defined as a process by which one assem-
bles the parts of a mechanism.[49] A montage needs a mechanic; it
involves fitting together ready-made parts to form a machine or
product. It was during the First World War that the term "mon-
tage" came to be used in the arts. To understand the use of news-
paper clippings and its meaning, to understand why and when the
cutting-and-pasting practices of scissors, paper, and scrapbooks
became so important, one has to take into account the principle
of montage. This principle has in turn to be understood against
the background of the conveyor belt and the division of labor: the
first conveyor belt was installed in 1913 in Henry Ford's factory,
at approximately the same time as film and its cutting techniques
were developed. The common principle here is the creation of a
product out of ready-made parts.

The newspaper was a medium in which montage techniques
had always been used (cross-reading), but now, in addition, parts
of newspapers were being inserted into the *papiers collés* of the
Cubists, the collages of the futurists, and the montages of the
Dadaists. Newspapers were used in these contexts because of their

material capacities and their typography. For the Dadaists, news-paper fragments became irreplaceable. In 1916, Tristan Tzara wrote the following instructions for making a Dadaist poem:

> Take a newspaper.
> Take scissors.
> Select from this newspaper an article of the same length as you plan to give your poem.
> Cut out the article.
> Cut out carefully every word of this article and put them into a bag.
> Shake lightly.
> Take out one snippet after another.
> Copy down conscientiously in the order in which they came out of the bag.
> This poem will be similar to you.
> And therewith you will be an infinitely original author with a charming sensibility not however comprehensible to the people.[50]

Because the newspaper represented even in its uncut form a kind of bound-together fragment of reality, Tzara took this as his method and produced out of the ready-made parts new poems. Tzara is a wonderful example because of his unique technical description. Likewise, the architect Johannes Baader, high priest of the Dada movement, created the "Dadacon." This "most mon-umental book of all times, bigger than the Bible," was made out of thousands of newspaper pages pasted in the manner of a photo-montage. "This method was used to induce swooning while leaf-ing through the pages."[51]

Like Dada poets, their colleagues, visual artists, worked in that manner. George Grosz (1893–1959), a founding member of the Berlin branch of Dada along with John Heartfield, Raoul Haus-

mann, and Hannah Höch, participated in the First International
Dada Fair in 1920 and edited satirical journals together with Wie-
land Herzfelde, Carl Einstein, and others.[52] Grosz emigrated to
New York in 1933 and lived there until 1959, when he returned to
Berlin. Throughout his career as a painter, which started right be-
fore the First World War, he was also well known for his collages
and montages. Some of them he produced together with his col-
league Heartfield. The main goal of their work was to criticize the
Weimar Republic via an "optical inventory" of hunger and hate,
war cripples and beggars, spivs and prostitutes.[53] For Grosz and
Heartfield, clipping newspapers and magazines provided a realis-
tic picture of social and political conditions of the time. Like Tzara
in his instructions for making a Dadaist poem, they were con-
vinced that everyone could take a newspaper and scissors and
make a collage. Everyone could be an artist because reality and its
material fragments are available everywhere and can be assembled
as in a factory. The purpose of the imperative "Take a newspaper,
take scissors" is to inspire a certain automatism that would lead to
a portrayal or even a copy of reality opposed to typical bourgeois
moral and aesthetic ideas. Art and reality were not two distinct
spheres but mechanically, and thus intrinsically, combined in the
works of the artists.

In 1920, Grosz made the collage and watercolor *Brillanten-
schieber im Café Kaiserhof* (Jewel spiv in Café Kaiserhof) (color
plate IX).[54] The Kaiserhof was a famous café where, in 1921, a
reception was given for Einstein upon his return from his journey
from the United States.[55] But in Grosz's view, criminals also met
there. While the newspaper clipping on the right side of this pic-
ture is obviously a collage, the other fragments only come into
clear focus on second view: from the houses in the background to
the hair and shoe of the fat man, and the eyes, nose, and legs of the
man with the green hat, to the mustache, eyes, and cuff links of

the man in the foreground and the things in front of him — pearls, biscuit box, money — everything is pasted onto the watercolor to tell a story about hard-boiled criminals and profiteers in Berlin. The incomplete cutting on the right side reads sequentially, "profiteer," "court," "accusation," "jail," and "decision." The cutout seems quite realistic, and the whole collage might tell a humorous and critical story about, say, a man reading a newspaper that reports on colleagues (or himself) who have been arrested and brought to jail for profiteering. The fat man discovers his own fate in the medium by which his story is told. The picture is stamped (not signed) "Grosz Berlin Wilmersdorf"; Grosz understood himself during that period as a *constructeur*, someone who works in an industrial manner. Consequently, in the catalog of the First International Dada Fair, Grosz himself described this picture as a "Tatlinistischer Planriss: Brillantenschieber im Café Kaiserhof."[56] Construction is a feature from the ground up: the architect of this *Planriss* tells a story in watercolor and collage. A story line follows the movements of the picture: The head of the man with the green hat is framed by two houses, while his trousers and feet are close to the marketer himself. The man in the background with the green suit has a house fragment on his back. Both figures seem to step into the café. Leaving the reality of the city behind, they enter the atmosphere of the very elegant but worried criminals, who dominate the picture with their pale heads. Imagine them getting up; their movements would be stiff and right-angled. They are ready to behave and move like the rectangular shape of the collage material in the picture: the houses, the newspaper clipping, the biscuit box, and so on. The way Grosz cut out the fragments and positioned them in the watercolor is clearly linked to the way he represented the figures in his picture.

The journal and newspaper fragments that shaped this and other montages were not cut out randomly or out of "found

materials" but assembled consciously. They were extracted from Grosz's huge newspaper-clipping collection. Because he understood himself to be a mechanic (someone who makes a montage), he stocked his collection with prefabricated and machine-produced elements, so that it served as a kind of spare-part depot for his art.[57] His collection includes more than forty-three folders filled with cuttings and clippings, most of them cut out of journals and magazines, weekly newspapers, cheap art books, calendars, and advertisements.[58] Each folder contains a single object group: noses; volcanoes; skyscrapers; guns; landscapes and dunes; bomb craters and ruins; profiles and heads; women's accessories and Old Masters (figure 8.3). The organizing folders are labeled with little paintings of the contents: wonderful volcanoes and little eyes, green landscapes, and a fleshy denture. When one looks through these folders, it becomes obvious that, wherever he was, he collected material. Sometimes fragments are already pasted onto sheets of paper, thus forming little pre-collages reminiscent of pages of department-store catalogs or the surrealistic encounter of an umbrella with a sewing machine (figure 8.4).

In a 1918 letter to his brother-in-law and Dadaist colleague, Otto Schmalhausen, Grosz wrote: "I have put together for you some so-called colorful hosp.-parcels.[59] ... Especially for someone in a military hospital this is powerful means to restore health; it will stimulate, and an ill, bored mind will find — fluttering over all sorts of journals, brochures, and such — momentary, restorative edification!" He then lists all sorts of advertisements, stock-market news, fashion guides, and price lists. This "is in miniature a much more diverse cross section of life than a single novel ... will ever be."[60] The quotation shows how valuable everyday newspapers and magazines were for Grosz: a series of pictures, price lists, and articles could represent the real world. It is impossible to determine exactly which clippings he collected by himself and

Figure 8.3. George Grosz, "Skyscraper" folder with clippings. Courtesy of Stiftung
Archiv der Akademie der Künste, Berlin, George-Grosz-Archive 1180/1.

Figure 8.4. George Grosz, collage in "Skyscraper" folder with clippings. Courtesy of Stiftung Archiv der Akademie der Künste, Berlin, George-Grosz-Archive 1180/1.

which were given to him by friends, but it is obvious from the material that he did not hire a press service to supply them.

Grosz and Gehrcke, 1920

While Gehrcke had only one collection, devoted to a single person and a single heading and used as material and factual evidence for his writings, Grosz had two collections: one was of material for his art; the other dealt with his work and his person. Grosz is in this regard the perfect example of an artist in the sense understood by the Comte de Chambure. The articles were pasted on sheets of paper and collected in a ring binder. (It is, however, not possible to determine whether the materials were bound in this manner by Grosz or by later archivists.)

Only a few clippings dating to the period before 1933 still exist, and these are principally articles that report on his 1921 trial in Berlin. This trial became famous because Grosz and others who organized the First International Dada Fair were charged with having insulted the *Reichswehr* and the military class in general. They had hung a puppet from the ceiling of the exhibition room (like the ubiquitous crocodile in the cabinet of curiosities) dressed like an officer, its head covered with a pig mask.[61] The fair had taken place from June 30 to August 25, 1920, in Berlin. During that time, newspapers reported on the exhibition, and the German *Spiessbürger* (petite bourgeoise) were irritated and agitated against it. While the exhibition was still on, Paul Weyland organized with Ernst Gehrcke an event at the Berlin Philharmonic on August 24, 1920, that ended up becoming equally famous (at least in physics circles). Gehrcke presented his objections to Einstein's relativity theory.[62] Weyland polemicized against Einstein, who was present, in a rude way, referring heavily to the public perception of Einstein but not to the content of his work. He accused him of instrumentalizing science for the sake of his public

authority and of self-glorification through scientific pontificating. His talk culminated in the declaration that Einstein no longer was interested in physics but was a "scientific Dadaist."[63] That, too, was reported in newspapers.

Paper Persona

This right-wing agitator attempted to describe Einstein as a criminal whose anarchist mind functioned without order, who talked nonsense, and who thereby endangered serious scientific endeavor. His Einstein resembled what the critics of the Dada circle at that time took to be a Dadaist. It is not surprising that Weyland took up a contemporary catchphrase and used it as an insult against Einstein. But clearly Einstein was not a Dadaist and had no relevant contacts with the Dada circle in Berlin whatsoever. Neither did Gehrcke. For his part, Grosz would hardly have known what the Physikalische-Technische Reichsanstalt was or did. Still, the question remains: How can a Dadaist be scientific and a scientist Dadaistic?

Both Gehrcke and Grosz used clippings as material in their books and images. Clipping collections were depots of reality that provided the material for their work, enabling them to rework this first layer of reality (as they called it) into a second, more focused version. Whether "raw gold," as the historians called it, or "hosp.-parcels" that doubled as a realistic novel, as Grosz saw it, montages of clippings form in both cases "cultural historical images." The clipping and the "clipping industry" served as a conveyor belt for the intellectual in the Weimar Republic; the "factual material" and the "documentary support" had to be selected, evaluated, and then mounted together. Just as Gehrcke used the clipping as source material and worked with it like an obsessive archivist, longing for completion, Grosz took the cutting as an image and an authentic entity. Both wanted

to "describe their own times," to "hold a mirror" up to them.

The difference between the physicist and the artist was that Gehrcke tried to build up a series of historical documents, to objectify the snippets of history. Bringing them together and giving them an order meant to him making sense out of formerly unrelated cuttings. By contrast, Grosz collected cut images and clippings but created in his collages juxtapositions that were ruled not by the order of the former content but by the visual necessities of the new collage. Gehrcke hired a clipping service and therefore acquired his clippings from a factorylike filter institution. He ordered preselected pieces of history that he pasted together. Grosz searched for himself, cutting out what grabbed his attention and creating a well-ordered collection, an "optical inventory." His reality bits are fragments that served as fragments, whereas Gehrcke wanted to create something complete out of fragments that he valued as evidence. Gehrcke thus completely denied the fragmentary nature of his clippings.

But how can a Dadaist be scientific and a scientist Dadaistic? A closer look at Grosz reveals that the apparently random encounters between reality fragments in his collages follow an idiosyncratic and even rigid order. His folders were organized by headings that gave him access to the items when he wanted them: eyes, volcanoes, jewelry, bomb craters. He was no accidental collector, and in that sense his practice was scientific or systematic. Grosz created a visual commonplace book, a *Zitatenschatz*, out of which he could create new images. Gehrcke, on the other hand, had some quite Dadaistic aspects, since his collection of "raw material" did not in itself add up to the filtered and clean historical source he wanted: witness the contaminated pages, such as the one juxtaposing the horse and the *Einstein-Tower*. Unintended and unavoidable juxtapositions generated their own meanings and fantasies, as a result of the cutting practices, rather than those

intended by the collector. Gehrcke filtered out a single person and an argument, whereas Grosz needed the order of visual likeness. The heading "Einstein" brought together materials about one person alone, whether newspaper articles or photographs. In contrast, the category "eyes" was one a clipping service would not have been able to use, because it was much too vague for their usual indices. "Eyes" might have included the eyes of Marlene Dietrich or Albert Einstein, or even a portion of another random image that looked like an eye.

At this point, it becomes clear that the true Dadaist was neither Einstein nor Grosz but Gehrcke. Looking at his collection and how he gathered it, compared with the Dada artist and his practices, we can see that Gehrcke pasted in the manner Tzara proposed in his poem: just as the poem was created with a newspaper and scissors and glue, Gehrcke took the snippets as they came from the cutting-service bureaus and pasted them together in scrapbook-like manner. An obsessive collector, paranoid about Einstein and his theory, frugal with paper, he used wastepaper to paste down what the clipping factory supplied him. He thus fulfilled Tzara's prediction: "This poem will be similar to you." Through his practice, he created a public persona for Einstein: he made his own Einstein out of paper, a paper persona. The *Aufklebesystem* around 1900 created not only different ways of producing text but also paper individuals that could not be separated from their textual existence.

Gehrcke was absolutely aware of the power of newspapers and tried to react to that in filtering out relevant information. But he could not escape the medium. Through his technique, he copied the effect he wanted to unmask. While he was gathering the "factual evidence," he produced another layer of newspaper evidence that was neither objective nor factual but a media phenomenon: an article is an article is a clipping.

327

CHAPTER NINE

Talking Pictures:

Clement Greenberg's Pollock

Caroline A. Jones

Talking Things

Objects of visual art are peculiar kinds of things that need other
kinds of things to function. We might even say that together the
artwork and its interpreter form one talking thing — in this case,
an asymmetrical chunky thing comprising text by the art critic
Clement Greenberg and painting by Jackson Pollock.[1] A book and
its reader resemble this kind of thing, as does an image in the
mind's eye.[2]

Instrumentally, then, I am interested in the person "Jackson
Pollock" only insofar as the complex paintings produced by this
artist worked on the critic Clement Greenberg, and I am here
concerned with Greenberg only as he gave voice to the paintings
of Pollock. These constraints have the virtue of keeping my talk-
ing thing fairly compact. But they also have the vice of a radical
compression that makes Pollock material and Greenberg discur-
sive (where both were both). At least let it be clear that I am not
pursuing a biographical or intellectual explanation of Greenberg
as the originator of his own speech or of Pollock as the chthonic
producer of an unprecedented picture.[3] What the dyadic heuristic
of my "talking thing" here hopes to accomplish is twofold. The
thingness keeps the materiality of Pollock's painting in view, while

the *talking* reminds us of the temporal discourse of Greenberg's prose.

"Talking Pictures" is also, of course, a pun. Greenberg might have spit out the phrase brusquely if someone had asked him what he thought he was doing in 1950. But the pictures also take action in such a phrase: they "speak" to him. Further, I want the pun of *real* talking pictures, "the talkies" that came at a specific moment in technologies of machine vision, just prior to Greenberg's adulthood. "Talkies" specifically alludes to the 1950 movie of Pollock painting. The reference also calls up the more general modernist modes of segmenting and inscribing human gesture and voice, modes that became ever more pervasive as the twentieth century unreeled. What I want here is less a trajectory than a mesh: Greenberg entered an existing visibility, apprenticed himself to its effects in myriad ways, encountered Pollock's paintings, and made them modern for himself and others by weaving them into what he took to be the texture of modernity, a process necessarily inflected by the materiality of Pollock's paintings — and the looping hermeneutic could spiral on. But there was more than art talk and pictures structuring this web. The matrix ordering the visibility Greenberg entered, I will argue, formed patterns at both larger and more microscopic scales than the Pollock paintings he wrote about. At the periphery of the critic's vision were canvases seen but not written down, political situations, economic relations, national cultures, previous compositions and various colors (occasionally creatively misperceived), and, especially, life amid the urban grids of Manhattan. At an even more dispersed scale was a broad visual culture of filmed images that aimed to break the fluid rhythms of the laboring body into perceptual units, and to inscribe and register them against similar modernist grids. Industrial traditions of time-motion studies, and their accompanying technologies of visualization (the graph, the gridded photo-

graph, the film, the time exposure), flooded the popular press in the mid-1940s and early 1950s and organized certain readings of Pollock's paintings. What I will emphasize here is the *modernity* of these visual regimes, the mesh of the visibility becoming a fabric of discursive reinforcements for what it meant to be modern. To synopsize: one mode (talking pictures) attempted to make seamless the regimented movements of the modern body, and the other (stop-action) hoped to arrest singular segments in order to expose the structuration of the modern self *as traumatic*. (This essay limits itself to the first of these modes, but the second haunts its premises.) The disciplinary regime of Greenberg's formalism accommodated both: it aimed to be a perfect and efficient set of practices and reading protocols for producing Pollock's paintings as the right thing for the job of making modernism visible in, and to, its subjects.

Caveats are necessary: Greenberg is not meant to stand for modernism *tout court* (not even metonymically). There are many ways to be modern. There are, equally, many modes of modernization, many kinds of modernity, and many facets of aesthetic modernism. If we can agree that "the modern" has something to do with the human experience of technologies of speed, textures of urban density, and the pervasive regimentation introduced by industrial production, then we can postulate that aesthetic modern*ism* is a self-conscious effort to make culture out of those experiences. Little is fixed beyond this definition, however. What is certain is that the great variety of cultural forms produced to engage with our modernizing environments will always be historically specific: inflected by national institutions, economic practices, technological circumstances, natural resources, political systems, aesthetic traditions, artisanal practices, body disciplines, geographic locations, local cultures, and ideological commitments — not to mention temporal frames. As a way of saying anything of

331

value about this vast terrain, I have chosen to take but a tiny piece of it here. One talking thing.

Greenberg/Pollock isn't, for all that, a bad piece to take if one is interested in a particularly extensive, hegemonic modernism that celebrated rationality rather than rebellion. In the speech of this tough-talking intellectual, with his odd Brooklyn and Southern accent, Yiddish slang, sensuous good looks, British aesthetics, and French taste in art, the materiality of Pollock's painting was configured in a highly specific way, its modernity (Greenberg insisted) instantiating civilized order. We need to be reminded that this was a surprising view of these paintings at the time the Pollock/Greenberg "talking thing" came into view in 1943. By 1960 it had become robustly active in its artworld setting, endorsed by every major U.S. art museum. But in the early forties, Pollock's meaning was utterly up for grabs. Greenberg was "hit" by certain of Pollock's paintings, and the "hit" of Pollock's gesture on canvas, I will argue, was precisely where the paintings' ordered modernism could be seen to lie.

My narrative opens with a paradox that I hope will sharpen our questions about both "talk" and "things." The paradox is found in the criticism that Greenberg crafted around two Pollock pictures, which came to his attention just a few months after they had been painted (figures 9.1 and color plate VII). The works in question are titled *Totem Lesson 1* and *Totem Lesson 2*; Greenberg saw them in an exhibition mounted at the Art of This Century Gallery in the spring of 1945, and the paradox is historical in nature: Greenberg wrote about these canvases in a way that more accurately describes paintings the artist would not produce until 1947. It is helpful here to be anachronistic and look at those later "drip" or "skein" paintings (of the sort illustrated in figure 9.2, titled *Cathedral*). Most obviously, these later radical Pollock works were made up of drips and skeins of paint — there are no brush

strokes in these canvases. Materially, they presented a radical challenge to interpretation, and many found it difficult to bridge the earlier approach (figures 9.1 and color plate VII), so manifestly indebted to European surrealism, and the other (figure 9.2), seemingly unlike art at all. Working his way through such shifts, Greenberg came to be the foremost American exponent of formalist criticism, which he employed to celebrate abstraction, flatness, and alloverness. But the paradox comes in those very values, for they emerged in Greenberg's writing on Pollock four years before these "breakthrough" drip paintings of the late 1940s were made. While something art historians vaguely call "influence" certainly operated (in all directions) among Greenberg, Pollock, and the hidden interlocutor of Pollock's wife (the painter Lee Krasner), the period of their intimacy came later, after the early 1940s essays that pose the historical conundrum in question.[4]

What I want to articulate here is a claim that Greenberg's early Pollock criticism, and certain of Pollock's early paintings, crystallize a specific moment in the history of labor and modernity. I further want to claim that the form of that crystallization (as *rational*) was by no means obvious, at least in the 1940s.[5] In Greenberg's articulations, these paintings were the products of a highly disciplined cultural actor, their forms urbane and internally ordered. In sum, they were entirely appropriate for "our modern sensibility" and its urban industrial surround. Though hotly contested, Greenberg's view of Pollock eventually came out on top. It was *this* talking thing that formed the fiduciary and patrimonial core of the postwar collections at New York's Museum of Modern Art (for example). *This* Pollock was part of ongoing pictorial traditions, not radically disruptive of them; *this* Pollock was deemed continuous with a Cubist-derived logic that Greenberg had celebrated as "rationalized décor." Greenberg crafted a Pollock who wasn't primitive and chaotic; his Pollock could be

333

Figure 9.1. Jackson Pollock, *Totem Lesson 1*, 1944, oil on canvas, 70 x 44 in.
(177.8 x 111.8 cm). Collection Harry W. and Mary Margaret Anderson, Atherton, CA.
© 2003 The Pollock-Krasner Foundation / Artist Rights Society (ARS), New York.

Figure 9.2. Jackson Pollock, *Cathedral*, 1947, enamel and aluminum paint on canvas, 71½ x 35⅟₁₆ in. Dallas Museum of Fine Arts, Gift of Mr. and Mrs. Bernard J. Reis. © 2003 The Pollock-Krasner Foundation / Artist Rights Society (ARS), New York.

the very mascot of modernism in this, "the most historically advanced country on earth."[6]

How and where did Greenberg find the material forms necessary to construct this talking thing? How did Pollock's early pictures come to produce, in Greenberg, a *modern* subject? In the mesh of things and talk, there was embedded a painting that itself remained largely unspoken but whose materiality, mode of production, and rich social meanings worked (on and through Greenberg) to provoke a compelling articulation of the mid-century modernist visibility. Based on a *prior visual experience that the critic never articulated in print*, Greenberg's accounts of Pollock's 1945 paintings offered visualizations of modern labor and subjectivity that only later (and by separate routes) emerged to dominate Pollock's career. Greenberg saw more than he said about Pollock's paintings, but his writing nonetheless worked to *produce* a visibility that came to structure all later perceptions (and productions) of Pollock's best-known work.

To summarize my goal: if words can be written before the things they describe come into view (talking a thing into existence), it is equally the case that many things are made about which nothing is said (mute things). We could allow them to remain "mute," but instead I take their materiality as a challenge, providing us with a renewed opportunity to speak an occluded history. The questions they provoke lie at the heart of my project and, it would seem, of art-historical practice as a whole: If it is said, then is that what is historically available to be seen? If it is not said, then is it not seen at all?

336

Greenberg's Pollock

That's for Clem.

— Pollock to Krasner about *Eyes in the Heat* (1946)

The *Totem* paintings were not the very first Pollock works to be reviewed by Greenberg in the critic's weekly art column for *Nation* magazine. In fact, the paradox I have staged is best revealed by comparing what Greenberg had to say about Pollock in 1945 with the critic's very first review of this painter's work in 1943. This earlier review, the very first emergence of Pollock into Greenberg's prose, came at a distinctly traumatic moment for the critic — shortly after his dismissal from the army, where he had suffered what he termed a "nervous breakdown" on the banal training grounds of Battle Creek, Michigan. Describing Pollock's early, heavily surrealist paintings (such as the 1943 *Guardians of the Secret* in figure 9.3), Greenberg had written:

> There are both surprise and fulfilment in Jackson Pollock's not so abstract abstractions. He is the first painter I know of to have got something positive from the muddiness of color that so profoundly characterizes a great deal of American painting. It is the equivalent, even if in a negative, helpless way, of that American chiaroscuro which dominated Melville, Hawthorne, Poe.... The mud abounds in Pollock's larger works, and these, though the least consummated, are his most original and ambitious.... In the large, audacious *Guardians of the Secret* ... space tautens but does not burst into a picture; nor is the mud quite transmuted.[7]

The backhanded praise and double negatives are typical of Greenberg's tough, acerbic prose. More interesting, the words he brings to his description seem, as they would be two years later, frankly inaccurate for the painting he describes. Indeed, I would argue

337

Figure 9.3. Jackson Pollock, *Guardians of the Secret*, 1943, oil on canvas,
48⅜ x 75⅜ in. (122.89 x 191.47 cm). San Francisco Museum of Modern Art,
Albert M. Bender Collection, Albert M. Bender Bequest Fund purchase. © 2003
The Pollock-Krasner Foundation / Artist Rights Society (ARS), New York.

that these words are better suited to the later 1945 *Totem* paint-
ings at which we have already glanced. Clearly, we can see more
"mud" and negative helplessness in those later *Totem Lesson* paint-
ings than in the earlier work Greenberg is talking about in 1943
(*Guardians*). In contrast with the primary palette in *Guardians*,
the *Totem* paintings Greenberg singles out for explicit praise two
years later are uningratiating combinations of dour grays, tarry
blacks, ochers, and sienna brown. If all pigment, at its source, is
mud (the earths of Italy: ocher, umber, and sienna), then these
Totem paintings are closer to that fact than *Guardians* ever was.
Neither of the later canvases seems to achieve what Greenberg
claimed to seek in modernism, as he had celebrated it in his 1945
review, a modernism that blended the "rationalized décor" he saw
in Piet Mondrian with the ambitious nonobjective expressionism
he liked in Wassily Kandinsky.[8] What he now saw in the *Totem*
paintings in 1945 led him suddenly to pronounce that this second
one-man show of Pollock "establishes him, in my opinion, as the
strongest painter of his generation and perhaps the greatest one
to appear since Miró" (figure 9.4).

I hope we can accept at the outset that we are not talking about
concrete visual "facts" that inhere in these objects, "facts" that
Greenberg merely "observes" more perspicaciously than his
colleagues in criticism.[9] Admitting to Pollock's biographers in
the 1980s "that his review of the 1945 show was, in part at least,
a delayed reaction to the first show" from 1943, Greenberg had
found it important by 1945 to secure Pollock in a lineage that *res-
cued* the painter he had earlier held in ambivalent regard — rescued
him, first, from obscurity (mud) and, second, from negativity
(helplessness).[10] Imposing an implicit synthesis between the thesis
of Mondrian's avant-garde geometric purity (afflicted, as he saw it,
with "naïveté") and the antithesis of Kandinsky's expressionism
(which Greenberg identified as "falling…short of Mondrian" but

339

Figure 9.4. Joan Miró, *Constellation: Awakening in the Early Morning*, 1941,
gouache and oil wash on paper, 18⅛ x 15 in. (46.0 x 38.0 cm). Kimbell Art
Museum, Fort Worth, acquired with the generous assistance of a grant from
Mr. And Mrs. Perry R. Bass. © 2003 Successio Miro / Artist Rights Society (ARS),
New York / ADAGP, Paris.

having a "better sense of what was going on"), Pollock's negativity was now read by the critic as a necessary tonic, revealed as a type of emotional *honesty* distinct from Europeans' "self-deception":

> The only optimism in [Pollock's] smoky, turbulent painting comes from his own manifest faith in the efficacy, for him personally, of art. There has been a certain amount of self-deception in School of Paris art since the exit of cubism. In Pollock there is absolutely none, and he is not afraid to look ugly — all profoundly original art looks ugly at first.[11]

"Mud" is inept, but *looking ugly* is a strategy. Greenberg explains the goal of these unappealing *Totem* paintings, where "every possible ounce of intensity [has been wrung] from every square inch of surface [in these] suffocatingly packed ... oils." Make no mistake about it: the suffocation, the ugliness, the packed, intense surfaces that Greenberg constructs in his prose (not, I insist, entirely evident in the canvases themselves) are all linked to his 1945 proclamation about Pollock, in which this little-known American artist becomes "the strongest painter ... since Miró." The *Totem* paintings become exemplary for the self-education of the modernist viewing subject (here Greenberg), a process necessary in its own right but also forced on the critic by his own imperative to *see* Pollock's work clearly, to get beyond its initial ugliness to the profound originality of the modern, becoming art. It is crucial to examine, in slow motion, the one-two punch of this left-handed criticism:

> Pollock's single fault [in the *Totem* paintings] is not that he crowds his canvases too evenly but that he sometimes juxtaposes colors and values so abruptly that gaping holes are created.

Greenberg provides something to project onto *Totem Lesson 1* (as potentially "too evenly" crowded?), and something else we might surmise is applicable to *Totem Lesson 2* (juxtaposing abrupt values, if not colors *per se*). Does it matter that neither attribute really suits? When we invert Greenberg's typically twisted sentence to its implied positives (run the film backward, as it were), we understand that it would be *better* to crowd canvases evenly than to risk creating "holes" in the image, *better* to produce a decorative, allover surface than to risk a *retardataire* (and possibly gendered) dimensional illusion.

This is the sense in which this criticism of 1945 already achieves a kind of painting that Pollock will only later come to produce. The criterion of crowded alloverness will fit much more effectively the skein paintings that begin in 1947 — and therein lies the paradox.

That paradox cannot be resolved by the Zeitgeist argument that many others were making such allover paintings in 1945. There is simply no such fluorescence of the mode until after 1947, although Greenberg was always careful to state that there were precedents for isolated aspects of Pollock's work. (See figure 9.5 for a typical, if rarely acknowledged, precedent in Mark Tobey and figure 9.6 for an example of the later fluorescence, here in work by Pollock's partner, Lee Krasner.)[12] Let me be precise, then, about the stakes of my claim: in order for the little-known painter Jackson Pollock to be understandable as part of "rationalized décor," certain reading practices had to be initiated in front of certain canvases that were seen to exhibit specific kinds of labor and perform certain kinds of cultural work. For this talking thing to function *as modernist*, Greenberg needed to produce those reading regimes. Greenberg's words began to consolidate those practices, but his words were themselves stimulated by specific visual experiences. The visual experiences could not have come from the *Totem* paintings. That much is clear.

Figure 9.5. Mark Tobey, *Crystallization*, 1944, tempera on board, 18 x 13 in. (457 x 330 mm). Iris & B. Gerald Cantor Center for Visual Arts at Stanford University; Mabel Ashley Kizer Fund, Gift of Melita and Rex Vaughan, and Modern and Contemporary Acquisition Fund.

Figure 9.6. Lee Krasner, *White Squares*, 1948, Oil on canvas, 24 x 30 in. (61 x 76.2 cm). Whitney Museum of American Art, New York, Gift of Mr. and Mrs. B.H. Friedman. © 2003 The Pollock-Krasner Foundation / Artist Rights Society (ARS), New York. Photograph Copyright © 2000: Whitney Museum of American Art, New York.

The *Totem* paintings, in fact, destabilize the standard figure-ground relationship that painters such as Joan Miró pursued (see figure 9.4); Greenberg's back-and-forth descriptions reveal his anxiety about this ambiguity. The *Totem* paintings' forms appear to be reserved from a thick, deep ground; these reversed depth relations empty out the expected phallic significance of the totemic forms, emphasizing their potential gendering as "holes." Hence the need for Greenberg's insistence that the "strongest" and "greatest" parts of these paintings were an alloverness (evenly crowded) and flatness (avoidance of "gaping holes") that had not yet really been achieved. Why would Greenberg find himself making such claims, albeit in recognition of a long-delayed approval of paintings such as *Guardians of the Secret* (about which he'd recalled, "I wasn't bowled over at first. I didn't realize what I'd seen until later")?[13] Why move against the evident direction of Pollock's work in producing these effects for the two *Totem* paintings, which don't yet exhibit the kind of behavior he describes? Only the thing in its combinatorial form (critic + artwork) could enter the desired modernist visibility. And only a very different, utterly shadowed painting and its mute impact could suggest the way.

Seeing and Saying

I've already alluded to a painting that was seen but not said in 1944. It provided the critic with an overwhelming experience he never wrote about — a painting that behaved in just the way he suggested in his 1945 review, a painting that was intensely crowded and allover, a painting that built on earlier pictorial traditions yet stimulated entirely new protocols of reading, a painting that fused rationalized décor and expressiveness in an entirely new way. The canvas in question, which clearly informed the implicit progressivist goal propelling the visibility Greenberg saw-into-being around the work of Jackson Pollock, was a nonobjective,

345

expressionistic, sublimely packed 20-foot mural Pollock had painted in a burst of energy for Peggy Guggenheim's apartment. It was probably completed in the very last weeks of 1943, but in any case sometime before the second week of January 1944.[14] It was called simply *Mural* (figure 9.7 and color plate VIII).

Greenberg acknowledged only decades later that his experience of this enormous wall decoration cured the ambivalence of his 1943 review. As he put it: "I took one look at it, and I thought, 'Now *that's* great art,' and I knew Jackson was the greatest painter this country had produced." He commented even later to his biographer that he remembered being "hit" by the painting. These are the scraps of oral evidence for an encounter otherwise unrecorded in print.[15] But the effects of that encounter on Greenberg are manifest in his subsequent reviews and clarified by the visual datum of *Mural* itself. The painting's materiality (the physical construction of this part of our thing) gives credence to the supposition that it was the unwritten experience of *Mural* that inscribed itself into Greenberg's criteria for Pollock's later works. Unlike any of the canvases the artist would produce for the next two years, this one was evenly, even obsessively crowded, without a gaping hole in sight.

Greenberg is said to have seen this canvas in Guggenheim's apartment soon after its completion. It is even conceivable he was at its January 1944 "inaugural," an extremely charged social event in which Greenberg's ex-lover was being feted with her new boyfriend, who was Guggenheim's amicable ex-husband.[16] Greenberg's experience of violence (being "hit" by *Mural*) is understandable. The only work of Pollock's that had approached *Mural* in size was the ephemeral 25-foot painting on which the struggling artist had collaborated with many other assistants, working in the Manhattan workshop of the Mexican revolutionary painter David Alfaro Siqueiros in 1936. *That* untitled piece was to be part

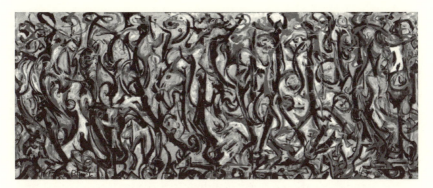

Figure 9.7. Jackson Pollock, *Mural*, 1943, and 8b, detail, oil on canvas, 97¼ x 238 in. University of Iowa Museum of Art, Gift of Peggy Guggenheim. © 2003 The Pollock-Krasner Foundation / Artist Rights Society (ARS), New York.

of the May Day parade, produced using spray guns and industrial automobile paints and avoiding, whenever possible, what Siqueiros spurned as "the stick with the hairs on its end."[17] Siqueiros's socialist imagery went unrecorded, although Greenberg may have seen it. But in any case, by the time the critic encountered Pollock's 1944 *Mural*, other models would have been on his mind — most notably, that world-famous, quintessentially avant-garde mural, Pablo Picasso's antifascist *Guernica* (itself inspired by the revolutionary Mexicans). The very title of Pollock's painting, *Mural*, would have summoned such heroic precedents — only to empty them. As suggested by the painting's neutral title, Pollock knew that his brief for Peggy Guggenheim was no May Day affair. The picture's location, the circumstances of its commission, and its ostensive "generic" function would all have emphasized the gap between the aspirations of revolution and the realities in this heiress's apartment. In contrast to the Manhattan streets, or even the Museum of Modern Art where Picasso's *Guernica* waved its antifascist flag, Guggenheim's foyer secured a safe zone for the play of capital. Amid wartime uncertainty, the heiress's sheltered nest was a plausible site for the fulfillment of the "rationalized décor" Greenberg had first intuited in Mondrian and now saw realized in this Pollock painting.

To summarize brutally, Greenberg had located an outward momentum in the grids of Mondrian's paintings but not in the working-class streets Siqueiros had hoped to animate. Instead, a modernist Mondrian such as *Broadway Boogie Woogie* was seen by the critic to fold the geometries of the industrialized environment into itself and reexpress them — tame them, as it were — for the reduced confines of the urban interior (figure 9.8). Extending this dynamic, the mural could emerge "as a living, modern form" (in the critic's words). Mondrian's New York paintings in particular (clearly modeled on the Manhattan street grid) set the

Figure 9.8. Piet Mondrian. *Broadway Boogie Woogie*, 1942–1943. oil on canvas, 50 x 50 in. (127 x 127 cm). Museum of Modern Art, New York. © 2003 Mondrian / Holtzman Trust/ Artist Rights Society (ARS), New York. Digital image © The Museum of Modern Art / Licensed by SCALA / Art Resource, NY.

template for Greenberg's attempts to articulate what modernism was about and to become its attentive subject. Mondrian's grid canvases guided Greenberg, as a viewer and reader, to rationalized décor. As the critic put it: "The final intention of [Mondrian's] work is to expand painting into the décor of the man-made world — what of it we see, move in, and handle. This means imposing a style on industry, and thus adumbrates the most ambitious program a single art has ever ventured upon."[18]

These were still only potentialities in Mondrian, however; Greenberg felt them to be realized fully in Pollock's larger, truly environmentally scaled painting. In his 1944 obituary of the great Dutch modernist, Greenberg acknowledged that Mondrian's own intentions were "somewhat different" from the reading he imposed on them, and yet the passage he uses from Mondrian's writings could be the epigraph for his own emerging sublimating agenda: "If we cannot free ourselves, we can free our *vision*." Thus Greenberg's well-documented postwar turn from Marxism (which had aimed at changing the *external circumstances* of the unfree self) to capitalist democracy's ideology of *interior freedom* was already written into his reading of Mondrian before the war's end. Greenberg's interpretation of Mondrian's famous hope to free vision was as "a refuge from the tragic vicissitudes of time."[19] This refuge (painting) would be not the traditional "windows in the wall" of Renaissance illusion but, as Greenberg put it, "islands radiating clarity, harmony, and grandeur — passion mastered and cooled, a difficult struggle resolved, unity imposed on diversity." These "islands" of radiant control were found in Pollock. Pollock's primitivism would be sublimated in order to construct Greenberg (and his readers) as the emerging subjects of a bureaucratized American culture after the Second World War.[20]

Greenberg's notion of "struggle resolved" into an ordered radiance would become explicit in his review of Pollock from

1946. Greenberg's high estimation of Pollock's importance continued, but by now the artist and the critic had become friends. Indeed, a month or so after Greenberg started going out to Springs (in Easthampton, New York) to talk with Pollock about his work, the painter set aside one of his new paintings (*Eyes in the Heat,* figure 9.9), saying to Lee Krasner, "That's for Clem."[21] Alloverness was now a personal injunction, and our talking thing changed rapidly. Greenberg's experience of Mondrian's modernism began to be mapped directly onto Pollock's subjectivity. A famous passage from the critic's 1946 review of Pollock is often cited for its hysterical masculinity but rarely opened out or analyzed as to how it functioned in the construction of Pollock's art (or in Greenberg's experience of himself as subject to that art's modernist regimes):

> Pollock submits to a habit of discipline he derived from cubism; and even as he goes away from cubism he carries with him the unity of style with which it endowed him when in the beginning he put himself under its influence. Thus Pollock's superiority to his contemporaries ... lies in his ability to create a genuinely violent and extravagant art without losing stylistic control. *His emotion starts out pictorially; it does not have to be castrated and translated in order to be put into a picture.* [Emphasis added.][22]

Again, let's take that pitch in slow motion. What is Greenberg's conception of emotion, and what processes have been seen to occur such that it "starts out pictorially"? Emotion here is not merely the interior response of a feeling subject to exterior stimuli. Rather, it needs to be constructed as a material entity that must be trained in some way before it can produce a work that will "body forth into visibility," as Greenberg puts it.[23] It needs to be a kind of tablet for inscription, at once a form and a surface

Figure 9.9. Jackson Pollock, *Eyes in the Heat*, 1946, oil on canvas, 54 x 43 in. (137.2 x 109.2 cm). The Solomon R. Guggenheim Foundation, New York, Peggy Guggenheim Collection, Venice. © 2003 The Pollock-Krasner Foundation / Artist Rights Society (ARS), New York. Photograph © The Solomon R. Guggenheim Foundation, New York.

that can be ordered, internally and "pictorially," within (and *as*) the subject.

I use Greenberg's phrase "body forth" advisedly, of course, for the critic's discourse on emotion figures an entity with strengths, skills, and weaknesses similar to a body — specifically, a male body at risk in its peripheral extensions. It is a body whose interiority is already structured like a surface, riddled with vulnerable protrusions. This is a point at which the function of the visibility and the parallel stratum of statements can be seen to come together to constitute the experience of the self at the most intimate level (as Greenberg ambiguously phrases it, the self is both his own and Pollock's). To raise the specter of castration (only to deny it) is to assert Pollock's virility, but it also serves to demonstrate that the artist's manhood is vulnerable and needs asserting. That which can be castrated is a protuberance, but the metaphor of castration itself is predicated on an analogy with female *lack* (per Jacques Lacan), an obverse that is an infolding, a figure for the subject as produced from an interiorization of the outside (with its markings and wounds). As Gilles Deleuze describes it, quoting Michel Foucault: "I do not encounter myself on the outside, I find the other in me ('it is always concerned with showing how the Other, the distant, is also the Near and the Same'). It resembles exactly the invagination of a tissue in embryology, or the act of doubling in sewing: twist, fold, stop and so on."[24] The body image here, with its interior pictorial surface, is thus a prime exemplar of the folding of subjectivation, and it is in these terms that Greenberg conceives an already-inscribed "emotion" with its seamless relation to the outside (the subject being what Deleuze and Foucault identify as the enfolded "inside *of* the outside").[25] The "already-pictorial" emotion is, I submit, also *already castrated* (this is the sense in which that wound no longer needs inflicting). It is the subject experiencing himself in the visibility, experiencing him-

353

self as the interior (wound) enfolded traumatically from an exterior world.[26] Cubist disciplines, Mondrian's rationalized urban grids, industrial organization — all have already been internalized, already been inscribed on the pictorial imagination, "processed" and "rendered" of the body member precisely so that the painting can prosthetically "body forth."

This extraordinary insertion of Pollock into an ordered, disciplined production occurred in 1946, long after Greenberg had been "hit" by *Mural*'s marks. But the argument was implicit even in 1943. In that earliest review, Greenberg had argued that Picasso, Cubism, Mondrian, *and* the Mexicans were all things that Pollock (and other American artists) had to "go through"; Pollock needed to internalize and then metabolize these influences in order to "paint mostly with his own brush."[27] When Greenberg saw *Mural* a few months later (in his postwar, postnervous-breakdown condition), he decided that this "processing" had been achieved. Earlier European orders had now been internalized, and the Mexicans' radical social realism had also been transcended. Revolution was fine in its place, and Greenberg had been among its most fervent supporters, but he had begun to see a new role for modernism in its only viable postwar form (industrial capitalism, with its radiating "islands" of control).[28] If the Pollock *Mural* was to play its part in an heiress's apartment rather than agitating a left-wing parade audience of revolutionary workers, so be it. In place of the collective would be the internally organized unit of the individual, who had enfolded the implied order of the industrial Cubist grid. In this context, the painting would stand for the individual experiencing a radiant control homologous with urban industrial disciplines and behavioral regimes.

This is the narrative Greenberg amalgamated to his experience of being "hit" by *Mural* and brought to bear on his subsequent reading of the *Totem* paintings. In place of existential action

(emblematized by the claims of the competing critic Harold Rosenberg), gestural painting is seen as the product of internalized pictorial discipline, framed and filtered by its enfolded industrial urban setting. To what extent were these frames and filters produced by an encounter with the mural painting itself (rather than a visual afterimage produced by the more obvious grids of Mondrian)? To complete the argument, we must go back to Greenberg's first experience of *Mural* and imagine it immediately confronting visitors as they entered the foyer of Guggenheim's Upper East Side apartment. Only in a closer reading of the "hit" of the brush strokes can we see how Greenberg could envision it "expand[ing] painting into the décor of the man-made world." Size was also a major aspect of *Mural*'s materiality. Indeed, Pollock's canvas was crammed (and heedlessly cropped to fit) into the far wall of Guggenheim's foyer, so that it became coextensive with one's field of vision upon crossing the boundary from public into semi-private space (see figure 9.7).[29] Even in reproduction, the painting presents itself as seething with expanding energies, just barely attaining that goal of "a difficult struggle resolved, unity imposed on diversity."

What *was* this mural?

To intimates (not yet to Greenberg) Pollock related the long-awaited inspiration for the painting, a "vision" that finally came to him in the remaining hours before the commission was due — an animal stampede. The "vision" was also concocted from memories of a specific stampede Pollock had witnessed as an adolescent hunting mustangs out west. Could a pictorial evocation of a panic-stricken rampage of startled animals map effectively onto that modernist, urban, compensatory freeing of vision that Greenberg was trying to describe? Certainly for Pollock the process of making *Mural* was narrated as a simultaneous freeing and constriction: "Cows and horses and antelopes and buffaloes.

Everything is charging across that goddamn surface."[30] With Pollock's inclusion of animals long eliminated from the land (antelope and buffalo), we can recognize his narrative as *restitutive* — restoring but also releasing and transmogrifying the conflicted memory of his participation in that senseless hunt for wild horses that were then shot and left to bleed in the dust next to a water hole that had been newly fenced as part of the move to industrialize the "wilderness" of the American West.[31]

The narrative of Pollock's mustang hunt is manifested in the end only by the abstract, friezelike structure of the painting's composition and its cadence of progressively transforming linear figures. But it is precisely within this friezelike structure that we can see how rationalized order is produced. Reading (as one reads the Roman alphabet) from left to right, we see the canvas "begin" with abstractions of arching black spines, stamping hooves, rearing heads, and swelling rib cages, all distilled to tangles of looping strokes and baroque, eddying, wavelike forms. Approaching the composition's midpoint, this swirling rhythm abruptly shifts. Here (one imagines this midpoint as directly opposite the entrance to Guggenheim's foyer), we encounter the rigid uprights of a different structure altogether. This initiates the "human" — verticals ordered by looping circles (lariats and lassos, not the animals' sinuous rococo waves). Here too is the embedded structure of the modernist grid. The formal progression to *Mural*'s right half thus cooks the raw narrative of the stampede, rendering it as synchronous with modernist primitivism itself (curving diagonals progressing to verticality, nature to culture, animal to human, outback to city, chaos to order). The temporal progression, a viewing time structured by traditions of left-right reading of the pictorial field, mirrors a historical chronology of progress in domestication, containment, and control. The image here instantiates "passion mastered and cooled," emotion tempered by the

ordering rationality of the (Western) pictorial regime and its en-
abling ideologies (from Manifest Destiny to eminent domain).

Beyond the covert masculine signifiers of stallions and vertical
hunters, and far more important to my larger argument, were the
repeating, expansive gestures that constructed *Mural* itself (color
plate VIII). The gestures are still brush strokes, to be sure. But
they are worlds apart from the tiny movements of the wrist, the
small flicks of the brush, the caress of the palette that had long
constituted the body disciplines of making art in the Western
tradition. The way in which Pollock's expansive gestures *hit* the
canvas did not fill in a sketch or round out an armature but con-
stituted the pictorial structure of the canvas itself. This was very
different from the boxy structures Greenberg had identified in
Guardians of the Secret from a few months before. In that much
smaller canvas, Greenberg had perceived Cubism in the taut geo-
metric configuration, an arrangement of blocky underpainted areas
that were quite separate from the graffitoed lines that crawled, as
scripted afterthoughts, over the "mud-like," organized ground.
After experiencing *Mural*, Greenberg could argue that Cubist-
based geometric order had been both atomized and internalized
by the painter. Such regimes were performed in Pollock's repeti-
tive large-body movements and dispersed over a shallow pictorial
surface, organized by that now-implicit Cubist grid.

It was not just Greenberg who felt this order. As anyone could
sense, *Mural* had been built up from a sequence of strong-armed,
repeating, coordinated movements on the part of the painter,
movements that not only duplicated themselves in the slightly
varied figures seen marching across the surface but constituted
graphic "hits" that repetitively echoed and subtly altered each of
those figures in turn. The painter's arm made successive passings of
the loaded brush layering black, then slate, salmon red, yellow (but
not always in that order, and never "filling in" a predetermined

357

outline or gestalt).[32] Nor was Greenberg the only one to recognize that this kind of abstract movement was a major instance of the surrealists' celebrated compositional device *écriture automatique*. But Pollock's ordered repetitions posed awkward problems for automatism's ideology of unconscious release. The scale, too, was unprecedented. This was no surrealist parlor game with pen and pencil, stimulant to the invention of motifs that could then be transferred to cabinet pictures or personal poems. Pollock's automatism was bigger, less poetic. His moves were closer to *automation*.

Pollock's painting processes synthesized for Greenberg a violent dialectic between human gesture and industrial order. The very automaticity of the painting, in conjunction with its animal expressiveness, was what "hit" Greenberg so hard and helped him forge himself as modern. Much later, when Pollock's painting process was photographed, some would see the painter's repeating movements in terms of a shamanistic dance.[33] But repetition itself was all one could see on this canvas, and Greenberg felt its *modern* force.[34] The painter's repeating large-body movements could be tracked in *Mural*, their traces seen as replicating the internal discipline and external body techniques of an industrial line worker — whether smelting iron and pouring steel (operations Pollock had gone to sketch at Bethlehem Steel the summer after Siqueiros), roping animals for the abattoirs (the intended fate of those mustangs), processing those animals sequentially (figure 9.10), or, as Pollock himself had done with his father, posting guardrails, dumping stone, and shoveling asphalt in the industrializing American West. These kinds of movements are mind-numbingly repetitive; indeed, it is that mechanical requirement for invariance that constituted the single greatest problem for twentieth-century automation. How to stem the loss of productivity, the lapse in precision, and the mismatch to machine rhythms that

Figure 9.10. Artist unknown, "Apparatus for Catching and Suspending Hogs," 1882,
U.S. patent 252,112. From Siegfried Giedion, *Mechanization Takes Command*
(New York: Oxford University Press, 1948), fig. 117.

were attributed to "worker fatigue"? *Mural*'s repeating large-body movements, its progressive left-right ordering of abstracted figural forms, and the implicit grid that organized its pictorial surface crystallized this problematic and combined to knock Greenberg into a new experience of reading. Saccadic scanning of the picture was organized by a narrative of progression from left to right — moving toward modernist order — and the segmented, repeating large-scale body discipline the viewer encountered could be mapped on a grid and extended imaginatively into "rationalized décor." Greenberg saw a potential for such expansion locked in Mondrian's work; his ekphrastic reaction to *Mural* brought it into visibility and made Pollock an instrument of the mid-century bureaucratization of the senses. *Mural*'s large scale and repeated *hits* of paint enfolded the critic in a visual surface so dense with kinesthetic significance that it could truly "body forth" the modern viewing subject in an activated urban grid.

Modernism's Visibility

It might be argued that Greenberg's personal need to be ordered by modernism forced him to *mis*read these early works of Pollock's, projecting what he elsewhere called "hallucinated uniformity" onto paintings that most found frankly confusing.[35] But the charge that Greenberg was misreading would fail to account for either prior critical readings that found Pollock curiously "ordered" or the general enthusiasm that greeted Greenberg's views.[36] We have traced the force (and even obsessive consistency) of Greenberg's account. I now want to argue that there were other constituents of this modern "reading discipline" beyond our one talking thing.

Let us start from Greenberg's hunch that Pollock's labor was implicitly ordered, pictorial from the start, a perception based, I've argued, on the way that this laboring body was *disciplined* to lay quick large strokes of color over and over again along a repet-

360

itive friezelike configuration in the object called *Mural*. The absolute freedom that automatism was supposed to foster was here both magnified and contained. The body's movements were segmented and isolated into clear trajectories. The resulting gestures and the lines they formed were seemingly clarified by a preexisting regimen that was not so much conscious as habitual. Such repeating movements were rapid and would have been hard to follow if they had not been made graphic through their inscription on the surface of the canvas.

Rapid habitual movements and the systems for inscribing them came to modernism from modernization. From the very origins of machine vision, scientists adopted new technologies of visualization to take human movements apart and render them into graphic, measurable segments. "Chronophotography" was the name the French physiologist Etienne-Jules Marey gave to his graphical inscription systems; the photographer Eadweard Muybridge pursued different means to achieve visually similar ends. These interests were quickly taken up by artists such as the American realist painter Thomas Eakins (a commissioner of Muybridge), who made his own "Marey-wheel" photographs of human movement in 1885 (figure 9.11). Interestingly, this particular image was illustrated in the *Magazine of Art* the year Pollock got the commission for *Mural*, and there is surely some connection between the two pictures' repeating, segmented, dynamic forms.[37] It is an art-historical truism that such images of "animal locomotion" (in Muybridge's phrase) informed modernist movements from Cubism, to futurism, to Dada-surrealism — surviving even into minimalism.[38] But these visual homologies are not the whole story. Eakins's photographs were only part of a steady parade of mechanical inscriptions of movement, intended for science, industry, and art and ranging from still photographs sequentially arranged, to multiple exposures on the same negative, to time-

lapse photographs, and, finally, of course, to cinematically projected film. What all these technologies had in common was their capacity to *fix* the fluid movements of the human body, usually by breaking a single gesture into measurable temporal and spatial units graphically inscribed. Accompanying the desire for this aggressive segmentation was its restitutive opposite: the yearning to reconnect, reassemble, and make those segments *flow* again — through Zoetropes, Kinematiscopes, tachistoscopes, Marey-wheels, Moviolas, and so on (figure 9.12). But the organizing phenomenon that changed visual culture was the mechanical segmentation and inscription of human movement.

The legions of filmic records of Pollock painting fit within this tradition, but what I am arguing is that Pollock's paintings, and Greenberg's readings of them, were *already* beneficiaries of this industrial-scientific visualization regime (figure 9.13). *Mural*, and Greenberg's reading of Pollock's repeating gestures, preceded by half a decade the 1950s photographs that codified "action painting" as inscribed gestures once and for all. That post-1950 trajectory does not make the case, but seals it. Art historians have already suggested that the Albanian-American photographer Gjon Mili's complex 1949 images of Picasso painting with light were a crucial stimulus for Hans Namuth's decision to film Jackson Pollock a few months later painting on glass.[39] *Life* magazine published this Mili image in January 1950 (figure 9.14). Its multiply exposed, time-lapse, strobe-flash brilliance probably fired the competitive energies of many a New York painter and photographer; certainly it would have gotten to Pollock, who once cursed, "That goddamn Picasso did everything!" What this scholarship misses, however, is the specific *modernity* of such images and the discursive role they played in rationalizing, segmenting, and disciplining the body well before Namuth started putting Pollock on camera in 1950.

Figure 9.11. Thomas Eakins, *Jesse Godley (Motion study-male walking)*, 1884, silver print, 5¹⁄₁₆ x 6⅞ in. Philadelphia Museum of Art: gift of Charles Bregler. This image was published in the New York–based *Magazine of Art*, Jan. 1943.

<div align="center">WHICH HAVE ALREADY APPEARED.</div>

Phantoscope	Rayoscope	Vileocigraphoscope
Criterioscope	Motiscope	Pantominograph
Biograph	Kinotigraph	Ammotiscope
Cinematograph	Phenakistoscope	Acheograph
Vitascope	Venetrope	Kinographoscope
Kinematograph	Vitrescope	Lifeoscope
Wondorscope	Zinematograph	Sygmographoscope
Animatoscope	Vitopticon	Kineoptoscope
Vitagraph	Stinnetiscope	Cleroscope
Cosmoscope	Vivrescope	Velograph
Anarithmoscope	Daramiscope	Stereoptigraph
Panoramograph	Lobsterscope	Eragraph
Katoptukum	Corminograph	Moto-Photoscope
Magniscope	Kineoptoscope	Zoopraxoscope
Zoeoptotrope	Scenamotograph	Tachyscope
Phantasmagoria	Kineograph	Thaumototrope
Projectoscope	Thromotrope	Thropograph
Variscope	Kinebleboscope	Mimicoscope
Cinograph	Pictorialograph	Musculariscope
Cinnemonograph	Kinegraphoscope	Involograph
Hypnoscope	Vileograph	Shadographoscope
Centograph	Kinevitograph	Counterfivoscope
X-ograph	Photokinematoscope	Realiphotoscope
Electroscope	Kineselograph	Rythmograph
Cinagraphoscope	Mophotoscope	Photoscope
Kinetoscope	Phototrope	Originagraph
Craboscope	Movementoscope	Persistoscope
Viletoscope	Touniatoscope	Selfseminograph
Cinematoscope	Vilophotoscope	Getthemoneygraph
Mutoscope	Waterscope	Parlorgraph
Cinoscope	Visionscope	Phasmatrope
Animaloscope	Phonendoscope	Klondikoscope
Theatograph	Lumiograph	Stroboscope
Monograph	Heliographoscope	Chronomatograph
Motorgraph	Pantobiograph	Scenoscope
Kineatograph	Zoetrope	Tropograph
	Chronophotographoscope	

Figure 9.12. Charles Francis Jenkins, *Animated Pictures: An Exposition of the Historical Development of Chronophotography, Its Present Scientific Applications and Future Possibilities, and of the Methods and Apparatus Employed in the Entertainment of Large Audiences by Means of Projecting Lanterns to Give the Appearance of Objects in Motion* (1898; New York Arno, 1970), p. 24.

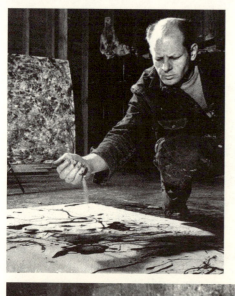

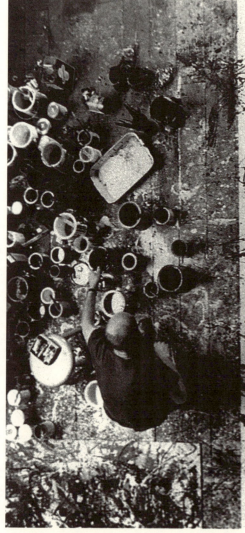

Figure 9.13. Images of Pollock painting (*counterclockwise from top left*): Martha Holmes, *Life*, Aug. 8, 1949; Rudolph Burckhardt, 1949/1950 © Estate of Rudy Burckhardt/Licensed by VAGA, New York, NY; Hans Namuth, 1950, as published in *Art News*, May 1951; and Hans Namuth and Paul Falkenberg, 16 mm film, *Pollock Painting*, 1950, as computerized for Pepe Karmel and the Museum of Modern Art in 1998.

Figure 9.14. Gjon Mili, *Pablo Picasso* "drawing a centaur with light at the Madoura Pottery in Vallauris, France," 1949, published in *Life*, Jan. 30, 1950.

Let's follow the traces of this visual culture a bit further back. Gjon Mili had come from Eastern Europe to study engineering at the Massachusetts Institute of Technology, where he and "Doc" Harold Edgerton developed existing stroboscopic flash technologies for widespread use in industrial photography. Both the ontogeny and the destiny of the nineteenth-century strobe seemed to be forever split between art and science. Ottomar Anschutz put it to use in what he called his "Projecting Electrotachyscope" in 1894 (a popular Berlin entertainment); the Paris-based Seguin brothers soon developed it industrially, marketing it in 1925 for the observation of rapidly rotating machines. Edgerton entered the picture on this particular cutting edge. Within a few years of the Seguins' work, he concluded his 1927 MIT thesis by photographing working industrial machinery with stroboscopic light. At around the same time, he was collaborating with his classmate Mili to bring these techniques to photography in general. Their dreams came true as Mili's photographs started reaching the mass readership of *Life*.

I've argued that the inscription of human movement was the visual payoff of a segmentation that had broader industrial roots, but the inscriptions themselves took disparate technological and visual forms. For example, Mili's 1941 photograph of the jazz drummer Gene Krupa used a long exposure to record multiple stroboscopic flashes that segmented sequences from the fluid trajectory of the drummer's arm. (Figure 9.15 illustrates a similar technique.) The 1946 photograph of the skater Carol Lynne, by contrast, combined a single flash exposure taken at the apogee of her leap with a time-lapse record of the movement of tiny flashlights attached to her skates (figure 9.15). The results are visually quite different: the one type produces repetitive, echoing, transforming segments broken out of a single gesture, the other creates a fluid graphic form as an index of the line traced in space by

Figure 9.15 (*above*). Gjon Mili, *segmentation* of human movement, in this case a ballet dancer *en pointe*, ca. 1941 (courtesy MIT Museum, Cambridge, MA); (*right*) *graphicalization* of similar movement, here skater Carol Lynne, *Life*, 1946.

LIFE

CAROL LYNNE by MILI

MARCH 26, 1945 **10** CENTS

YEARLY SUBS

some "significant" part of the moving body. We might call the first segmentation, the second graphicalization. The first (1941) characterizes the modernity of Pollock's *Mural* (1943–1944). The second (1946) finds itself most clearly expressed in the skein paintings to come (1947).

But I hope it will be clear that Pollock's modernity (in Greenberg's view) is not just a "look" of graphic segmentation. Modernity and modernism are precipitates of modernization, and it is utterly significant that these visual discourses of segmentation and graphicalization were most powerfully employed in Taylorist initiatives for rationalizing and instrumentalizing human labor in the industrial West. As I have suggested, Greenberg experienced such regimes as organizing mid-century subjectivity in general, discovering that "only in art as yet...has an appropriate vision of efficiency as an ideal been bodied forth, a vision of that complete and positive rationality which seems to me the only remedy for our present confusions."[40] Modern art, in his view, was sealed off from ideological manipulation by its very self-reflexivity. But its self-reflexive disciplines were themselves produced by, and productive of, modern rationality and its industrial forms. The central impact of Mili's work was not to be a footnote to action painting but to visualize the gospel of a fully Taylorized *Life*, that illuminating organ of Henry Luce's "American century." As such, it was intended for man, woman, child, and animal — as in the major spread by Mili that reached readers in the fall of 1946, just weeks before Pollock first lifted his brush from the canvas to begin tracing his repeating gestural trajectories in midair (figure 9.16).[41]

The connection, then, is fairly robust between the machine-vision technologies informing the largely European photographers who segmented and recorded Pollock's processes in photographs and film and the same technologies as they were used in the modernizing imperative to make everyday laboring humans "efficient."

CONTINUED ON NEXT PAGE 105

Figure 9.16. Gjon Mili and the editors of *Life*, "Easier Housekeeping – Scientific Analysis Simplifies a Housewife's Work," Sept. 9, 1946.

What I am not yet prepared to claim is that the aerial gestures Pollock pursued in the skein paintings (see figure 9.2) were themselves suggested by such time-lapse graphicalizations of human movement. My argument only requires a visual culture in which they could be *read* that way. I am not, after all, pursuing Pollock's *intention*. My talking thing, remember, is a composite of Greenberg's words and Pollock's image. Pollock's *Mural*, as a uniquely material precipitate of its own production, joins Greenberg's integrated production of modernism through it. Cubist geometries and segmented movement were both aspects of the march of industrial progress folded into the very interior of the human subject. I hope to have demonstrated that Greenberg learned how to be modern by reading Pollock in just this way.

As one viewer exclaimed in heartfelt reaction to a Mili photograph of a dancer frozen in mid-leap, "This photograph ... embodies dramatically the answer to what was one of the largest, most painful questions of my life — a question I thought had no solution — how could I be both free and orderly at once?"[42] I have attempted to show that similar "answers" were provided by Greenberg, whose search for modern subjectivity led him to construct a new reading practice around Pollock's paintings (through the initial impetus of *Mural*). Greenberg's visual systematics produced Pollock as constructively modern, productive, ordered, civilized, "Athenian," and controlled. The critic's dynamic, ongoing production of modern subjectivity through Pollock — those visual systematics — have been denoted here in philosophical shorthand as the Deleuzian/Foucauldian concept of the "visibility."[43]

Visibilities are systems. Here the seen was read into the said. But equally, the visibility can function to produce the unseen along with the seen. It is the nature of the visibility, particularly modernism's historical variant, to operate through its others, its shadows, its residues, its unprocessed remnants, and its high-

lighted icons. Difference provides the very possibility of signifi-
cation, in visual as well as discursive registers. The articulation
Greenberg provided was thus only one aspect of the ways in
which Pollock's work functioned (although it tied up a fair num-
ber of loose ends). The very wrinkles in the folds of Greenberg's
texts could produce their own shadows, as subsequent purveyors
of the "post-Pollockian performative" would explore.[44] What I
want to insist is that the shallow surfaces of Pollock's painting
were themselves a prime stimulus of this system — just as com-
plex, just as productive, and just as necessary as the critic's words.

Immaterial images certainly wield power; disembodied words
attempt to animate ideas. But "things" have an unscripted and
underdetermined agency. The conceit of my thing, a set of "talking
pictures," has aimed to force us to think about materiality as itself
an agent in discourse. I have attempted to produce the text/ure of
material vividly, but only to show the canvas *thing* in its *visibility
through text*. The art historian stalks this thing-in-a-visibility at
some disadvantage, bound by archives, texts, and their "illustra-
tions" and mortgaged to the academic genre of the book or the ped-
agogical imperative of the slide or raster image. We like to imagine
that our critics escape those mediating conditions. And indeed, the
critic Greenberg, in his fresh encounter with some unexpected
objects, became a different thing. Certainly, institutionally, he func-
tioned as an ekphrastic machine for "manipulating attention."[45] But
he could successfully make his modernism only if that manipulation
could be felt to echo the murmuring chatter of others. His reading
of an ordered Pollock was magnified and enlarged by the mirrors of
an "anonymous" visual culture of segmented, graphically inscribed
labor. *My* reading, in turn, offers a theory of visual culture that cri-
tiques the economy of the printed page by delineating the micro-
physics of its power. The art comes first in this argument, but the
critic is instrumental to its insertion in the visibility.

Notes

INTRODUCTION: SPEECHLESS

1. And to talk for; see Miguel Tamen, *Friends of Interpretable Objects* (Cambridge, MA: Harvard University Press, 2001).

2. Moshe Habertal and Avishai Margalit, *Idolatry*, trans. Naomi Goldblum (Cambridge, MA: Harvard University Press, 1992), pp. 108–36.

3. Euclid, *The Elements*, 1.5, 3 vols., 2nd ed., trans. with intro. and commentary by Sir Thomas L. Heath (New York: Dover, 1956), vol. 1, p. 155.

4. John Gilissen, "La Preuve en Europe du XVIe au début du XIXe siècle: Rapport de synthèse," in *La Preuve: Deuxième Partie: Moyen Age et temps modernes*, Recueils de la Société Jean Bodin pour l'histoire comparative des institutions 17 (Brussels: Editions de la Librairie Encylopédique, 1965), pp. 755–833.

5. Lorraine Daston, "Marvelous Facts and Miraculous Evidence in Early Modern Europe," *Critical Inquiry* 18 (1991), pp. 93–124.

6. Roland Barthes, "Le Mythe, aujourd'hui," in *Mythologies* (Paris: Seuil, 1957), pp. 191, 206, 181, 216, 232.

7. Hugo von Hofmannsthal, "Ein Brief," in *Der Brief des Lord Chandos: Schriften zur Literatur, Kunst, und Geschichte* (Stuttgart: Reclam, 2000), p. 59.

8. Joseph Leo Koerner, "Factura," *Res* 36 (1999), p. 5.

9. Martin Heidegger, "Das Ding," in *Vorträge und Aufsätze* (Pfullingen: Neske, 1954), pp. 157–75.

10. Arjun Appadurai, introduction to *The Social Life of Things* (Cambridge, UK: Cambridge University Press, 1986), pp. 3–63; Daniel Miller, *Material Culture and Mass Consumption* (Oxford: Blackwell, 1987). Miller also provides an overview of philosophical and sociological theories of objectification from Hegel through Bourdieu on pp. 19–82.

11. Miller, *Material Culture*, pp. 98–99; Fred R. Myers, *The Empire of Things: Regimes of Value and Material Culture* (Santa Fe, NM: School of American Research Press, 2001), pp. 14 et passim.

12. Nicholas Thomas, *Entangled Objects: Exchange, Material Culture, and Colonialism in the Pacific* (Cambridge, MA: Harvard University Press, 1991), p. 28.

13. Marcel Mauss, *The Gift: The Form and Reason for Exchange in Archaic Societies*, trans. W.D. Hall (1925; New York: Norton, 1990); Marilyn Strathern, *The Gender of the Gift: Problems with Women and Problems with Society in Melanesia* (Berkeley: University of California Press, 1988); Annette B. Weiner, *Inalienable Possessions: The Paradox of Keeping While Giving* (Berkeley: University of California Press, 1992); Annette B. Weiner, "Cultural Difference and the Density of Objects," *American Ethnologist* 21 (1994), pp. 391–403.

14. H.W. Janson, "The Image Made by Chance," in Millard Meiss (ed.), *De artibus opuscula XL: Essays in Honor of Erwin Panofsky*, 2 vols. (New York: New York University Press, 1961), pp. 254–66.

15. Several stimulating meditations on literature, materiality, and things have appeared recently, including Bill Brown, "How to Do Things with Things (A Toy Story)," *Critical Inquiry* 24 (1998), pp. 935–964; Bill Brown, "Thing Theory," *Critical Inquiry* 28 (2001), pp. 1–16; Daniel Tiffany, *Toy Medium: Materialism and Modern Lyric* (Berkeley: University of California Press, 2000).

CHAPTER ONE: BOSCH'S EQUIPMENT

1. A.M. Koldeweij, Paul Vandenbroeck, and Bernard Vermet, *Hieronymus Bosch* (Ghent and Rotterdam: NAi and Ludion, 2001), pp. 228–38.

2. *Ibid.*, p. 233.

3. Brian O'Doherty, *Inside the White Cube* (Berkeley: University of California Press, 2000).

4. Hans Belting, *Bild und Kult* (Munich: Beck, 1990); Victor Stoichita, *L'Instauration du tableau* (Paris: Méridiens Klincksieck, 1993).

5. Suzanne Sulzberger, *La réhabilitation des primitifs flamands 1802–1867* (Brussels: Palais des Académies, 1961), pp. 53–79.

6. On the framing of objects by modern museums and its relation to Enlightenment ideals, see Boris Groys, *Logik der Sammlung* (Munich: Hanser, 1997), pp. 7–24.

7. Hans Blumenberg, *Lebenszeit und Weltzeit* (Frankfurt: Suhrkamp 1986), pp. 7–68.

8. Svetlana Alpers, "The Museum as a Way of Seeing," in Ivan Karp and

Steven D. Lavine (eds.), *The Poetics and Politics of Museum Display* (Washington, DC: Smithsonian Institution Press, 1990), pp. 25–32.

9. Koldeweij, Vandenbroeck, and Vermet, *Bosch*, p. 233.

10. Felipe de Guevara, *Comentarios de la pintura, 1560–1563*, ed. Antonio Ponz (Madrid, 1788); cited by J.K. Steppe, "Jheronimus Bosch: Bijdragen bij gelegenheid van de herdenkingstentoonstelling te 's-Hertogenbosch," in *Jheronimus Bosch: Bijdragen bij gelegenheid van de herdenkingstentoonstelling te 's-Hertogenbosch 1967* ('s-Hertogenbosch: Noordbrabants Museum, 1967), p. 21.

11. Bosch's power derives from making the extraordinary seem ordinary; this contrasts with Pieter Bruegel the Elder, his greatest heir, who makes the ordinary seem odd or dislocated. On this distinction, see Stanley Cavell, "The Uncanniness of the Ordinary," in *In Quest of the Ordinary* (Chicago: University of Chicago Press, 1998), pp. 166–67.

12. Evidence of Bosch's artistic self-assertion occurs on his drawing *The Woods Have Ears, the Field Has Eye*s, with its autograph inscription "Miserrimi quippe est ingenii semper uti inventis et numquam inveniendis." Celebrating novelty in production, and locating the source of inventiveness within inner and native capacities ("ingenium"), Bosch insists, in a way familiar from humanistically informed painters like Albrecht Dürer, on a difference in *agency* between craft products (handmade tokens of an existing type) and art (new inventions). After his death, "inventor" becomes Bosch's most common title.

13. Marcel Mauss and Henri Hubert, *A General Theory of Magic*, trans. Robert Brain (New York: Routledge, 1972).

14. Marilyn Strathern, *The Gender of the Gift: Problems with Women and Problems with Society in Melanesia* (Berkeley: University of California Press, 1988), pp. 177–80.

15. See, for example, Karel van Mander, *Lives*, pp. 436–37 (fol. 293v, l. 1); Peter Parshall, "Imago Contrafacta: Images and Facts in the Northern Renaissance," *Art History* 16 (1993), p. 555.

16. Dominus Lampsonius, cited in Karel van Mander, *The Lives of the Illustrious Netherlandish and German Painters*, ed. and trans. Hessel Miedema (Doornspijk: Davaco, 1994), p. 195.

17. Carl Justi cites a letter from Philip II to his daughter praising a procession he'd seen in Lisbon, where the devil looked like a painting by Bosch. "Die Werke des Hieronymus Bosch in Spanien," *Jahrbuch der preussischen Kunstsammlungen* 10 (1889), pp. 120–44.

18. On these badges, see H.J.E. van Beuningen, A.M. Koldeweij, and Dory

Kicken, *Heilig en Profaan*, 2 vols. (Cothen: Stichting Middeleeuwse Religieuze en Profane Insignes, 1993 and 2001).

19. In 1488, Bosch achieved the elite status of "sworn brother" in the Confraternity of Our Lady. With its center in 's-Hertogenbosch, this religious organization was dedicated to the cult of a miraculous statue of the Virgin; badges of the effigy were sold by the thousand at the Church of St. John. In 1491–1492, the confraternity commissioned a new name board recording its deceased and living brothers. According to the records, the cost was only eighteen pennies, "apart from what Hieronymus did, for which he made no charge and wished to donate to the confraternity." See Jan Mosmans, *Jheronimus Anthonis-zoon van Aken alias Hieronymus Bosch* ('s-Hertogenbosch: Mosmans, 1947), p. 34; Pater Gerlach, "Jeronimus van Aken alias Bosch en de Onze Lieve Vrouwe-Broederschap," in *Jheronimus Bosch: Bijdragen*, p. 53.

20. Frans de Potter, *Gent van den oudsten tijd tot heden* (Ghent: Annout-Braeckman, 1883–1901), vol. 3, p. 34; cited in Dirk Bax, *Hieronymus Bosch: His Picture-Writing Deciphered*, trans. M.A. Bax-Botha (Rotterdam: Balkema, 1979), p. 206.

21. Bax, *Hieronymus Bosch*, pp. 109 and 240.

22. Michael Mollat, *The Poor in the Middle Ages*, trans. Arthur Goldhammer (New Haven, CT: Yale University Press, 1986), pp. 290–93.

23. Cited in Koldeweij, Vandenbroeck, and Vermet, *Bosch*, p. 114.

24. Koldeweij, Vandenbroeck, and Vermet, *Bosch*, p. 237.

25. On the distinction between "models of" and "models for," see Clifford Geertz, "Religion as a Cultural System," in *The Interpretation of Cultures* (New York: Basic Books, 1973), pp. 91–94.

26. Bax, *Hieronymus Bosch*, p. 205.

27. Alfred Gell, *Art and Agency* (Oxford: Clarendon, 1998), p. 16.

28. Prague, Národní Gallery, Inv. H2-418.

29. When Thomas Edison, credited with inventing what was called, primitivistically, "the talking machine," first heard his voice played back to him singing "Mary Had a Little Lamb," he remarked that he was "never so taken aback in [his] life." Roland Gelatt, *The Fabulous Phonograph: From Edison to Stereo* (New York: Appleton-Century, 1954), p. 25. As Michael Taussig has shown, "taken aback" signals a reversion to childhood, the primitive, and the fetish that seems at odds with the machine's inventor; see *Mimesis and Alterity: A Particular History of the Senses* (New York: Routledge, 1993), p. 211.

30. See Joseph Leo Koerner, "The Icon as Iconoclash," in Bruno Latour and Peter Weibel (eds.), *Iconoclash: Beyond the Image Wars in Science, Religion, and Art*

(Cambridge, MA: MIT Press, 2002), pp. 181–83; and Joseph Leo Koerner, *The Reformation of the Image* (Chicago: University of Chicago Press, 2004), ch. 7.

31. Cited in Ulrich von Wilamowitz-Moellendorff, *Der Glaube der Hellenen*, 2nd ed. (Darmstadt: Wissenschaftliche Buchgesellschaft, 1955).

32. Frag. 62 = Simplicius, *Physica* 381.29; cited in Sarah P. Morris, *Daidalos and the Origins of Greek Art* (Princeton, NJ: Princeton University Press, 1992), p. 221.

33. 68 B 142; cited in Morris, *Daidalos*, p. 221.

34. Frag. 204; cited in Morris, *Daidalos*, p. 222.

35. On abduction, see Gell, *Art and Agency*, pp. 14–16; on the myth of Daedalus, see Joseph Leo Koerner, *Die Suche nach dem Labyrinth* (Frankfurt: Suhrkamp, 1983).

36. Morris, *Daidalos*, p. 225.

37. Koerner, "Icon as Iconoclash," p. 182.

38. Martin Heidegger, "Die Zeit des Weltbildes," *Holzwege*, 5th ed. (Frankfurt: Klostermann, 1980), pp. 73–110.

39. Miguel Tamen, *Friends of Interpretable Objects* (Cambridge, MA: Harvard University Press, 2001).

40. Gell, *Art and Agency*, pp. 126–33.

41. On voice in Schumann, see Slavoj Žižek, *The Plague of Fantasies* (London: Verso, 1997), pp. 192–212.

42. For a classic statement on Bosch as standing "on the border of two epochs," see Ludwig von Baldass, *Hieronymus Bosch* (Vienna: Schroll, 1944), p. 5. On historical thresholds, see Hans Blumenberg, *Legitimacy of the Modern Age*, trans. Robert M. Wallace (Cambridge, MA: MIT Press, 1983), pp. 457–82; and Reinhart Koselleck, *Futures Past*, trans. Keith Tribe (Cambridge, MA: MIT Press, 1985), pp. 231–66.

43. John Austin, *Sense and Sensibilia* (Oxford: Oxford University Press, 1964), p. 8; see Simon Schaffer's essay in this volume.

44. See Fritz Koreny and Erwin Pokorny, *Hieronymus Bosch: Die Zeichungen in Brüssel und Wien* (Rotterdam: Museum Boijmans Van Beuningen, 2001), p. 7, for current bibliography; also see Fritz Koreny, Erwin Pokorny, and Georg Zeman, *Early Netherlandish Drawings from Jan van Eyck to Hieronymus Bosch*, exh. cat. (Antwerp: Rubenshuis, 2002), pp. 168–72. Roger H. Marijnissen, always Bosch's most dyspeptic interpreter, writes that the Treeman "acts more or less as the prototype of Bosch's hybrid demonic rabble, which repeatedly presents the viewer with an apparently insoluble – and hence annoying – puzzle"; see *Hieronymus Bosch: The Complete Works* (Antwerp: Mercatorfonds, 1987), p. 91.

45. Fritz Koreny puts the number of authentic drawings by Bosch at seventeen (in eleven sheets), down from Max J. Friedländer's list of eighteen sheets (*Die altniederländische Malerei*, vol. 5: *Geertgen van Haarlem und Hieronymus Bosch* [Berlin: Cassirer, 1927]) and Charles de Tolnay's twenty-nine (*Hieronymus Bosch*, 2 vols. [Baden-Baden: Holle, 1965]). Dating this artist's works is as vexed a problem as separating authentic works from copies or imitations. It remains unclear whether *The Garden of Earthly Delights* was produced before or after the Vienna sheet. I suspect it was made afterward, perhaps for an admirer of the *Garden*. From the evidence of dendrochronology and style (the panels were made after 1460–1466, and a copy after it was executed on wood from after 1449–1450) Bernard Vermet has suggested that the triptych could have been made before 1500 (Koldeweij, Vandenbroeck, and Vermet, *Bosch*, pp. 90–91); the majority of scholars date it later, to circa 1504, based on its provenance (see below). The drawings "after" the *Treeman* are in Berlin (Kupferstichkabinet Inv. KdZ. 711; see Stephanie Buck, *Die niederländischen Zeichnungen des 15. Jahrhunderts im Berliner Kupferstichkabinett* [Turnhout: Brepols, 2001], cat. I. 35r) and the Staatliche Kunstsammlungen, Kupferstichkabinett, Dresden (Koldeweij, Vandenbroeck, and Vermet, *Bosch*, pp. 146–47).

46. Steppe, "Jheronimus," p. 8.

47. J.K. Steppe, "Problemen betreffende het werk van Hieronymus Bosch," *Jaarboek van de Koninklijke Vlaamse Academie voor Wetenschappen, Letteren en Schone Kunsten van België* 24 (1962), pp. 166–67; and Steppe, "Jheronimus," pp. 7–12 and 28–30. In their famous use of this archival material, E.H. Gombrich ("The Earliest Description of 'Bosch's Garden of Delights,'" *Journal of the Warburg and Courtauld Institutes* 30 [1967], pp. 403–406), and Otto Kurz ("Four Tapestries after Hieronymus Bosch," *Journal of the Warburg and Courtauld Institutes* 30 (1967), pp. 150–62, make no mention of Steppe's prior discovery, which was known by 1967; see Paul Vandenbroeck, "High Stakes in Brussels, 1567: *The Garden of Earthly Delights* as the Crux of the Conflict Between William the Silent and the Duke of Alva," in A.M. Koldeweij and Bernard Vermet (eds.), *Hieronymus Bosch: New Insights* (Ghent: Ludion, 2001), p. 87. Beatis's account, written the year after Bosch's death in 1516, suggests that the *Garden* was made around 1504 for Hendrik II of Nassau, stadtholder of Holland, Zealand, and Friesland.

48. Jacqueline Folie, "Les Oeuvres authentifiées des Primitifs flamands," *Bulletin de l'Institut royal de patrimoine artistique* 6 (1963), pp. 236–39; also see G.C.M. van Dijck, *Op zoek naar Jheronimus van Aken alias Bosch: De feiten* (Zaltbommel: Europese Bibliotheek, 2001), pp. 110–11.

49. In his analysis of Bosch's semantic complexity, Albert Cook refers the reader to a certain "white pistil" in the *Garden* that "extrudes as its flower the sponge- or bloblike excrescence of bluish black shading into brown and flecked with seeds whiter and larger than those on the strawberries, but distributed in a similar pattern"; see *Changing the Signs* (Lincoln: University of Nebraska Press, 1985), p. 84. This particular pistil about which Cook wants to speak can be distinguished from others around it by its "affinities — distant ones — with a peacock's tail (and its iconography), and closer ones with the truffle, the beef heart, a darkened version of a lung, a mashed version of a bunch of grapes, and doubtless others." By the time the writer thinks his readers are with him, they will have either lost their way or been caught up in a different detail, since to their eyes another flower, pod, or shell looks more like a "beef heart."

50. The didactic function of this isolation might be described as follows: like Bosch hermit-saints who remain self-enclosed and apathetic toward the multitude of devils and phantasms surrounding them, we experience — of necessity — the solitude of contemplation before Bosch.

51. José de Sigüenza, writing in 1605, called it "the Strawberry Plant"; later Spaniards called it "Worldly Doings" (*El trafago*), "Luxury" (*La lujuria*), and "The Vices and Their Ends"; see Justi, "Die Werke," pp. 125–30. Gombrich proposed "As It Was in the Days of Noe"; see "Bosch's 'Garden of Earthly Delights': A Progress Report," *Journal of the Warburg and Courtauld Institutes* 32 (1969), p. 162–70. And the curators of the Rotterdam show suggested "The Grail Triptych"; see Koldeweij, Vandenbroeck, and Vermet, *Bosch*, p. 110.

52. Hans Belting, *Hieronymus Bosch* (Munich: Prestel, 2002), p. 26.

53. "The art of Bosch," wrote André Chastel, "proceeds on the basis of a deliberate flight from the object that can be given a name." "La Tentation de Saint Antoine ou le songe du mélancholique," *Gazette des beaux-arts* 15 (1936), pp. 218–19; cited and discussed in Michel de Certeau, *The Mystic Fable*, trans. Michael B. Smith (Chicago: University of Chicago Press, 1992), p. 51.

54. Frank Kermode, *The Genesis of Secrecy* (Cambridge, MA: Harvard University Press, 1979), pp. 3–4. Erwin Panofsky closes *Early Netherlandish Painting* (Cambridge, MA: Harvard University Press, 1958) with the statement that, with regard to Bosch, "we have bored a few holes through the door of the locked room; but somehow we do not seem to have discovered the key" (p. 357).

55. The most notorious "heretical" readings of Bosch are Wilhelm Fraenger's, collected in his *Hieronymus Bosch*, ed. Patrik Reuterswärd (Dresden: Kunst, 1975); his thesis that the *Garden*, and many other works by Bosch, were made for

an Adamite sect in 's-Hertogenbosch was first published in 1946, in a work with the evocative title *Hieronymus Bosch: Das tausendjährige Reich.*

56. Sigüenza responded to unrecorded accusations of heresy. Fraenger's work has generated a whole sub-literature of refutations (see Walter S. Gibson, *Hieronymus Bosch: An Annotated Bibliography* (Boston: G.K. Hall, 1983), passim. And Lynda Harris's neo-Fraengerian account, *The Secret Heresy of Hieronymus Bosch*, 2nd ed. (Edinburgh: Floris, 2002), will no doubt occasion a new counter-literature.

57. Van Dijck, *Op zoek*, p. 91.

58. See the formulas collected in Richard Kieckhefer, *Forbidden Rites: A Necromancer's Manual of the Fifteenth Century* (Stroud, UK: Sutton, 1997), pp. 126–31.

59. On the categories *Gegenstand*, *Zeug*, and *Kunstwerk*, see Martin Heidegger, *Being and Time*, trans. Joan Stambaugh (Albany: State University of New York Press, 1996), pp. 62–71; also "Das Ding," in *Vorträge und Aufsätze*, 4th ed. (Pfullingen: Neske, 1978), pp. 157–80; *Die Frage nach dem Ding: Zu Kants Lehre von den transzendentalen Grundsätzen, Gesammtausgabe, 2, Abteilung: Vorlesungen, 1923–1944* (Frankfurt: Klostermann, 1984), vol. 41, p. 211; and "Der Ursprung des Kunstwerkes," in *Holzwege*, 6th ed. (Frankfurt: Klostermann, 1980), pp. 4–25.

60. On *adynata*, see Ernst Robert Curtius, *European Literature and the Latin Middle Ages*, trans. Willard R. Trask (Princeton, NJ: Princeton University Press, 1953), pp. 94–96.

61. The several extant sheets covered with little sketches of misshapen beggars are all probably by Bosch imitators, and it will be Bruegel, in his little panel in the Louvre, who brings us face-to-face with this ambiguous subject. But these all descend from some lost Bosch, one perhaps similar to a tapestry in the Palacio Real in Madrid. For their part, sixteenth-century publishers thought that the subject was Bosch's, or that by saying it was would help sales, since the engraving after the Albertina sheet bears the words "Jer. Bosche Invent."

62. Mikhail Bakhtin, *Rabelais and His World*, trans. Hélène Iswolsky (Bloomington: Indiana University Press, 1984), pp. 303–67.

63. On this identity in Descartes, see Edward S. Casey, *The Fate of Place* (Berkeley: University of California Press, 1997), pp. 152–53.

64. Wilhelm Fraenger, *Hieronymus Bosch*, trans. Helen Sebba (New York: Putnam, 1983), p. 44; on the etymology of the *nobiskrug* see Hanns Bächtold-Stäubli, *Handwörterbuch des deutschen Aberglaubens* (Berlin: Gruyter, 1927–1942), vol. 4, p. 203.

65. Koreny and Pokorny, *Hieronymus Bosch*, p. 9.

66. Isaiah Shachar, *The Judensau* (London: Warburg Institute, 1974).

67. Friedrich Winkler, *Dürer und die Illustrationen zum Narrenschiff: Deutscher Verein für Kunstwissenschaft* (Berlin: Deutscher Verein für Kunstwissenschaft, 1951), p. 60.

68. Jean Wirth, *Hieronymus Bosch: Der Garten der Lüste* (Frankfurt: Fischer Verlag, 2000), pp. 60–62. Sodomy is neither a surprising nor an exclusive valence for Bosch's monster, whose heterogeneous conformation allows it to hint at many sins; on this match between hybrid forms and multifarious admonishments, see Lorraine Daston and Katharine Park's discussion of sixteenth-century prodigy literature in *Wonders and the Order of Nature, 1150–1750* (New York: Zone Books, 1998), pp. 182–83. On the other hand, in Renaissance demonology, sodomy, specifically understood as anal sex between men, functioned as a master trope for all sins; see Armando Maggi, *Satan's Rhetoric: A Study of Renaissance Demonology* (Chicago: University of Chicago Press, 2001), p. 93.

69. For example, Augustine, *De libero arbitrio* 2.19.54; discussed in Paul Ricoeur, *The Conflict of Interpretations*, ed. Don Ihde (Evanston, IL: Northwestern University Press, 1974), p. 275.

70. *Caesarii Heisterbacensis monachi Dialogus miraculorum*, ed. Joseph Strange, 2 vols. (Cologne: Herberle, 1851), 5: 28; 3: 6; cited and discussed in Aron Gurevich, *Medieval Popular Culture: Problems of Belief and Perception*, trans. János M. Bak and Paul A. Hollingsworth (Cambridge, UK: Cambridge University Press, 1988), p. 188.

71. In 1586, the Spanish writer Ambrosio de Morales, explaining Bosch's *Hay Wain* triptych, wrote that "this 'wagon of hay,' as it is called in Flemish, means the same thing as a 'wagon of nothingness' in Castilian"; see (James Snyder, ed., *Bosch in Perspective* (Englewood Cliffs, NJ: Prentice-Hall, 1973), p. 32.

72. I would propose here reading Bosch's art against Lucretius's famous description of the *eidola* as "films peeled off from the surface of things" (*De rerum natura* 4.26). This passage has an interesting reception in modern anthropology from James George Frazer to Michael Taussig and Alfred Gell.

73. Bax, *Hieronymus Bosch*, pp. 237–38, suggests it is the carcass of a goose.

74. Jan F.A. Beins, *Misvorming en verbeelding* (Amsterdam: Oorschot, 1948), p. 109.

75. I borrow the phrase "exact fantasies" from Susan Buck-Morss, who uses it to describe the writing of Walter Benjamin in *The Origin of Negative Dialectics* (New York: Free Press, 1977), p. 86.

76. Taussig, *Mimesis and Alterity*, p. 34.

77. Heidegger, *Being and Time*, p. 68.

78. Steppe, "Jheronimus," p. 21.

79. Gerd Unverfehrt, *Hieronymus Bosch: Die Rezeption seiner Kunst im frühen 16. Jahrhundert* (Berlin: Mann, 1980), p. 33.

80. Buck, *Niederländischen Zeichnungen*, cat. I.32r and I.32v.

81. José de Sigüenza, *Tercera parte de la historia de la orden de S. Geronimo* (Madrid, 1605), p. 837.

82. Van Dijck, *Op zoek*, pp. 107, 111, and passim.

83. Cited in Daston and Park, *Wonders and the Order of Nature*, p. 167.

84. Ernesto Grassi, *Rhetoric as Philosophy*, trans. John Michael Krois and Azizeh Azodi (Carbondale: Southern Illinois University Press, 1980), pp. 8–10 and 76–94.

85. On consistency as a feature of realism, see Hans Blumenberg, "Wirklichkeitsbegriff und Möglichkeit des Romans," with his supplementary remarks, in Hans Robert Jauss (ed.), *Nachahmung und Illusion* (Munich: Eidos, 1969), pp. 9–27 and 219–20.

86. Panofsky famously argued that such details are only apparently random, being legible symbols "disguised" for the purpose of visual consistency (*Early Netherlandish Painting*, pp. 140–48).

87. On diabolical signs, see Maggi, *Satan's Rhetoric*.

88. Daniela Hammer-Tugendhat, *Hieronymus Bosch: Eine historische Interpretation seiner Gestaltungsprinzipien* (Munich: Fink, 1981), pp. 59–68.

89. Joseph Leo Koerner, "Hieronymus Bosch's World Picture," in Peter Galison and Caroline Jones (eds.), *Picturing Science / Producing Art* (New York: Routledge, 1998), pp. 320–23.

90. On the etymological relations among these words, see Vilém Flusser, *The Shape of Things: A Philosophy of Design* (London: Reaktion, 1999), p. 103.

91. Bax, *Hieronymus Bosch*, p. 241.

92. Otto Pächt, *The Master of Mary of Burgundy* (London: Faber and Faber, 1948), pp. 32–34.

93. For an account of the reflexivity of the graphic mark, see Richard Wollheim, *Painting as an Art* (Princeton, NJ: Princeton University Press, 1987), pp. 13–54 and passim.

94. Otto Benesch, "Der Wald der sieht und hört," *Jahrbuch der preussischen Kunstsammlungen* 58 (1937): 258–66; Belting, *Hieronymus Bosch*, p. 38.

95. On the example of objects (automata) that seem to be persons, Freud explained that the uncanny feelings they arouse are caused by the threat of castration. "The Uncanny," *Standard Edition of the Complete Works of Sigmund*

Freud, 24 vols. (London: Hogarth, 1966), vol. 17, pp. 219–52.

96. The *Woods Have Ears, the Field Has Eyes* in Berlin and the *Owl's Nest* in Rotterdam.

97. Otto Benesch, "Die grossen flämischen Maler als Zeichner," *Jahrbuch der Kunsthistorischen Sammlungen in Wien* 53 (1957), pp. 9–32.

98. Georg Simmel, *The Philosophy of Money*, 2nd rev. ed., trans. Tom Bottomore et al. (London: Routledge, 1990), p. 66.

99. Steppe, "Jheronimus," p. 21.

100. Peter van den Brink, "The Art of Copying," in *Brueghel Enterprises*, exh. cat. (Ghent: Ludion, 2001), pp. 36–39.

101. Vandenbroeck, "High Stakes," pp. 87–92.

102. Hans Blumenberg, *Shipwreck with Spectator*, trans. Steven Rendall (Cambridge, MA: MIT Press, 1997).

103. Karel G. Boon et al., eds., *Jheronimus Bosch*, exh. cat. ('s-Hertogenbosch: Noordbrabants Museum, 1967), p. 219, cat. 104.

CHAPTER TWO: THE FREESTANDING COLUMN IN EIGHTEENTH-CENTURY
RELIGIOUS ARCHITECTURE

1. I am using the term "explanation" instead of "interpretation" in reference to Michael Baxandall, *Patterns of Intention: On the Historical Explanation of Pictures* (New Haven, CT: Yale University Press, 1985).

2. Julien David Le Roy, *Les Ruines des plus beaux monuments de la Grèce* (Paris: H.L. Guérin, L.F. Delatour, 1758), pt. 2, "Discours sur les principes de l'architecture civile," p. ii.

3. Eugène-Emmanuel Viollet-le-Duc, *Entretiens sur l'architecture* (Paris: A. Morel et Cie, 1863–1872), esp. p. 51. On the relation between Viollet-le-Duc's theory and racial considerations, see Martin Bressani, "Science, histoire, et archéologie: Sources et généalogie de la pensée organiciste de Viollet-le-Duc" (Ph.D. diss., Université de Paris IV, 1997).

4. Erwin Panofsky, *Gothic Architecture and Scholasticism* (Latrobe, PA: Archabbey Press, 1951).

5. Erwin Panofsky, *Abbot Suger on the Abbey Church of Saint-Denis and Its Art Treasures* (Princeton, NJ: Princeton University Press, 1946).

6. Pierre Bourdieu, postface to Erwin Panofsky, *Architecture gothique et pensée scolastique* (Paris: Minuit, 1978), pp. 133–67.

7. Gilbert Simondon, *Du mode d'existence des objets techniques* (Paris: Aubier, 1969).

8. Cornelius Castoriadis, *L'Institution imaginaire de la société* (1975; Paris: Seuil, 1999), p. 526.

9. On the history of the colonnade of the Louvre, see, for instance, Antoine Picon, *Claude Perrault, 1613–1688; ou, La Curiosité d'un classique* (Paris: Picard, 1988); Michael Petzet, *Claude Perrault und die Architektur des Sonnenkönigs: Der Louvre König Ludwigs XIV. und das Werk Claude Perraults* (Munich: Deutscher Kunstverlag, 2000).

10. For a complete description of the iron reinforcements of the colonnade, see Pierre Patte, *Mémoires sur les objets les plus importants de l'architecture* (Paris: Rozet, 1769), pp. 269–77.

11. Charles Perrault and Claude Perrault, *Nouvelle Eglise de S. Geneviève*, MS Res. W 376.

12. See *Le "Gothique" retrouvé avant Viollet-le-Duc* (Paris: Caisse Nationale des Monuments Historiques et des Sites, 1979).

13. On Sainte-Geneviève, see among others Michael Petzet, *Soufflots Sainte-Geneviève und der französische Kirchenbau des 18. Jahrhunderts* (Berlin: de Gruyter, 1961); *Le Panthéon: Symbole des révolutions* (Paris: Picard, 1989).

14. M. Brébion, *Mémoire à Monsieur le comte de la Billarderie d'Angiviller*, 1780, quoted in Petzet, *Soufflots Sainte-Geneviève*, p. 147.

15. On the political significance of the Greek trend in the arts, see, for instance, Daniel Rabreau, "La Basilique Sainte-Geneviève de Soufflot," in *Panthéon*, pp. 37–97.

16. See, for instance, Michel Gallet, "Gabriel à Orléans et à Blois," in Yves Bottineau and Michel Gallet (eds.), *Les Gabriel* (Paris: Picard, 1982), pp. 48–54.

17. Michel de Frémin, *Mémoires critiques d'architecture contenant l'idée de la vraie et de la fausse architecture* (Paris: Saugrain, 1702), pp. 26–40.

18. Jean-Louis de Cordemoy, *Nouveau Traité de toute l'architecture* (Paris: Coignard, 1706), p. 176.

19. Robin Middleton, "The Abbé de Cordemoy and the Graeco-Gothic Ideal," *Journal of the Warburg and Courtauld Institutes* 25 (1962), pp. 278–320, 26 (1963), pp. 90–123, esp. p. 283.

20. Denis Diderot, *Pensées sur l'interprétation de la nature* (Paris, 1754), p. 23.

21. See Antoine Picon, *French Architects and Engineers in the Age of the Enlightenment* (Cambridge, UK: Cambridge University Press, 1992); Antoine Picon, *L'Invention de l'ingénieur moderne: L'Ecole des Ponts et Chaussées 1747–1851* (Paris: Presses de l'Ecole Nationale des Ponts et Chaussées, 1992).

22. Marc-Antoine Laugier, *Essai sur l'architecture* (1753; new ed., Paris,

Duchesne, 1755), pp. 8–9. On Laugier, see Wolfgang Herrmann, *Laugier and Eighteenth Century French Theory* (1962; new ed., London: Zwemmer, 1985). On the general theme of the primitive shelter, also see Anthony Vidler, *L'Espace des lumières: Architecture et philosophie de Ledoux à Fourier* (New York: Princeton Architectural Press, 1987; French trans., Paris: Picard, 1995).

23. Laugier, *Essai sur l'architecture*, p. 177.

24. Charles Francois, Viel, *De l'impuissance des mathématiques pour assurer la solidité des bâtimens et recherches sur la construction des ponts* (Paris, 1805), p. 25.

25. Jean-Rudolphe Perronet to Soufflot, Jan. 26, 1770, reproduced in Mae Mathieu, *Pierre Patte, sa vie et son oeuvre* (Paris: Alcan, 1940), pp. 400–401.

26. Etienne Bonnot de Condillac, "Cours d'etudes pour l'instruction du Prince de Parme" and "V. De l'art de penser," *Oeuvres philosophiques de Condillac* (Paris: PUF, 1947–1951), vol. 1, p. 769. On Condillac's definition of "analysis" and the later interpretations given to this key term of eighteenth-century philosophy, see Gilles Gaston Granger, *La Mathématique sociale du marquis de Condorcet* (1956; Paris: O. Jacob, 1989); E. Brian, "La Foi du géomètre: Métier et vocation de savant pour Condorcet vers 1770," *Revue de synthèse* 1 (1988), pp. 39–68.

27. J.D. Garat, "Analyse de l'entendement programme," in *Séances des écoles normales, recueillies par des sténographes, et revues par les professeurs*, vol. 1, pp. 138–69, esp. p. 148.

28. Jean Le Rond d'Alembert, "Eléments des sciences," in *Encyclopédie; ou, Dictionnaire raisonné des sciences, des arts, et des métiers* (Paris: Briasson, 1751–1772), vol. 5, pp. 491–97; Jean Le Rond d'Alembert, *Essai sur les éléments de philosophie* (Amsterdam: Z. Chatelain et fils, 1759).

29. Denis Diderot, "Bas," in *Encyclopédie*, vol. 1, pp. 98–113. On this article, see J. Proust, "L'Article *Bas de Diderot," in Michèle Duchet, and Michèle Jalley (eds.), *Langue et langages de Leibniz à l'Encyclopédie* (Paris: Union Générale, 1977), pp. 245–71.

30. See Antoine Picon, "Gestes ouvriers, opérations et processus techniques: La Vision du travail des encyclopédistes," *Recherches sur Diderot et sur l'Encyclopédie* 13 (Oct. 1992), pp. 131–47.

31. See Picon, *L'Invention de l'ingénieur moderne*, as well as Ken Alder, *Engineering the Revolution: Arms and Enlightenment in France, 1763–1815* (Princeton, NJ: Princeton University Press, 1997).

32. See Daniel Rabreau, *Claude-Nicolas Ledoux, 1736–1806: L'architecture et les fastes du temps* (Bordeaux: William Blake and Company, 2000).

33. Charles-Nicolas Cochin, *Projet d'une salle de spectacle pour un théâtre de*

comédie (Paris, Ch. A. Jombert, 1765); Pierre Patte, *Essai sur l'architecture théâ-trale* (Paris: Moutard, 1782).

34. Claude-Nicolas Ledoux, *L'Architecture considérée sous le rapport de l'art, des moeurs, et de la législation* (Paris, 1804), pp. 217–24, pl. 113.

35. Julien David Le Roy, *Histoire de la disposition et des formes différentes que les chrétiens ont données à leurs temples, depuis le règne de Constantin le Grand jusqu'à nous* (Paris: Desaint et Saillant, 1764), pp. 59–61.

36. See Jean-Claude Perrot, *Genèse d'une ville moderne: Caen au XVIIIe siècle* (Paris: Mouton, 1975); Michel Le Moël and Sophie Descat, *L'Urbanisme parisien au siècle des Lumières* (Paris, Action Artistique de la Ville de Paris, 1997); Isabelle Backouche, *La Trace du fleuve: La Seine et Paris (1750–1850)* (Paris: Editions de l'Ecole des Hautes Etudes en Sciences Sociales, 2000).

37. On this new type of bridge, see, for instance, Picon, *L'Invention de l'ingénieur moderne*, pp. 64–80.

38. Jean-Rudolphe Perronet, *Description des projets et de la construction des ponts de Neuilli, de Mantes, d'Orléans, de Louis XVI, etc.* (Paris, 1782–1783; new ed., Paris, Didot fils aîné, Jombert jeune, 1788), p. 623.

39. *Ibid.*, p. 269.

40. I have studied this question in Antoine Picon, "Towards a History of Technological Thought," in Robert Fox (ed.), *Technological Change: Methods and Themes in the History of Technology* (London: Harwood Academic, 1996), pp. 37–49; Antoine Picon, "Imaginaires de l'efficacité, pensée technique, et rationalisation," *Réseaux: Communication, technologie, société* 19, no. 109 (2001), pp. 17–50.

41. See Joseph Rykwert, *On Adam's House in Paradise: The Idea of the Primitive Hut in Architectural History* (New York: Museum of Modern Art, 1972).

42. The so-called quarrel of the Panthéon has been repeatedly studied by historians. See, for instance, Jacques Guillerme, "Le Panthéon: Une Matière à controverse," in *Panthéon*, pp. 151–73.

43. Kenneth Frampton, *Studies in Tectonic Culture: The Poetics of Construction in Nineteenth and Twentieth Century Architecture* (Cambridge, MA: MIT Press, 1995), pp. 29–34.

44. François Blondel dealt at length with this particular question in his *Résolution des quatre principaux problèmes de l'architecture* (Paris, 1673).

45. The point was made by Guillaume Lamy in his *Discours anatomiques* (Rouen: J. Lucas, 1675). On the debate caused by his anti-finalist position, see Henri Busson, *La Religion des classiques (1660–1685)* (Paris, PUF, 1948), pp. 137–64.

46. See, of course, Michel Foucault et al., *Les Machines à guérir: Aux origines de l'hôpital moderne* (Brussels: Mardaga, 1979).

47. See Edoardo Benvenuto, *An Introduction to the History of Structural Mechanics* (New York, Springer, 1991).

48. On Cauchy's contribution to the theory of elasticity, see, for instance, Amy Dahan-Dalmedico, "Aspects de la mathématisation au XIXème siècle entre physique mathématique du continu et mécanique moléculaire: La Voie d'A.-L. Cauchy" (Ph.D. diss., Nantes, 1990); Bruno Belhoste, *Augustin-Louis Cauchy: A Biography* (New York: Springer, 1991).

49. I am indebted to Norton Wise for this remark.

50. Jean-Louis Viel de Saint-Meaux, *Lettres sur l'architecture des anciens et celle des modernes* (Paris, 1787), p. 9.

51. Joseph Rykwert, *The First Moderns: The Architects of the Eighteenth Century* (Cambridge, MA: MIT Press, 1980); Alberto Pérez Gómez, *Architecture and the Crisis of Modern Science* (Cambridge, MA: MIT Press, 1983).

CHAPTER THREE: STAGING AN EMPIRE

We thank Lorraine Daston and the Max Planck Institute for the History of Science, Berlin, for generous support of this research, as well as the "Things That Talk" working group for their insightful comments. Thanks also to the institute's extraordinary library staff and to Frau Schendel of the Staatliche Schlösser und Gärten, Potsdam-Sanssouci, Plankammer.

1. "Palimpsest," *Oxford English Dictionary*, quoting George Henry Lewes, *The Study of Psychology* (1879), p. viii.

2. Basic are Michael Seiler's many publications: most extensively in *Pfaueninsel, Berlin* (Tübingen: Wasmuth, 1993), with photos by Stefan Koppelkamm; most accessibly in the guidebook *Die Pfaueninsel* (Potsdam: Stiftung Preussische Schlösser und Gärten Berlin-Brandenburg, 2000); and most concisely in "Die *Pfaueninsel*: Inszenierung des Exotischen," in *Nichts gedeiht ohne Pflege: Die Potsdamer Parklandschaft und ihre Gärtner* (Potsdam: Stiftung Preussische Schlösser und Gärten Berlin-Brandenburg, 2001), pp. 78–84. Earlier well-documented studies are those of Caesar von der Ahé, Karl Breuer, and August Kopisch, referenced below.

3. August Kopisch, *Die königlichen Schlösser und Gärten zu Potsdam, von der Zeit ihrer Gründung bis zum Jahre MDCCCLII* (Berlin: Ernst und Korn, 1854), p. 45; Günter Rau, "Das Glaslaboratorium des Johann Kunckel auf der *Pfaueninsel* in Berlin: Archäologische Untersuchungen 1973/74," *Ausgrabungen in Berlin* 5 (1974), pp. 155–74.

4. Seiler, *Pfaueninsel, Berlin*, pp. 6–17. Karl Breuer, "Die Pfaueninsel bei Potsdam: Eine Schöpfung Friedrich Wilhelms II und Friedrich Wilhelms III" (diss., Technische Hochschule zu Berlin, 1923), pp. 36–46 and 50–53.

5. Georg Forster, *A Voyage Round the World* (London, 1777); *Reise um die Welt* (Berlin, 1778).

6. Kopisch, *Schlösser und Gärten*, pp. 153–56.

7. Volker Klemm and Günther Meyer, *Albrecht Daniel Thaer: Pionier der Landwirtschaftswissenschaften in Deutschland* (Halle: Niemeyer, 1968), pp. 35–41; Wilhelm Körte, *Albrecht Thaer: Sein Leben und Wirken, als Arzt und Landwirth* (Leipzig: Brockhaus, 1839), pp. 167–68; Mijndert Bertram, "Von Hannover nach Preussen — Hardenberg, Scharnhorst und Thaer," in Kathrin Panne (ed.), *Albrecht Daniel Thaer — Der Mann gehört der Welt* (Celle: Bomann-Museum, 2002), pp. 9–24, esp. pp. 16–17 and 20–22.

8. Albrecht Daniel Thaer, *Einleitung zur Kenntniss der englischen Landwirthschaft und ihrer neueren praktischen und theoretischen Fortschritte, in Rücksicht auf Vervollkommnung deutscher Landwirthschaft für denkende Landwirthe und Cammeralisten*, 3 vols. (1798–1804), esp. vol. 1, pp. 83–86 and 267–96 on crop rotation and pp. 139–209 on fertilizers; Körte, *Thaer*, pp. 79–130; Klemm and Meyer, *Thaer*, pp. 43–58; Theodor Fontane, *Denkmal Albrecht Thaers zu Berlin* (Berlin: Bosselmann, 1862), in Karl-Robert Schütze (ed.), *Denkmal Albrecht Thaers* (Berlin: Domäne Dahlem, 1992), pp. 7–18.

9. Rudolph Stadelmann, *Preussens Könige in ihrer Thätigkeit für die Landeskultur: Vierter Theil: Friedrich Wilhelm III (1797–1807)* (Leipzig: Hirzel, 1887), pp. 102–106, on p. 103; pp. 210–326 contain these and other official letters from the king and Hardenberg to Thaer.

10. Herbert Sukopp, "Das Naturschutzgebiet *Pfaueninsel* in Berlin-Wannsee, I: Beiträge zur Landschafts- und Florengeschichte," *Sitzungsberichte der Gesellschaft Naturforschender Freunde zu Berlin* 8 (1967), pp. 93–129: rotation schemes on pp. 104–5 (from Stiftung Schlösser und Gärten, Potsdam-Sanssouci, *Akten des Hofmarschallamtes, betreffend: Die Pfauen Insel*, vol. 1, 1797–1808, fols. 96–97) and pp. 106–107; Kopisch, *Schlösser und Gärten*, p. 163; Seiler, *Pfaueninsel, Berlin*, pp. 17–18.

11. Herbert Pruns, "Albrecht Daniel Thaer und die ästhetisch gestalteten Kulturlandschaften," in Körte, *Thaer*, pp. 183–216. For Goethe's full poem, which was set to music by his friend Carl Friedrich Zelter for a *Liedertafel*, see Jürgen Gruss, "Ein Glückwunsch vom 'Stapelort deutscher Dichtkunst,'" in Schütze, *Denkmal*, pp. 97–106.

12. Peter Gerrit Thielen, *Karl August von Hardenberg, 1750–1822: Eine*

Biographie (Cologne and Berlin: Grote, 1967), pp. 237–39 and 264; Ernst Pett, *Die Pfaueninsel: Geschichte und Geschichten zwischen Potsdam und Berlin* (Berlin: Haude und Spener, 1966), pp. 42–48. Hardenberg's character-evaluation of the king and queen (about 1808) in Georg Stein (ed.), *Publikationen aus den Preussischen Staatsarchiven*, vol. 93, new ser., first section: *Die Reorganisation des Preussischen Staates unter Stein und Hardenberg: Erster Teil: Allgemeine Verwaltungs- und Behördenreform* (Leipzig: Hirzel, 1931), pp. 570–75.

13. Hanno Beck, *Alexander von Humboldt*, 2 vols. (Wiesbaden: Steiner, 1959), vol. 2, pp. 14–15; Douglas Botting, *Humboldt and the Cosmos* (New York: Harper and Row, 1973), pp. 185–89. Halina Nelken, *Alexander von Humboldt: His Portraits and Their Artists* (Berlin: Reimer, 1980), pp. 30–32. Heinz Ohff, *Preussens Könige* (Munich: Piper, 1999), pp. 180–81.

14. Alexander von Humboldt, "Etwas von den Amerikanischen Krokodilen," *Neue Berlinische Monatschrift* 1 (1804), pp. 437–40, on p. 439.

15. Michael Dettelbach, "Romanticism and Administration: Mining, Galvanism, and Oversight in Alexander von Humboldt's Global Physics" (diss., Cambridge University, 1992); Michael Dettelbach, "Global Physics and Aesthetic Empire: Humboldt's Physical Portrait of the Tropics," in D.P. Miller and P.H. Reill (eds.), *Visions of Empire: Voyages, Botany, and Representations of Nature* (Cambridge, UK: Cambridge University Press, 1996), pp. 258–92.

16. Dettelbach, "Romanticism and Administration," pp. 22–23 and 26–28; Alexander von Humboldt, *Aphorismen aus der chemischen Physiologie der Pflanzen* (Leipzig: Voss, 1794), originally appended to Humboldt's *Florae fribergensis specimen, plantas cryptogamicas praesertim subterraneas exhibens* (Berlin: Rottmann, 1793); Thaer, *Einleitung*, vol. 1, pp. 147–48. Körte, *Thaer*, pp. 98–99, gives Thaer's chemical sources.

17. Karl Bruhns, *Alexander von Humboldt: Eine Wissenschaftliche Biographie*, 3 vols. (1872; repr., Osnabrück; Zeller, 1969), vol. 1, pp. 95–103 and 290–91; Botting, *Humboldt and the Cosmos*, p. 19.

18. Dettelbach, "Romanticism and Administration," pp. 20, 29–33, 39–42.

19. Beck, *Humboldt*, vol. 1, pp. 64–70; Dettelbach, "Romanticism and Administration," passim; Ilse Jahn and Fritz G. Lange, eds., *Die Jugendbriefe Alexander von Humboldts, 1787–1799* (Berlin: Akademie, 1973); letters with Schiller, Goethe, Carl Freiesleben, Reinhard von Haeften, and others give a distinct sense of Humboldt's ideals, attachments, and ideas.

20. Schiller to Körner, Aug. 6, 1797, and Körner to Schiller, Aug. 25, 1797, in Karl Goedeke (ed.), *Schillers Briefwechsel mit Körner, von 1784 bis zum Tode Schillers,*

2nd ed. (Leipzig: Veit und Comp., 1878), pt. 2 (1793–1805), pp. 267–69.

21. Alexander von Humboldt, *Ansichten der Natur* (Tübingen: J.G. Cotta, 1808), p. 4.

22. We use the revised German edition, with commentary, of Hanno Beck et al., *Alexander von Humboldt, Mexico-Werk: Politische Ideen zu Mexico, Mexicanische Landeskunde* (Darmstadt: Wissenschaftliche Buchgesellschaft, 1991), with plates from the *Atlas géographique et physique du royaume de la nouvelle-espagne* (*Mexico Atlas*) (Paris: Schoell, 1811).

23. Beck, *Humboldt*, vol. 1, p. 11; Johann Kaspar Lavater, *Physiognomische Fragmente zur Beförderung der Menschenkenntnis und Menschenliebe*, illust. Daniel Chodowiecki, 4 vols. (1775–1778), repr. (Zürich: Füssli, 1968–1969).

24. Beck, *Mexico-Werk*, pp. 119–20.

25. Alexander von Humboldt, *Atlas géographique et physique des régions équinoxiales du nouveau continent, fondé sur des observations astronomiques, des mesures trigonométriques, et des nivellements barométriques* (Paris: Librairie de Gide, 1814–1834); Pliny the Younger, *Briefe*, Latin-German ed., Helmut Kasten (Darmstadt: Wissenschaftliche Buchgesellschaft, 1995), bk. 8, letter 24, pp. 488–89. Nelken, *Alexander von Humboldt*, pp. 34–35; Dettelbach, "Global Physics and Aesthetic Empire," pp. 288–89; *Alexander von Humboldt: Netzwerk des Wissens* (Berlin: Cantz, 1999), pp. 132–33. The mountain, commonly said to be Chimborazo, in Ecuador, is surely intended to be Popocatépetl, behind the pyramid of Cholula, consistent with the otherwise Mexican iconography: Aztec prince, fallen bust of an Aztec priestess, and pyramid of Cholula. See Humboldt's *Vues des cordillères, et monuments des peuples indigènes de l'amérique: Planches* (Paris: Schoell, 1810), pls. 1 (priestess) and 7 (pyramid) and *Mexico Atlas*, pls. 3, 9, 16.

26. Beck, *Humboldt*, vol. 1, pp. 35–37; Botting, *Humboldt and the Cosmos*, p. 217; Caesar von der Ahé, "Die Menagerie auf der 'Königlichen *Pfaueninsel*,'" *Mitteilungen des Vereins für die Geschichte Berlins* (1930), pp. 1–24, on p. 8.

27. [Heinrich] Wagener, "Die Fregatte 'Royal Louise,'" *Mitteilungen des Vereins für die Geschichte Potsdams*, new ser. (1875), pp. 128–42, on pp. 128–31; Christian Voigt, "Die ehemalige Königliche Matrosenstation zu Potsdam," *Mitteilungen des Vereins für die Geschichte Potsdams*, new ser. (1929), pp, 219–63, on pp. 229–32; Wilfried M. Heidemann, "Royal Louise: Die Fregatte vor der *Pfaueninsel*, 1832–1945," *Mitteilungen des Vereins für die Geschichte Berlins* 82 (1986), pp. pp. 406–24, on 407–408; Botting, *Humboldt and the Cosmos*, p. 218.

28. Michael Seiler, "Entstehungsgeschichte des Landschaftsgartens Klein-Glienicke," in Jürgen Julier, Susanne Leiste, and Margaret Schütte (eds.), *Schloss*

Glienicke: Bewohner, Künstler, Parklandschaft (Berlin: Staatlichen Schlösser und Gärten, 1987), p. 114.

29. A. Bethge (Königlicher Garten-Intendantur-Sekretär), *Die Hohen-zollern-Anlagen Potsdam's: Historisch-gärtnerische Skizzen* (Berlin: Beuchert und Radetzki, 1888), p. 103.

30. Von der Ahé, "Menagerie," pp. 8–9.

31. Conrad Matschoss, *Die Entwicklung der Dampfmaschine: Eine Geschichte der ortsfesten Dampfmaschine und der Lokomobile, der Schiffsmaschine und Lokomo-tive*, 2 vols. (Berlin: J. Springer,1908), vol. 1, pp. 164–66. Another very promis-ing young engine builder, G.C. Freund, had died in 1820; see Heinrich Weber, *Wegweiser durch die wichtigsten technischen Werkstätten der Residenz Berlin*, 2 vols. (Berlin: 1819–1820), vol. 2, pp. 65–81.

32. M. Norton Wise, "Architectures for Steam," in Peter Galison and Emily Thompson (eds.), *The Architecture of Science* (Cambridge, MA: MIT Press, 1999), pp. 107–40, gives an interpretation of how English gardens projected steam tech-nology into the Prussian landscape. See also Jan Pieper, "Die Maschine im Interieur: Ludwig Persius' Dampfmaschinenhaus im Babelsberger Park" (Ger-man and English), *Daidalos* 53 (1994), pp. 104–15.

33. Caroline to Wilhelm von Humboldt, Nov. 13, 1815, in Anna von Sydow (ed.), *Wilhelm und Caroline von Humboldt in ihren Briefen* (Berlin, 1912), vol. 5, p. 123.

34. Conrad Matschoss, "Geschichte der Königlich Technischen Deputation für Gewerbe: Zur Erinnerung an das 100 jährige Bestehen. 1811–1911," *Beiträge zur Geschichte der Technik und Industrie: Jahrbuch des Vereins deutscher Ingenieure* 3 (1911), pp. 239–75, esp. pp. 239–50. Conrad Matschoss, *Preussens Gewerbe-förderung und ihre grossen Männer* (Berlin: Vereins Deutscher Ingenieure, 1921), pp. 30–31. On the Cockerills, see Heinrich Lotz, "John Cockerill, in seiner Bedeutung als Ingenieur und Industrieller, 1790–1840," *Beiträge zur Geschichte der Technik und Industrie* 10 (1920), pp. 103–20.

35. Gerhard Hinz, *Peter Josef Lenné und seine bedeutendsten Schöpfungen in Berlin und Potsdam* (Berlin: Deutscher Kunstverlag, 1937), pp. 50–51; Kopisch, *Schlösser und Gärten*, p. 173; Wolfgang Stichel, *Die Pfaueninsel: Ein Führer durch Geschichte und Natur* (Berlin-Hermsdorf: Verlag naturwissenschaftlicher Publika-tionen, 1927), p. 43.

36. Stiftung Schlösser und Gärten, Potsdam-Sanssouci, *Akten des Hofmar-schallamtes, betreffend die Bauangelegenheiten in Potsdam von 1821–1825*, vol. 7: Lenné's list, Jan. 26, 1823, fols. 164–65; William Cockerill's estimate, Feb. 15,

1823, fols. 184–85. Weber, *Wegweiser*, vol. 2, pp. 307–10, includes a list of prices for Cockerill engines.

37. Von der Ahé, "Menagerie," pp. 9–10; and Caesar von der Ahé, "Das Maschinenhaus auf der *Pfaueninsel* und seine Bewohner," *Mitteilungen des Vereins für die Geschichte Berlins* (1933), pp. 8–13. *Akten des Hofmarschallamtes*, vol. 2: Hofmarschall von Maltzahn's proposal to the king, Mar. 6, 1824, fol. 166; overview of costs (A.D. Schadow), Mar. 1, 1824, fol. 167; detailed cost breakdown (Rabe), fols. 168–88; new Cockerill estimate and its acceptance (Bussler), June 4, 1824, fol. 226; fountain (Rabe and Mendelssohn-Bartholdy), Nov. 3 and 4, 1834, fols. 240 and 241.

38. Von der Ahé, "Maschinenhaus," p. 9; Seiler, *Pfaueninsel*, pp. 21–22 and 25–26.

39. Theodor Fontane, "Frau Friedrich," in *Wanderungen durch die Mark Brandenburg, dritter Theil: Ost-Havelland* (Berlin: Hertz, 1873), pp. 155–59; Werner Hahn, "Erinnerungen von der *Pfaueninsel*," *Der Bär* 12 (1886), pp. 81–84 and 105–108.

40. Von der Ahé, " Maschinenhaus," p. 9; von der Ahé, "Menagerie," p. 4, quoting the theologian Eduard Reuss.

41. Eduard Schmidt-Weissenfels, *Die Stadt der Intelligenz: Geschichten aus Berlin's Vor- und Nachmärz* (Berlin: Seehagen, 1865), p. 51; S.H. Spiker, *Berlin und seine Umgebungen im neunzehnten Jahrhundert* (Berlin: Gropius, 1832; repr., Leipzig: Zentralantiquariat der DDR, 1968), pp. 78–80.

42. Friedrich Schleiermacher, *Vorlesungen über die Ästhetik* (Berlin, 1842; repr., Berlin: de Gruyter, 1974), pp. 482–83; partially quoted in Seiler, *Pfaueninsel, Berlin*, p. 20. Schadow's report is reproduced with annotations in Helmut Börsch-Supan, "J.G. Schadow: Eine Reisebeschreibung von Freiwilligen des Berliner Künstler-Vereins," in Berlin Museum (ed.), ". . . *Und abends in Verein": Johann Gottfried Schadow und der Berlinische Künstler-Verein, 1814–1840* (Berlin: Arenhövel, 1983), pp. 71–86, p. 82.

43. Christian Rother, *Verhältnisse des Seehandlungs-Instituts und dessen Geschäftsführung und industrielle Unternehmungen* (Berlin: Decker, 1845), China trade, p. 14; Christian Rother, *Nachtrag* (Berlin: Decker, 1847), gives a valuable summary of the activities and factories of the Seehandlung.

44. "Lichtenstein, Martin Heinrich Karl," in *Allgemeine Deutsche Biographie*; Alexander von Humboldt and Heinrich Lichtenstein, *Amtlicher Bericht über die Versammlung deutscher Naturforscher und Ärzte zu Berlin im September 1828* (Berlin: Trautwein, 1829); *Humboldt: Netzwerk des Wissens*, p. 186.

45. Alexander von Humboldt, *Voyage de Humboldt et Bonpland: Deuxième partie: Observations de zoologie et d'anatomie comparée*, 2 vols. (Paris: Schoell et Dufour, 1811), pls. 5, 8, 27–30; von der Ahé, "Menagerie," p. 15; Kopisch, *Schlösser und Gärten*, p. 170. Stichel, *Die Pfaueninsel*, p. 21.

46. The following account derives from the fascinating study by Anneliese Moore, "Harry Maitey: From Polynesia to Prussia," *Hawaiian Journal of History* 2 (1977), pp. 125–61. See also Wilfried M. Heidemann, "Der Sandwich-Insulaner Maitey von der Pfaueninsel," *Mitteilungen des Vereins für die Geschichte Berlins* 80 (1984), pp. 154–72; and Caesar von der Ahé, "Der Hawaianer auf der Pfaueninsel," *Potsdamer Jahresschau* (1933), pp. 19–31.

47. Kurt Nowak, *Schleiermacher: Leben, Werk, und Wirkung* (Göttingen: Vandenhoeck und Ruprecht, 2001), pp. 378–85. Charles E. McClelland, *State, Society, and University in Germany, 1700–1914* (Cambridge, UK: Cambridge University Press, 1980), pp. 146–47.

48. *Königlich privilegirte Berlinische Zeitung von Staats und gelehrten Sachen (Vossische Zeitung)*, Oct. 18, 1824.

49. Von der Ahé, "Menagerie," p. 20; Kopisch, *Schlösser und Gärten*, p. 171.

50. Börsch-Supan, "J.G. Schadow," "Extreme der Menschheit" on p. 83; Gottfried Schadow, *Polyklet oder von den Maassen des Menschen nach dem Geschlechte und Alter mit Angabe der wirklichen Naturgrösse nach dem rheinländischen Zollstocke* (Berlin, 1834); Gottfried Schadow, *National-Physionomieen; oder, Beobachtungen über den Unterschied der Gesichtszüge und die äussere Gestaltung des menschlichen Kopfes… als Fortsetzung des hierüber von Peter Camper ausgegangenen* (Berlin, 1835), quotation on pp. 26–27; drawings of the shorter Licht brother (called Joh. Ehrentreu Teodor) and comparison of their hands on pl. 29 of the accompanying atlas.

51. Moore, "Maitey," pp. 147–48.

52. Michael Seiler, *Das Palmenhaus auf der Pfaueninsel: Geschichte seiner baulichen und gärtnerischen Gestaltung* (Berlin: Haude und Spener, 1989), gives a rich account.

53. Alexander von Humboldt and Aimé Bonpland, *Ideen zu einer Geographie der Pflanzen nebst einem Naturgemälde der Tropenländer* (Tübingen: Cotta,1807), reprinted in Mauritz Dittrich (ed.) (Leipzig: Akademische Verlagsgesellschaft, 1960), p. 69; Beck, *Humboldt*, pp. 80–85.

54. Alexander von Humboldt, "Ueber die Mittel, die Ergründung einiger Phänomene des tellurischen Magnetismus zu erleichtern," *Annalen der Physik und Chemie* 91 (1829), p. 333; Humboldt and Lichtenstein, *Amtlicher Bericht*, p. 19; Paul Ortwin Rave, *Karl Friedrich Schinkel: Berlin, dritter Teil: Bauten für Wis-

senschaft, Verwaltung, Heer, Wohnbau, und Denkmäler (Berlin: Deutscher Kunst-verlag, 1962), p. 363 (with picture).

55. Humboldt, *Vues des cordillères,* for example, pls. 31, 33, 41–42, 63; Ulrike Harten, ed., *Die Bühnenentwürfe,* vol. 17 of Helmut Börsch-Supan and Gottfried Riemann, eds., *Karl Friedrich Schinkel, Lebenswerk* (Munich and Berlin: Deutscher Kunstverlag, 2000), pp. 132–35, 228, 233–35, 237, 266, 271, 274, 340; Friedrich Muthmann, *Alexander von Humboldt und sein Naturbild im Spiegel der Goethezeit* (Zurich: Artemis, 1955), pp. 91–102.

56. Schinkel's twelve living pictures, as drawn by Wilhelm Hensel (married to Fanny Mendelssohn-Bartholdy, daughter of Abraham), were published as *Die Lebenden Bilder und pantomimischen Darstellungen bei dem Festspiel Lalla Rukh* (Berlin: Wittich, 1823). Full report with songs in *Neue Berliner Monatsschrift für Philosophie, Geschichte, Literatur, und Kunst,* new ser. 1 (1821), pp. 315–43. See also Fontane, *Wanderungen,* pp. 385–87 and 454–57.

57. Gaspare Spontini, *Nurmahal; oder, Das Rosenfest von Caschmir: Lyrisches Drama in zwei Abtheilungen; nach dem Gedicht Lalla Ruhk des Th. Moore,* drama-tisirt von C. Herklots (Darmstadt, 1828); Seiler, *Palmenhaus,* p. 55.

58. Alexander von Humboldt, *Kosmos: Entwurf einer physischen Weltbeschrei-bung,* vol. 2 (Stuttgart and Tübingen: Cotta, 1847), p. 97.

59. *Ibid.,* p. 98.

60. *Ibid.,* p. 100.

61. National Galerie, ed., *Karl Blechen: Leben, Würdigungen, Werk* (Berlin: Deutscher Verein für Kunstwissenschaft, 1940), pp. 436–43, gives black-and-white reproductions plus several of Blechen's sketches for the Indian women.

62. "Bericht über die Berliner Kunst-Ausstellung," *Museum, Blätter für bildende Kunst* 40 (1834), p. 323.

63. Oliver Rackham, *The Illustrated History of the Countryside* (1994; Lon-don: Cassel, 2000), pp. 157–58.

CHAPTER FOUR: A SCIENCE WHOSE BUSINESS IS BURSTING: SOAP BUBBLES AS COMMODITIES IN CLASSICAL PHYSICS

1. Karl Marx, *Capital,* ed. Ernest Mandel and Ben Fowkes (London: Pelican, 1976), vol. 1, pp. 165 and 177; Michael Faraday, *The Chemical History of a Candle,* ed. William Crookes (London: Chatto and Windus, 1873), pp. v–vi.

2. Asa Briggs, *Victorian Things* (Harmondsworth: Penguin, 1990), p. 326; Anne McClintock, *Imperial Leather: Race, Gender and Sexuality in the Colonial Contest* (London: Routledge, 1995), p. 208. See also Thomas Richards, *The Com-*

modity Culture of Victorian England: Advertising and Spectacle, 1851–1914 (London: Verso, 1991), pp. 121–39.

3. For an exemplary early-twentieth-century philosophical tradition that identified reasoning on soap bubbles with the ideal type of scientific argument, see John Dewey, *How We Think* (Boston: Heath, 1910), pp. 70–72; Carl Hempel, *Aspects of Scientific Explanation* (New York: Free Press, 1965), pp. 335–38. Austin's apothegm is in his *Sense and Sensibilia* (Oxford: Oxford University Press, 1964), p. 8.

4. Justus von Liebig, *Familiar Letters on Chemistry*, ed. John Gardner (London: Taylor and Walton, 1844), 2nd ser., letter 3; George Dodd, *Days at the Factories; or, The Manufacturing Industry of Great Britain Described* (London: Charles Knight, 1843), p. 190; F.W. Gibbs, "The History of the Manufacture of Soap," *Annals of Science* 4 (1939), pp. 181–88; Charles Wilson, *The History of Unilever: A Study in Economic Growth and Social Change*, 2 vols. (London: Cassell, 1954), vol. 1, pp. 3–20.

5. Dodd, *Days at the Factories*, p. 201; McClintock, *Imperial Leather*, pp. 210–11 and 419.

6. Christopher Hamlin, *A Science of Impurity: Water Analysis in Nineteenth-Century Britain* (Bristol: Adam Hilger, 1990), pp. 129–33; Thomas Huxley, "On the Reception of the Origin of Species," in Francis Darwin (ed.), *Life and Letters of Charles Darwin*, 3 vols. (London: John Murray, 1887), vol. 2, p. 200. Compare John Tyndall, *Essays on the Floating-Matter of the Air in Relation to Putrefaction and Infection*, 2nd ed. (London: Longmans, 1883), pp. 273–74 and 303.

7. Edwin Chadwick, *Report on the Sanitary Condition of the Labouring Population of Great Britain*, ed. M.W. Flinn (Edinburgh: Edinburgh University Press, 1965), pp. 318 and 425; Charles Kingsley, *The Water-Babies*, 4th ed. (London: Macmillan, 1889), pp. 326 and 329.

8. Hannah Mitchell, *The Hard Way Up: The Autobiography of Hannah Mitchell, Suffragette and Rebel*, ed. Geoffrey Mitchell (London: Virago, 1977), p. 39; Carl Chinn, *They Worked All Their Lives: Women of the Urban Poor, 1880–1939* (Manchester: Manchester University Press, 1988), pp. 16–17; Sigfried Giedion, *Mechanization Takes Command: A Contribution to Anonymous History* (New York: Norton, 1969), p. 564.

9. Briggs, *Victorian Things*, p. 326; Wilson, *Unilever*, vol. 1, pp. 43–44; Michael Dempsey, *Bubbles: Early Advertising Art from A. & F. Pears Ltd.* (London: Fontana, 1978), pp. 3–4; W. Hamish Fraser, *The Coming of the Mass Market 1850–1914* (London: Macmillan, 1981), p. 135; McClintock, *Imperial Leather*, pp. 212–13. Compare Robert Opie, *Rule Britannia: Trading on the British Image* (Harmondsworth, UK: Penguin, 1985).

10. Laurel Bradley, "Millais's 'Bubbles' and the Problem of Artistic Advertising," in Susan Casteras and Alicia Faxon (eds.), *Pre-Raphaelite Art in Its European Context* (London: Associated University Presses, 1995), pp. 193–209.

11. G.H. Fleming, *John Everett Millais: A Biography* (London: Constable, 1996), pp. 266–70; Laurel Bradley, "From Eden to Empire: John Everett Millais's *Cherry Ripe*," *Victorian Studies* 34 (1991), pp. 179–203.

12. Colleen Denney, *At the Temple of Art: The Grosvenor Gallery, 1877–1890* (London: Associated University Presses, 2000); Thomas P. Hughes, *Networks of Power: Electrification in Western Society, 1880–1930* (Baltimore: Johns Hopkins University Press, 1983), pp. 97–98.

13. John Guille Millais, *The Life and Letters of John Everett Millais*, 2nd ed. (London: Methuen, 1905), pp. 305–308; Fleming, *Millais*, pp. 271–72; Dempsey, *Bubbles*, p. 4; Diana Hindley and Geoffrey Hindley, *Advertising in Victorian England, 1837–1901* (London: Wayland, 1972), pp. 43–44; Bradley, "Millais's Bubbles"; William Sharpe, "J.E. Millais' *Bubbles*: A Work of Art in the Age of Mechanical Reproduction," *Victorian Newsletter* 70 (1986), pp. 15–18.

14. Richards, *Commodity Culture*, pp. 122 and 140–41; McClintock, *Imperial Leather*, pp. 214 and 223–25.

15. Sharpe, "Millais' *Bubbles*," p. 17. For the tradition of bubbles as signs of transience, see Wolfgang Stechow, "Homo Bulla," *Art Bulletin* 20 (1938), pp. 227–28.

16. Hooke's report on bubbles is in Thomas Birch, ed., *History of the Royal Society*, 4 vols. (London: Millar, 1756–1757), vol. 3, p. 29 (March 28, 1672); Newton's in *Opticks* (New York: Dover, 1952), pp. 214–20.

17. L. Bandera Gregori, "Filippo Pelagio Palagi: An Artist Between Neoclassicism and Romanticism," *Apollo* 97 (1973), pp. 500–509. For Chardin's image, see Pierre Rosenberg, *Chardin* (Paris: Réunion des Musées Nationaux, 1979), p. 206; Michael Fried, *Absorption and Theatricality: Painting and Beholder in the Age of Diderot* (Berkeley: University of California Press, 1980), p. 50. The Nobel laureate Pierre de Gennes chose François Boucher's *The Bubble Blower* as illustration of his prizewinning work: "Soft Matter," *Reviews in Modern Physics* 64 (1992), p. 647.

18. For Millais's rainbow and Lockyer's campaign, see Norman Lockyer, "Physical Science for Artists," *Nature* 18 (May 1878), p. 30, and Norman Lockyer, "Science and Art," *Nature* 28 (May 1883), p. 51; John Gage, *Colour and Culture* (London: Thames and Hudson, 1993), p. 114. Gardner's *Soap Bubbles* is reproduced in "World's Columbian Exposition of 1893," Paul Galvin Digital History Collection (http://columbus.gl.iit.edu/dreamcity/00044036.html).

19. William Thomson, "Capillary Attraction" (1886), in *Popular Lectures and Addresses*, 3 vols., 2nd ed. (London: Macmillan, 1891), vol. 1, pp. 1–63; Silvanus Thompson, *The Life of William Thomson*, 2 vols. (London: Macmillan, 1910), vol. 2, pp. 852–55.

20. John Paris, *Philosophy in Sport Made Science in Earnest* (London, 1827); A.J.J. van de Velde, ed., *Joseph Plateau, 1801–1833: Briefwisseling met Adolphe Quetelet* (Brussels: Paleis der Academiën, 1948), pp. 27–36; Joseph Plateau, *Statique expérimentale et théorique des liquides soumis aux seules forces moléculaires*, 2 vols. (Paris: Gauthier-Villars, 1873).

21. Joseph Plateau, "On the Phaenomena Presented by a Free Liquid Mass Withdrawn from the Action of Gravity," *Taylor's Scientific Memoirs* 4 (1846), pp. 16–43; Joseph Plateau, "Experimental and Theoretical Researches on the Figures of Equilibrium of a Liquid Mass," *Taylor's Scientific Memoirs* 5 (1852), pp. 584–712; P.M. Harman, ed., *Scientific Letters and Papers of James Clerk Maxwell* (Cambridge, UK: Cambridge University Press, 1990–), vol. 1, pp. 20–22; [Robert Chambers], *Explanations* (London: John Churchill, 1845), pp. 13–17.

22. Plateau to Faraday, June 12, 1844, and Faraday to William Buckland, Jan. 12, [1849], in F. James (ed.), *Correspondence of Michael Faraday* (London: Institution of Electrical Engineers, 1991–), vol. 3, p. 229 and vol. 4, pp. 1–2; Faraday, *Chemical History of a Candle*, pp. 124 and 142; Thomas Martin, ed., *Faraday's Diary*, 8 vols. (London: Bell, 1932–1936), vol. 5, pp. 306–7 (June 24, 1850); Michael Faraday, "On the Magnetic and Diamagnetic Condition of Bodies" (1850), in *Experimental Researches in Electricity*, 3 vols. (London: Taylor and Francis, 1830–1855), vol. 3, pp. 183–87; John Tyndall, *Faraday as a Discoverer*, 5th ed. (London: Longmans, 1894), pp. 130–31.

23. Maxwell to Peter Guthrie Tait, Feb. 15, 1857, and Maxwell to Cecil James Monro, Feb. 18, 1862, in Harman, *Scientific Letters and Papers of Maxwell*, vol. 1, pp. 443 and 707; I.B. Hopley, "Maxwell's Apparatus for the Measurement of Surface Tension," *Annals of Science* 13 (1957), pp. 180–87 and Maxwell to Tait, July 18, 1868, in Harman, *Scientific Letters and Papers of Maxwell*, vol. 2, p. 389; James Clerk Maxwell, "Plateau on Soap-Bubbles" (1874) and "Capillary Action" (1876), in W.D. Niven (ed.), *Scientific Papers of James Clerk Maxwell*, 2 vols. (Cambridge, UK: Cambridge University Press, 1890), vol. 2, pp. 393–99 and 541–91.

24. Arthur Rücker, "Soap Bubbles" (1875), in *Science Lectures for the People: Seventh Series* (Manchester: John Heywood, 1876), pp. 33–48; Arthur Rücker, "On Black Soap Films," *Nature* 16 (1877), pp. 331–33; A.W. Reinold and Arthur Rücker, "On the Thickness of Soap Films," *Proceedings of the Royal Society* 26

(1878), pp. 334–45. For the "phoneidoscope," a Cambridge device using soap films to visualize standing waves, see [Sedley Taylor], "Proceedings of the Physical Society," *Nature* 17 (1878), p. 415; and James Clerk Maxwell, "The telephone" (1879), in Niven, *Scientific Papers of Maxwell*, vol. 2, p. 754.

25. William Thomson, lecture notes, 1852, in David Wilson, *Kelvin and Stokes* (Bristol: Adam Hilger, 1987), p. 165; William Thomson, "The Size of Atoms," *Nature* 1 (1870), pp. 551–53 and "The Size of Atoms" (1883), in *Popular Lectures*, p. 174; Thomson to Stokes, Jan. 7, 1883, Stokes to Thomson, Jan. 9, 1883, Thomson to Stokes, Jan. 11, 1883, in David B. Wilson (ed.), *The Correspondence Between Sir George Gabriel Stokes and Sir William Thomson* (Cambridge, UK: Cambridge University Press, 1990), pp. 537, 539, 540, 544. For Thomson's theory of air and ether, see Crosbie Smith and M. Norton Wise, *Energy and Empire: A Biographical Study of Lord Kelvin* (Cambridge, UK: Cambridge University Press, 1989), pp. 420 and 441–44.

26. Smith and Wise, *Energy and Empire*, pp. 464–65; William Thomson, *Baltimore Lectures on Molecular Dynamics and the Wave Theory of Light* (London: Clay, 1904), pp. 282–83.

27. Thompson, *Life of William Thomson*, p. 872; Plateau, *Statique expérimentale*, pp. 213–14; William Thomson, "On the Division of Space with Minimum Partitional Area," *Philosophical Magazine* 24 (1887), pp. 503–14; William Thomson, "On Models of the Minimal Tetrakaidekahedron," *Proceedings of the Royal Society of Edinburgh* 15 (1887), p. 33. Thomson sent proofs of the paper to Lord Rayleigh and to Stokes: see Thomson to Rayleigh, Nov. 20, 1887, Rayleigh Papers, Terling; and Thomson to Stokes, Nov. 23, 1887, in Wilson, *Correspondence Between Stokes and Thomson*, p. 593.

28. Thompson, *Life of William Thomson*, pp. 870–71; Agnes Gardner King, *Kelvin the Man* (London: Hodder and Stoughton, 1925), p. 42. For subsequent work on the extremum problem, see D'Arcy Wentworth Thompson, *On Growth and Form*, abr. ed. (Cambridge, UK: Cambridge University Press, 1961), pp. 119–25; Michele Emmer, "Soap Bubbles in Art and Science," in Michele Emmer (ed.), *The Visual Mind: Art and Mathematics* (Cambridge, MA: MIT Press, 1993), pp. 135–42; Sidney Perkowitz, *Universal Foam: the Story of Bubbles* (London: Vintage, 2001), pp. 19–20.

29. Thomas Williams, *Soap Bubbles* (Liverpool: Journal of Commerce, 1890), pp. 6, 10, 13–14.

30. John Barnes, *Dr. Paris's Thaumatrope or Wonder-Turner* (London: The Projection Box, 1995), pp. 7–11; Michael Faraday, "On a Peculiar Class of Optical

Deceptions" (1831), in *Experimental Researches in Chemistry and Physics* (London: Taylor and Francis, 1859), pp. 291–311; Maxwell to Thomson, Oct. 6, 1868, in Harman, *Scientific Letters and Papers of Maxwell*, vol. 2, p. 447. For pre-cinematic machinery, see Jonathan Crary, *Techniques of the Observer: on Vision and Modernity in the Nineteenth Century* (Cambridge, MA: MIT Press, 1991), pp. 105–12; Laurent Mannoni, *The Great Art of Light and Shadow: Archaeology of the Cinema* (Exeter: University of Exeter Press, 2000), pp, 205–17 and 238–39.

31. Lord Rayleigh (Robert Strutt), "Charles Vernon Boys," *Obituary Notices of Fellows of the Royal Society* 4 (1944), pp. 771–88; H.G. Wells, *Experiment in Autobiography* (London: Gollancz, 1934), p. 211; Charles Vernon Boys, "Experiments with Soap-Bubbles," *Philosophical Magazine* 25 (1888), p. 409–19.

32. Charles Vernon Boys, *Soap Bubbles and the Forces Which Mould Them* (London: SPCK, 1890), pp. 9 and 134–35; Charles Vernon Boys, *Soap Bubbles: Their Colours and The Forces Which Mould Them*, rev. ed. (London: SPCK, 1911), pp. 22 and 170–71; Charles Vernon Boys, "Notes on Photographs of Rapidly Moving Objects and on the Oscillating Electric Spark," *Philosophical Magazine* 30 (1890), p. 248; [Norman Lockyer], "Soap Bubbles," *Nature* 43 (1891), p. 317.

33. Lord Rayleigh, "On the colours of thin plates" (1886), in *Scientific Papers*, 6 vols. (Cambridge, UK: Cambridge University Press, 1899–1920), vol. 2, pp. 498–512; Thomson to Rayleigh, Aug. 5, 1889, and Jan. 13, 1890, Rayleigh Papers; Peter Guthrie Tait, "Notes on Ripples in a Viscous Liquid," and Charles Michie Smith, "The Determination of Surface-Tension by the Measurement of Ripples," *Proceedings of the Royal Society of Edinburgh* 17 (1890), p. 116; Thomson to Rayleigh, March 30, 1890, in Lord Rayleigh [Robert Strutt], *John William Strutt Third Baron Rayleigh* (London: Arnold, 1924), pp. 246–47.

34. Lord Rayleigh [John Strutt], "On the Tension of Recently Formed Liquid Surfaces" (1890), in *Scientific Papers*, vol. 3, pp. 342, 344, 346; Lord Rayleigh [John Strutt], "Measurements of the Amount of Oil Necessary in Order to Check the Motions of Camphor upon Water" (1890), in *Scientific Papers*, vol. 3, pp. 347–50; Lord Rayleigh [John Strutt], "Foam" (1890), in *Scientific Papers*, vol. 3, pp. 351, 359, 362.

35. Stokes to Rayleigh, March 7–8, 1890, in Joseph Larmor (ed.), *Memoir and Correspondence of the Late Sir George Gabriel Stokes*, 2 vols. (Cambridge, UK: Cambridge University Press, 1907), vol. 2, pp. 114–15; Thomson to Rayleigh, April 16, 1890, Rayleigh Papers; Boys, "Notes on Photographs of Rapidly Moving Objects," pp. 248 and 250–54; Boys, *Soap Bubbles* (1911), pp. 127–33.

36. Lord Rayleigh [John Strutt], "Instantaneous Photographs of Water Jets"

(1890), *Scientific Papers*, vol. 3, p. 382; Rayleigh, *John William Strutt*, pp. 182–83; Lord Rayleigh [John Strutt], "On the Tension of Water Surfaces" (1890) and "On the Theory of Surface Forces" (1890), in *Scientific Papers*, vol. 3, pp. 383–425; Lord Rayleigh [John Strutt], "Experiments upon Surface Films" (1892), *Scientific Papers*, vol. 3, p. 569.

37. Lord Rayleigh [John Strutt], "Some Applications of Photography" (1891), in *Scientific Papers*, vol. 3, pp. 446–48.

38. "The Velocities of Projectiles," *Nature* 42 (1890), pp. 250–51; Charles Vernon Boys, "On Electric Spark Photographs," *Nature* 47 (1893), pp. 415–21 and 440–46; Charles Vernon Boys, "On the Photography of Flying Bullets by the Light of the Electric Spark," *Journal of the Royal United Services Institution* 37 (1893), pp. 855–73. For Mach and Boys, see Peter Geimer, "Ein Projektil und sein Selbstporträt," in Christoph Hoffmann and Peter Berz (eds.), *Über Schall: Ernst Machs und Peter Salchers Geschossfotografien* (Göttingen: Wallstein, 2001), pp. 347–50. For Boys's Edinburgh show, see C.G. Knott, *Life and Scientific Work of Peter Guthrie Tait* (Cambridge, UK: Cambridge University Press, 1911), p. 34.

39. Frederick Talbot, *Moving Pictures: How They Are Made and Worked* (London: Heinemann, 1912), p. 39; John Barnes, *The Beginnings of Cinema in England, 1894–1896*, rev. ed. (Exeter: University of Exeter Press, 1998), pp. 8, 15–17, 38–41, 46; Mannoni, *Great Art of Light and Shadow*, pp. 434–35. For Boys's use of the animatograph, see Boys to Stokes, Dec. 23, 1897, and Stokes to Boys, Dec. 25, 1897, in Larmor, *Memoir and Correspondence of Stokes*, vol. 2, pp. 353–54.

40. Arthur Worthington, *A Study of Splashes*, ed. Keith Irwin (New York: Macmillan, 1963), pp. ix–xviii; Arthur Worthington, "On the Surface Forces in Fluids," *Philosophical Magazine* 18 (1884), pp. 334–64; Arthur Worthington, "On the Stretching of Liquids," *British Association Reports* (1888), pp. 583–84; Worthington to Stokes, March 22, 1881, June 7, 1881, April 29, 1882, May 7, 1882, and Stokes to Worthington, May 18, 1882, in Stokes MSS, University Library Cambridge, MSS Add 7656 W1089–93; Arthur Worthington, "The Splash of a Drop and Allied Phenomena," *Proceedings of the Royal Institution* 14 (1894), pp. 300 and 302.

41. Worthington, "Splash of a Drop," p. 289; Worthington, *Study of Splashes*, pp. 2 and 118–20. For *Pearson's Magazine*, see Peter Broks, *Media Science Before the Great War* (London: Macmillan, 1996), pp. 18–19 and 108. For Thomson's new work on foam shapes, see "On the Molecular Tactics of a Crystal" (1893), in Thomson, *Baltimore Lectures*, pp. 602–42.

42. Henri Béhar, *Les Cultures de Jarry* (Paris: PUF, 1988), pp. 193–99; Keith

Beaumont, *Alfred Jarry: A Critical and Biographical Study* (Leicester: Leicester University Press, 1984), pp. 179–203; Alfred Jarry, *Gestes et opinions du docteur Faustroll, pataphysicien*, ed. Noel Arnaud and Henri Bordillon (Paris: Gallimard, 1980), pp. 184–85 and 216–18. Citations from Jarry are from *Adventures in 'Pataphysics*, ed. Alastair Brotchie and Paul Edwards (London: Atlas, 2001), p. 36, and *Exploits and Opinions of Doctor Faustroll, Pataphysician*, ed. Simon Watson Taylor (Boston: Exact Change, 1996), pp. 14–17.

43. Béhar, *Cultures de Jarry*, pp. 195–99; Jarry, *Doctor Faustroll, Pataphysician*, pp. 100–6. For Grandville, see Walter Benjamin, *Paris, capitale du XIXe siécle*, 2nd ed. (Paris: Cerf, 1993), pp. 40 and 850; Stanley Appelbaum, ed., *Fantastic Illustrations of Grandville* (New York: Dover, 1974), p. 49. For Guillemin, see Bruno Béguet, ed., *La Science pour tous: Sur la vulgarisation scientifique en France de 1850 à 1914* (Paris: CNAM, 1990), pp. 44 and 164.

44. For inventory investment and the early museum, see Harold Cook, "Time's Bodies: Crafting the Preparation and Preservation of Naturalia," in Pamela Smith and Paula Findlen (eds.), *Merchants and Marvels: Commerce, Science, and Art in Early Modern Europe* (London: Routledge, 2002), pp. 223–47. Boys's remark from *Soap Bubbles* (1890), p. 134, is omitted from later editions.

CHAPTER FIVE: *RES IPSA LOQUITUR*

1. "Self-Operating Processes of Fine Art: The Daguerreotype," *Spectator* 12, no. 553 (Feb. 2, 1839) p. 17. The author of the article notes: "We have not seen one impression of these light-created monochromes."

2. It is, he says, a "chemical process of picturing and engraving," one among a small number of "other [recently invented] self-acting machines of mechanical operation." *Ibid.*, p. 18.

3. *Ibid.*

4. "Some who have never raised their minds to the consideration of the real dignity of the art, and who rate the works of an artist in proportion as they excel, or are defective in the mechanical parts, look on theory as something that may enable them to talk but not to paint better, and confining themselves entirely to mechanical practice, very assiduously toil on in the drudgery of copying, and think they make a rapid progress while they faithfully exhibit the minutest part of a favorite picture." Sir Joshua Reynolds, *Discourses on Art* (New Haven, CT: Yale University Press, 1959), discourse 2, p. 29.

5. *Ibid.*, discourse 1, p. 17. Reynolds immediately follows with: "This seems to me to be one of the most dangerous sources of corruption; and I speak of it

from experience, not as an error which may possibly happen, but which has actually infected all foreign Academies."

6. *Ibid.*, discourse 7, p. 117.

7. "He who endeavors to copy nicely the figure before him not only acquires a habit of exactness and precision, but is continually advancing in his knowledge of the human figure." *Ibid.*, discourse 1, pp. 20–21.

8. Some colleagues who have commented on this paper have suggested that the non-machine sense of "mechanical" is parasitic on the machine sense. My highly informal research suggests otherwise. The oldest sense (1432–1450) for the word as given in the *Oxford English Dictionary* is "1. Of arts, trades, occupations: Concerned with machines or tools. Hence, a. Concerned with the contrivance and construction of machines or mechanism." But the next listed sense of "mechanical" (1450) is: "b. Concerned with manual operations; of the nature of handicraft."

9. What examples of natural accuracy could the author have in mind? Does he imagine, for example, that sexual reproduction is a form of copying?

10. "Self-Operating Processes of Fine Art," p. 18.

11. Although the daguerreotype permits nature to produce engravings of *her* face, the author of another precocious review of the daguerreotype, published in April 1839, writes: "M. Daguerre has not succeeded in copying the living physiognomy in a satisfactory manner, though he does not despair of success." "New Discovery in the Fine Arts: The Daguerreotype," *New Yorker*, April 20, 1839, p. 31.

12. "[P]hotography has become a household word and a household want; is used alike by art and science, by love, business, and justice; is found in the most sumptuous saloon, and in the dingiest attic — in the solitude of the Highland cottage, and in the glare of the London gin-palace — in the pocket of the detective, in the cell of the convict, in the folio of the painter and architect, among the papers and patterns of the mill owner and manufacturer, and on the cold brave breast on the battle-field." Lady Elizabeth Eastlake, "Photography," *Quarterly Review* (London), 1, no. 101 (April 1857), reprinted in Beaumont Newhall (ed.), *Photography: Essays and Images* (New York: Museum of Modern Art, 1980), p. 81. All page citations to this essay refer to the Newhall volume.

13. The "improvements" to lenses related to their increased resolving power (for making more detailed copies) and to their ability to produce brighter images (and thus quicker exposures).

14. Eastlake, "Photography," p. 84.

15. *Ibid.*, p. 93.

16. The extension of "our" here is obviously restricted to the "small minority" who desires art.

17. Eastlake, "Photography," p. 91.

18. The green of the foliage reflects a small proportion of the blue radiation falling on it. In order for the foliage to register on the plate, it is necessary to prolong the exposure, but areas of the scene that are rich in blue radiation are overexposed in the process of waiting for the green areas to register.

19. "The power of selection and rejection, the living application of that language which lies dead in his paint-box, the marriage of his own mind with the object before him, and the offspring, half stamped with his own features, half with those of Nature, which is born of the union — whatever appertains to the free-will of the intelligent being, as opposed to the obedience of the machine — this, and much more than this, constitutes that mystery called Art, in the elucidation of which photography can give valuable help, simply by showing what it is not." Eastlake, "Photography," p. 94.

20. Handmade copies are likewise "literal, unreasoning imitations."

21. Eastlake, "Photography," p. 89.

22. *Ibid.*, p. 93. Emphasis added.

23. *Philadelphia Photographer* 2, no. 22 (Oct. 1865), pp. 155–57.

24. "The Howland Will Case," *American Legal Review* 4, no. 625 (July 1870), pp. 644–53.

25. A recent textbook of legal evidence, which repeats the century-and-a-half-old formulation of "hearsay," defines it as follows:

> *Hearsay testimony* is secondhand evidence, it is not what the witness knows personally, but what someone else told him or her. Gossip is an example of hearsay. In general, hearsay may not be admitted in evidence, but there are exceptions. For instance, if the accused is charged with uttering certain words, a witness is permitted to testify that he or she heard the accused speak them.
>
> The following examples illustrate hearsay that is inadmissible:
>
> 1. SN Water, the accused, is being tried for desertion. BMC Boate cannot testify that BM3 Christmas told him that SN Water said he (Water) intended to desert.
>
> 2. The accused is being tried for larceny of clothes from a locker. A testifies that B told him that she saw the accused leave the space where the locker was located with a bundle of clothes about the same time the

clothes were stolen. This testimony from A would not be admissible to prove the facts stated by B.

Neither BMC Boate nor A would be allowed to testify, but the trial counsel could call BM3 Christmas and B as witnesses. The fact that hearsay evidence was given to an officer in the course of an official investigation does not make it admissible.

26. It may be that now current attitudes toward polygraph tests parallel the attitudes toward photography that held them to be hearsay evidence.

27. J.A.J., "The Legal Relations of Photographs," *American Law Register* (Albany, New York), 1, no. 1 (Jan., 1869), pp. 59–60.

28. "The Legal Relations of Photography," *Albany Law Journal* 5 (Jan. 25, 1873). "It has been asserted that the last objects which a dying man sees remain sufficiently long upon the retina of the eye to admit of being enlarged and preserved by photography. If this be true, in the case of a murdered man, the surrounding objects and persons in their actual attitudes may be ascertained. Although we have no case in which this scientific fact has been utilized in the identification of a murderer, such a use is by no means improbable in the future."

29. *William Eborn v. George B. Zimpelman, Adm'r &c.*, 47 Texas 503 (1877).

30. *Ibid.*

CHAPTER SIX: THE GLASS FLOWERS

My hearty thanks to Susan Rossi-Wilcox of the Harvard Museum of Natural History, Don Pfister of the Harvard University Herbaria, Chris Meechan of the National Museum and Gallery at Cardiff, Henri Reiling of Utrecht University, James Peto of the Design Museum in London, and the staff of the Harvard University Archives for their generosity in making materials concerning the Blaschka models available to me and for their knowledgeable counsel. I am also grateful to Debora Coen for research assistance in the Harvard archives, to Rupal Pinto for allowing me to read her senior thesis, to Denise Phillips for advice concerning Dresden scientific societies, and to Martha Fleming for information about the artistic uses to which the Blaschka models have recently been put.

1. Goodale had begun negotiations with the Blaschkas soon after the Department of Botany was granted permission to construct the central portion of the Harvard University Museum in 1885. The story of his first visit to the Dresden workshop was subsequently told and retold: see [George Lincoln Goodale], *The Ware Collection of Blaschka Glass-Models of Plants in Flower* (Cambridge, MA: n.p.,

1915), Harvard University Archives, HUF 231.115.34; and *Harvard University Annual Reports of the President and the Treasurer, 1890–91*, pp. 160–61.

2. The Ware family connection with Harvard College went back generations; Henry Ware had been president in 1828–1829. Rupal Pinto, "Making Harvard's Glass Flowers: The Interface of Botany, Gender, and Artistic Virtuosity in America" (senior honors thesis, Department of the History of Science, Harvard University, 2002), pp. 69–70.

3. Accounts of her visits may be found in "How Were the Glass Flowers Made? A Letter by Mary Lee Ware," *Botanical Museum Leaflets* 19 (1961), pp. 125–36 (the letter in question, dated Oct. 3, 1928, is addressed to Professor Oakes Ames); earlier visits in the company of Goodale are recorded in the diaries (1901) of Henrietta Jewell Goodale, Schlesinger Library, Radcliffe College, 2001-M34.

4. They are arranged according to the Engler-Gilg system of plant classification. See Richard Evans Schultes and William A. Davis, *The Glass Flowers at Harvard*, photographs by Hillel Burger (1982; Cambridge, MA: Botanical Museum of Harvard University, 1992), p. 10; Adolf Engler, *Die natürlichen Pflanzenfamilien nebst ihren Gattungen und wichtigeren Arten insbesondere der Nutzpflanzen* (Leipzig: Engelmann, 1887).

5. Pliny the Elder, *Historia naturalis*, 35.36.65; on the *fortuna* of this story, see Ernst Kris and Otto Kurz, *Legend, Myth, and Magic in the Image of the Artist*, trans. Alastair Laing and Lottie M. Newman (1934; New Haven, CT: Yale University Press, 1979), pp. 62–64. On metal casts and Palissy ware, see Ernst Kris, "'Der Stil Rustique': Die Verwendung des Naturabgusses bei Wenzel Jamnitzer und Bernard Palissy," *Jahrbuch der Kunsthistorischen Sammlung*, new ser., 1 (1926), pp. 137–208. On automata, see Musée National des Techniques, *Jacques Vaucanson* (Ivry: Salles et Grange, 1986); and Horst Bredekamp, *Antikensehnsucht und Maschinenglauben: Die Geschichte der Kunstkammer und die Zukunft der Kunstgeschichte* (Berlin: Klaus Wagenbach, 1993).

6. On the fascination with facsimiles, see Hillel Schwartz, T*he Culture of the Copy: Striking Likenesses, Unreasonable Facsimiles* (New York: Zone Books, 1996), esp. pp. 351–54 concerning artificial flowers.

7. Mary B. Hesse, *Models and Analogies in Science* (London: Sheed and Ward, 1963); Mary Morgan and Margaret Morrison, eds., *Models as Mediators: Perspectives on Natural and Social Sciences* (Cambridge, UK: Cambridge University Press, 1999); Soraya de Chadarevian and Nick Hopwood, eds., *Models: The Third Dimension of Science* (Standord, CA: Stanford University Press, forthcoming).

8. On embryos, see Nick Hopwood, *Embryos in Wax: Models from the Ziegler*

Studio (Cambridge, UK, and Bern: Whipple Museum of the History of Science and Bern Institute of the History of Medicine, 2002); Nick Hopwood, "'Giving Body' to Embryos: Modeling, Mechanism, and the Microtome in Late Nineteenth-Century Anatomy," *Isis* 90 (1999), pp. 462–96. On sponges, see Stefan Richter, "Franz Eilhard Schulze und die zoologische Lehrsammlung der Berliner Universität," *Theater der Natur und Kunst / Theatrum Naturae et Artis: Wunderkammern des Wissens: Essays* (Berlin: Henschel, 2000), pp. 119–34.

9. Matthias Jacob Schleiden, *Grundzüge der wissenschaftlichen Botanik, nebst einer methodologischen Einleitung als Anleitung zum Studium der Pflanze*, 4th ed. (1842–1843; Leipzig: Wilhelm Engelmann, 1861), p. 86.

10. The type species of the genus or "genotype," formerly used to establish a genus; see Société Zoologique de France, *De la nomenclature des êtres organisés* (Paris: Société Zoologique, 1881), p. 30. On the Gray-Sprague collaboration, see A. Hunter Dupree, *Asa Gray, 1810–1888* (New York: Athenaeum, 1968), pp. 167–68.

11. Alphonse de Candolle, *La Phytographie; ou, l'Art de décrire les végétaux considérés sous différents points de vue* (Paris: Masson, 1880), p. 321.

12. The Harvard botanist Don Pfister told me that he uses the Glass Flowers for his class on trees: students are first sent out into Harvard Yard to examine specimens in situ, and then directed to selected models in the museum. But he believes that he is alone among his colleagues in this practice. He also recalled that a colleague had allegedly used the Glass Flowers to prepare for her preliminary examinations in systematics, adding that he thought the collection could only be used selectively, one or two models studied at a time; the effect of the whole would be "overwhelming" in its detail. Personal communication, May 9, 2002.

13. Miguel Tamen, *Friends of Interpretable Objects* (Cambridge, MA: Harvard University Press, 2001), p. 137.

14. Brian Waldron of Masterpiece International, the firm that transported a few of the models to the French millennial exhibition in Avignon, not only personally supervised the loading and unloading at Logan Airport but also made the acquaintance of baggage handlers beforehand to ensure the most careful treatment of the shipment. Personal communicaton, Oct. 7, 2002.

15. *Harvard University Annual Reports of the President and the Treasurer, 1941–42*, p. 448.

16. Fine examples of these approaches include: Henri Reiling, "The Blaschkas," *Journal of Glass Studies* 40 (1998), pp. 105–26; Carlo G. Pantano, Susan Rossi-Wilcox, and David Lange, "The Glass Flowers," *Prehistory and History of Glassmaking Technology* 8 (1998), pp. 61–78; James Peto and Ann Jones, introduc-

tion to *Leopold and Rudolf Blaschka,* catalog of exhibition at Design Museum, London (London: Futura, 2002), pp. 8–11; Chris Meechan and Henri Reiling, "Leopold and Rudolf Blaschka and Natural History in the 19th Century," in *ibid.*, pp. 12–23; Carrie Call Breese, "A Glass Menagerie: The Glass Marine Animals of Leopold and Rudolf Blaschka," *Glass Line,* http://exo.com/~jht/hotglass/access/v11n3/blaschka.html; Marianne Moore, "Silence," in *The Complete Poems of Marianne Moore* (Harmondsworth, UK: Penguin, 1994), p. 91; Christopher Williams's installations in Los Angeles and elsewhere: http://www.moma.org/exhibitions/muse/artist_pages/williams_vietnam.html.

17. Wilfrid Blunt and William T. Stearn, *The Art of Botanical Illustration,* rev. ed. (London: Antique Collectors' Club, 1994), pp. 288–91.

18. Rudolph Blaschka to Walter Deane, June 15, 1908, Walter Deane Collection (Blaschka), Gray Herbarium, Harvard University.

19. George H. Kent, *The Ware Collection of Blaschka Glass Flower Models* (Cambridge, MA: George H. Kent University Bookstore, 1908), p. 7.

20. For a detailed account of the zoological models, see Reiling, "Blaschkas"; also see Henri Reiling, "Glazen zeedieren in Utrecht," *Mededelingen Nederlandse Vereniging van Vrienden van Ceramiek en Glas* 151 (1994), pp. 2–13. Chris Meechan has compiled a census of the models still extant in British museums.

21. Rudolph Blaschka, "Hydroidquallen oder Craspedoten" (read April 29, 1880), *Sitzungsberichte und Abhandlungen der Naturwissenschaftlichen Gesellschaft Isis in Dresden* (1880), pp. 45–49. "Herr L. Blaschka, welcher sich besonders für die Quallen (unter sich auch *Craspedoten* fanden) ihres glassartigen Aussehens wegen interessirte" (p. 49).

22. Meechan and Reiling, "Leopold and Rudolf Blaschka," pp. 16–21.

23. The Prince introduced Leopold Blaschka to Professor Heinrich Gottlieb Ludwig Reichenbach, director of the Dresden Botanical Garden from 1820 to 1874, where the models of tropical plants were displayed in 1863, prompting Blaschka's move from Bohemia to Dresden that same year. Reiling, "Blaschkas," p. 106; Rolf Hertel, "Heinrich Gottlieb Ludwig Reichenbach: Ein bedeutender Naturforscher des 19. Jahrhunderts," *Sitzungsberichte und Abhandlungen der Naturwissenschaftlichen Gesellschaft Isis in Dresden* (1993–1994), p. 202; Stadtarchiv Dresden, Gewerbeamt A, Bürger- und Gewerbeakten, Sig. 2.3.9. Nr. B.4236. The magnum opus on orchids by Heinrich Gustav Reichenbach (son of Heinrich Gottlieb Ludwig and also a botanist), *Xenia Orchidacea,* 3 vols. (Leipzig: Brockhaus, 1858–1900), also known as the *Reichenbachia,* was so costly that the Harvard botanist Asa Gray could not afford to purchase it for the library of the

Botanical Garden. It was finally acquired by donation. Goodale to Charles W. Eliot, Oct. 7, 1905, Charles W. Eliot Presidential Papers, box 215, Harvard University Archives, UA5.150.

24. Pantano, Rossi-Wilcox, and Lange, "Glass Flowers," pp. 65–66. Concerning the mid-nineteenth-century vogue for jewelry with natural, especially floral, motifs, see Brigitte Marquardt, *Schmuck: Realismus und Historismus (1850–1895): Deutschland-Österreich-Schweiz* (Berlin: Deutscher Kunstverlag München, 1998), p. 50. One of Leopold Blaschka's floral brooches on the then-popular light blue enamel backgrounds survives in the Harvard collection.

25. The naturalist and artist Maria Sibylla Merian, for example, published a three-part "Blumenbuch" (1675–1680) meant to serve as a pattern book for embroiderers and other artisans involved in the decorative trades. Merian in turn had borrowed heavily from the images in Nicolas Robert's several flower books, which first appeared in 1640 and were still being pillaged and reprinted as copybooks in Amsterdam in 1794. Merian's and Robert's careers were typical of those of many seventeenth- and eighteenth-century flower painters for whom the distinctions between scientific and ornamental illustration hardly held. Sam Segal, "Maria Sibylla Merian als Blumenmalerin," in Kurt Wettengl (ed.), *Maria Sibylla Merian, 1647–1717: Künstlerin und Naturforscherin,* Austellungskataloge des Historischen Museums Frankfurt am Main (Frankfurt: Gerd Hatje, 1997), pp. 68–87. On the use of botanical forms in late-nineteenth-century decorative arts, see Anton Seder, *Die Pflanze in Kunst und Gewerbe,* 2 vols., ed. Martin Gerlach (Vienna: Gerlach und Schenk, 1886).

26. Quoted in Peto and Jones, Introduction, p. 10.

27. Rudolph Blaschka to Walter Deane, June 15, 1911, Deane Collection (Blaschka).

28. Reiling, "Blaschkas," p. 118. Some of these drawings are preserved at the Rakow Library, Corning Museum of Glass, New York.

29. Rudolph Blaschka to Walter Deane, Dec. 12, 1901, Deane Collection (Blaschka).

30. Philip Henry Gosse, *A Naturalist's Rambles on the Devonshire Coast* (London: John Van Voorst, 1853), pp. 322, 335, 340–42.

31. Blaschka, "Hydroidquallen," p. 48.

32. "The Glass Flowers," *China, Glass, Lamps* 7 (1894), p. 2.

33. Peter Dittmayer, *Die Kulturgeschichte des Glases* (Engelsbach: Fouqué Litteraturverlag, 2002), pp. 123–26.

34. Quoted in Pantano Rossi-Wilcox, and Lange, "Glass Flowers," p. 65.

35. Rudolph Blaschka to Walter Deane, June 15, 1911, Deane Collection (Blaschka).

36. In correspondence from 1863 to 1874 with Dresden officials, Leopold consistently signs his letters "Glasskünstler"; this is also the designation on the documents granting him Dresden citizenship on May 29, 1874: Stadtarchiv Dresden, Gewerbeamt A, Bürger- und Gewerbeakten, Sig. 2.3.9. Nr. B.4236. According to the records of the Naturwissenschaftlichen Gesellschaft ISIS in Dresden, Leopold Blaschka had become a member of the Botany Section in 1873; Rudolph was admitted in 1880. *Mitglieder Verzeichnis der Isis, Gesellschaft für specielle, besonders vaterländische Naturkunde* (Dresden: E. Blochmann und Sohn, 1861–1896).

37. Reiling, "Blaschkas," pp. 107–15; Meechan and Reiling, "Leopold and Rudolf Blaschka," p. 20.

38. Rudolph Blaschka to Walter Deane, Jan. 28, 1900, Feb. 9, 1902, Feb. 7, 1898, June 15, 1911, Jan. 18, 1920, Deane Collection (Blaschka).

39. Pantano, Rossi-Wilcox, and Lange, "Glass Flowers," pp. 68–69 and 70–76.

40. Schultes and Davis, *The Glass Flowers*, pp. 9–10; the notebooks with orders to commercial glass firms are preserved at the Rakow Library, Corning Museum of Glass, New York.

41. Ware, "How Were the Glass Flowers Made?" p. 132.

42. Rudolph Blaschka to Walter Deane, Jan. 6, 1906, Deane Collection (Blaschka).

43. Rudolph Blaschka to Walter Deane, June 15, 1911, Deane Collection (Blaschka).

44. Rudolph Blaschka to Walter Deane, Jan. 6, 1906, Deane Collection (Blaschka).

45. By 1915, a case devoted to the packing methods had become part of the Ware Collection display at the Botanical Museum; see Goodale, *Ware Collection*, p. 5.

46. Schultes and Davis, *Glass Flowers*, pp. 6–8. Goodale's successor, Oakes Ames, noted with gratitude that "all of the glass models have been prepared for display and set in place by his [Bierweiler's] own hand." *Harvard University Annual Reports of the President and the Treasurer, 1931–32*, p. 248.

47. Rudolph Blaschka to Walter Deane, June 15, 1908, Deane Collection (Blaschka).

48. *Ibid.*

49. Rudolph Blaschka to Walter Deane, June 28, 1900, Dec. 11, 1902, May 16, 1909, Deane Collection (Blaschka).

50. Rudolph Blaschka to Walter Deane, Oct. 23, 1899; and Rudolph Blaschka to Goodale, Jan. 18, 1920, Deane Collection (Blaschka).

51. Oakes Ames, *The Ware Collection of Blaschka Glass Models of Plants in the Botanical Museum of Harvard University* (Cambridge, MA: Botanical Museum of Harvard University, 1947), Harvard University Archives, HUF 231.147.4.

52. Goodale to Charles W. Eliot, Hosterwitz, Aug. 3, 1899, Eliot Presidential Papers, box 108, UA5.150.

53. Goodale to Charles W. Eliot, Cambridge, Dec. 9, 1903, Eliot Presidential Papers, box 215, UA5.150.

54. Goodale to Eliot, Hosterwitz, Aug. 3, 1899, Eliot Presidential Papers, box 108, UA5.150.

55. "Glass Flowers," p. 2.

56. See Dupree, *Asa Gray*, pp. 388–93, for this shift in the direction of Harvard botany; also see Robert Tracy Jackson, "George Lincoln Goodale," *Harvard Graduates' Magazine,* Sept. 1923, pp. 54–59, for details of Goodale's career.

57. George Lincoln Goodale, *Concerning a Few Common Plants*, 2nd ed. (Boston: Boston Society of Natural History, 1879), pp. 42–43.

58. *Ibid.*, p. 6.

59. *Ibid.*, p. 54.

60. George Lincoln Goodale, *Physiological Botany: Outlines of the Histology of Phaenogamous Plants* (New York: Ivison, Blakeman, Taylor, and Company, 1885), pp. 2–3 and 6.

61. An 1885 Blaschka catalog advertising models of marine invertebrates claimed that they had been purchased in Germany, the United States, New Zealand, India, Britain, and numerous other countries. Leopold Blaschka, *Katalog über Blaschka's Modelle von wirbellosen Thieren* (Stolpen: Gustav Winter, 1885), Museum für Naturkünde der Humboldt-Universität Berlin. In 1880, Alexander Agassiz, who succeeded his father as director of the Museum of Comparative Zoology, ordered a complete series of Blaschka echinoderms; Agassiz had extensive dealings with Henry Augustus Ward, who was the Blaschkas' sole dealer in the United States. *Harvard University Annual Reports, 1880–81*, p. 125; Mary P. Winsor, *Reading the Shape of Nature: Comparative Zoology at the Agassiz Museum* (Chicago: University of Chicago Press, 1991), pp. 144–45; Mary P. Winsor, *Starfish, Jellyfish, and the Order of Life: Issues in Nineteenth-Century Science* (New Haven, CT: Yale University Press, 1976), ch. 7; Reiling, "Blaschkas," p. 117.

62. J.G. Ballard, "The Garden of Time," in *The Best Short Stories of J.G. Ballard*, intro. by Anthony Burgess (New York: Henry Holt, 1978), pp. 141–48. I am

grateful to Wendy Doniger for drawing my attention to this story.

63. Winsor, *Reading the Shape of Nature*, pp. 120–29. Goodale announced the contract with the Blaschkas as a way in which "an interesting exposition of the scientific and the popular sides can be satisfactorily assured." *Harvard University Annual Reports of the President and the Treasurer, 1889–90*, p. 169.

64. Goodale to Eliot, Cambridge, May 18, [1900?], Eliot Presidential Papers, box 108. Blaschka botanical models were also part of the Harvard displays at the expositions in Chicago and St. Louis. Goodale to Eliot, Cambridge, March 28, 1893, box 108; Goodale to Jerome Green (Eliot's secretary), Cambridge, Oct. 13, [1903?], box 215. For more on Goodale's extensive fund-raising activities, see Goodale to Eliot, Cambridge, May 28, 1902, box 108; Goodale to Eliot, Cambridge, Dec. 11, 1896, box 108.

65. *Harvard University Annual Reports of the President and the Treasurer, 1889–90*, p. 169; George Lincoln Goodale, address to President Eliot, ca. 1894, quoted in Pinto, "Making Harvard's Glass Flowers," p. 32.

66. Pierre-Joseph Redouté, *Les Liliacées*, 8 vols. (Paris, 1802–1816), text by A.-P. de Candolle for vols. 1–4, by F. de Laroche for vols. 5–7, and by A. Raffeneau-Delile for vol. 8; Abigail Jane Lustig, "The Creation and Uses of Horticulture in Britain and France in the Nineteenth Century" (Ph.D. diss., University of California, Berkeley, 1997), p. 72.

67. Candolle, *Phytographie*, pp. 51–52.

68. Major Gabriel Seelig, Notes on Botany 1, 1895–1896, Prof. Goodale, p. 48, Harvard University Archives, HUC.8895.309, box 645; *Harvard University Annual Reports of the President and the Treasurer, 1890–91*, p. 158.

69. Walter Deane, "The Glass Models," *Botanical Gazette* 19 (1894), p. 147.

70. Kent, *Ware Collection*, p. 10.

71. *Harvard University Annual Reports of the President and the Treasurer, 1911–12*, p. 182; *Harvard University Annual Reports of the President and the Treasurer, 1914–15*, p. 215. I have found little direct evidence of how the models were used in teaching botany at Harvard; student notes and syllabi from Goodale's classes do not refer to them explicitly. But they are mentioned in connection with some botany classes in the 1920s as "surpass[ing] the most elaborately drawn textbook figures." *Harvard University Annual Reports of the President and the Treasurer, 1926–27*, p. 229. For the use of the marine models, however, see Sabine Hackethal and Hans Hackethal, "Modelle als Zeugnisse biologischer Forschung und Lehre um 1900: Neuzugänge in der Historischen Arbeitsstelle des Museums für Naturkunde Berlin," in Armin Geus, Thomas Junker, Hans-Jörg Rheinberger,

Christa Riedl-Dorn, and Michael Weingarten (eds.), *Repräsentationensformen in der biologischen Wissenschaften, Verhandlungen zur Geschichte und Theorie der Biologie* 3 (1999), pp. 177–90.

72. Deane, "The Glass Models," *Botanical Gazette*, quoted in Goodale, *Ware Collection*, p. 7.

73. William G. Farlow to Roland Thaxter, Cambridge, Dec. 12, 1889, Harvard University Herbarium Archives.

74. Thaxter to Farlow, New Haven, Dec. 10, 1899, Harvard University Herbarium Archives.

75. Farlow to Thaxter, Cambridge, Feb. 7, 1891, Harvard University Herbarium Archives.

76. Goodale to Eliot, Hosterwitz, Aug. 3, 1899, Eliot Presidential Papers, box 108, UA5.150. The fate of these models from about 1900 to 1925 is unclear; the *Harvard University Annual Reports of the President and the Treasurer, 1925–26*, p. 227, notes that "the models of the cryptogams which have been in storage for many years were mounted on plaster tablets, carefully labelled, and … arranged in botanical sequence on the third floor of the Museum."

77. On laboratories and lectures, see Farlow to Thaxter, Cambridge, June 8, 1890, and Dec. 12, 1891, Harvard University Herbarium Archives; on the public display of cryptogams, see *Harvard University Annual Reports of the President and the Treasurer, 1897–98*, p. 233.

78. See, for example, Oliver Sacks, *Oaxaca Journal* (Washington, DC: National Geographic, 2002), pp. 42–44.

79. George Lincoln Goodale, "The Development of Botany as Shown in This Journal," *American Journal of Science* 46 (1918), p. 413.

CHAPTER SEVEN: IMAGE OF SELF

I would like to thank my research assistants Susanne Pickert, Arthur Zipf, and above all Rainer Egloff for their help. In addition, I am most grateful to Dr. John E. Exner Jr., president of the International Rorschach Society, for permission to use the Rorschach archives, and to Dr. Rita Signer for her kind assistance and good advice.

1. Alfred Binet and Victor Henri, "La Psychologie individuelle," *Année psychologique* (1895–1896), p. 444.

2. E.A. Kirkpatrick, "Individual Tests of School Children," *Psychological Review* 7 (1900), pp. 274–80.

3. Cicely J. Parsons, "Children's Interpretations of Ink-Blots," *British Journal of Psychology* 9 (1917), pp. 74–92.

4. George Dearborn, "A Study of Imaginations," *American Journal of Psychology* 9 (1898), p. 184, pp. 184–85.

5. Hermann Rorschach, *Psychodiagnostics*, trans. Paul Lemkavu and Bernard Kronenberg (Bern: Hubner, 1921), p. 16.

6. John E. Exner Jr., *The Rorschach: A Comprehensive System*, 3 vols. (New York: Wiley Interscience, 1986–1995), vol. 1, p. 69.

7. Henri Ellenberger, "The Life and Work of Hermann Rorschach (1884–1922)," *Bulletin of the Menninger Clinic* 18 (1954), p. 177.

8. *Ibid.*, p. 178.

9. *Ibid.*, p. 182.

10. *Ibid.*, pp. 182, 185, 186.

11. Szymon Hens, "Phantasieprüfung mit formlosen Klecksen bei Schulkindern, normalen Erwachsenen und Geisteskranken" (Inaugural diss., University of Zurich, 1917). Hens pointed out, for example, that manic patients characteristically exhibited a "flight of ideas" whereas depressives used the test as an opportunity to stress their inadequacy. In normal patients he emphasized the tight connection between associations and the daily occupation of the people tested (at least among the adults). So while he in some ways linked particular responses to the individual character (unlike Binet), at no point did he frame the responses as a unique trace of the individual (in Carlo Ginzburg's sense).

12. Even when a very young man of seventeen, Rorschach objected to sectarian affiliation. In 1902, he apparently wrote to Ernst Haeckel, who responded on October 22: "Your reservations about becoming a schoolteacher on the grounds that you may have to teach religious instructions do not seem right to me. Please take the concept 'religion' just as I defined it in my book 'Weltraetsel' . . . a compromise with the official ethics of church religion. That is what hundreds of my students do. *Unfortunately*, with the reigning orthodoxy, one *must* handle things diplomatically." From Rita Signer, translations of documents in the Hermann Rorschach Archives.

13. Morgenthaler to Rorschach, Nov. 9, 1919, in John E. Exner Jr. (ed.), "Lieber Herr Kollege: Correspondence Between Hermann Rorschach and Walter Morgenthaler (1919–1921)," trans. Manuela Holp (International Society for Rorschach and Projective Methods, Rorschach Archives, Bern, 1999); hereafter, RMC. I have modified the translations significantly. On the Rorschach-Morgenthaler correspondence, see "Der Kampf um das Erscheinen der Psychodiagnostik," *Rorschachiana* (1954), pp. 255–62.

14. Rorschach to Morgenthaler, Nov. 11, 1919, RMC.

15. Rorschach to Morgenthaler, Jan 7, 1920, RMC.

16. Rorschach to Morgenthaler, March 22, 1920, RMC.

17. Rorschach to Morgenthaler, April 18, 1921, RMC.

18. *Ibid.*

19. Rorschach, galley-proof corrections of cards, Rorschach Archives, Bern.

20. Morgenthaler to Rorschach, Aug. 9, 1920, and Rorschach to Morgenthaler, Aug. 11 and 20, 1920 (note by editors), RMC.

21. Binswanger to Rorschach, Jan. 1922; Rorschach to Binswanger, Jan. 1922; Binswanger Archives. An excellent study of Binswanger is Susan Lanzoni, "Bridging Phenomenology and the Clinic: Ludwig Binswanger's 'Science of Subjectivity'" (Ph.D. diss., Harvard University, 2001).

22. Ellenberger, "Rorschach," pp. 196–97.

23. *Ibid.*, p. 198.

24. The most astute analyst of Foucault's and Hadot's conceptions of the "technique of self" is Arnold Davidson, who develops his ideas in "Ethics as Ascetics: Foucault, the History of Ethics, and Ancient Thought," in Jan Ellen Goldstein (ed.), *Foucault and the Writing of History* (Oxford: Blackwell, 1994), and in his introduction to *Philosophy as a Way of Life*, by Pierre Hadot (Oxford: Blackwell, 1995). For Hadot, see *ibid.*, especially part 2 ("Spiritual Exercises"). For Foucault, see *The Care of the Self: The History of Sexuality Volume 3* (New York: Random House, 1986), pp. 43–45, and Foucault, *L'Herméneutique du sujet* (Paris: Gallimard, 2001).

25. Rorschach, *Psychodiagnostics*, p. 16.

26. *Ibid.*, p. 18.

27. *Ibid.*, p. 22.

28. Exner, *Comprehensive System*, vol. 2, p. 22.

29. Rorschach, *Psychodiagnostics*, p. 78. EB (the *Erlebnistyp* index) is defined as the number of M-coded responses divided by the weighted sum of color responses:

$$(0.5 \text{ x \# FC}) + (1.0) + (1.0 \text{ x \# CF}) + (1.5 \text{ x \# C}).$$

In the scheme, the number of FC responses measures affective adaptability; the number of CF responses tracks non-adaptable affectivity, and the number of pure C responses indicates the degree of impulsiveness. *Ibid.*, p. 99.

30. Jung cited in Rorschach, *Psychodiagnostics*, p. 81.

31. According to the *Standard Edition* of Freud, vol. 3, p. 184n, the first published occurrence of the term "projection" is in "Further Remarks on the Neuro-Psychoses of Defence" (1896), vol. 3, *Standard Edition of the Complete Psychological Works of Sigmund Freud* (London: Hogarth Press, 1962), p. 184; the first unpub-

lished use of "projection" in draft H of a study of paranoia sent to Fliess on January 24, 1895 (for which see *Standard Edition*, vol. 1, pp. 206ff.). Perhaps the most famous reference in Freud to projection is in *Totem and Taboo*, vol. 13, *Standard Edition*, esp. pp. 61–64, and 65n. H.A. Murray, *Explorations in Personality* (New York: Oxford University Press, 1938); L.K. Frank, "Projective Methods for the Study of Personality," *Journal of Psychology* 8 (1939), reprinted in Michael Hirt (ed.), *Rorschach Science* (New York: Free Press of Glencoe, 1962). Compare Exner, *Comprehensive System*, vol. 1, pp. 14–18 and many other places.

32. Rorschach, *Psychodiagnostics*, p. 83.

33. *Ibid.*, pp. 86–87.

34. *Ibid.*, p. 87.

35. *Ibid.*, pp. 94–102, quotation on p. 99. Compare: "The contrast may be expressed in still another way, namely, that introversives are cultured, extratensives are civilized" (p. 110).

36. Exner, *Comprehensive System*, vol. 1, p. 474.

37. Caroline Bedell Thomas, Donald C. Ross, and Ellen S. Freed, *An Index of Rorschach Responses* (Baltimore: Johns Hopkins Press, 1964).

38. http://www.parinc.com/product.cfm?ProductID=203. Accessed December 2001.

39. This is a sample from Version 4 of ROR-SCAN's Interpretive Scan. The protocol is from Irving B. Weiner's *Principles of Rorschach Interpretation* (Mahway, NJ: Lawrence Erlbaum Associates, 1998) (Case 9: "Violence potential in a man who had to have his own way"), ch. 14, p. 379.

40. Rorschach, *Psychodiagnostics*, pp. 103–104.

41. Marguerite R. Hertz, "Current Problems in Rorschach Theory and Technique," in Michael Hirt (ed.), *Rorschach Science*, pp. 391–430, esp. pp. 401–10.

42. Frank, "Projective Methods," p. 43.

43. Frank, "Projective Methods," pp. 44–48, quotations on pp. 44 and 48.

44. Mark N. Resnick and Vincent J. Nunno, "The Nuremberg Mind Redeemed: A Comprehensive Analysis of the Rorschachs of Nazi War Criminals," *Journal of Personality Assessment* 57, no. 1 (1991), pp. 19–29. There is a moral-epistemic chasm that opens as one sees the apparatus of experimental psychology attempting to assess a group that included Hermann Göring, Alfred Rosenberg, Albert Speer, and Arthur Seyss-Inquart. On the one hand, the authors judge that the group was lacking in introspection: "average German citizens–products of a rigid, paternalistic, male-dominated society [with] mildly paranoid features [but] no evidence of thought disorder or psychiatric condition." On the other hand,

they were "character-disordered criminals" of a type that is "not rare," indeed commonly found in "the upper echelons of most closed systems...civil service, government, intelligence agencies, the military, and the large public and private companies" (pp. 27–28).

45. Rorschach, *Psychodiagnostics*, p. 110.

46. See Peter Galison, "Judgment Against Objectivity," in Peter Galison and Caroline A. Jones (eds.), *Picturing Science, Producing Art* (New York: Routledge, 1998).

47. Hertz, "Current Problems," p. 416.

CHAPTER EIGHT: NEWS, PAPER, SCISSORS: CLIPPINGS IN THE SCIENCES AND ARTS AROUND 1920

Besides the members of our group, I would like to thank Mechthild Fend, Michael Hagner, Claudia Swan, Fernando Vidal, and Milena Wazeck. for stimulating discussions and corrections.

1. See Gloria Meynen, "Büroformate: Von DIN A4 zu Apollo 11," in Herbert Lachmayer and Eleonora Louis (eds.), *Work & Culture: Büro: Inszenierung von Arbeit* (Klagenfurt: Oberösterreichisches Landesmuseum, 1998), pp. 80–88; and http://www.mackido.com/Interface/ui_horn1.html.

2. Elizabeth Eisenstein, *The Printing Press as an Agent of Change: Communication and Cultural Transformations in Early-Modern Europe* (Cambridge, UK: Cambridge University Press, 1979).

3. See, for example, Anthony Grafton, *The Footnote: A Curious History* (London: Faber and Faber, 1997); William Clark, "On the Ministerial Archive of Academic Acts," *Science in Context* 9 (1996), pp. 421–86; Anne Blair, "Humanist Methods in Natural Philosophy: Commonplace Book," *Journal of the History of Ideas* 53 (1992), pp. 541–51; Lorraine Daston, "Perchè i fatti sono brevi?" *Quaderni Storici* 108 (2001), pp. 745–70; Helmut Zedelmaier, *Bibliotheca universalis und Bibliotheca selecta: Das Problem der Ordnung des gelehrten Wissens in der frühen Neuzeit* (Cologne: Böhlau, 1992); Lucia Dacome, "Policing Bodies and Balancing Minds: Self and Representation in Eighteenth Century Britain" (Diss., University of Cambridge, 2000).

4. See the articles in Anke te Heesen (ed.), *Cut and Paste um 1900: Der Zeitungsausschnitt in den Wissenschaften* in *Kaleidoskopien* 4 (2002): Thomas Schnalke on Rudolf Virchow (pp. 82–98), Michael Hagner on Oskar Vogt (pp. 116–29), Dieter Hoffmann on Ernst Gehrcke (pp. 70–80), and Marcus Popplow on Franz Maria Feldhaus (pp. 100–14); Markus Krajewski, "Der Privatregistrator: Franz

Maria Feldhaus und seine Geschichte der Technik," in Wolf Kittler and Sven Spieker (eds.), *Packrats and Bureaucrats* (forthcoming).

5. See Jürgen Stenzel, "Mit Kleister und Schere: Die Handschrift von *Berlin Alexanderplatz*," *Text + Kritik* 13/14 (1972), pp. 39–44. On Döblin and the art collage, see Jochen Meyer, "Alfred Döblin, *Berlin Alexanderplatz*, 1929," in Almut Otto, ed., *Das XX. Jahrhundert, ein Jahrhundert Kunst in Deutschland* (Berlin: Nationalgalerie, 1999), pp. 526–27.

6. Maud Lavin, *Cut with the Kitchen Knife: The Weimar Photomontages of Hannah Höch* (New Haven, CT: Yale University Press, 1993); Kathrin Hoffmann-Curtius, "Michelangelo beim Abwasch: Hannah Höchs Zeitschnitte der Avantgarde," in *Frauen Kunst Wissenschaft* 12 (1991), pp. 59–80.

7. Not to mention the art historian Aby Warburg in Hamburg, who amassed and ordered clippings at the beginning of the First World War and even impressed his whole family into service doing so. See Ernst H. Gombrich, *Aby Warburg: Eine intellektuelle Biographie* (Frankfurt: Suhrkamp, 1984), pp. 280–81; and Carl Georg Heise, *Persönliche Erinnerungen an Aby Warburg* (Hamburg: Gesellschaft des Bücherfreunde, 1959), p. 48.

8. Friedrich A. Kittler, *Discourse Networks 1800/1900.* (Stanford, CA: Stanford University Press, 1990).

9. See Emil Dovifat, ed., *Handbuch der Publizistik* (Berlin: de Gruyter, 1969), vol. 3, pp. 81ff.; and Thomas Nipperdey, *Deutsche Geschichte 1866–1918* (Munich: Beck, 1990), vol. 1, p. 798. For press agencies, see Jürgen Wilke, ed., *Telegraphenbüros und Nachrichtenagenturen in Deutschland* (Munich: Saur, 1991); a research overview of the press and the public is given by Jörg Requate, "Öffentlichkeit und Medien als Gegenstände historischer Analyse," *Geschichte und Gesellschaft* 25 (1999), pp. 5–32;. for Berlin, see Peter Fritzsche, *Reading Berlin 1900* (Cambridge, MA: Harvard University Press, 1996).

10. Eberhard Buchner, *Das Neueste von gestern: Kulturgeschichtlich interessante Dokumente aus alten deutschen Zeitungen* (Munich: Langen, 1912/13), vol. 1, p. x.

11. Hans Bohrmann and Wilbert Ubbens, eds., *Zeitungswörterbuch: Sachwörterbuch für den bibliothekarischen Umgang mit Zeitungen* (Berlin: Deutsches Bibliotheksinstitut, 1994), p. 196.

12. François Auguste de Chambure, *A travers la presse*, 7th ed. (Paris: Fert, Albouy, 1914), p. 545. "L'abonné qui reçoit une coupure soigneusement découpée et pliée, colée sur une fiche portant le titre, l'adresse et la date du journal d' où la coupure a été extraite, ainsi que le nom de l'auteur de l'article, ne peut s'imaginer la suite d'opérations minutieuses par lesquelles a passé, dans ce grand organisme,

l'information qu'il vient de recevoir et dont l'arrivée lui semble toute naturelle." According to the historian Franz Maria Feldhaus, the first clipping office in Germany was founded by Clemens Freyer in 1885 in Berlin. Initially, according to Feldhaus, he only collected for "statesmen and politicians." See Feldhaus to Freyer, May 16, 1910, Akten Nr. 693, I. Depositum Feldhaus, Deutsches Technikmuseum Berlin. Virchow ordered his clippings mainly from Freyer.

13. [P.A.], "Herr der tausend Scheren," *Daheim* 28 (1900), pp. 22; see also Irene-Hertha Schmidt, *Die wirtschaftliche Bedeutung und Organisation der Zeitungsausschnitte-Büros* (Berlin, 1939).

14. [W.R.], "Angewandte Journalistik," *Österreichisch-ungarische Buchhändler-Correspondenz: Organ des Vereins der österreichisch-ungarischen Buchhändler* 46 (Nov. 14, 1906), p. 655.

15. [P.A.], "Herr der tausend Scheren."

16. [W.R.], "Angewandte Journalistik," p. 656.

17. *Ibid.*, pp. 655–56.

18. In possession of the Max Planck Institute for the History of Science Library, legacy of Ernst Gehrcke.

19. Ernst Gehrcke, *Die Relativitätstheorie eine wissenschaftliche Massensuggestion* (Berlin: Arbeitsgemeinschaft dt. Naturforscher zur Erhaltung reiner Wissenschaft, 1920), p. 3.

20. I am following here the account of Carsten Könneker, *"Auflösung der Natur, Auflösung der Geschichte." Moderner Roman und NS-"Weltanschauung" im Zeichen der theoretischen Physik* (Stuttgart: Metzler, 2001), p. 17. Könneker evaluates and summarizes the cultural historical meanings of quantum physics on modern novels and mass media; esp. on Gehrcke, see pp. 134–39.

21. See Albrecht Fölsing, *Albert Einstein: Eine Biographie* (Frankfurt: Suhrkamp, 1993), pp. 513ff; and Könneker, *"Auflösung der Natur, Auflösung der Geschichte,"* pp. 119 and 129.

22. Gehrcke, *Die Relativitätstheorie eine wissenschaftliche Massensuggestion*, p. 11.

23. *Ibid.*, p. 29.

24. Ernst Gehrcke, *Die Massensuggestion der Relativitätstheorie: Kulturhistorisch-psychologische Dokumente* (Berlin: Meusser, 1924), p. v.

25. Interestingly enough, he refers mainly to the earlier descriptions and definitions of the masses, as in Gustave Le Bon, *Psychologie des foules* (1895), and Otto Stoll, *Suggestion und Hypnotismus in der Völkerpsychologie* (Leipzig, 1894). Besides those two authors he mentioned the following titles in a short bibliography on the masses and mass phenomenon: Siegfried Sieber, *Die Massenseele*

(Dresden, 1918); William McDougall, *The Group Mind* (Cambridge, 1920); Walther Moede, *Experimentelle Massenpsychologie* (Leipzig, 1920); Sigmund Freud, *Massenpsychologie und Ich-Analyse* (Leipzig, 1921).

26. Gustave Le Bon, *Psychologie der Massen* (Leipzig 1932), p. 10; see also Joachim Ritter and Karlfried Gründer, eds., *Historisches Wörtbuch der Philosophie* (Basel: Schwabe, 1971–), vol. 5 (1980), pp. 825–32 and 836–38.

27. Gehrcke, *Massensuggestion der Relativitätstheorie*, p. 100.

28. *Ibid.* p. 1.

29. *Ibid.* p. 1.

30. *Ibid.* p. v.

31. *Ibid.* p. 1.

32. See Klaus Hentschel, *Interpretationen und Fehlinterpretationen der speziellen und der allgemeinen Relativitätstheorie durch Zeitgenossen Albert Einsteins* (Basel: Birkhäuser, 1990), p. 57, where he gives a classification of the different kinds of literature on relativity theory.

33. Gehrcke, *Massensuggestion der Relativitätstheorie*, p. 2.

34. See Dietmar Jazbinsek, *Grosstadt-Dokumente* (Berlin, 1997); this series was a type of sociological travel guide to Berlin published by the writer Hans Ostwald.

35. Buchner, *Das Neueste von gestern*, vol. 1, pp. viii, x, xi, xiii, xiv.

36. *Ibid.*, p. 34.

37. Eberhard Buchner, *Kriegsdokumente: Der Weltkrieg 1914 in der Darstellung der zeitgenössischen Presse* (Munich: Langen, 1914), vol. 1, p. vii.

38. Ernst Goetz, "Sammlung und Nutzbarmachung der Zeitung," *Die Grenzboten* 75 (1916), pp. 124 and 125; see also Ernst Goetz, "Die historische Berechtigung und Bedeutung des hessischen Kriegszeitungsarchives," *Quartalblätter des Historischen Vereins für das Grossherzogtum Hessen* 1 (1916), pp. 29–37.

39. "The war is not yet ended and it has already been transcribed hundreds and thousands of times onto printed paper, it has already been offered as a new attraction to the tired palates of readers greedy for history." Friedrich Nietzsche, "Vom Nutzen und Nachtheil der Historie für das Leben," in *Sämtliche Werke*, eds. Giorgio Colli and Mazzino Montinari (Munich: Deutscher Taschenbuch Verlag, vol. 1, 1980), p. 279.

40. Goetz, "Sammlung und Nutzbarmachung der Zeitung," p. 124.

41. Stanislaw Jarkowski, "Die Zeitungsausschnitte als zeitungswissenschaftliches Quellenmaterial," *Zeitungswissenschaft*, Dec, 11, 1931, p. 417.

42. Friedrich Johann Kleemeier, "Ein Reichs-Zeitungs-Museum," *Börsenblatt für den Deutschen Buchhandel*, Aug. 22, 1908, p. 8888; Otto Kilger, *Das pflicht-*

gemässe Sammeln von Tageszeitungen in Deutschland: Nebst Standortnachweis für Sachsen, Thüringen, und Anhalt (Leipzig: Harrassowitz, 1938).

43. http://henrichs.cultd.net/04/4_o.htm, p. 1.

44. Paul Valéry feared the decline of literature and reading. Heavily criticizing the "telegraphism" of his time, referring to newspapers and public advertisements on the streets, he states: "The human being no longer sees and reads." Paul Valéry, *Cahiers*, ed. Hartmut Köhler and Jürgen Schmidt-Radefeldt (Frankfurt: Fischer, 1987–), vol. 6, p. 336. His general motif of critique was that "the newspaper is a squared location where author and audience are matching in a way, until only feebleminded persons are left over" (p. 294).

45. See *Brücken-Zeitung: Zeitschrift für Organisierung der geistigen Arbeit* 9 (1913); Karl Wilhelm Bührer and Adolf Saager, *Die Organisierung der geistigen Arbeit durch "Die Brücke"* (Ansbach: Seybold, 1911).

46. "Durch sorgfältige Auswahl seines Orientierungsmaterials kann man sich aber auch anhand von Büchern und Zeitungen sehr wohl ein besseres Bild von der Aussenwelt machen als dies bisher bei uns der Fall war." Carl Friedrich Roth-Seefrid, *Die Geisteskartothek: Ein zweckmässiges Hilfsmittel im Kampf um unsere wirtschaftliche Existenz* (Munich, 1918), p. 33.

47. "Was in der materiellen Welt das Werkzeug in seiner Überlegenheit über den nackten Menschen oder die Maschine in ihrer Überlegenheit über das Handwerkszeug ist, das ist die grosse Kartei für die geistige Arbeit." Heinz Potthoff, "Geisteskartei" *Die Umschau: Wochenschrift über die Fortschritte in Wissenschaft und Technik*, Aug. 24, 1918, p. 418.

48. Robert Musil, *Nachlass zu Lebzeiten*, 3rd ed. (Zurich: Humanitas, 1936).

49. Hanno Möbius, *Montage und Collage: Literatur, bildende Künste, Film, Fotografie, Musik, Theater bis 1933* (Munich: Fink, 2000), pp. 15–30.

50. Karl Riha, ed., *113 DaDa Gedichte* (Berlin: Wagenbach, 1982), p. 69.

51. George Grosz, *Ein kleines Ja und ein grosses Nein: Sein Leben von ihm selbst erzählt* (Hamburg: Rowohlt, 1955), p. 131. See also Herta Wescher, *Die Geschichte der Collage: Vom Kubismus bis zur Gegenwart*, 2nd ed. (Cologne: DuMont Schauberg, 1974), pp. 135–209; Diane Waldman, *Collage, Assemblage, and the Found Object* (London: Phaidon, 1992).

52. Grosz's relation to print media began in 1910, when a first drawing was published in a newspaper. Starting in 1916, he edited together with Herzfelde and Heartfield the journal *Neue Jugend* in the Malik-Verlag; see Peter-Klaus Schuster, ed., *George Grosz: Berlin, New York* (Berlin: Ars Nicolai, 1994), p. 244.

53. Helen Adkins, "Erste Internationale Dada-Messe," in *Stationen der Mod-*

erne: Die bedeutenden Kunstausstellungen des 20. Jahrhunderts in Deutschland, ed. Berlinische Galerie, 2nd ed. (Berlin, 1988), p. 164.

54. It was reproduced in George Grosz, *Mit Pinsel und Schere: 7 Materialisationen* (Berlin: Malik, 1922).

55. Gehrcke, *Massensuggestion der Relativitätstheorie*, p. 43.

56. Schuster, *George Grosz*, p. 420.

57. George Grosz, "Zu meinen neuen Bildern," *Das Kunstblatt* 1 (Jan. 1921), pp. 9–16.

58. This collection is housed in the Akademie der Künste, Archiv George Grosz, Berlin. The collection was gathered by Grosz from about 1933 onward; it can be assumed that he worked in a similar way before his emigration. I would like to thank Michael Krejsa for his generosity in making these materials available to me.

59. In German it reads "bunten Laz.-Pakete." The reference is to a *Lazarettpaket*, or parcel sent to the military hospital.

60. Herbert Knust, ed., *George Grosz: Briefe, 1913–1959* (Reinbek bei Hamburg: Rowohlt, 1979), p. 63.

61. For more details on the trial and the fair, see *Stationen der Moderne*, pp. 156–83.

62. Könneker, *"Auflösung der Natur, Auflösung der Geschichte,"* pp. 131ff.; Fölsing, *Albert Einstein*, pp. 513–33; Andreas Kleinert, "Paul Weyland, der Berliner Einstein-Töter," in Helmuth Albrecht (ed.), *Naturwissenschaft und Technik in der Geschichte* (Stuttgart, 1993), pp. 119–232.

63. Paul Weyland, *Betrachtungen über Einsteins Relativitätstheorie und die Art ihrer Einführung* (Berlin, 1920), pp. 19–20.

CHAPTER NINE: TALKING PICTURES: CLEMENT GREENBERG'S POLLOCK

1. It might be tempting to adopt an even greater plurality, such as Bruno Latour's concept of the *collectif*. See Latour, *Politique de la nature* (Paris: La Découverte, 1999); and Albena Yaneva, "When a Bus Met a Museum" (paper presented at the Max Planck Institute for the History of Science, Berlin, 2002).

2. On books as talking things, see Miguel Tamen, *Friends of Interpretable Objects* (Cambridge, MA: Harvard University Press, 2001).

3. The biographical, hagiographic, and intellectual-historical approaches are bracketed off explicitly in my other book-thing. See Caroline A. Jones, *Eyesight Alone: Clement Greenberg's Modernism and the Bureaucratization of the Senses* (Chicago: University of Chicago Press, forthcoming).

4. According to the various biographers of Greenberg, Pollock, and Krasner,

Greenberg first met Lenore Krassner in 1937 through their mutual friend Harold Rosenberg; Lee Krasner (as she shortened her name) met Pollock in early 1942, and she introduced Pollock to Greenberg when they bumped into each other on the street in December of that year, just before Greenberg went into basic training. After the war, sometime around the spring of 1946, the two men became friends; by July, Greenberg had been invited out to Springs, in East Hampton, New York, and contacts were frequent and intense, until Greenberg's "falling out" with Pollock in November 1952.

5. Many competing interpretations were forwarded by the artists themselves; others were later codified by Greenberg's nemesis the critic Harold Rosenberg in his "The American Action Painters," *Art News* 51 (1952). See Michael Leja, *Reframing Abstract Expressionism* (New Haven, CT: Yale University Press, 1993); and Ann Eden Gibson, *Issues in Abstract Expressionism: The Artist-Run Periodicals* (Ann Arbor, MI: UMI Research Press, 1990).

6. Clement Greenberg, "The Present Prospects of American Painting and Sculpture," *Horizon*, Oct. 1947, now anthologized in John O'Brian, ed., *Clement Greenberg: The Collected Essays and Criticism*, 4 vols. (Chicago: University of Chicago Press, 1986–1993), vol. 1, pp. 165–66. See the media response in "Jackson Pollock: Is He the Greatest Living Painter in the United States?" *Life*, Aug. 8, 1949.

7. Greenberg, "Review of Exhibitions of Marc Chagall, Lyonel Feininger, and Jackson Pollock," *Nation*, Nov. 27, 1943, in O'Brian, *Clement Greenberg*, vol. 1, pp. 165–66.

8. On Mondrian: "Rationalized décor — rectilinear lines and bright, clear colors — means the conviviality and concord of an urban tomorrow stripped of the Gothic brambles and rural particularities that retarded life in the past. Mondrian's pictures are an attempt to... stabilize life itself." Greenberg, "Review of Exhibitions of Mondrian, Kandinsky, and Pollock," *Nation*, Apr. 7, 1945, in O'Brian, *Clement Greenberg*, vol. 2, p. 15. Versus Kandinsky: "The late Kandinsky... fell somewhat short of Mondrian in practice but *maintained a better concept of what was going on.*" *Ibid.*, p. 16; emphasis added.

9. Let me hasten to note that I do want there to be "facts" in objects. Paint is applied in a sequence that hardens and cannot be reversed (although it can be removed or abraded away). Stone is chipped, clay blasted with heat, bronze cast, and physical forms become fixed until such time as they are altered through damage or reworking. Finally, and in some sense most interesting for historians of modernism, there are stubborn materialities of medium that fall outside (and are often *selected* to be external to) artistic control. These material effects sup-

port what I take to be the point of my paper: that the interpretive life of made things is underdetermined by material arrangements.

10. Greenberg, interviewed sometime between 1982 and 1988 by Steven W. Naifeh and Gregory White Smith, *Jackson Pollock: An American Saga* (1989; New York: HarperPerennial, 1991), p. 497. Some have cast doubt on this popular biography's use of the interview format, but I take these interviewees (taped, transcribed) to be part of the hum of discourse continually hammering at and tinkering with the constructions we call "Pollock" and the various visibilities they intersect. Contrast my reading with that of T. J. Clark, *Farewell to an Idea: Episodes from a History of Modernism* (New Haven, CT: Yale University Press, 1999), p. 439, n. 58.

11. Greenberg, "Review of Exhibitions of Mondrian, Kandinsky, and Pollock..." pp. 16–17.

12. Greenberg's 1945 statement of approval for an evenly dispersed yet ordered allover abstraction was very early; just five years later, that kind of painting was everywhere to be seen. See the more detailed discussion in my *Eyesight Alone*. See also Ann Eden Gibson, *Abstract Expressionism: Other Politics* (New Haven, CT: Yale University Press, 1997), particularly her discussion of Janet Sobel.

13. Greenberg, interviewed in the 1980s by Naifeh and Smith, *Jackson Pollock*, p. 870.

14. The Museum of Modern Art has only added to the confusion regarding the date of this mural. See footnote 17 to "Chronology" in Kirk Varnedoe and Pepe Karmel, *Jackson Pollock* (New York: Museum of Modern Art, 1998), p. 329, which cites a postcard from February 1944 in which Pollock claimed to his brother Frank to have painted "quite a large painting for Miss Guggenheim's house during the summer...it was grand fun." Naifeh and Smith are quite clear about a much later date, basing their account of an extremely compressed production on interviews with many individuals who saw the empty canvas in late December 1943 (see in particular the documented dinner with Ethel and Bill Baziotes, recorded as December 23, 1943, when all parties recall the canvas as still untouched; *Jackson Pollock*, p. 866). Most concur that *Mural* must have been painted in early January, just before it was due to be installed in Guggenheim's Manhattan apartment. See Naifeh and Smith, *Jackson Pollock*, pp. 466–69.

15. The first quotation is from Greenberg's interviews in the 1980s with Naifeh and Smith, *Jackson Pollock*, p. 472; the second quotation is from his interview with Florence Rubenfeld in the 1990s, in her *Clement Greenberg: A Life* (New York: Scribner, 1997), p. 75. See also the brief comment by Greenberg in a 1968 interview anthologized in Helen Harrison, ed., *Such Desperate Joy:*

Imagining Jackson Pollock (New York: Thunder's Mouth Press, 2000), p. 253.

16. Naifeh and Smith, *Jackson Pollock*, p. 469, and legions of others, describe the infamous dinner party in which a drunken Pollock lurched through the festive high-class group of literati into the living room, where he unzipped his pants and urinated into the marble fireplace. The occasion was a going-away soiree for Peggy Guggenheim's American friend and Greenberg's former lover Jean (Bakewell) Connolly.

17. Quoted by Rosalind Krauss with no attribution in her *The Optical Unconscious* (Cambridge, MA: MIT Press, 1993), p. 289. For a general discussion of Pollock and Siqueiros, see the excellent essay by Jürgen Harten, "When Artists Were Still Heroes," in *Siqueiros/Pollock Pollock/Siqueiros* (Düsseldorf: Kunsthalle Düsseldorf, 1995), pp. 43–57.

18. Greenberg, "Obituary of Mondrian," *Nation*, March 4, 1944, in O'Brian, *Clement Greenberg*, vol. 1, p. 188.

19. *Ibid.* Mondrian, in Greenberg's own quotation, clarifies his meaning. "At the moment, there is no need for art to create a reality of imagination.... Art should not follow the intuitions relating to our life in time, but only those intuitions relating to true reality." The key phrase here to me is not some escape from time and its "tragic vicissitudes" but a vision of "true reality" from which art should be posed not as an escape but as a confirmation.

20. *Ibid.* In *Eyesight Alone*, I argue that this cultural bureaucratization was itself part of the larger bureaucratization of the senses, in which Greenberg's formalism played only a part.

21. Naifeh and Smith, *Jackson Pollock*, p. 527.

22. Greenberg, "Review of Exhibitions of the American Abstract Artists: Jacques Lipchitz, and Jackson Pollock," *Nation*, April 13, 1946, in O'Brian, *Clement Greenberg*, vol. 2, pp. 74 and 75.

23. Greenberg, "Our Period Style," *Partisan Review*, Nov. 1949, in O'Brian, *Clement Greenberg*, vol. 2, p. 325.

24. Gilles Deleuze, "Foldings, or the Inside of Thought," in *Foucault*, trans. and ed. Seán Hand, foreword by Paul Bové (Minneapolis: University of Minnesota Press, 1988), p. 98. What Deleuze quotes is from Michel Foucault, *Les Mots et les choses* (Paris: Gallimard, 1966), p. 350, translated by Alan Sheridan as *The Order of Things* (New York: Pantheon, 1970), p. 339.

25. The body is both prime metaphor *for* enfolding (the allusion to embryology is significant here, because the corpuscle becomes the *corps* through thousands of microscopic foldings, extrusions, and invaginations) and a primary site

for subjectivation *through* folding: "Subjectivation is created by folding." Deleuze, *Foucault*, p. 104. Also: "The outside is not a fixed limit but a moving matter animated by peristaltic movements, folds and foldings that together make up an inside: they are not something other than the outside, but precisely the inside *of* the outside." *Ibid.*, pp. 96–97.

26. This process of enfolding from the visibility, and the links I draw to Greenberg's metaphor of castration, are related to Lacan's connection between castration and the subject's formation in language. See Jacques Lacan, *The Four Fundamental Concepts of Psychoanalysis*, trans. Alan Sheridan (London: Hogarth, 1977); and Jacques Lacan, *Ecrits: A Selection*, trans. Alan Sheridan (London: Tavistock, 1977).

27. Greenberg, "Review of Exhibitions of Marc Chagall...," p. 166.

28. By "only viable postwar form," I mean to suggest Greenberg's ideology, not the reality of competing political positions at the time. Greenberg's former Trotskyism was aligning itself with the "vital center" of postwar American capitalist democracy. The best historical analysis of this depoliticization in art remains Serge Guilbaut, *How New York Stole the Idea of Modern Art* (Chicago: University of Chicago Press, 1983).

29. The story goes that when the painting proved too large for the foyer wall, Marcel Duchamp advised Guggenheim to crop it, saying something like in this type of painting, it didn't matter." Naifeh and Smith, *Jackson Pollock*, p. 469.

30. Harry Jackson's recollection of Pollock's statement; *ibid.*, p. 468.

31. *Ibid.*, pp. 112–13, 468.

32. The detail (reproduced here in color plate VIII) shows that black may have been the first to go down, but there are subsequent passings of black *over* slate and salmon red and yellow, just as there are passages of yellow and salmon red that go over slate, and so on. What I want to emphasize here are the structural, large-body repetitions that go into this painting, in contrast to the Hollywood brushwork performed by Ed Harris in mimicry of Pollock for his 1999 film.

33. It is this post-1950 possibility that informs most of the readings of Pollock produced by younger artists such as Allan Kaprow and Robert Smithson, as I argue in *Machine in the Studio* (Chicago: University of Chicago Press, 1996).

34. This is a key point. Sport, or dance, or even agriculture was also a plausible part of Pollock's own habitus, or available in the associational frame of his viewers, critics, and collectors. But such traditional movement still took modern, routinized, aggregative forms under industrialization (wheat harvesting is very different when you're feeding stalks of grain into a threshing machine). *Greenberg's* Pollock was utterly enslaved to the modern body disciplines that

came from segmented industrial labor and the bureaucratic efficiencies it enabled. As Greenberg argued in 1949 in "Our Period Style," "The new art style breathes rationalization" (p. 147). Later, in his response to T.S. Eliot's cultural criticism, Greenberg averred that the rule of efficiency was necessarily, if not joyfully, "internalized" — "as it must be if industrialism is really to function." ("Plight of Our Culture," in O'Brian, *Clement Greenberg*, vol. 1, p. 147 .)

35. For "hallucinated uniformity," see Greenberg, "The Crisis of the Easel Pictures," *Partisan Review*, Apr. 1948, in O'Brian, *Clement Greenberg*, vol. 2, p. 224.

36. See, for significant examples of "order" in Pollock's art, Jean Connolly, "Art," *Nation*, May 29, 1943; Edward Alden Jewell, "Art: Briefer Mention," *New York Times*, Nov. 14, 1943, sec. 2, p. 6; "The Passing Shows," *Art News*, April 1, 1945, p. 6; Manny Farber, "Jackson Pollock," *New Republic*, June 25, 1945, p. 871. Most are excerpted in Pepe Karmel and Kirk Varnedoe, *Jackson Pollock: Interviews, Articles, and Reviews* (New York: Museum of Modern Art, 1999).

37. To my knowledge, Jeremy Lewison is the first to make this connection directly to Pollock's *Mural*. See his *Interpreting Pollock* (London: Tate Gallery Publishing, 1999), p. 33.

38. For the minimalists' interest, note the serialism of Sol LeWitt, who made an early sculpture that incorporates segments of Muybridge photographs.

39. See Krauss, *Optical Unconscious*, p. 301.

40. Greenberg, "Our Period Style," p. 326.

41. Mili was joined by the Motion and Time Study Laboratory of Purdue University, brought in by the editors of *Life* "to undertake a research program in which the methods of work analysis long used in industry would be applied to the home." See *Life*, Sept. 9, 1946, p. 97.

42. Donna Lamb, "Freedom and Order in Gjon Mili's Photo 'Harlem Lindy Hoppers,'" *San Antonio Register*, Aug. 20, 1998, available as of November 2001 at the somewhat murky and cultish "Aesthetic Realism" Web site, http://www.aestheticrealism. org/Dance_dl.htm.

43. Deleuze's most accessible writing on the topic of the visibility can be found in his *Foucault* and in *The Fold: Leibniz and the Baroque*, foreword and trans. Tom Conley (Minneapolis: University of Minnesota Press, 1993).

44. Amelia Jones, *Body Art: Performing the Subject* (Minneapolis: University of Minnesota Press, 1998).

45. Greenberg, "Interview Conducted by Lily Leino," USIS (Feature of the United States Information Bureau), Apr. 1969, in O'Brian, *Clement Greenberg*, vol. 4, pp. 308, 309.

Contributors

Lorraine Daston is Director at the Max Planck Institute for the History of Science in Berlin, Germany. Among her books are *Classical Probability in the Enlightenment*, *Wonders and the Order of Nature, 1150–1750* (with Katharine Park), and *Wunder, Beweise, und Tatsachen: Zur Geschichte der Rationalität*. She has co-edited a collection of essays on *The Moral Authority of Nature*; recent publications include articles on the history of intelligence, facts, objectivity, and scientific attention.

Peter Galison is the Mallinckrodt Professor of the History of Science and of Physics at Harvard University. He is the author of *How Experiments End*, *Image and Logic: A Material Culture of Microphysics*, and *Einstein's Clocks and Poincaré's Maps: Empires of Time*. He has also co-edited a series of volumes aimed at linking the history of science with other disciplines; these include *The Disunity of Science*, *Picturing Science*, *Producing Art*, *The Architecture of Science*, and *Scientific Authorship*. His current work is on the history of scientific objectivity.

Anke te Heesen is Research Scholar at the Max Planck Institute for the History of Science in Berlin, Germany. She curated several exhibitions and is currently working on a study of the notation systems of scientists. She is the author of *The World in a Box* and editor of *Sammeln als Wissen: Das Sammeln und seine wissenschafts-geschichtliche Bedeutung* and *Cut and Paste um 1900: Der Zeitungs-ausschnitt in den Wissenschaften*.

Caroline Jones teaches contemporary art and theory in the History, Theory, and Criticism Program of the Department of Architecture at the Massachusetts Institute of Technology. The producer and director of two documentary films and the curator of exhibitions, she is the author of *Modern Art at Harvard*, *Bay Area Figurative Art, 1950–1965*, and the award-winning *Machine in the Studio: Constructing the Postwar American Artist*. She co-edited *Picturing Science, Producing Art*. Her most recent book, *Eyesight Alone: Clement Greenberg's Modernism and the Bureaucratization of the Senses*, will be published in 2004.

Joseph Leo Koerner is Professor of the History of Art at University College London and the Courtauld Institute of Art. His books include *Caspar David Friedrich and the Subject of Landscape*, *The Moment of Self-Portraiture in German Renaissance Art*, and *The Reformation of the Image*.

Antoine Picon is Professor of the History of Architecture and Technology at the Harvard Graduate School of Design. He has published extensively on the relations among architecture, urban design, science, and technology. His books include *French Architects and Engineers in the Age of Enlightenment*, *Claude Perrault, 1613–1688; ou, La Curiosité d'un classique*, *L'Invention de l'ingénieur moderne*. In 1997, he edited a dictionary of the history of

engineering for the Centre Georges Pompidou titled *L'Art de l'ingénieur: Constructeur, entrepreneur, inventeur*. His recent works include *La Ville territoire des cyborgs* and *Les Saint-Simoniens: Raison, imaginaire, et utopie*.

Simon Schaffer is Reader in History and Philosophy of Science at the University of Cambridge. He has published several essays on Victorian physics, technology, and society. In 1995, he helped curate two exhibitions on late-nineteenth-century physics: *Empires of Physics* and *The New Age*. In 2000, he co-organized an exhibition on digitization in art and science, *NOISE: Information and Transformation*. His most recent publication is an essay on Charles Babbage as utopian professor.

Joel Snyder is Professor of Art History at the University of Chicago and a co-editor of the journal *Critical Inquiry*. He has written extensively on the history and theory of photography and film.

Elaine M. Wise is a research associate in the Department of History at the University of California, Los Angeles. With M. Norton Wise, she has published "Reform in the Garden" in *Endeavour*.

M. Norton Wise is Professor of History at the University of California, Los Angeles. He studies the cultural history of science in terms of technologies that mediate between theories and things and between science and culture. His most recent works include an edited volume titled *Growing Explanations: Historical Perspectives on the Sciences of Complexity* and a book on bourgeois Berlin and laboratory science (in preparation).

Index

433

445

Designed by Bruce Mau with Sarah Dorkenwald
Typeset by Archetype
Printed and bound by Maple-Vail on Sebago acid-free paper